STONEHENGE COMPLETE Christopher Chippindale

REVISED EDITION

With 266 illustrations, 13 in color

THAMES AND HUDSON

for Thomas, again

'I have been intent not to go by hearsay, but have fished for the certainty of this story out of common records, or at least by report of men of worthy credit'

AFTER JOHN SLEIDAN

Any copy of this book issued by the publisher as a paperback is sold subject to the condition that it shall not by way of trade or otherwise be lent, resold, hired out or otherwise circulated without the publisher's prior consent in any form of binding or cover other than that in which it is published and without a similar condition including these words being imposed on a subsequent purchaser.

© 1983 and 1994 Christopher Chippindale

Published in paperback in the United States of America in 1994 by Thames and Hudson Inc., 500 Fifth Avenue, New York, New York 10110

Library of Congress Catalog Card Number 93-61371

ISBN 0-500-27750-8

All Rights Reserved. No part of this publication may be reproduced or transmitted in any form or by any means, electronic or mechanical, including photocopy, recording or any other information storage and retrieval system, without prior permission in writing from the publisher.

Printed and bound in Slovenia by Mladinska Knjiga

Half-title Stonehenge in the snow, 1947. The classic photograph by Bill Brandt. Title page Inside the ruined sarsen building of

ruined sarsen building of Stonehenge.

This page Stonehenge has been used as an emblem by all manner of organizations (since the Stonehenge astronomy boom especially in the western USA). This is the logo of the Sarsen Press, Redwood City, California.

CONTENTS

	Preface	6
	Introduction	10
1	To the medieval eye	20
2	In the age of Queen Elizabeth	29
3	During the English Renaissance	43
4	Mr Aubrey and Dr Stukeley	66
5	A delusion of Druids	82
6	The sublime and the romantic	96
7	The making of Ancient Wiltshire	113
8	Of age, evolution and astronomy	126
9	Victorian visitors	141
10	The proprietor and his public	157
11	1900 and after	164
12	The destruction of half Stonehenge	179
13	Wessex to Mycenae, and back	198
14	The moon behind the megaliths	220
15	Alternative visions	233
16	A future for Stonehenge	251
17	Stonehenge: a basis of knowledge	264
	In conclusion	273
	Visiting Stonehenge	275
	Further reading	275
	Notes	276
	Acknowledgments	288
	Sources of the illustrations	288
	Index	291

1 Stonehenge in rural peace, from a late Victorian travel book.

Stonehenge sets a puzzle that has never been solved. For centuries the people who have gone to see it have found it a mirror which reflects back, more or less distorted, that view of the past which the on-looker takes there. This book brings together a great many images in that mirror.

Imagination has made Stonehenge a field of conjecture 'where the mazes of wild opinion are more complex and intricate than the ruin'.¹ I have explored those mazes and set down some of the truth I found there.

I have tried to include everything important, interesting or odd that has been written or painted, discovered or felt, about the most extraordinary of all ancient buildings. The book is written as a history of Stonehenge since its re-discovery in AD 1130; through that history it shows during eight centuries what we have felt about the past and its remains, and tells the prehistory of Stonehenge, which goes back about four thousand years further, as that has been gradually revealed.

A brief introduction describes Stonehenge, for those who have never seen it, and as a reminder and reference for those who have. The chapters which follow are, approximately, in chronological order, each concentrating on a single theme at the period when it was dominant.

Naturally, ideas of Stonehenge have followed the fashions of the age. In medieval times it found a place in patriotic schemes of early British history. The 17th-century age of learning marks the first attempts to analyse it. In the 18th century its history was submerged under religious dogma. The best paintings relating to it are from the golden age of English landscape watercolours in the early 19th century.

But there have been surprises, especially in recent years. By the late 1930s professional archaeologists thought they had at last got the measure of Stonehenge. All those amateurish speculations, Druidical fantasies and the rest of the 'pompous nonsense' were to be swept away by the objective facts contained in a few excavation reports.² Not so. The past few decades have been much odder than any that went before. The archaeologists, the experts in whose domain Stonehenge seemed naturally to belong, found the initiative was instead seized by the astronomers. The place itself was taken possession of by a free festival, and orthodox academic knowledge obscured by a cloud of 'New Age' beliefs.

Stonehenge in the 1980s and 1990s is an odd place, even by the standards of Stonehenge. Passing fads, like the epidemic of 'crop circles' in English cornfields of the late 1980s, have paid their respects to it. Its custodians, though they keep the place physically secure, have not learnt how to explain its elegance and mystery to an enormous public. Its surroundings and presentation, British MPs decided in 1993, are so poor they have become a 'national disgrace'. Perhaps they will be better in the new millennium – but a decade ago we all expressed this hope for the 1990s.

The stones themselves still stand, enduring in a society which is not. All these pressures and delusions cannot destroy the wonder of the little setting of rocks that is the greatest memorial of the men, and the women, of a vanished age.

For this second edition of *Stonehenge Complete*, written ten years after the first, I have revised the text throughout. In the earlier chapters, alterations are minor. At the end, where recent events change much, they are large.

London & Devizes, Midsummer 1982; Cambridge, Autumn 1993

2 A Bibliohenge. The books are closed as well as rotting.

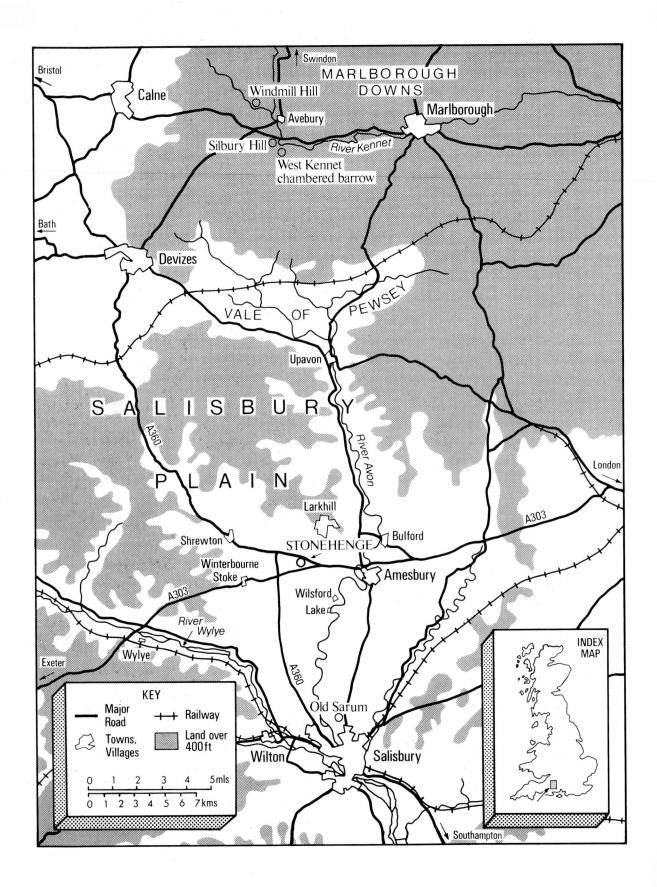

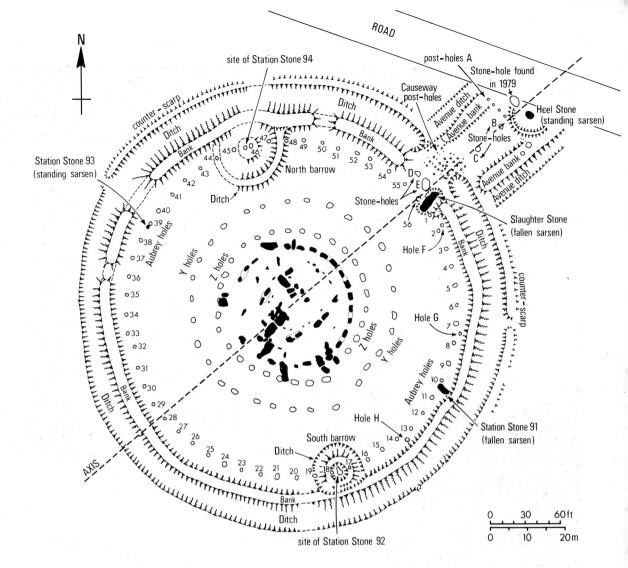

3 (opposite) The position of Stonehenge on the Wessex chalklands, a little above the River Avon. Some 15 miles north, across the low-lying Vale of Pewsey, is the Avebury complex of monuments. 4 (above) The general plan of Stonehenge shows its outlying features: earthworks (bank, ditch and counterscarp, causeway entrance and Avenue, North and South Barrows); stones (Heel, Slaughter, and two Station stones); and the rings of Aubrey holes, Y and Z holes.

5 (right) The five central stone settings: outer sarsen (numbers 1–30); outer bluestone (numbers 31–49); inner sarsen (numbers 51–60); inner bluestone (numbers 61–72); and Altar Stone (number 80); also lintels with numbers from 101 upwards.

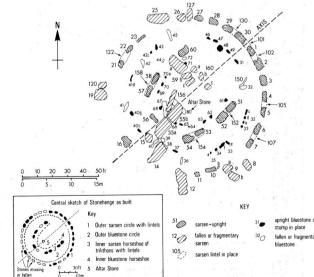

LETE STONEHENGE COMPLETE STONEHENGE STONEHENGE COMPLETE STONEHENGE COMP

> Stonehenge is the ruin of a single stone building. As great buildings go, it is a plain structure. It was built of about 162 stone blocks altogether, none of them decorated and most of them rather simply arranged. And it is not very large, only thirty-five paces across; it would all but fit inside the dome of St Paul's Cathedral or squeeze into the reading room under the dome of the Library of Congress.

> Yet these few pieces and their design, which is carried out with great precision and subtlety, still hold secrets. Of all the discoveries of post-war years, the most remarkable – the finding of prehistoric carvings on the stones – was made without archaeological excavation, or astronomy, or abstruse science. The carvings had always been there, looked at but not seen by generations of curious visitors and diligent scholars. It only took observant eyes to recognize the outlines of a dagger and an axe, weathered from their original sharpness but clear nonetheless. Once you knew what to look for, they could be seen from a full hundred yards away when the light was right. And a few days after the first carvings were found, a ten-year-old boy, now knowing what to look for, spotted a second group.

> 'The greatest thing a human soul ever does in this world,' thought Ruskin, 'is to see something and tell what it saw in a plain way.' Very few have done so at Stonehenge. This Introduction states only the plain facts: where Stonehenge is, and what the visitor looks at. What the visitor has seen and told is the subject of the rest of the book.

> Stonehenge lies in the county of Wiltshire in central southern England, about 30 miles north of the English Channel coast, and about 80 miles west of London. It stands at a height of about 330 ft above sea level, on the spread of rolling chalk downland known, although it is not at all flat, as Salisbury Plain. Near it are a great many prehistoric earthworks, but the nearest settlement of recent centuries is the little town of Amesbury, in the valley of the river Avon $2\frac{1}{2}$ miles to the east. The cathedral city of Salisbury is 8 miles to the south.

The name 'Stonehenge', which is of Saxon origin (though the building is very much older), comes from the roots 'stone' and 'henge', or 'hang'. It is the place of 'hanging stones', that is, of the stone lintels of the sarsen circle and horseshoe. Those stone lintels, and the shaping of many of the

6 (opposite) A recent aerial view of Stonehenge from the north. The central cluster of stones is the main sarsen and bluestone ruin. Outside it, marked by a semicircle of white dots, is the ring of Aubrey holes, then the bank, the ditch, and the visitors' pounded pathway. The standing outlier. centre left. is the Heel Stone. Running past it can faintly be seen in the grass the marks of the Avenue bank and ditch, which continue in the field beyond the road. All the other tracks visible are modern.

stones into trimmed rectilinear forms, are the unique features which set Stonehenge apart from the stone circles in western Britain which it otherwise resembles.

There seems nothing very special about the placing of Stonehenge. It stands towards the top of a gentle slope, not especially prominent but visible from a mile or two in most directions. As you approach it, you see a tight huddle of stones, mid grey in colour. The actual stone is rather brightly coloured, mostly orange-brown and blue, but a close overcoat of lichens growing on it conceals the natural colours under a

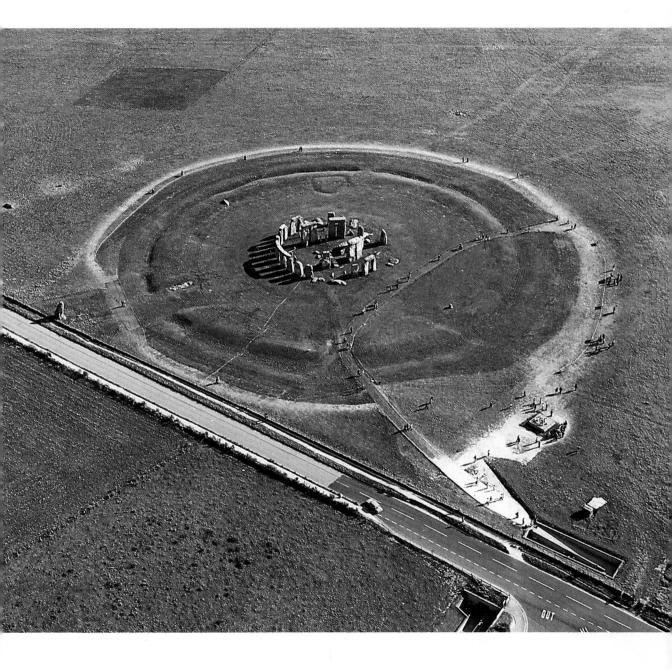

grey-green cover. About half the original stone structure is entirely missing, and some of what remains is fallen and broken, or hidden under the turf. But enough survives to show the original form.

The building is made of single, very large stone blocks, some much weathered, but with their intended shape always clear. Each upright and each horizontal lintel is made of a single large stone ('monolith'). No mortar was used; the joints are all dry-stone.

When you are close, tumbled stones and broken fragments confuse, but the pattern of the main structure is straightforward enough seen from the air, or when you walk within it. There are five concentric elements. Working from the outside in, they are:

The outer sarsen circle*

Thirty squared uprights, of a variety of sandstone known as sarsen, are arranged in a true circle about 100 ft in diameter. Each stone stands about $13\frac{1}{2}$ ft above the ground, and is about 7 ft wide. The space between adjacent stones is about $3\frac{1}{2}$ ft. Their average thickness is about $3\frac{3}{4}$ ft, and the smoother of the two faces is the one turned towards the inside.

The uprights support horizontal stone lintels, which form a continuous circle of stone, its flat top about 16 ft above the ground. Each lintel is some $10\frac{1}{2}$ ft long, $3\frac{1}{2}$ ft wide, and $2\frac{3}{4}$ ft thick. The lintels do not just sit on top of the uprights. They are held in position by a kind of joint which has no place in a conventional stone building; the technique is called – by inference from the standard carpenter's technique in woodworking which it closely resembles – 'mortice and tenon'. Each upright bears on its top surface two conical projections, or 'tenons', one for each of the two lintels it supports. Each end of each lintel has a corresponding hollow, or 'mortice', which fits snugly over the tenon to hold it in place. And each lintel is secured to its neighbours by 'toggle' joints, a vertical tongue at the end of the lintel nesting into a corresponding groove in its neighbour – a translation into stone of carpenter's tongue-and-groove.

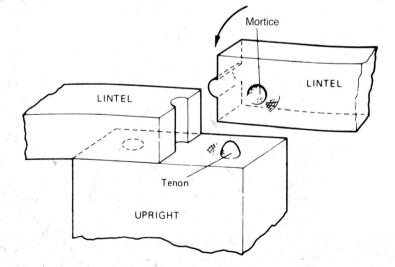

In the conventional numbering system, devised by Petrie and still used to identify each stone of Stonehenge, the outer sarsen uprights are numbered 1-30 (ill. 5). The lintels they support are similarly numbered 101-130.

7 The system of mortice and tenon joints. Most of the lintels have been robbed, but more than half of the thirteen that survive are, after 4,000 years, still in place. What little wear they suffer is due to the slight movement of the stones with changing temperature and, perhaps, in high winds.

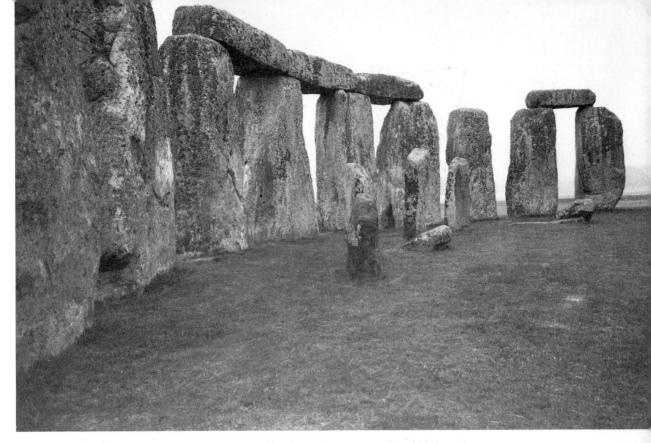

8 (above) The outer sarsen circle, with its run of continuous lintels (some now missing), and the much smaller bluestone uprights within.
9 (below) The inner sarsen horseshoe, of separate trilithons, and the much smaller bluestone uprights within.

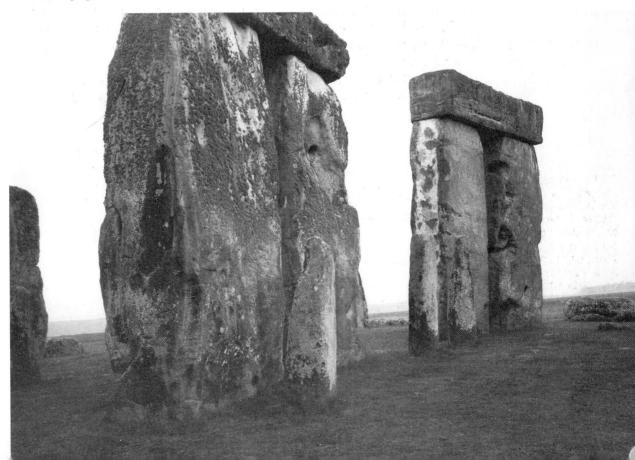

The sarsen circle is most complete on the north-eastern side, where eleven uprights in succession remain standing, and support a continuous run of three lintels. To the south and south-west little remains; one stone on that side, number 11 in the conventional numbering, is very much shorter, narrower and thinner than the rest, and suggests the supply of full-size stones ran out before the circle was completed. Most of the lintels, the smallest of the shaped sarsens, have disappeared.

The outer 'bluestone' circle*

Immediately within the sarsen circle is a setting of much smaller upright stones, without lintels, forming a less regular circle about 75 ft in diameter. The size of the stones varies. Most are $6\frac{1}{2}$ ft or a little more high, $3\frac{1}{4}$ to $4\frac{1}{2}$ ft wide, and some $2\frac{1}{2}$ ft thick.

These stones, distinctly bluish in colour and mostly flecked with pink spots, are of a geological group of igneous rocks. All but two are untrimmed boulders, but they are rectilinear, more or less, as the stone naturally splits that way. The two which are trimmed have cut into them one mortise hole at each end; evidently they were shaped as lintels for two bluestone trilithons, and then re-used as simple uprights in the circle. Only six now stand upright; others lean, or lie flat or in pieces. Originally there were perhaps sixty.

The inner sarsen trilithons**

Inside the bluestone circle stand the other sarsen structures, five 'trilithons', each consisting of two uprights under a horizontal lintel. (The word 'trilithon' was invented in the 18th century by William Stukeley from the Greek for 'three stones'.) Like the outer circle, the trilithons are made of dressed sarsen blocks, with the smoother face towards the inside, and the lintels are held in place with mortise-and-tenon joints. But the lintels are not continuous, and each trilithon is an independent structure.

The trilithons are arranged symmetrically in a horseshoe shape, about 45 ft across, with its open end towards the north-east. The north-east pair are the smallest, their overall height being about 20 ft; the central pair are taller, and the great trilithon on the south-west stood well over 24 ft high. The uprights of each trilithon are comparable to those of the outer circle in width and in thickness, but the gap between the uprights is much smaller, just a thin space between the two great blocks.

Three of the five trilithons stand intact, both of the central pair and the easterly of the smaller pair. Of the other one and of the great trilithon, respectively, only one upright is left standing; the broken remains of the second upright and the lintel lie on the ground in front. The surviving upright of the great trilithon, of which 22 ft are above ground and another 8 ft below, is among the tallest of the ancient stones still standing in the British Isles. All fifteen stones making up the trilithons are still there.

The outer bluestones are numbers 31–49, with alphabetical suffixes up to, for instance, 32e for broken or supplementary stones. The bluestone lintel, reused as an upright, is number 150.

* The inner sarsen uprights are numbers 51–60, and their lintels 152, 154, 156, 158, 160.

The inner bluestone horseshoe*

Just within the sarsen horseshoe is a horseshoe of upright bluestones \star without lintels, just as there is a bluestone circle within the sarsen circle. Those in the horseshoe are carefully dressed into square-section pillars about 2 ft across. The shortest is under 6 ft high, and they increase in size towards the south-west, in the same way as the sarsen trilithons, to a maximum of about 8 ft. Six of the original nineteen are still in place.

The 'Altar Stone'**

Lying in the surface of the ground, towards the apex of the horseshoe, is a single large slab of grey-green sandstone, geologically quite different from the sandstone of the sarsens, and about 16 ft long. It once stood upright, probably, but now lies snapped in two and largely hidden under the fallen pieces of the great trilithon. Its name, along with those of the 'Slaughter', 'Heel' and 'Station' Stones, is a modern fancy as to its original purpose.

In summary, the five components of the building are, from the outside inwards: sarsen circle with continuous lintels, bluestone circle, sarsen horseshoe of trilithons, bluestone horseshoe, Altar Stone.

Both horseshoe settings fall symmetrically about an axis for the building, aligned north-east to south-west.

Outside the main building of Stonehenge are other stones and eroded remains of earthworks. The building stands on almost, but not quite, level ground in the centre of a circular enclosure, bounded by a ditch, of inner diameter about 330 ft. The chalk dug from the ditch was piled up on the inside to form a bank. The bank is now heavily eroded, and the ditch silted so its bottom is now less than 3 ft below the bank top.

Just inside the bank are two 'Station Stones', blocks of sarsen, which stand one on the north-west and one on the south-east. Two little ditches round their sites mark the places where their vanished twins used to stand, at the north and south 'barrows'.

On the axis, to the north-east is a break in bank and ditch, forming a causeway about 35 ft wide. Flat in the turf on the east side of the causeway lies the 'Slaughter Stone', a rough-dressed slab of sarsen about 21 ft by over 7 ft. Its upper surface, all humps, bumps and hollows often filled with rainwater, gave it this name, as it seemed in the 18th century so obviously suited to catch the blood of victims sacrificed on it.

Also close to the axis, and about 85 ft outside the causeway, stands the 'Heel Stone', a single untrimmed sarsen almost 16 ft high.

Running out from the ditch, close to the point where it breaks for the causeway, are two parallel banks and ditches about 70 ft apart, which define the 'Avenue'. They run along the axis, pass each side of the Heel Stone (where they are cut across by a modern road) and run down the hill in the field beyond, where they are hard to see in the long grass.

The inner bluestones are numbers 61-72.

The Altar Stone, numbered 80, is usually identified by its name, as are the outliers, though they have numbers too: the Station Stones, for instance, are 91–94.

15

10 (following page) The

hollows and runnels filled

with water rather than blood, sprawled in the

grass by the entrance

causeway.

Slaughter Stone, its

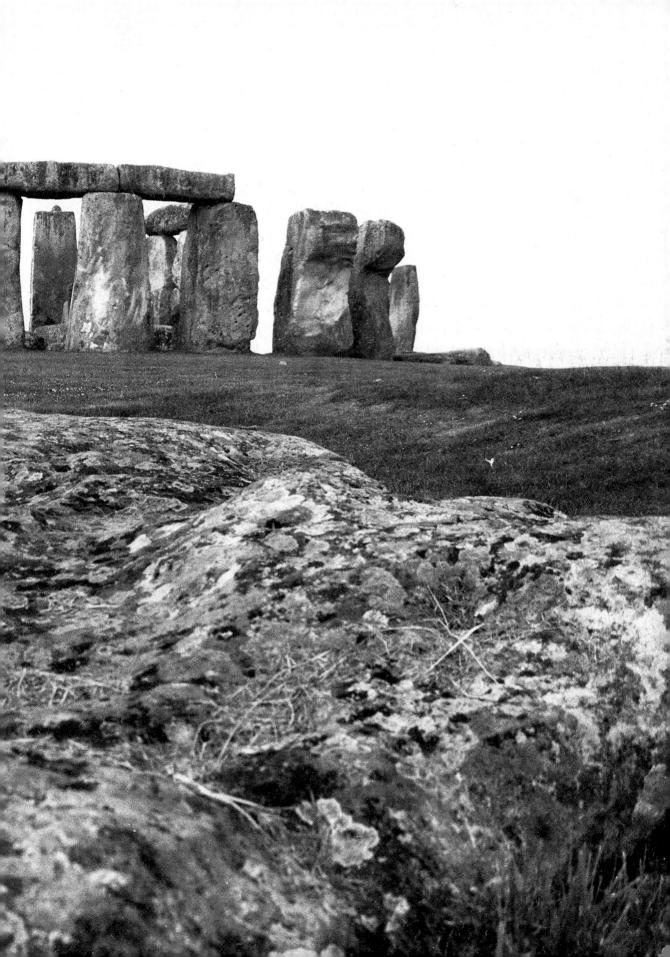

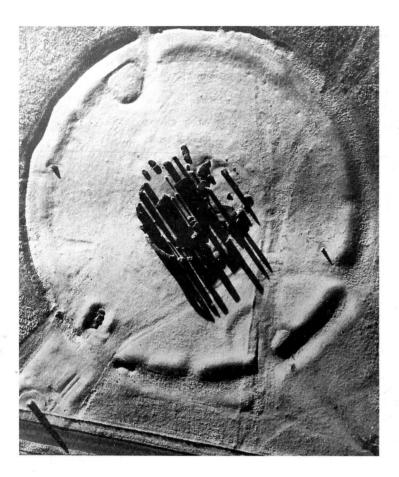

11 The best impression of the surface features is to be had from an aerial photograph taken with the sun very low in the sky, in this case early on a winter morning.

As well as the central setting, three outlying stones throw long shadows, the Heel Stone (bottom left) and both Station Stones (centre left and centre right). The Slaughter Stone (midway from Heel Stone to central ruin) lies flat in its hollow.

The bank is brightly high-lighted, the ditch is in shadow, and the counterscarp outer bank can be seen outside the ditch, lower right. Just inside the bank (top, a little left of centre) is the irregular ring of the South Barrow, site of a missing Station Stone. Its partner opposite, the North Barrow (lower right), is largely obscured by cart-tracks, which have also damaged the Avenue (lower left), whose banks and ditches can be seen running out from the causeway by the Slaughter Stone. The Heel Stone is seen to stand well to one side of the central axis of the Avenue.

There is a second, narrower causeway through the bank and ditch at the south. The other breaks, including the two used by the visitors' path, are modern.

Various other dips and rises can be seen on the surface, especially when the late afternoon sun throws long shadows. Most of these are recent marks resulting from the roads which ran across the site until about sixty years ago. But some are ancient, such as an outer second bank or 'counterscarp', much slighter than the main bank inside, which is visible outside the ditch to the north of the causeway.

The positions of a ring of regularly spaced pits just within the bank, the 'Aubrey holes', have been marked on the eastern side only by round concrete markers let into the turf. Two more rings of pits, the Y and Z holes, lie under the grass in the open area between the building and the Aubrey holes. These, like other holes within the building and near the causeway, cannot be seen on the surface.

There are many refinements to be spotted in the shaping and the placing of the stones. The uprights of the outer circle are not parallel-sided. They taper towards the top. The taper is often not straight but convexly curved in a manner reminiscent of entasis, the deliberate

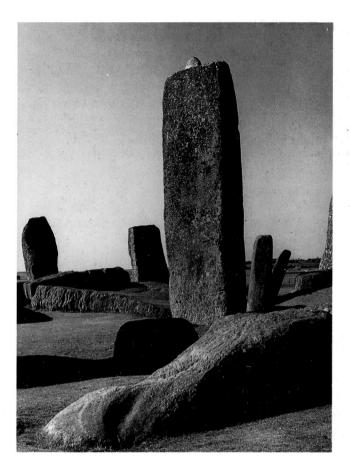

12 The precise shaping of the sarsen uprights, not just into neat straight edges but subtle convex curves, is shown by the outline of stone 56. Whether entasis was intended is a different matter; certainly, the sarsens do not look to be straight-edged, which is the supposed purpose of entasis.

slight curving of the columns in classical Greek temples supposed to give an optical illusion of exact straightness. The uprights are not all of equal width, but they are placed with their centres the same distance apart, so that there is a slight variation in the spaces between them. The two uprights each side of the axis, numbers 30 and 1, are set a little further apart than the standard, giving a hint of an entrance way, and the spaces between those and their neighbours are reduced to compensate. The depth to which the stones are set into the ground is adjusted so the line formed by their tops is close to horizontal, even though the overall length of the stones varies somewhat and the ground on which the building stands slopes a little. The lintels are not straight, but curve on both inside and outside faces so they meet in a smooth circle. Their depth is varied, and they may be cut away a little where they sit on an upright, to allow for the slight differences in the heights of the uprights. The upper surface of the lintels therefore forms - or did form before most of the lintels disappeared and the survivors shifted slightly – a circle, nearly 100 ft across and 16 ft above ground, which is within an inch or so of being precisely circular and perfectly level.

STONEHENGE COMPLETE STONEHENGE COMPLETE STO EHENGE COMPLETE STONEHENGE COMPLETE STONEH GE COMPLE **1 TO THE MEDIEVAL EYE**LETE STONEHENGE OMPLETE STONEHENGE COMPLETE STONEHENGE COM ETE STONEHENGE COMPLETE STONEHENGE COMPLETE

'Eternall markes of treason may at Stoneheng vew'

'Stanenges, where stones of wonderful size have been erected after the manner of doorways, so that doorway appears to have been raised upon doorway; and no one can conceive how such great stones have been so raised aloft, or why they were built there.'¹

These few words, in their original Latin, are the first notice we have of Stonehenge. They were written about the year 1130 by a man we know as Henry of Huntingdon. An archdeacon at Lincoln, he was commissioned by the new bishop, Alexander of Blois, to write a history of England. He prefaced the history proper with a short account of Britain, her counties and cities, and her marvels. One is Stonehenge. The other three include the caves in the mountain called 'Pec', from which gust winds of great strength (this must be the cavern in the Peak District of Derbyshire now called The Devil's Arse); and the huge caves of 'Chederhole' (Cheddar Gorge).

For the rest, Henry depended on the usual sources, especially the famous early histories of Bede and Nennius, to write a conventional medieval English history. As usual, it began with Brutus, great-grandson of Aeneas of Troy, leading a band of Trojans on the long sea voyage from the Mediterranean to the northern island then called Albion. There they settled, Brutus becoming the first king of the Britons, their name derived from his own. Among the stories Henry took from Nennius' *Historia Britonum* was the treacherous massacre, by Hengist the Saxon, of the British nobles gathered to celebrate a truce between the Saxons and Britons.

Henry is clear enough regarding the size of the stones and the lintels that form doorways, but what are his 'doorways raised upon doorways'? Stonehenge never had a second storey,² but it does have two sets of lintels, in the sarsen circle and in the sarsen horseshoe. Lintels of each set, seen from certain angles, do seem to stand one above the other.

Of the place-name, Stanenges in Henry's chronicle and also Stanheng, Stanhenge and Stanhenges in early manuscripts, clearer sense can be made. It derives from the Old English 'stān', meaning a stone, and one of two words: either Old English 'hencg', equivalent to the modern word hinge (because the lintels hinge on the uprights, or on each other), or Old English 'hen(c)gen', meaning a gallows or instrument of torture in general (from the shape of the uprights and lintels, remembering that medieval gallows were made of two uprights and a horizontal crosspiece, not in the inverted L-shape usually thought of today).³ Whatever the exact meaning, its Old English derivation shows that Stonehenge was noticed and had an established name before the Norman scholars wrote of it. This in itself is remarkable. None of the other stone circles of Britain was known so early; they seemed no more than natural objects 'in which by a whim of the Creator the stones stood on end and in some sort of order'.⁴ Stonehenge, in the middle of the open and stone-free downs, regularly shaped and with great rocks raised aloft, was literally outstanding, an oddity to rank with the other and natural curiosities of the kingdom.

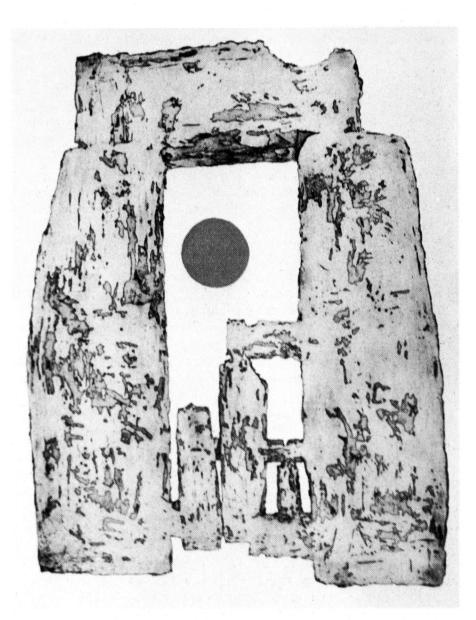

13 In this 1960 etching by Julian Trevelyan, the doorways do appear 'to have been raised upon doorways'. The sun is framed between the trilithon's uprights. Bishop Alexander was of a powerful Norman family, and the year 1139 saw Henry travelling to Rome through Normandy, where he stayed at the great monastery of Bec. In the library there he was entirely astonished to read a newer history of Britain, written by Geoffrey of Monmouth about 1136 and dedicated in part to Bishop Alexander, which went far beyond the cautious orthodoxy of Henry's own chronicle.⁵

The *Historia Regium Britanniae* by Galfridus Monemutensis, the *History of the Kings of Britain* by Geoffrey of Monmouth, was quite novel. Among a mass of new detail, new people and new events is the story of the building – or rather the re-building – of Stonehenge.

The British king, Vortigern, who has seized the throne by treason and murder is the unhappy ally of his father-in-law, the Saxon king Hengist, whose vast army threatens the kingdom. A parley is arranged 'at the Cloister of Ambrius [Amesbury] on the first day of May'. The Britons expect honest talk of peace, but the Saxons are ready for treachery. At Hengist's call, they pull out hidden daggers, murder 460 British lords and capture king Vortigern. Giving Hengist all he possesses, Vortigern is released and flees to Wales, where he builds a great tower on Mount Erith [Snowdon] with the help of Merlin, wizard, prophet and son of an incubus.

The rightful British king, Aurelius Ambrosius, comes home from his exile in Brittany, rallies the scattered British armies and burns Vortigern and his tower. In a great battle with the Saxons, Aurelius triumphs and Hengist is executed. The victor determines to set up a great and everlasting memorial to the massacre at Mount Ambrius. When the carpenters and masons cannot contrive a novel building, Merlin is called for. 'Send,' he says, 'for the Giants' Round* which is on Mount Killaraus in Ireland. In that place there is a stone construction which no man of this period could ever erect, unless he combined great skill and artistry. The stones are enormous, and there is no one alive strong enough to move them. If they are placed in position round this site, in the way they are put up over there, they will stand for ever. ... Many years ago the Giants transported them from the remotest confines of Africa and set them up in Ireland at a time when they inhabited that country. Their plan was that, whenever they felt ill, baths should be prepared at the foot of the stones; for they used to pour water over them and to run this water into baths in which their sick were cured.'

The king's brother, Utherpendragon, takes fifteen thousand men to Ireland to bring back the stones. They defeat the Irish army, go to Mount Killaraus, and try to dismantle the Round with hawsers and ropes and scaling-ladders. Merlin, seeing what a mess they are making, bursts into laughter, and takes down the stones himself, more easily than anyone would believe. He has them carried to the ships, and a fair wind takes the fleet over to England. Merlin puts up the stones round the British sepulchre, in just the same way as they had stood in Ireland, proving that his artistry was worth more than any brute strength. Aurelius on his

'Chorea gigantum', the medieval Latin name for Stonehenge, is generally translated as 'Giants' Ring' or 'Giants' Dance'. I prefer 'Giants' Round', which expresses both its shape and the idea of dancing. These two views, both from 14th-century manuscripts, are the earliest depictions of Stonehenge that survive and among the very few occasions that prehistoric monuments were illustrated in medieval times.

14 (right) Merlin pops a Stonehenge lintel up on to its uprights 'more easily than anyone would believe'. The mere mortals underneath look suitably amazed.
15 (below) A squared-up Stonehenge is squeezed into a history of the world, which is set out like a ledger-book with each line representing a year. The vertical columns, beginning at the left with years from the Creation and years anno domini, include the calendrical variables that define Easter, successive Popes, and the Kings of the Britons (Aurelius Ambrosius is at the top corner of Stonehenge).

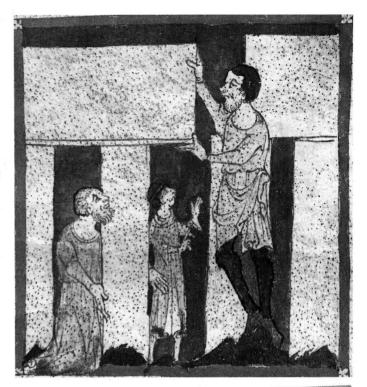

Zhui Abme	Anni Icavnati	lare bifornits Anni lunares Cicli lunares	dum folams.	Inductiones.	Dies infihe	pontracis	T a		Seges bure			Rogesfanno
e tin.bc.lt.	cor.br.	8 8 8	ð m	A	<u>.</u>	- Tom	a a a a a a a a a a a a a a a a a a a		0		For ter fis 6ma	2
tin.Dc.In.	corc.lari.	NUI	c un	ir	Hon.apal.	-1-x-2	buriepe p.in.m	ide hor tepe for	mus		antringozons	
m. Dr. lui.	cccc. toru.	xun b		ŕ	rin. klana.	5	Anna 2 - durthand	DATIS CHIE HI (1)	duin rolati		Thep meaning to	Hel
mi.dc.lm.	cccr. brun.	rin .	6 VI F VII	<u>x1</u>	kl, Applie.	Sumple Inc of	al ale Olar 2700	the sugar letter	10 71 (00000)		land lien plagran	mini
m.Dc.lui.	mar. Im v.	lec.ml 1	e ven	xii xiii	m. klam.	iucftrene	ar Dina imire 4 admin	oit' debutt fur.d	om fuo.	101	brama origut p pu laria. Reges au	Ana
m.dc.lon.	cer. lor in-		¢ n.	m	v.lal.apzil.	Lato reupian	neter. Sol Co.	n gregori i dual	in the second se	(1857 ·	lin fays	mū.
mi.de.lig.	cccc. ber vn.	titi tititi	b r a ri	26	v. tel.man.	AT	Jenon fortef. frs 71	no ann artal	and contraction		Inap ng Alle.	lifte
tm. ocdr.	cccc.lorus.	ν	6 m	14	um.kl.apul.	fely. Dur offer	The reno for	nor nor Tyur cepe path nob	wig.	1 11/2	ลมศิกรปกน	alle
m.dc.In.	tere bore	VI F	e mit	***	jous auzue.	m. creas abr	p anynura mlat	ud an in the second	1. 7.	1		nmi r anfi
min.dr.lmu.	ecce. Ippen.	VII	C PU	nn V	Hon.ap.ul?	gleannaas	1000. TUI. 1/240	nete Quo fro : rellaut	e tremor Au	the lite an	octano lu	ñ faro
m.de.lem,	ecce. hogens.	172	6 xun	VI	mn.id. AnnP.					reli'ambeo		li and
m.dc.hru.	cccc. loorm.	x a	6 xun f xum		klas aphlio.		Stonbenges 1	inta ambelburgin	anghafica	fuis-fill con fhontunt a	······································	borge
mi.oc. lyon.	ecce. loarm.	, xi	e xix	11	Vm.Waput.				TTI	1118. 1. 1	igania section	flozant i gally in
tin. dr. hom.	rece. logron.	xm	D xx	r	m.kl.aunl?		HLL		LL	.m.n. C	vie. Incepie	gainy un
mi.de.lyr.	cccc. Loocium.	XIIII C	b you a you	<u>)ri</u>	rb.kl.man.	huchman		Se importita ni	ovi:frante m		ti anis aring	Ream
thi.dc.bon.	etter. re.	XUI	Gyam	XIII	Vm. klapar	Celair hur s	E TRANSFORMER	him centecta ap	of fouhenges!	-	tranatur m	gmg
m. de. hom.	cccc. xc.i.	xvii xvii e	f mm	xilli	Pon.amil.	12 nos fir i	Trotano diozen	gani Cepe Gelatin	the unitacen	That i tener		weiter
nn.dc. lynm.	((c	nr	r xorus	1	rim. Beadl.	fe minin	T Angla Hic and A	afi' cimolin do.	pria manu	ertper fa mi	MARCH_	ui8
m.dc. lixu.	tece.xe.w.	u.xl 1	6 mun	. 11	un.id? April?	Anafta [fa	Ban funtry impany	it, ay. tipfernt che	mo mutis.	abelimo	1 11+	Close file
m.dc.larbn.	cccc.rc.vi.		A xyum H 1 [c.]	r. Im	vu.kl.appl.	Yuch B	State States	a sta		te umba:		ne fill t
m.dc.lown.	ccce. xc.vn.	nu	en h	m V	Vm. id. apul			1000		Sing	Fui tene flormer	Thguer
m.dc.banc.	ccce.re.w.	V Vi	0 m	10	m. kl. Apal. m. 13? Apal.	cus. but liss	My for her many	hui repe fle	omer un ta	CHUC:	inbutama fis oubuci utble	nathan
the delaton.	.d.	Vn b	av	Vm	m.H.apal?	offittunt ut	in Dephieta n	m denuel ana	ar Vloore	\sim	gion archieps.	TOIC ILL
nn.dc.lporu.	D.1.	Vm	6 11	tr	x.h. man.	tahas froze	ng aremens dien st	1. Aphilo Aeni	n' gan	1. H.A.	5	fulari.
m. dc. loorut.	D.m.	ir r	f un e um	r	rum.hl.apal.	evelfis cane.		Stran Coll. 2014	Time Alternation		Sie de Doun	Auguf
mi.dc. horo.	ð.m.	6 m	c m	211	run kliman.	Gals@rmrm		asty append	in for	Attr u	merch winte	d umm
m. dc. 1000.	0. V. 0. VI.	<u>xu</u> xu	b r a xi	xuu	m.id.aput.	mmily72.100 pmno 80000		A AND AND	Vn Vn	rpen rerpe	flornir fes minel cono	cíp.
mi.dc. hyvon.	D. Vn.	xtim	Gxu	xb	run.R.mai,		T	Contract and	N	fill mha	bangonens m	hu't
nin. oc. hanne.	ð.vm.	rv f	e xui	1	Vm.18. apl?		butui Ifte with	Ann -		nu and	hallet mr pigat	and fur in
m.a.w.	d. 1r.	201	o yann c yu	th	mad apal	DA. The ho	al d. Dour and	m. Deve hui's	uftini - im	THE CHART	and the surface of the	Atter
mu.bc. xc.m.	d.n.	run	b xm	m	m.b.apal.	HIS.YI. DICH.		penatoris ba	Rugges	ine on	Jucinit manii	ralle nard?
m.dc.rc.m.	ð.xn.	ec. rl 1	6 xun	- VI	vn.id.appil.	CSIN POINT ?	10	inco crato	of	och fili"	UxHaxonins. 1	rgnalú
fin.de. rc. v.	D. rm.	Vm. 11	e nr	VH	m.kf.apzil?	erudiuit. ? on	10	but in Stor		epte ani		lobuu mehn a
int. DC. IT. VI.		***		Vm	m.klan.	neroalianta		A construction	all and the second	tiount.		vermei rus dea
11. DC. FC.Du.		im c	a totu	ic k	m.H.Appl.	gan hiam m	D.A.	James Contra	~	THUNK .	Prini tex Bef c	or pall dm. Si.
tin. dc. ye. 12;		Vi	o xm	n	wn.kl.man.	peru alt	as a series of the units	man . mis zouch		Ye rente		profili line -
nn.drc.	g'nk.	Vn	f xxam	m	n.hP.apulis	lohes Jur led an	ipour ar	nigia, pamöthor	uni uga gg		aus cen 1	Epnu:
-			1			- A HOLE		migni cotti	oz fusul fermi		omuf .	nnozi
	1.000					1.	1	ne Herrpfv			a title sol	n fr. mains alass
		1		: 41		2	1		t de			ana enti asteri
			1	19							14 B	Contra Sala

death is buried within the Giants' Round. Utherpendragon succeeds and in his due turn is buried there. His son Arthur becomes king of the Britons, and the great chivalrous hero of the age.⁶

From Geoffrey's detailed account of successive rulers, and the length of their reigns, it is easily calculated that Ambrosius was crowned about the year AD 480, and that Stonehenge was set down in Wiltshire about 485. In his dedication to the book, Geoffrey claims the history not for himself but as a translation from 'a certain very ancient book written in the British language' - yet his contemporaries knew of no such book. Some of them were sceptical. William of Newburgh showed that the heroic victories of Geoffrey's Arthur were quite at odds with 6th-century history as it was known from sound authorities, such as Bede, who had not mentioned Stonehenge or Arthur at all. 'It is quite clear,' William declared, 'that everything this man wrote about Arthur and his successors, or indeed about his predecessors from Vortigern onwards, was made up, partly by himself and partly by others, either from an inordinate love of lying, or for the sake of pleasing the Britons." Certainly, some of Geoffrey's new tales - such as the sacking of Rome by a Briton named Belinus, an event known to no other historian - were startling to the limit of credibility. But the medieval scholars make no criticism of the transport of Stonehenge by magic, which of all the episodes in a purportedly factual history reads most oddly today.⁷

The new history, whether translation or fantasy, was an immense success. Even Henry of Huntingdon filled out gaps in his own history with Geoffrey's story.⁸ And the later medieval English and Welsh chroniclers, like Wace, Gerald of Wales and Alexander Neckham, uniformly re-tell the Merlin story. Sometimes details of the story drifted.9 Stonehenge comes to England at different times, and Arthur may be crowned king there. There were a few doubts as to the glory of it all, for as 'the consuetude of every nacion is to extolle some of their blode in lawde excessive . . . so the Britons extollede Arthur'.¹⁰ But for the most part the British History, or 'English Brut', flourished as one of the most popular of all medieval secular books; almost 200 manuscript copies still survive. Its Stonehenge story closely echoed the history of Geoffrey's own time. William the Conqueror had built the great abbey at Battle, to commemorate his victory over the English near Hastings, on the site, its altar above the precise spot where King Harold had fallen; and the Norman kings of England had mostly been buried in churches of their own foundation.¹¹

In France, Germany and beyond, Geoffrey's history fathered a great many Arthurian verse romances. The Stonehenge story itself does not travel far. Merlin is still prominent, as prophet and soothsayer, but his magic skills are often reduced, as they are in Ariosto's *Orlando Furioso*, to those of an ornamental and interior decorator, building a fountain and painting a hall 'by demons' labour in a single night'. And Stonehenge gained, as early as 1155, a French name to go with its English and Latin ones:¹² Bretun les suelent en bretanz Apeler carole as gaianz, Stanhenges unt nun en engleis Pieres pendues en franceis.

Geoffrey's Brut made a rattling good history, telling what English audiences wanted to hear: adventures of suspense, valour and chivalry on a resoundingly patriotic theme. William Caxton, the first English printer, when asked by 'divers gentlemen' to print a history of England, naturally chose a version of it. His *Chronicle of England* was translated from the French 14th-century manuscript *Brut d'Engleterre* and published at Westminster in 1480. This charming re-telling of the Stonehenge story is therefore a version made into English from the Latin (itself translated from the British, if we believe in Geoffrey) via the French:

The British land in Ireland to take the stones 'that called is geants karoll': 'And whan the kyng of Irland that was callyd guillomez herd telle that stranngers were arryed in his londe he assembled a grete power & fought agenst hem, but he and his folke were discomfyted. The Britons went byfore till they come to the mounte of kylyon. and clymed onto the mount. But whan they sawe the stones & the maner how they stoode they had great meuiaylle & sayd bitwene hem that noman shold remeue for no strength ne engyne so huge they were & so long. but Merlyn thuzgh hys crafte and queyntise remeued hem & brought hem in to his shippes & come ageyene in to this land. And Merlyn sette the stones there that the kynge wold bane hem and sette hem in the same manner that they stoden in irland. & When the kyng sawe that it was made he thanked Merlyn and richely him rewarded at his own wylle & that place lete calle Stonhenge for evermore.'¹³

As the true fact of history the Brut did not deserve to last much longer. Its fantastic claims for Arthur and Merlin's magic were wholly demolished by many scholars, notably in 1534 by the Italian, Polydore Vergil, who complained that Geoffrey extolled the British 'above the noblenesse of Romains and Macedonians, enhauncinge them with moste impudent lyeing'.¹⁴ But no popular and patriotic story dies easily, and the Brut lingered on. As legendary history, it flourished anew in Tudor times, most successfully in Spenser's epic Arthurian romance, 'The Faerie Queene', which faithfully follows the Brut story-line. Vortigern, pushed out of the kingdom by Saxons, forces his way back:¹⁵

But by the helpe of *Vortimere* his sonne, He is againe vnto his rule restored, And *Hengist* seeming sad, for that was donne, Received is to grace and new accord, Through his faire daughters face, and flattring word;

Soone after which, three hundred Lordes he slew

Of British bloud, all sitting at his bord;

Whose dolefull moniments who list to rew, Th'eternall markes of treason may at *Stoneheng* vew.

And then Aurelius, triumphant

... peaceably did rayne, Till that through poyson stopped was his breath; So now entombed lyes at *Stoneheng* by the heath.

London in the late 1590s saw a string of plays (all now lost) on Merlin themes, and in the 1620s Thomas Rowley's *The Birth of Merlin*, later claimed as the work of Shakespeare. During the final act, Merlin the devil's son materializes in the nick of time when his father, with escorting spirits, threatens once more to ravish his mother, Joan Go-to-'t. Merlin commands the spirits away, traps the devil in a vast rock lying conveniently to hand, and promises Joan:¹⁶

And when you die I will erect a monument Upon the verdant plains of Salisbury No king shall have so high a sepulchre, With pendulous stones that I will hang by art, Where neither lime nor mortar shall be used, A dark enigma to they memory

Geoffrey's Stonehenge story makes its last stage entrance in *Merlin;* or, the Devil of Stone-Henge, a pantomime with music by the German composer, John Galliard, to a libretto by Lewis Theobald, which was produced at the Theatre-Royal in Drury Lane, London, in 1734. At that time a pantomime was a light musical entertainment, full of tricks and illusions, lasting an hour or so and put on as the 'afterpiece' to the evening's main spectacle. There was no speaking, the orchestra playing 'comic tunes' as the story was mimed between the songs.

The pantomime begins in colourful style on 'a desart heath' with 'prospect of Stonehenge'. After thunder and lightning, Harlequin and his company dance on-stage where they are greeted by the Ghost of Dr Faustus. Merlin, rising from amidst the Rocks, commands demons to send the Ghost to 'lowest Hell'. Away he sinks, singing the while, as 'an unseen force to Vales of Horror drags me down'. The action retires abruptly to a tavern:

Fill each Bowl with flowing Measure

'Till it sparkle o'er the Brim;

The Grave of Care, and Spring of Pleasure,

Is when the Brains in Nectar swim.

Merlin, in hiding again, is discovered, and changes the scene to 'a pleasant Prospect of the Infernal Regions', an original vision of Salisbury. Plain populated entirely by female spirits:

The Nymphs of these Plains, all courteous and free, In Passion still equal the Lover's Degree; No nice affectation, no surly Disdain, No studied Perverseness their Pleasures restrain...

The plot, if so it may be called, wanders on, ending with another prospect of Hell, less pleasant this time. Merlin's chorus of infernal spirits commands, 'Rejoice! thro' all these dreary Plains the Voice of Triumph spread!', and Faustus is taken away to the flames.

Although strongly cast, with the famous beauty Susannah Cibber as a nymph of the plain, *The Devil of Stone-Henge* folded after five performances.¹⁷ Fifty years later, John Goss, Vicar Choral of Salisbury, wrote 'entire new music' for an 'entire new entertainment', *The Druid's Temple, or Harlequin Stonehenge,* to be performed with 'new scenery, machinery and deceptions'. With all those 'news', we may guess it to have been just a re-working of *Merlin*. But that was the end of Stonehenge in music, except for a single performance in 1931 of a symphonic poem 'Stonehenge' conducted by the composer, Miss Susan Spain-Dunk, in Bournemouth Pavilion. It depicted the dignified symmetry of the solid and heavy stones, and, thought the Bournemouth critic, vividly represented the grim determination of its builders; this may have been a compliment.¹⁸

Geoffrey's story, as the stuff of real history, has against the odds managed a happier survival. Even if the Brut's fables would in the mid 16th century no longer suffice, something could be salvaged from them. Even Polydore Vergil, fiercest of the critics, believed Stonehenge really was the tomb of Aurelius Ambrosius, 'a rioll sepulcher in the fashion of a crowne of great square stones, even in that place wheare in skirmished he receaved his fatall stroke'.¹⁹

The problem then was where the stone came from: 'in a very extensive plain, at a great distance from the sea, in a soil which appeared to have nothing in common with the nature of stones or rocks' are these masses 'of immense size almost every one of which, if you should weigh them, would be heavier than even your whole house'.²⁰ It was a very strange stone, too: 'although they stande many a hondred yeares, hauyng no reparacion nor no solidacion of morter, yet there is no wynde nor wether that doth hurte or peryshe them'.²¹ (The rock of the plain, under only a few inches of soil, is chalk – the softest of calcareous rocks, porous, weak and unusable for building unless well protected from the weather. The only building stone to hand is the flint nodules, at their biggest the size of a man's head, which are dotted through the chalk. For want of anything better, flint is the common building stone for churches on the plain, Amesbury for one.)

A shrewd antiquary, John Rastell, writing a few years before Polydore Vergil, solved this question in a manner that seemed eminently reasonable and logical, and which was endorsed by 'clerkis and grete lernyd men'. The stones were of no recognizable building stone, but 'so hard that no yryn tole wyll cut them without great bysynes'. They were all of a single colour and grain right through, without the veins 'as grete stonis of merbell and other gret stonis commynly haue'. And they were of 'one facyon and bygnes save only there be ii. sortis & so most lykly to be caste and made in a molde'. Finally, 'men thynke it a thyng almost unpossyble to get so many grete stonis owte of anny quarre or rokk that should be so herd so equall of bygnes and fassyon'.²² A logical man could 'not irrationally conjecture that they are not Natural, or had their first growth here, but were Artificially cemented into that hard and durable Substance from some large Congeries of Sand, and other unctuous matter mixt together'.²³

When the source of the Stonehenge stone was found, very few years later, all this good sense was immediately shown to be wrong. Like every other theory of Stonehenge that has been proved false, the hypothesis nevertheless survived and flourished. An even more enduring example has been the idea that Stonehenge was built by giants; faintly hinted at in medieval times when the historical reality of giants was believed, this has been argued anew in the mid 20th century.²⁴ The concrete Stonehenge set in learned minds and was joined by the idea that the great pillars of Salisbury Cathedral, actually built of Chilmark limestone in the 13th century, were artificial. John Aubrey wearily noted about 1685: "Tis strange to see how errour hath crept in upon the people, who believe that the pillars of this church were *cast*, forsooth, as chandlers make candles . . . and not onely the vulgar swallow down the tradition gleb, but severall learned and otherwise understanding persons will not be perswaded to the contrary, and that the art is lost ... and the like errour runnes from generation to generation concerning Stoneheng, that the stones there are artificiall.' ²⁵

Forty years on, a truly obstinate historian could still copy out Geoffrey, abuse Polydore Vergil's 'foul-mouthed railery' and 'false Surmise to cover his own Ignorance', and even contrive new detail. The treacherous Saxons now hide their long knives not just under their garments but 'in their Britches'.²⁶ But he had no hope of convincing, and Geoffrey's History sank out of fashion, reaching its nadir in Victorian times, when it was just 'a bare-faced invention, and full of old wives tales, and idle stories'.²⁷ There remained only the coincidence, that the 460 noble British dead neatly matched the 450 or so ancient burial barrows visible in the area round Stonehenge.

16 Brian Hope-Taylor's vignette, quite the finest of the Stonehenge devices in current use, decorates the covers of the British archaeological journal, Antiquity, in an adaptation of this, its original form.

TONEHENGE COMPLETE STONEHENGE COMPLETE STO EHENGE COMPLETE STONEHENGE COMPLETE STONEHE **2 IN THE AGE OF QUEEN ELIZABETH** PLETE STONEHENGE OMPLETE STONEHENGE COMPLETE STONEHENGE COM TE STONEHENGE COMPLETE STONEHENGE COMPLETE

'A place so full of a grey pibble stone of great bignes'

William Camden's *Britannia*, the great Elizabethan compendium of antiquities, records of Stonehenge: 'in the time of King Henrie the Eighth, there was found neere this place a table of metall, as it had beene tinne and lead commixt, inscribed with many letters, but in so strange a Caracter, that neither Sir Thomas Eliot, nor master Lilye, Schoolemaster of Pauls, could read it, and therefore neglected it. Had it beene preserved, somewhat happily might have beene discovered as concerning *Stonehenge*, which now lieth obscured.'¹

It is a sign of the learning of Tudor times that the 'table of metall' found its way from the country to the experts in London. A few years later John Leland, who as a boy had been taught by Lily, embarked on his survey of the topography and ancient remains of England, *De Antiquitate Britannica*. Although he held a prebendship at Salisbury, he went to Stonehenge only once.² He did try to pull the truth of the Brut from its confusion of magic: 'Almost everything that is related about the bringing of these stones from Ireland is fictional. For everybody, however ignorant, ought to know that these enormous stones – which our own age, so short of talent, is unable to shift – were brought by Merlin from some quarry near by with remarkable ingenuity and using clever inventions. . . . It would have been beyond the ability of the Romans to move things of such weight from Ireland to Amesbury, since the Avon, * at its closest point, is nearly twenty miles away.'³

Elsewhere, Leland fills in the details. Merlin finds a vein of great rocks. The workmen dig great quarry pits, and with Merlin's ingenious machines get fifty huge slabs to the site of the British massacre. Merlin measures out a circle, and has the slabs set up with the lintel stones to make a sort of crown.⁴

As scholars were groping towards an understanding that Stonehenge was built like any other structure, modern times were approaching in another way. Stonehenge began to receive day-trippers. The first we can name is, fittingly since so many later visitors have come from abroad, a foreigner; and the route he took has been the standard outing, for a day by horsepower and a half-day since the internal combustion engine, ever since. Herman Folkerzheimer, a young Swiss Protestant, was trying to study philosophy and history in France during 1562. But the religious unrest made it prudent, he thought, to slip away to England, taking a boat from La Rochelle to Southampton. The crossing took eight days; * Not the Avon that flows through Amesbury and south to the English Channel at Christchurch, but the river of the same name that flows from northern Wiltshire through Bath and Bristol out to the Severn estuary and the sea route from Ireland. there was 'stinking meat' for food and 'everything so dirty and loathsome and disagreeable'; when the fresh water ran out, he had to drink vinegar. Hurrying up to Salisbury, where he had an introduction to Bishop Jewel, Folkerzheimer found the bishop's palace a fortunate island of refuge, its spacious great halls set in lush water meadows. One day he was taken on a jolly hunting trip, and 'on the 20th of July we rode into the country with a large retinue, as the bishop said he would shew me some things that would astound me'. First they went up the ridge north of Salisbury to Old Sarum, the Iron Age hill-fort and later the site of the Norman cathedral, castle and city, until Salisbury or New Sarum had been built down by the river in the early 13th century. Then past 'a camp of the ancient Romans, of which these are the vestiges that we see', and on to Stonehenge, the high point of the outing and suitably impressive. Folkerzheimer could not make much of it, beyond echoing his host: 'The bishop says, that he cannot see how even the united efforts of all the inhabitants of his diocese could move a single stone out of its place. His opinion, however, is that the stones were set up as trophies by the Romans, because the actual positioning of the stones resembles a voke.'5

onth Fudworth oton aston South Twenon ton Blacke Hedth Buckmernfter nne ington Orchetton A Bul uchefen the Ames urre maton oko Serwick Stanlof reat Idmertion

17 'Stonehinge' close by 'Ambersbury' in John Speed's map of 1625; it has been sketched as if with a close-set fence round it. In this drawing the hillocks are real hills, rather than barrows, and it is noticeable how churches and villages hug the valleys.

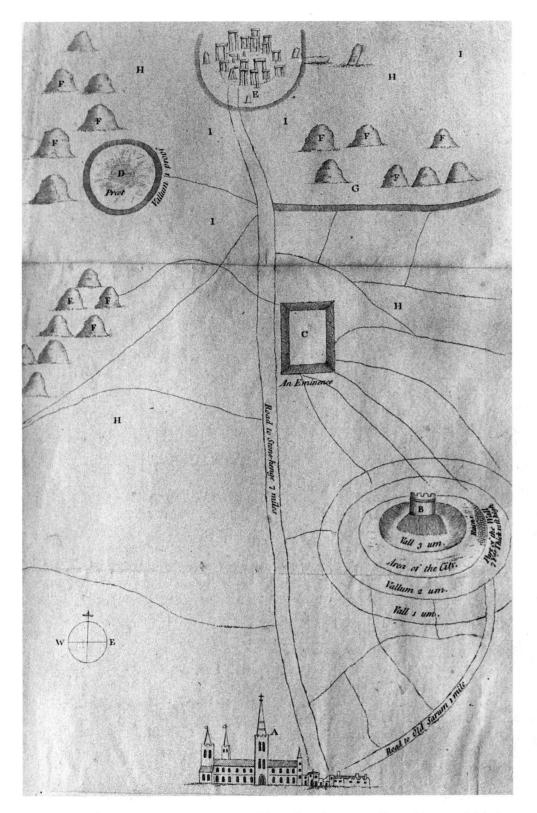

18 The Stonehenge day-excursion as enjoyed by Folkerzheimer and here drawn in the 18th century. From Salisbury cathedral the route goes to Old Sarum, along downland tracks past a rectangular camp on 'An Eminence' and on to Stonehenge, complete with Heel Stone (right) out beyond the ditch and Slaughter Stone flat to its left.

TTISTER CONTRACTOR STATES

To another refugee from Europe we owe the first detailed description and the first accurate view of Stonehenge. Lucas de Heere was born in Ghent about 1534. In 1559-60 he was in France, and by 1565 in Ghent again, married to a Protestant and a Protestant himself, painting and teaching art, judging water-tourneys at a festival, writing Flemish poetry, a member of the Chapter of Rhetoric. In 1567 the Duke of Alva came to the Netherlands in pursuit of heresy; the de Heeres, like so many Flemish Protestants, fled to England, where they stayed until the Pacification of Ghent in 1576 allowed them home. On his return his career thrived under the patronage of William of Orange, for whom he designed his masterpieces, the eight Valois tapestries now in the Uffizi, Florence.⁶

In his London years, de Heere was prominent in the Flemish refugee community of artists and intellectuals. Among his acquaintance was the topographical artist Joris Hoefnagel, who was drawing perspective views of the great European cities for the international atlas of major towns, the *Civitates Orbis Terrarum*.⁷

During 1573-5 de Heere wrote a *Corte Beschryvinghe van England, Scotland, ende Irland,* a kind of guide-book to his country of exile, and encompassing British institutions, manners, customs and costume (an especial interest), and history. Only one manuscript copy is known to exist,⁸ but works that in happier times at home would have been printed are known to have circulated in London as manuscript copies.⁹

De Heere's description begins with the Geoffrey story and a watercolour of Stonehenge 'as I myself have drawn them on the spot'. He goes on: 'These mentioned stones are massive [and] undressed, from hard coarse material, of grey colour. They are generally about 18 or 20 feet high and about 8 feet wide over all four sides (for they are square). They stand two by two, each couple having one stone across, like a gallows, which stone has two mortises catching two stone tenons of the two upright stones. There seem to have been three ranks of stones, the largest of which comprises about three hundred feet in compass. But they are mostly decayed. One finds here-about many small hillocks or monticules, under which are sometimes found giant's bones (of which I possess one from which it can easily be perceived that the giant was as much as 12 feet tall, like there are also in London and elsewhere which are longer) and pieces of armour from captains which have been buried there. Nearby can also be seen an earthen rampart made formerly by the Romans in their manner.¹⁰

20 Among the deepest and largest of the many carvings of visitors' names on Stonehenge is this, on the inner face of stone 53. It reads 'IOH:LVD:DEFERRE' (with the Es cut as Greek sigmas), that is, 'Johannes Ludovicus De Ferre'. The name is tantalizingly close to, but inescapably different from, Lucas de Heere. Nobody of the name has been traced from the 17th century, the likely date from the style of lettering and its weathering.

19 (opposite) Lucas de Heere's vision of the inhabitants of ancient Britain, drawn into his 'Corte Beschryvinghe' as naked warriors, elegantly painted. His illustration echoes John White's famous pictures of Virginian Indians, which it precedes by a few years.

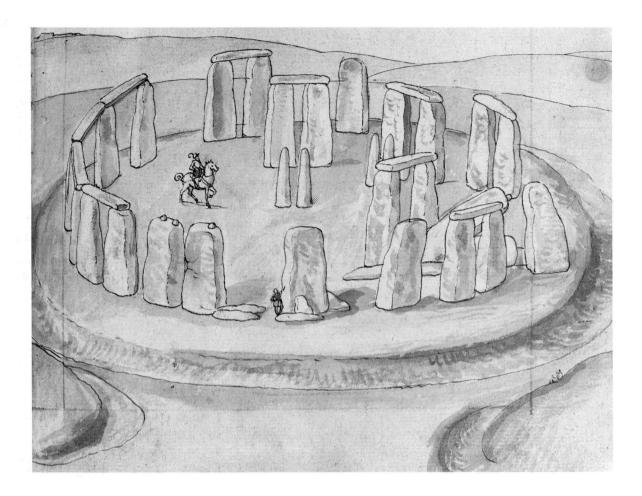

21 The Lucas de Heere watercolour, 'drawn on the spot'. The similar William Smith watercolour is reproduced as colour ill. I. These things are clearly illustrated in the watercolour. He has drawn a perspective view from a height just sufficient to make the structure of the monument apparent; no view from ground-level can begin to do that, as many illustrations in this book demonstrate. The perspective is from the north-west, the only side on which the ground rises as you move away from Stonehenge. The manuscript is a fair copy, handsomely written out in de Heere's own hand¹¹ and with decorated initial capitals. The watercolour falls at the exact point where Stonehenge occurs in the text, and is on an original sheet of the bound book, not on a loose sheet later inserted. Evidently de Heere has made this finished drawing from a sketch or sketches 'as he himself drew them on the spot'.

In the foreground are two round barrows, each with a ditch, and the ditch round Stonehenge, drawn close to the stones instead of thirty yards away. The outer sarsen circle looks much as it does today, complete with a run of adjacent lintels on the north-east side. Four bluestones of the inner horseshoe are detectable, together with three complete trilithons of the sarsen horseshoe. There are mistakes, and most of the fallen stones are left out. An obvious error is in stone 56, the leaning stone of the great trilithon; this is shown on the right, partly behind

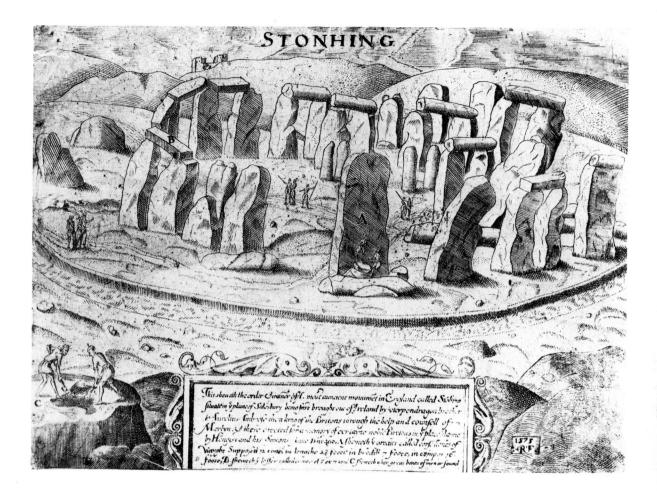

stones of the outer circle and with its mortice conspicuous, leaning *out* from the circle and almost fallen horizontal. Actually, it was leaning much less and *into* the circle.

Brother to the de Heere picture is a watercolour by the herald William Smith (col. ill. I), in his manuscript Particular Description of England of 1588.¹² His view of 'Stonhedge', again a perspective from the north-west, has most of de Heere's mistakes and some new ones; and the proportions of the stones are a little further from reality. His barrows are flat discs rather than steep-sided tumps. The gentleman leaning on stone 60 (centre front) is now writing three lines of graffiti (they are not detectable on the stone now). The earth rampart in the distance, a Roman camp to de Heere and to Bishop Jewel, has become a stone castle: an understandable error if Smith has misunderstood the Latin word 'castrum', used - by Folkerzheimer, among others - for an ancient earthwork fortification, but more commonly meaning a castle in the ordinary sense. It is the Iron Age hillfort, just by Amesbury, now called 'Vespasian's Camp'. Peeping over the hills is the spire of Salisbury Cathedral, which could be seen from Stonehenge until tree-planting on an intervening ridge¹³ blocked the view in the late 19th century.

22 The 'R.F.' print, cousin to the Lucas de Heere and William Smith watercolours, but further removed from reality. The de Heere and Smith watercolours have a cousin, an engraving of 'Stonhing' signed 'R.F. 1575'.¹⁴ Again it is a perspective from the north-west, with their mistakes and some more. Some of the lintels are rounded like tree trunks, and the stones sway and wobble in fidelity to the giant dance of a *chorea gigantum*. 'R.F.' shows in his style that he knows the reputation of Stonehenge, but not the place itself. In the left foreground men dig out of a barrow bones which, from their size, amply suit de Heere's buried giants. Outside the outer circle, in the left background, that is north-east of the central building, stand two large, low and lumpy stones. We may take these for the larger outliers, the Heel and Slaughter Stones. The distant earthwork is confidently shown as a solid medieval castle.

The de Heere and Smith watercolours and the R.F. print are so similar, their mistakes so repeated, and perspectives are so rare at this time, that they must derive from some lost common original. Oblique aerial views had long been used in landscape backgrounds to oil paintings, but the 'scenographic' prospect as a device for topographical exposition was established by Joris Hoefnagel. During 1568-9 Hoefnagel knew de Heere in London, and there are no other de Heere perspectives like his of Stonehenge. Foreground figures illustrating local customs, costumes or antiquities, like the barrow-diggers in R.F.'s print who illustrate all three aspects, are frequent in Hoefnagel perspectives. Hoefnagel also connects to William Smith, who contributed views of four English towns to the *Civitates*. Finally, the style of the R.F. print, as it is recognizable behind the engraver's, echoes Hoefnagel's.¹⁵

We can conclude, with some confidence, that de Heere went to Stonehenge in 1568-9 with Hoefnagel, and worked out from sketches 'drawn on the spot' a perspective view, the original from which the surviving versions derive.¹⁶ Of the three, only the print was widely seen in an incompetent re-engraving for the 1600 edition of Camden's *Britannia*. It then became the standard picture of Stonehenge,¹⁷ in Europe and in Britain, and led a long and merry dance; with each new copying the lintels more and more resemble sausage rolls, the sway of the stones is more lumpenly jovial.

Camden, often better on later than prehistoric remains, did not make much of Stonehenge ('a wretched anile account', Stukeley called it), preferring 'to lament with much griefe that the Authors of so notable a monument are thus buried in oblivion'. 'Weatherbeaten and decaied', it is 'such as *Cicero* termeth *Insanam Substructionem*', a gloomy thought which 'could not be so fitly expressed in words' as 'by the gravers helpe' in a drawing. The R.F. print confirms the craziness of it all, and makes one wonder when, or if, Camden actually saw Stonehenge for himself.¹⁸

The two problems about Stonehenge in the later 16th century became: where did the stones come from, if they were not an artificial cement? and how did they get there?

William Lambarde, ten years after de Heere, answered both questions in a thoroughly modern mode. He rejects the fables and 'suche like

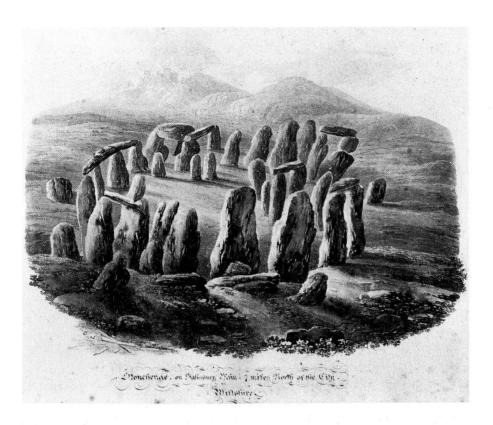

23 This 19th-century watercolour shows the 'dancing sausage-roll' variety of Stonehenge picture still flourishing. A novelty is the moving of Stonehenge from the chalk country to some wild upland moor. The distant stone castle, first added in error by 'R.F.', endures.

Toyes, whearwith *Galfrid* [Geoffrey] and many other have brought good Hystories into vile Contempt, and themselves the Wryters woorthely into Derision'. Stonehenge was not a marvel at all, the stones hanging 'with no more Wonder than one Post of a House hangeth above another, seinge that all the Stones are lett one in another by a Mortece and Tenant, as Carpenters call theim'. Nor was there wonder in how they were taken there, for 'by Art Thinges of greater Weight may be removed, especially if a Prince be Pay-maister', or where they came from, for 'theare is within the same Shyre great Stoare of Stone of the same Kinde, namely, above *Marlborow*, from whence I thinke they weare chosen by the Greatness, for other Difference eyther in Matter or Fashion I see none'.¹⁹

And Queen Elizabeth's godson, Sir John Harington, explored Merlin's work as a builder in a note to his famous translation of *Orlando Furioso* into 'English Heroical Verse' of 1591: 'that there was such a man, a great counsellor to king *Arthur*, I hold it certaine: that he had a castell in Wiltshire called after him *Merlins*burie (now Marleborow) it is verie likely: the old ruines whereof are yet seene in our highway from Bath to London. Also the great stones of unmeasurable bignesse and number, that lie scattered about the place, haue given occasion to some to report, and others to beleeue wondrous stratagems wrought by his great skill in Magike, as likewise the great stones at Stonage on Salisburie plaine, which the ignorant people beleeue he brought out of Ireland.'²⁰

This provenance for the large stones of Stonehenge has never been challenged. What the sarsens were, these great boulders scattered and flowing like rivers down the slopes of the downs between Marlborough and Avebury, was mysterious much longer. Sir Christopher Wren thought they were cast up, pitched all one way like shot arrows, out of a volcano. Dr Stukeley believed them to be 'solid parts thrown out to the surface of the fluid globe, when its rotation was first impress'd', and an otherwise sensible writer of the early 19th century was sure they were of 'atmospherical, or more appropriately, of *cometic origin*', and Stonehenge therefore a '*deposit of space*', with the fragments and minor masses tidily removed and the larger ones ingeniously re-arranged in a regular form.²¹

Modern geology is more prosaic. The sarsens are natural blocks of a kind of sandstone. In the Tertiary period, up to 70 million years ago, much of the chalk deposit, still lying on the sea-bed where it had been laid down, was covered with sand. In places the sand became firmly concreted into irregular blocks, and these remained when the chalk was raised into hills and the looser sand eroded away. These boulders are sarsens. They lie on or just under the chalk surface; their upper and lower faces, corresponding to the top and bottom of the sand stratum from which they formed, tend towards being flat and parallel. The finest sarsen deposits are those on the Marlborough Downs, but they do occur elsewhere in southern England.²²

Sarsen is astonishingly tough, the most obdurate of sedimentary rocks and several times harder than granite, although when freshly quarried in, for instance, the High Wycombe area (where the deposits are underground), they have proved much easier to work. If you hammer at the surface of a Wiltshire sarsen, you get not chips or lumps but, by the slowest of degrees, a trickle of dusty sand. Where no easier stone could be found, medieval builders broke sarsens as best they could into lumpy blocks; sarsens from Bagshot are the main material of Windsor Castle. 19th-century masons found an economical method of neatly splitting sarsen in the 'plug-and-feather' technique, and most of the Wiltshire sarsens were gobbled up by the 'macadamists' for the new metalled roads, or used for gateposts and buildings in Fyfield and near-by villages. Before, the only effective method of splitting sarsen was with fire and water: lighting a good fire along the line of division, flooding the hot stone with cold water, and hammering down the line, where the stone should snap. This technique, used by the Avebury stone-breakers of the 18th century, is the best guess for the prehistoric method of roughing sarsens into shape.²³

Only a small area, in National Trust care, now survives of the great spread visible in Elizabethan times and described by Richard Symonds, a royalist Colonel in the Civil War, as he moved with the King's troops to Fyfield 'through a miserable wett windy day' in November 1644 after the defeat at Newbury: 'a place so full of grey pibble stone of great bignes as is not usually seene; they breake them and build their howses of them

24 Only small areas of the Wiltshire sarsens survived 19th-century stone-breaking. This view of Fyfield shows the grey wethers spreading, as if in a grazing flock, down the dry chalk valley. The grass and scrub vegetation probably resembles that on the downs when Stonehenge was built.

25 Route of the sarsens to Stonehenge. The obstacles are the steep north and south slopes of the Vale of Pewsey and its marshy bottomlands. Professor Atkinson's suggested route keeps to the dry downland; he takes the sarsens across the Kennet at Avebury, down towards Devizes and across the Vale of Pewsey at its driest part, then up Redhorn Hill (the easiest slope of the scarp, but still steep enough to force the modern road into a hairpin bend), and across the downs past Robin Hood's Ball.

Others have believed the Avon valley, although wetter and wooded, would have been an easier route, using rafts or wooden trackways. One scheme, beginning in the smaller sarsen deposits at Lockeridge, south of the Kennet, takes the stones straight down the scarp, using wooden slides, across the Vale and down the Avon.

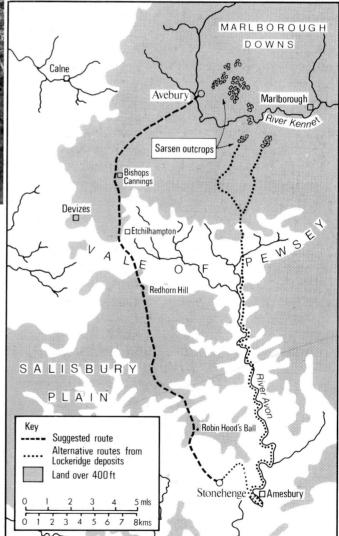

and walls, laying mosse between, the inhabitants calling them Saracens' stones, and in this parish, a myle and halfe in length, they lye so thick as you may goe upon them all the way. They call that place the Grey-weathers [a wether is a male sheep being grown up for mutton and wool], because a far off they looke like a flock of sheepe.'²⁴

The name 'sarsen', then, derives from 'Saracen', the Crusaders' name for the Moslem infidels, and a graphic indication of how out of place the great sarsen blocks look in a land of soft chalk and little brittle flints. 'Grey-wether', the commoner country name, was just as apt.

Unanswered questions about the Stonehenge sarsens remain. Their provenance is only a reasonable guess; there is no petrological proof that they come from the Marlborough deposits. The survivors on Lockeridge and Fyfield downs are mostly small. A single one is about 13 ft long, too short when trimmed to make a Stonehenge upright, but no other approaches it in size.²⁵ The earlier sarsen monuments – the stone circles and two great avenues of Avebury itself, the chambered tombs like West Kennet, and other monuments now lost – pre-empted a great many of the larger stones (600 is a cautious estimate) before the building at Stonehenge was begun. That needed 75 sarsens, ranging in size from the 23 ft plus of the ten uprights for trilithons to the 10 ft of the thirty outer lintels. Did the supply run out as, or before, Stonehenge was finished? Or did yet more giants remain for the Victorian quarrymen to break up?

A new survey of the scattered sarsens of the Wiltshire countryside shows a slight concentration around Amesbury, but not so many as to suggest a separate natural deposit there. Most likely these strays were looted from Stonehenge in medieval times.²⁶ Folk stories say they slipped out of the devil's grip as he flew overhead with them on the way to Stonehenge. One at Bulford, underwater in the river Avon, has been taken for a great boulder which slipped off its raft as it was poled downstream towards Stonehenge. But when Herbert Stone waded waist-deep to take a close look he found it was much too small - less than 3 ft square, 20 inches thick – and had an iron mooring ring set into it. The story told of this stone in the 18th century is better, a fine embroidering on Geoffrey's British history. Merlin, it says, employed the Devil to take from Ireland the 'parcel of Stones which grew in an odd Sort of Form in a Backside* belonging to an Old Woman'. Dressed as a gentleman, the Devil came to her at night, poured out 'a large Bag of Money' in strange denominations of 41/2-, 9- and 13-penny pieces, and offered 'as much for her stones as she could reckon' while he was taking them away. As 'the Removal of her Stones by a single Man would be a Work of almost Infinite Time', she saw she would be 'as rich as a Princess'. But no sooner had she laid a finger on the first coin than the 'common Deceiver of Mankind' shouted that the Stones were gone. So they were, tied up in an instant with a willow withy and conveyed to Salisbury Plain, where the withy slackened as the Devil crossed the Avon at Bulford and this stone fell in the river.²⁷

Not part of her anatomy, but dialect for back garden.

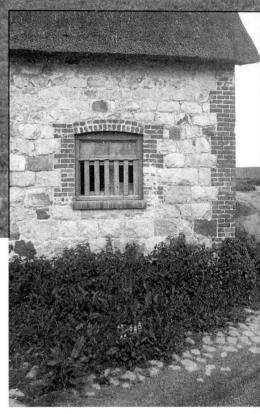

Styles of ancient and modern building in sarsen.

26 (above) The Devil's Den, in a sarsen valley a couple of miles east of Avebury, is the remains of a Neolithic burial chamber which has lost its covering mound. It shows the classic technique of megalithic construction, with slab uprights precariously supporting a roof slab held in place only by its own weight, of which Stonehenge is a development which keys stones in position with carpenters' joints.

27 (right) A Victorian barn at Fyfield shows how masons never managed to split sarsen into straight-edged blocks. Instead they used bricks to square up window openings and wall ends.

A Whig view of Stonehenge history in the 16th century, giving space to the perceptive rather than the further re-telling of the Brut, sees the problem of Stonehenge halfway solved during Elizabeth I's reign: men in ancient times brought the largest of the Marlborough sarsens to Stonehenge, and set them up with woodworker's joints to hold the lintels. This was in the best Renaissance tradition, reconstructing history from unremembered facts by careful observation of the topography (although Camden's *Britannia*, the exemplar of that tradition, failed at Stonehenge). The first question, 'What is Stonehenge?', was answered. The others have taken longer to answer: 'By what kind of men?' not until the reign of Victoria, and 'When?' in that of the second Queen Elizabeth. The last question, 'Why?', evades us still, as it evaded Harington, whose wiser sort of man 'can rather marvell at, than tell either why or how they were set there'.²⁸ During the 17th century, as the next chapter shows, there was a decline. The new sciences of Stuart times, instead of pressing on with topography and objective study, took to excavating the libraries in the hopeless pursuit of a documentary account of early Stonehenge. In the reign of Charles II, good topographic work was done, but all attention was on an academic dispute in which all parties were wrong. At the present day, when the quieter findings of prehistorians attract less notice than the exotic offerings of astronomy and alternative archaeology, Stonehenge in the reign of the Prince of Wales, if he is our future King Charles III, may come more closely to resemble Stonehenge in the reign of King Charles II.

Before plunging into the 17th century and among Romans, Danes, Phoenicians and worse, we may note the first use of Stonehenge in the modern spelling (in the *Britannia* and in Richard White's *Historiarum Britanniae*, the last important Stonehenge books in Latin²⁹), and find some refreshment in Samuel Daniel's enduring lament of the ignorance 'unsparing Time' forces on us:³⁰

And whereto serue that wondrous *Trophei* now,

That on the goodly Plaine neere Wilton stands? That huge dumbe heape, that cannot tell vs how, Nor what, nor whence it is, nor with whose hands, Nor for whose glory, it was set to shew How much our pride mocks that of other lands?

Whereon, whenas the gazing passenger Hath greedy lookt with admiration, And faine would know his birth, and what he were, How there erected, and how long agone Enquires, and askes his fellow traveller, What he hath heard, and his opinion:

And he knows nothing. Then he turns againe, And lookes, and sighs, and then admires afresh, And in himself with sorrow doth complaine The misery of dark Forgetfulness; Angry with Time that nothing should remaine Our greatest wonders wonder, to expresse.

The Ignorance, with fabulous discourse, Robbing faire Arte and Cunning of their right, Tels, how those stones, were by the Deuils force, From *Affrike* brought to *Ireland* in a night, And thence, to Britannie, by *Magicke* course, From Gyants hands redeem'd, by Merlins sleight . . .

With this old Legend then Credulitie Holdes her content, and closes vp her care: But is Antiquitie so great a liar?

'Indeede a stupendious Monument'

Stonehenge, then, 'by a certain extravagant Grandeur of the Work, has attracted the Eyes and Admiration of all Ages. After the Reformation, upon the Revival of Learning among us, the Curious began to consider it more intimately',¹ inspired in the new century by the new interest in the past whose clearest sign is the success of Camden's *Britannia*. When, for instance, the cartographer John Speed went to Stonehenge, he was cautioned that the stones 'seeme so dangerous, as they may not safely be passed vnder, the rather that many of them are fallen downe, and the rest suspected of no sure foundation: notwithstanding, at my being there, I neither saw cause of such feares, nor vncertaintie in accounting of their numbers, as is said to be'.

THE ENGLISH RENAISSANCE

Round the stones Speed saw the trench, as drawn into the R.F. print, and beyond 'vpon the plaines adioining, many round copped hilles, without any such trench, (as it were cast vp out of the earth) stand like great hay-cockes in a plaine meadow: In these, and thereabouts, by digging haue been found peeces of ancient fashioned armour, with the bones of men, whose bodies were thus couered with earth that was brought thither by their wel-willers and friends, euen in their head-peeces; of token of loue that then was used, as some imagine'.²

As all the early pictures show, Stonehenge stood in open and tree-less downland, in summer scattered with shepherd flocks, in winter deserted, in snow an entire empty expanse of white. Only the tumps of the ancient burial mounds and the shepherds' huts, little round structures of straw, ever broke the clear sweep of grass. (The woods and copses scattered in the modern view from Stonehenge are later planned plantings. Those close to Amesbury are of the 18th century, when the third Duke of Queensberry emparked the estate. Those west of Stonehenge, Fargo Plantation and Normanton Gorse, are 19th century, those to the north newer still. Because they are damaging to the archaeology, some of the trees are being cut down, or not re-planted when they fall.)³

A Royal Warrant of 1680 granted Thomas Hayward, the owner, the right to hold an annual fair at Stonehenge on 25 and 26 September.⁴ (Archaeologists have thought otherwise inexplicable post-holes are the traces of supports for the fair's temporary stalls.) Latterly, the Stonehenge fair was held at the summer solstice in June. The rest of the year we can be sure Stonehenge was entirely on its own. Since it was neither an object of value itself, nor the marker of a land boundary, it

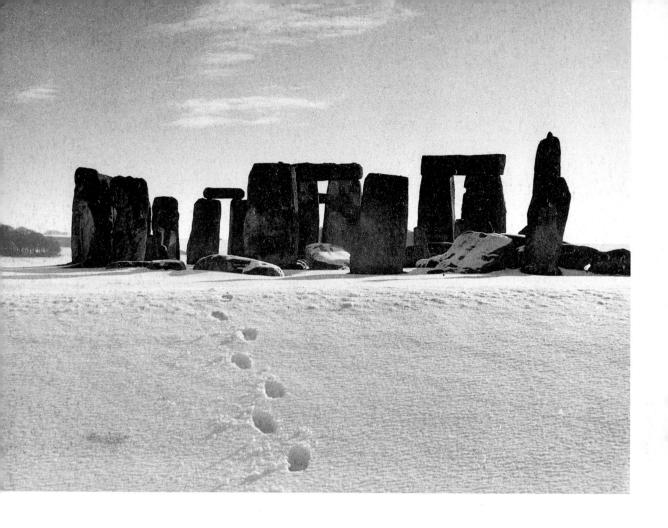

28 Stonehenge in the snow, alone in an empty landscape, as the 17th-century travellers more often found it.

does not figure in estate records.⁵ A sign of this emptiness is that Stonehenge never became a place-name in America, although there is an Amesbury in Massachusetts. In the end Stonehenge did travel overseas to another colony, as the name of a parish in Gough County, New South Wales. But there is a connection with the American Revolution, in the ownership of Stonehenge. About 1614 the west Amesbury estate was bought by a Robert Newdyk. Enmeshed in debts, he sold it about 1628 to Sir Lawrence Washington of Garsdon, an ancestor of the first President of the United States of America, in whose family it stayed almost fifty years.⁶

Curious visitors who asked their coachman or a loitering shepherd would hear the old story about the magic powers of the stones: 'if they be rubbed, or scraped, and Water thrown upon the Scrapings, they will (some say) heal any green Wound, or old Sore'. And a piece taken to a well would clear it of 'all the venemous creatures therein', especially 'the Toades, with which their wells are much infested'.⁷

Most popular was the tale that none could count the stones twice and arrive at the same number, a story elegantly set down by the Elizabethan poet Sir Philip Sidney:⁸

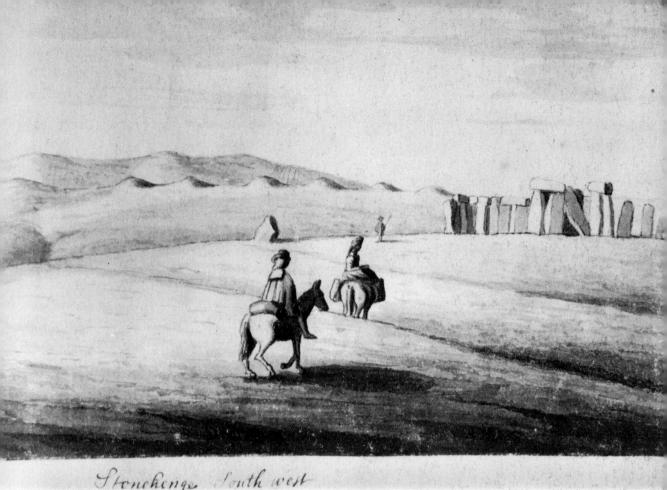

Neer Wilton sweet, huge heapes of stones are found But so confus'd, that neither any eye Can count them just, nor reason reason try What force them brought to so unlikely ground.

Trying to count the stones might even frighten you a little, for it was 'vulgarly said that whoever counts the stones of the Stonehenge will die' (which is – if you think about it – entirely true). Still, the 'miraculous, untellable Stones' worried someone enough to prompt him to consult the agony columnist of a 17th-century newspaper, whose advice was conscientiously ambiguous: to let them alone would 'shew a great command over your self'; to count them would prove that tale to be false and the Devil's power just a worthless fable. And Daniel Defoe heard that keeping a tally would not help: 'a baker carry'd a basket of bread, and laid a loaf upon every stone, and yet could never make out the same number twice'.⁹

Almost everyone did venture to slight the Devil with counting, and reckoned a number in the low 90s: John Evelyn 95 (in 1654), John Ray 94 (in 1662), Celia Fiennes 91 (between 1682 and 1696), Sir John Clerk 94

29 Excursionists head for Stonehenge on donkeyback, 1716. Behind the left-hand figure is the Heel Stone; beyond lie barrows in silhouette on the ridge. A shepherd is hovering by the stones ready to fleece them.

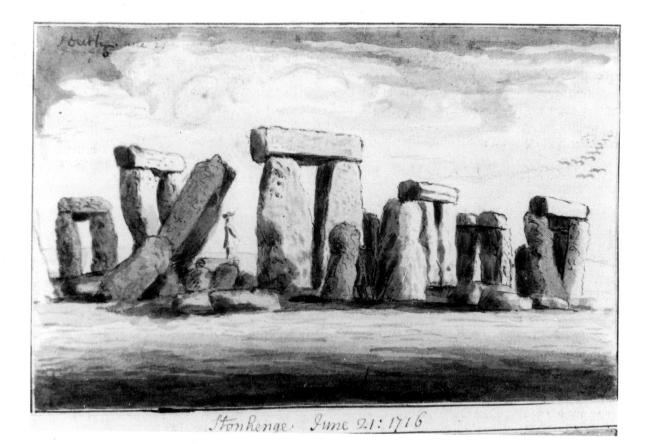

30 The visitors explore Stonehenge and compute the number of its stones. The date, 21 June 1716, hints at the summer solstice, which is today on 21 or 22 June. But in 1716 Britain had not yet adopted the Gregorian calendar, and the solstice was on 2 July. (in 1727), and Jonathan Swift either 92 or 93 (in 1730).¹⁰ The number depends on what qualifies. Ignoring the fragments which obviously join together into single stones brings the number down as low as 72. Adding the stones missing but implied in the design takes the number up towards 140. Even today, with the grass cropped to a municipal shortness, counting is not at all easy; the number you may come to is 91. It may be that outlying stones, beyond the four that survived through the 18th century, were counted in before they disappeared – perhaps those extra two marked on John Aubrey's sketch of 1666. Perhaps stones were broken in pieces about as fast as those pieces were removed, so the total number did not change even though bits were going. Certainly, they were being taken away in the middle of the 17th century, when 'not one fragment' of some inner bluestones that were standing when Inigo Jones first measured Stonehenge remained before he had finished there. A little later, 'one large stone was taken away to make a bridge'. Since then, nothing of consequence seems to have gone, the survivors protected (at least until the craze for souvenir-hunting took hold) 'by their own Weight & Worthlessness', since they were made of no 'Pretious matter (a Bait to tempt Avarice)'.¹¹

Among those who went to count the uncountable and to check the natural or artificial strength of the stones were both the great diarists of the 17th century. John Evelyn went on 22 July 1654: 'We passed over that goodly plaine or rather Sea of Carpet, which I think for evennesse,

extent Verdure, innumerable flocks, to be one of the most delightfull prospects in nature and put me in mind of the pleasant lives of the Shepherds we reade of in *Romances* & truer stories: Now we were arriv'd at *Stone-henge*, Indeede a stupendious Monument, how so many, & huge pillars of stone should have been brought together ... & so exceeding hard, that all my strength with a hammer, could not breake a fragment: which duritie I impute to their long exposure: To number them exactly is very difficult, in such variety of postures they lie & confusion....¹²

Samuel Pepys found his day-trip from Salisbury more alarming and expensive: 'Thence to the inn; and there not being able to hire coach-horses, and not willing to use our own, we got saddle-horses, very dear. Boy that went to look for them, 6 *d*. So the three women behind W. Hewer, Mumford and our guide, and I single to Stonehenge, over the Plain and some great hills, even to frighten us. Come thither, and find them as prodigious as any tales I ever heard of them, and worth going this journey to see. God knows what their use was! they are hard to tell, but may yet be told. Gave the shepherd-woman, for leading our horses, 4 *d*. So back by Wilton, my Lord Pembroke's house....'¹³

Most eminent of all visitors to Wilton House and to Stonehenge were the Stuart kings. James I paused there in his royal progress in 1620 and went to Stonehenge. And the future Charles II spent a hidden day at the stones during the Civil War. After the Royalist defeat at Worcester in September 1651, Charles fled in disguise for the south coast, flitting from safe house to safe house. On the 6th he came to Heale House at Woodford, half-way between Salisbury and Stonehenge. The next day all the servants went off to a Salisbury fair; the King and his protector, Col. Robert Phillips of Montacute House, made a show of leaving, 'rid about the Downes, and tooke a view of the wonder of that country, Stoneheng, where they found that the King's Arithmaticke gave the lye to that fabulous tale that those stones cannot be told alike twice together'. They came quickly back, and hid away in an upper room before the household returned.¹⁴

During his 1620 visit, James I was much intrigued by Stonehenge. The Duke of Buckingham, his host at Wilton, offered the owner, Robert Newdyk, 'any rate' if he would sell Stonehenge but 'he would not accept it'. The Duke did have a hole dug in the middle to see what was there; years later, when John Aubrey saw it, it was still 'about the bignesse of two sawe pitts'. From it had come perhaps 'Stagges-hornes and Bull's hornes and Charcoales', perhaps 'Stagges-hornes a great many, Batterdashers, heads of arrowes, some pieces of armour eaten out with rust, bones rotten, but whether of Stagges or men they could not tell' – or perhaps all these came from the Stonehenge barrows, like the 'bugle-Horne tip't with Silver at both ends'. All these finds have since been lost, and more besides: 'something was found, but what it was Mrs Mary Trotman [of West Amesbury farm] hath forgot'. And about this time, an Altar Stone 'found in the middle of the Area' was carried away to St

31 John Aubrey's drawing of a 'batter-dasher', which is everything the name suggests.

James's, Westminster, a royal prize for courtiers to admire. There could be money in it; in 1635 ploughing in the dip south of Stonehenge brought up 'as much Pewter as was sold for five pounds'.¹⁵

King James decided an expert study of Stonehenge was needed: certainly the random curiosities being dug up were not very informative. However crude its construction, Stonehenge was undeniably architecture and needed an architect to understand it. Inigo Iones, the great masque designer, neo-classical architect and Surveyor of the King's Works, was given 'his Majesty's Commands to produce, out of my own Practice in Architecture, and Experience in Antiquities Abroad, what possibly I could discover' about it. Jones was often working in Wiltshire. at Wilton House in 1633-40, at Calne church about 1639, at Fonthill perhaps, and in his last years with his assistant John Webb at Wilton House again, as it was rebuilt into the 'finest neo-classical house in England'.¹⁶ But at his death in 1652, the 'judicious Architect, the Vitruvius of his Age', left of the Stonehenge commission only 'some few indigested Notes', which Webb 'moulded off and cast into a Rude forme' as a full-length book: The Most Notable Antiquity of Great Britain, Vulgarly Called Stone-heng, on Salisbury Plain. Restored.¹⁷ It is the first book entirely about Stonehenge and seems to be the first book in any language devoted to a single prehistoric monument. None of the papers or drawings survive that it was 'moulded off' from. We cannot tell how much is by Jones, and how much by Webb. That matters little, for Webb learnt his architecture from Jones, married his niece, and himself built precisely in the Jones style (such as the new house for Amesbury manor. of about 1661). What is not by Jones is by his loyal disciple.¹⁸

As a young man in Italy, Jones had applied himself to search out the Roman ruins 'which in Despite of *Time* it self, and Violence of *Barbarians*, are yet remaining'; and in England, no ancient building seemed 'more worthy of searching after, than this of *Stone-Heng*: not only in regard of the *Founders* thereof, the *Time* when built, the *Work* it self, but also for the Rarity of its *Invention*, being different in *Form* from all I had seen before; likewise, of as beautiful *Proportions*, as elegant in *Order*, and as Stately in *Aspect*, as any.'

Could it be anything to do with the ancient Britons, that is, the people living in the island when the Romans settled, as they were known from the classical writers? Everything showed it could not. The Britons were uncouth and Hobbesian, 'a savage and barbarous People, knowing no use at all of Garments', and 'if destitute of the Knowledge, even to clothe themselves, much less any Knowledge had they to erect stately structures, or such remarkable Works as Stone-Heng'. Lacking 'constant habitations', ignorant of the skills of corn-growing, they squatted in caves, tents and hovels, living on milk, roots and fruits. Their priests, the Druids, roused them to worship in groves of trees, 'having of themselves, neither Desire, nor Ability to exercise, nor from others, Encouragement to attain whatever Knowledge in the Art of Building'. As Tacitus recorded, the Romans did not discover any grand buildings.

Opposite

I Perspective in the de Heere tradition, by William Smith, 1588. II Naive watercolour, Stonehenge surrounded by hedged fields, by George Wood, 1736. III Prospect after the David Loggan print (ill. 39), late 17th century (the earliest oil painting).

Following pages

Coloured views by 19thcentury landscape painters. **IV** *Iames Bridges, with* sunset, early/mid-19th century. **V** James Bridges, with full moon, early/mid-19th century. **VI** Copley Fielding, in glowing evening light, 1818. VII John Constable (in its final, exhibited form), with twin rainbows, 1835. VIII J.M.W. Turner, with

lightning and tragedy, 1828. For its engraved version see ill. 79.

IX–XII Light and colour among the sarsens.

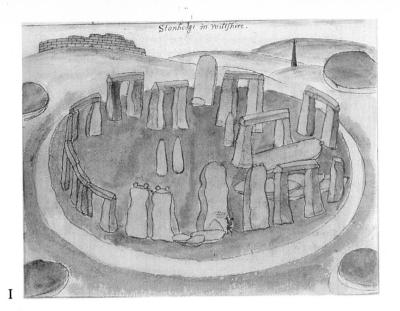

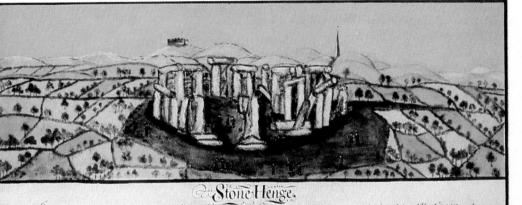

Sinchengen. The Unions Minument was coust by Alexel Citist yourganit and Minter of Statistic and the Anim of Working of the Statistic of the

Π

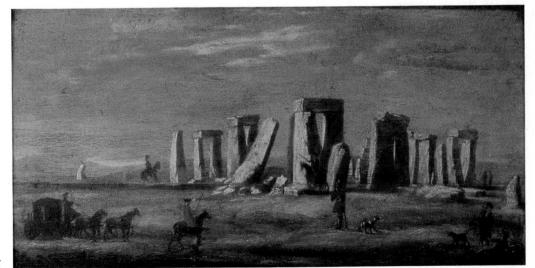

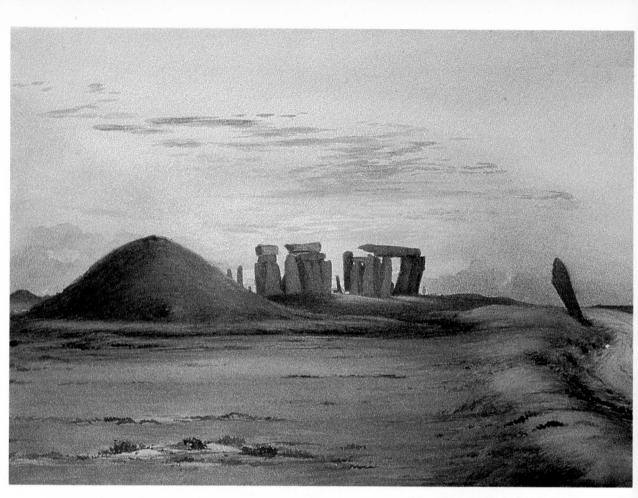

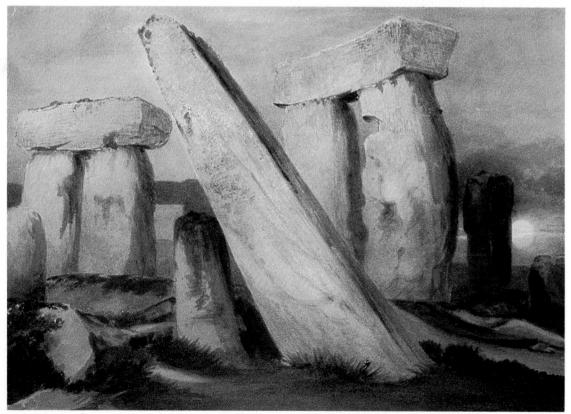

IV

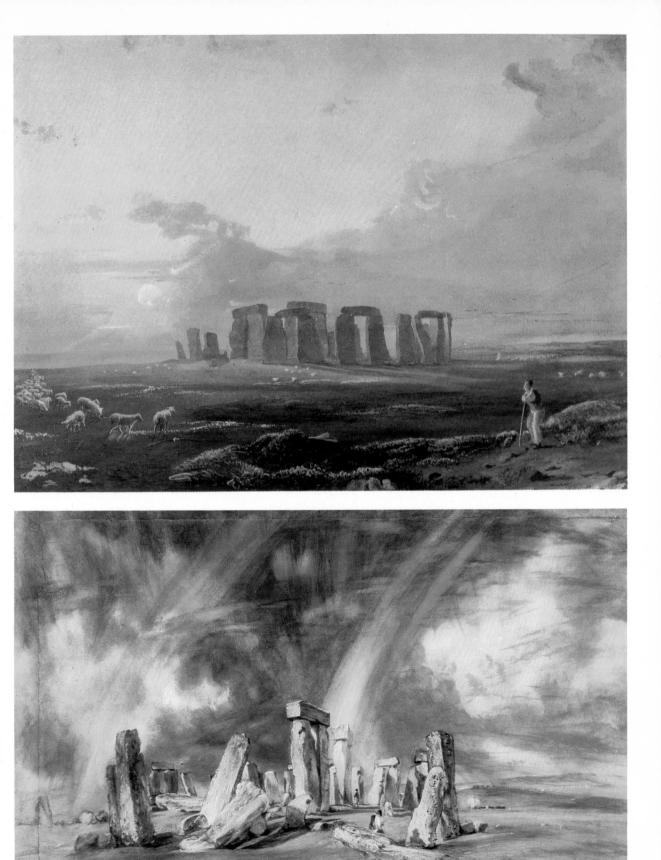

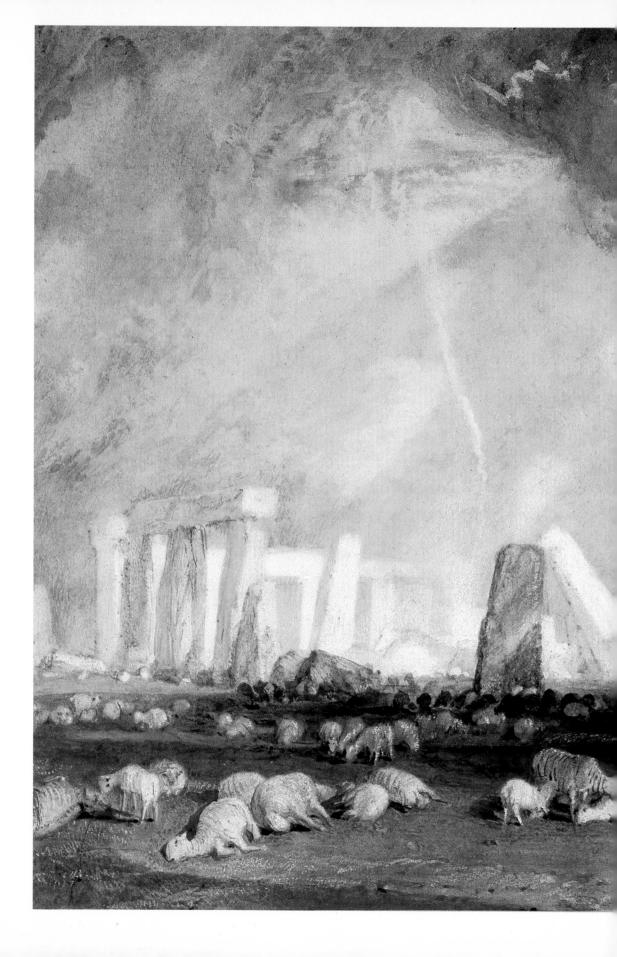

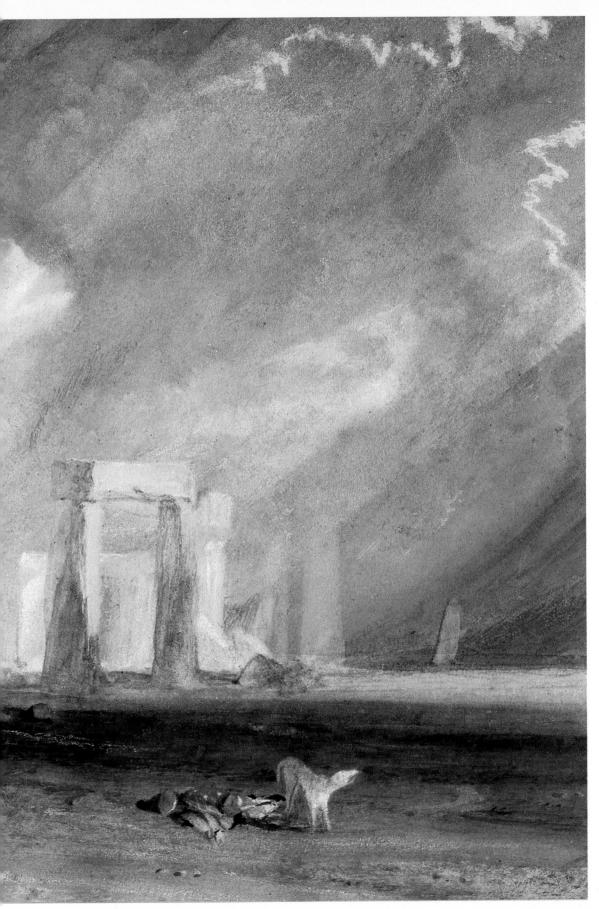

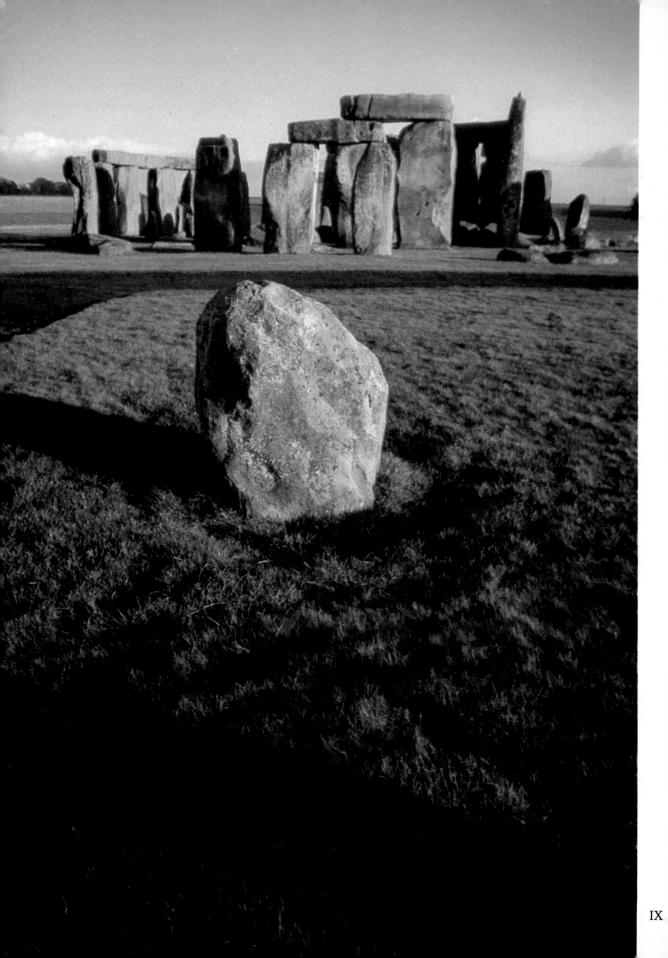

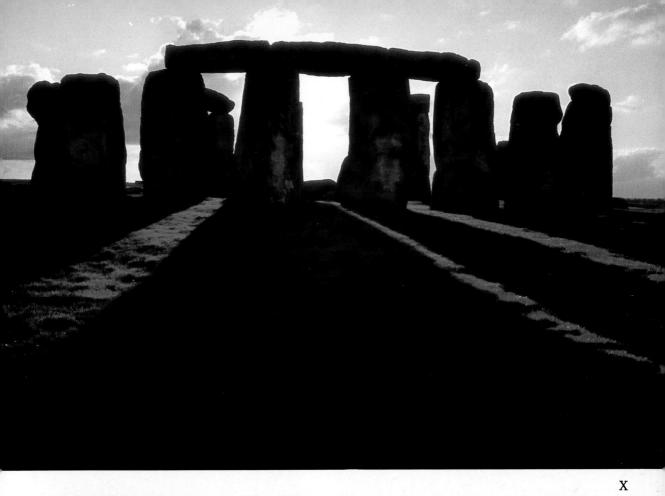

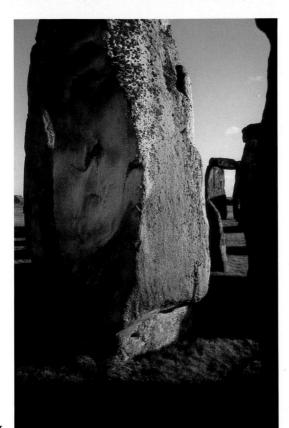

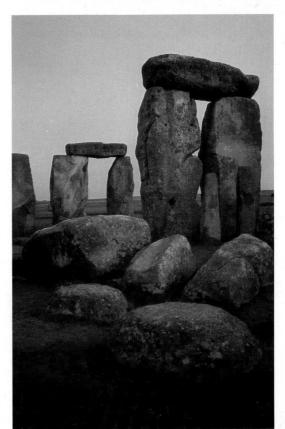

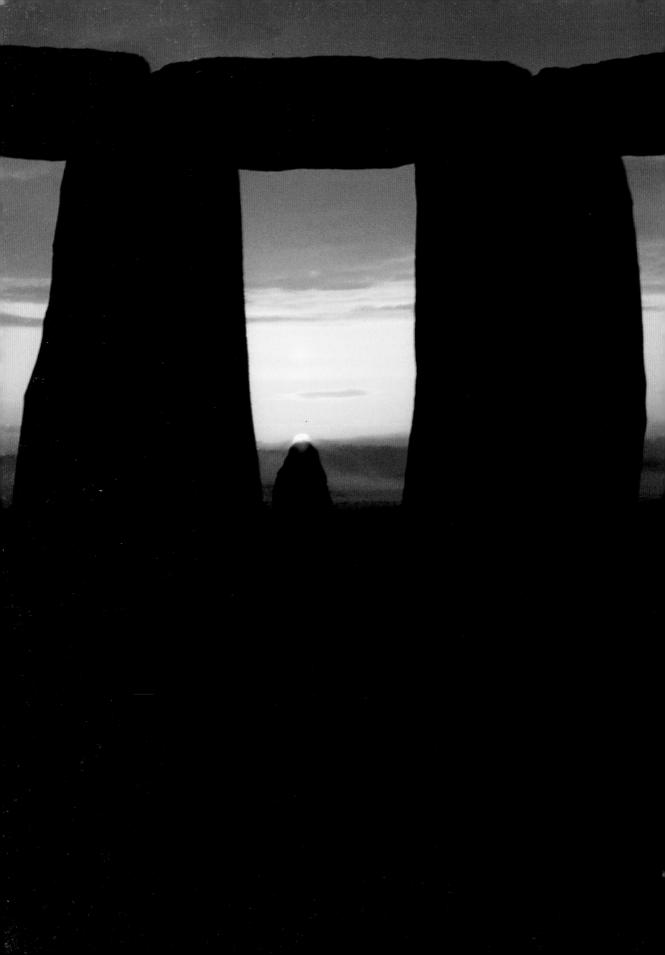

There being no temples to demolish, they instead 'cut down the *Britains* Woods and Groves, amongst them reckoned holy, and consecrated to their execrable Superstitions'.

Stonehenge showed nothing of this horrid savagery. It was a pure exercise in the geometric proportion which Jones so refined in his own designs: 'who cast their Eyes upon this Antiquity, and examine the same with Judgment, must be enforced to confess it erected by People, grand Masters of the Art of Building, and liberal Sciences, whereof the ancient *Britains* utterly ignorant, as a Nation wholly addicted to Wars, never applying themselves to the Study of Arts, or troubling their thoughts with any Excellency'.

Nor could the Britons after the Roman occupation have managed it, for 'all Sciences were utterly perished' and 'the *Arts* of *Design*, of which *Architecture* chief, were utterly lost even in *Rome* it self, much more in *Britain*, being then but a Tempest-beaten Province and utterly abandoned by the Romans'. Finally, in Saxon times there was 'nothing but universal Confusion, and destructive Broils of War'.

Accordingly, 'more propitious Times must be sought out for designing a Structure, so exquisite in the Composure as this: even such a flourishing Age, as when *Architecture* in rare Perfection, and such *People* lookt upon, as by continual Success, attaining unto the sole Power over *Arts*, as well as *Empires*, commanded all' – and that could only be the noble age of Rome.

Analysis of the monument gave independent proof. Jones's plan of Stonehenge 'as it now stands' records all the settings round the 'supposed Altar'. Adding the stones 'made subject to Ruin' by the 'Fury of all-devouring Age' and the 'Rage of Men likewise' completed its perfect geometric symmetry into a shape defined by four equilateral triangles within a circle.¹⁹ Turning to his own architectural library, Jones found, in an edition by the Italian Daniele Barbaro of Vitruvius' treatise²⁰ on proportions in architecture, a classical building with just the same form of plan. (Or, as the critics complained, he may have turned from his Vitruvius to cast Stonehenge into the same form.)

The elevation showed the order of the building, a combination very usual in Roman architecture in which the plainness and solidness of Tuscan blended with the delicacy of Corinthian. Reasoned surmise filled out the details and made Stonehenge a Roman temple to the god Coelus, probably of the time of Agricola, built in a variant of the plainest and most robust of classical styles; in short, a kind of natural architecture modified only by the civilizing discipline of rational spacing.²¹

Unfortunately, the best thing about this analysis is its nerve. The plan of Stonehenge does not follow equilateral triangles within a circle. The Barbaro plan was of a theatre with semicircular auditorium and rectangular stage, not of a circular building at all. The Stonehenge uprights do not have Tuscan proportions. Neither round nor square, without capitals or bases, they are not even columns in the first place. XIII (opposite) The beautiful deception. The classic misty view of the sun rising on the summer solstice morning, in exact and perfect alignment with the Heel Stone, as in fact it does not if you stand on the axis of Stonehenge.

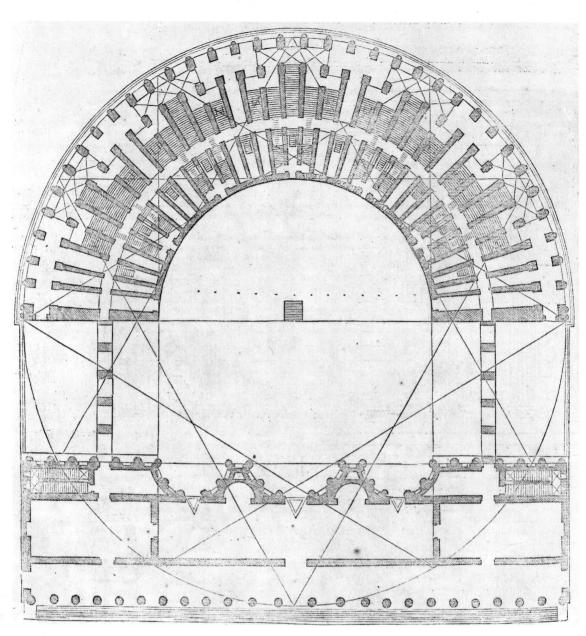

The Jones attribution of Stonehenge to the Romans depended on finding in it the geometrical construction of four equilateral triangles

32, 34 Vitruvian plan of a Roman theatre (above) and Jones's Stonehenge plan (opposite) with the same controlling construction. It was

made to fit by adding a trilithon and setting the trilithons as a regular hexagon.
33 Pen drawing (below), reversed left to right, perhaps the original for an illustration in 'Stone-heng Restored'.

35 *Jones's perspective (opposite, below) of Stonehenge as built, with extra trilithon.*

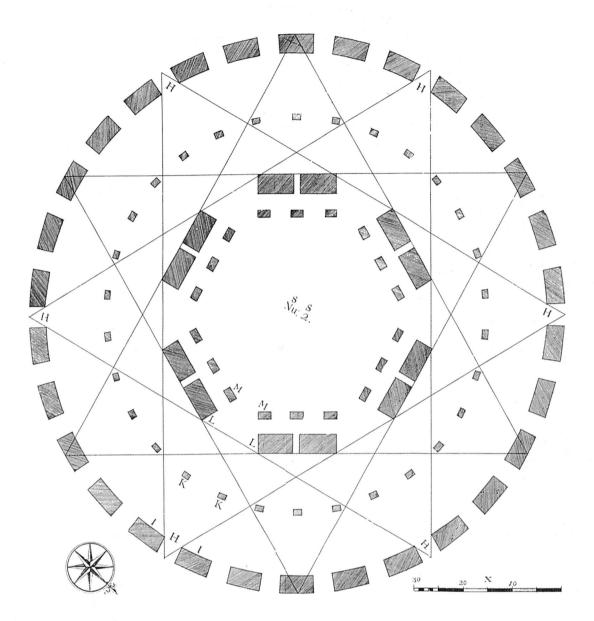

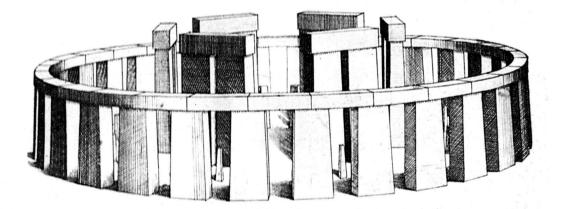

The strange thesis of Mr Jones and Mr Webb was rudely received, and sold badly. The Earl of Pembroke's own copy was famously annotated with derisive remarks, and most of the printed stock was still with the publisher ten years later when it was burnt in the Great Fire of London. To one of the critics, Dr Glisson, we owe a guess that came to the real date of Stonehenge as radiocarbon dating has now shown it to be: 'at least 3 or 4 thousand years old longe before ye Romans' came to Britain.²²

As direct descendants, *Stone-Heng Restored* still has lonely pamphlets, published by their authors, which try to prove Stonehenge is a Roman building.²³ Indirectly, too, it survives in the repeated conviction running through to the present that Stonehenge is far too capable to be native-built, so there must be a foreign civilizing expertise to be traced. Otherwise, in the literature of archaeology, it is a sport, a treatise in architectural theory accidentally applied to archaeology.

But the Jones restoration of Stonehenge is not only theory. Jones did use the Tuscan order in the proportions specified by Vitruvius when 'a plain, grave, and humble manner of *Building*, very solid and strong', was needed, in a stable and brewhouse at Newmarket, and in a sculpture gallery for the King's antique pieces. And when the Earl of Bedford asked Jones to design a cheap chapel – 'I would not have it much better than a barn' – for the parish of Covent Garden, he got 'the handsomest barn in England',²⁴ a plain church with Tuscan portico. Its proportions follow Vitruvius to the letter, just as Jones believed Stonehenge did: the wide-spaced columns 7½ diameters high are joined by a massive beam without mouldings. The eaves project a great distance, a quarter of the column height. This odd building is the Tuscan of Vitruvius, originally expounded as an essay in the theory of architecture, made into a real structure. His 'equally astonishing but, in its own way, logical attitude to Stonehenge' shows that same faith in the ancient masters, and a

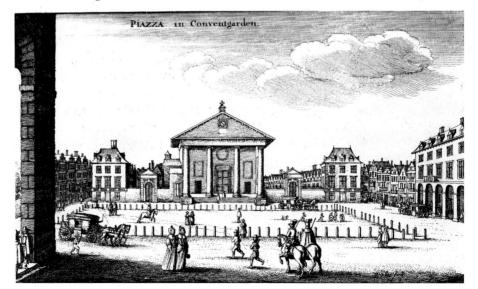

36 'The handsomest barn in England', Jones's church of St Paul's, Covent Garden, using the same Tuscan order and proportions he found in Stonehenge. special pleasure in finding in England the classical form so precisely carried out. $^{\rm 25}$

Edmund Bolton, a respected historian, and a friend of Jones, had seen the impossibility years before: 'The dumbness of it (unlesse the letters bee worne quite away) speakes; that it was not any worke of the *ROMANS*. For they were wont to make stones vocall by inscriptions. That STONAGE was a worke of the Britanns, the rudenesse it selfe perswades.' As to what the Britons meant it to be, Bolton like everyone else turned to the classics, who led him to Boadicea, the most notable of the few Britons a name could be put to: 'the clear testimonie of DIO, that the BRITANNS enterred her pompously, or with much magnificence, cannot be better verified than by assigning these orderly irregular, and formlesse vniforme heaps of massiue marble, to her euerlasting remembrance'.²⁶

The surveys of Leland and Camden found nothing like Stonehenge elsewhere in Britain, nor was there anything quite like it in Europe, 'no one Structure to be seen, wherein more clearly shines those harmoniacal Proportions' than Stonehenge.²⁷ In Holland there were hunebedden, or giants' graves, long tombs with huge capstones that might be imagined as Dutch Stonehenges.²⁸ But the Dutch had never settled in Britain. The Danes were more promising; they had occupied half Britain. In the early 17th century the Danish antiquary Olaus Worm was surveying the megalithic tombs, cousins to the hunebedden, which the Danes called dysser. After correspondence with him, Dr Walter Charleton, personal physician to the King, convinced himself that *dysser* were the prototype for Stonehenge, and issued a treatise making the Danes in the 9th century its builders.²⁹ This was another impossibility: the historians 'would not certainly have been silent of so considerable a structure', and the difference between the megalithic monuments was too great. As a later traveller reported, the Danes 'highly exaggerate when they deduce any resemblance between the stupendous fabric of Stone Henge, and these trifling, though genuine, remains of high antiquity'.³⁰

More telling than the Danish attribution is the suggested purpose of Stonehenge. Charleton took it for the ancient coronation place of the Danish kings, its very form the shape of a crown. No purpose could be more tactful for a leading courtier to suggest, only two or three years after the Restoration had ended the years of Republican confusion, when 'He who is so brain-sick as to question or dispute the Antiquity of KINGS and MONARCHICAL Government, will put the choicest Wits to their Trumps, to find a *Nomenclation* to expresse his Folly, the Word *Fanatick* being too weak and slender.'³¹ Nothing better illustrates the dependence of the ideas about Stonehenge on the preconceptions of those who study it than the instant appearance of this idea in 1663 (except perhaps its immediate disappearance afterwards). The message is pressed home by two dedicatory poems to Charleton's book, the one by Dryden remembering the flight from Worcester:³²

... STONE-HENGE, once thought a Temple, You have found A Throne, where Kings, our Earthly Gods, were Crown'd. Where by their wond'ring Subjects They were seen, Chose by their Stature, and their Princely Mien. Our Sovereign here above the rest might stand, And here be chose again to sway the Land.

These Ruins sheltred once *His* Sacred Head, Then when from *Wor'ster's* fatal Field *He* fled; Watch'd by the Genius of this Kingly Place, And mighty Visions of the Danish Race. His *Refuge* then was for a *Temple* shown: But, *He* Restor'd, 'tis now become a *Throne*.

John Webb's friends thought Dr Charleton's book 'but a capricious Conceit, it could make no Impression in the Breasts of judicious Men'. Finding, 'upon a second Perusal', that it reflected badly on the memory of Jones, Webb emitted a vast and windy *Vindication* of his master's work, prudently prefaced by an elaborate and loyal dedication from 'Dread Sir, Your Sacred Majesty's Ever Most Lowly, Ever Most Loyal *Subject* and *Vassal*'.³³ It is hard to believe that this Majesty – or any reader, then or since – enjoyed wading through its 125,000 porridgy words.

Webb was a working architect and knew Stonehenge at first hand, yet neither he nor Charleton makes any new observations, provides any new plan. The argument is wholly about words; every contrary written authority is consulted and quoted with triumph, but not the monument itself. The difficulty that trapped them, as it trapped Bolton and Jones, was the inability to conceive of a Britain before recorded history. The only possible builders were the occupying powers, Danish, Saxon, Roman (the Normans being too recent to qualify), and the native British. But, as Jones showed, nothing the classical sources said about the Britons and their priests, the Druids, fitted Stonehenge. The 17thcentury historians, dependent like the medieval chroniclers on the written records (and the fakes) of their predecessors, could go back only as far as 'the Beginning of their Pedigrees, as if there Nature and World was at a stop, and all knowledge beyond that was mere *Chaos* and Confusion'.³⁴

A more radical alternative, then and now, has been to abandon the known settlers of Britain, and search farther afield for more distant and colourful architects. The further they are away and the less is known about them, the more easily is discrepancy between Stonehenge and a supposed prototype evaded – for would not the shock of leaving its native land for the cold waste of Salisbury Plain modify any style of architecture? The ultimate personifications of this idea have been UFOnauts, infinitely remote, infinitely mysterious, infinitely capable; an earlier suggestion has been the people of lost Atlantis; and the

(Opposite) The Dutch and Danish 'Stonehenges' were poor things by the standards of the original.

37 The giants and their 'hunebedden' as a 17thcentury antiquary saw them: A normal-sized human makes a convenient snack.
38 Ole Worm's drawing of a Danish 'dysse'.

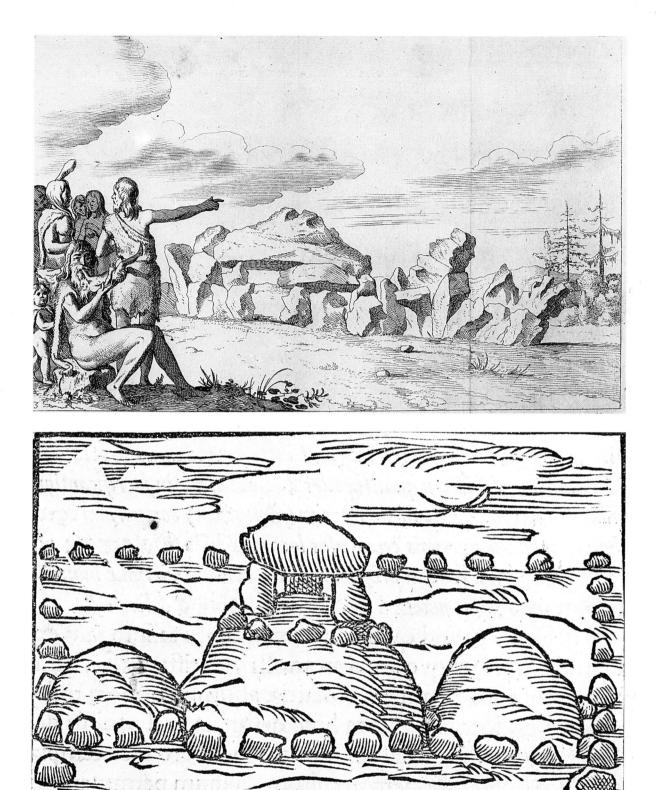

N

prototype for them all, in the less free-wheeling and imaginative world of the 17th century, were a real, historical people. The Phoenicians, as remote, powerful and mysterious as is necessary, were dragged in by the visionary Aylett Sammes, who is fairly described by the topographer Richard Gough as 'an impertinent pedant who knew nothing about antiquities'.³⁵ His *Britannia Antiqua Illustrata* of 1676 ruminates on the odder details of the Geoffrey story and then, with typographic weight, announces discovery: 'NOW to separate Truth from a Fable, and to find out an Ancient Tradition, wrapt up in ignorant and idle Tales; Why may not these Giants, so often mentioned, upon this, and other occasions, be the **Phoenicians**, as we have proved on other occasions, and the Art of erecting these Stones, instead of the STONES themselves, brought from the farthermost parts of *Africa*, the known habitations of the Phoenicians.' Note the 'why not', always a useful device when you want to convince and have no proof.

39 A busy day at Stonehenge, with trippers arriving from all directions. In these two prospects, from the west and the south, by the 17th-century engraver David Loggan, features such as the encircling ditch and Heel Stone are clearly seen.

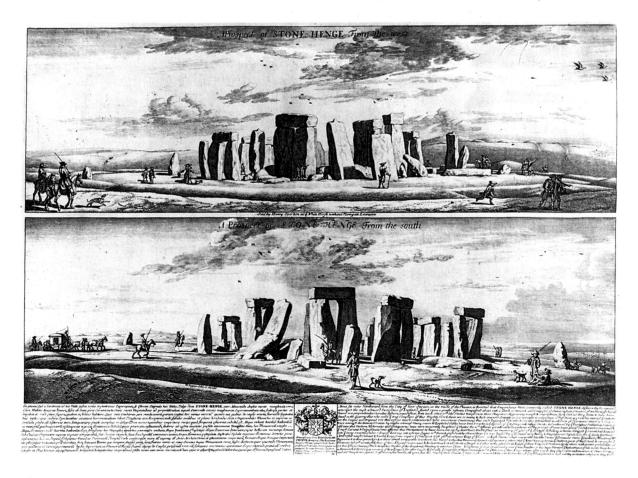

Sammes's Phoenicians, like the Trojans of the Brut, sailed round Spain to discover Britain, led 'some say by *Hercules*, others by *Himilco'*. Everything in early Britain is Phoenician, brought direct or through the Greeks, who by 'vanity and fraud' had stolen so much.³⁶ Inigo Jones had found a Tuscan-cum-Ionic order at Stonehenge – and were not both those orders Phoenician? Was not Hercules a most suitable leader for men who built in giant stones? And so on. Ever since, the Phoenicians have proved convenient when awkward facts of archaeology need explaining away: so the medieval stone monuments of Zimbabwe, in the country now named for them, were claimed as the work of Phoenician colonists 'in a magnificient parody of archaeological research' by white supremacists who would not believe black Africans could build well without enlightened help from abroad.³⁷

Stonehenge, in the 17th century, was mercifully not all pedantic and empty dispute. The dons of St John's College, Oxford, enjoyed performances of a Stonehenge pastoral in their hall. Kings and princes came to see the 'most admirable rarity' England afforded – William of Orange on his way from Torbay to be crowned in London; Cosmo the Third, Grand Duke of Tuscany, on his tour of England – and were tactfully told it was the trophy of some grand (and doubtless royal) victory. There was a strange comic tale of 'a wander witt of Wiltshire, rambling to Rome to gaze at Antiquities', but when he said 'he had never seen, scarce ever heard' of Stonehenge, the Romans 'kicked him out of doors, and bad him goe home'. The moral: 'I wish that all such Æsopicall Cocks, as slight these admired stones . . . and scrape for barley Cornes of vanity out of foreigne dunghills, might be handled, or rather footed, as he was'.³⁸

Commoner folk could enjoy 'The Description of Stonehenge', a verse printed in *Holborn-Drollery: Or, The Beautiful Chloret Surprized in the Sheets* . . . to which is Annexed Flora's Cabinet Unlocked. It falls between 'The Humours of the Tavern' and 'The Ladies Musick-Act', titles which sufficiently indicate the nature of the collection:³⁹

At distant view, methought I did descry Some town of note, or University. Who Farms the Fire-Hearth Money, I dare swear, Shall bid a good-Rate for the Chymneys there. But as I nearer came, it widen'd much, Shew'd like a Castle-ruines, or some such . . . Some call't the Devils Court; to make it true, Shew us his Lodging-Room, Bed, Piespot too, Yea and his Porter, that tall Crumpbackt-stone You meet aloof off from the rest lone. Who for a kinde one hath the Approbation, Will let you pass without Examination, You shall have free admission to his Shrine, And yet Beel-zebub keeps good Discipline . . .

STONEHENGE COMPLETE STONEHENGE COMPLETE ST IEHENGE COMPLETE STONEHENGE COMPLETE STONEF IGE COMPLE 4 **MR AUBREY AND DR STUKELEY** ONEHENGI OMPLETE STONEHENGE COMPLETE STONEHENGE COM E TE STONEHENGE COMPLETE STONEHENGE COMPLET

40 John Aubrey, in the portrait intended as the frontispiece to his 'Monumenta Britannica'.

Not entirely unregarded, and Aubrey was not the only man to see how Avebury resembled Stonehenge. Joshua Childrey's Britannia Baconica of 1660 notes: 'at Aubury in an Orchard there are halfe a dozen, or halfe a score stones little inferior to the Stonehenge for hugeness, some standing upright like the Stonehenge, & others lying flat on the ground.14

**A 'Lesbian rule' is an easily adjusted standard, by analogy with the pliable rules, made of lead, used by masons on the island of Lesbos.

'Nice plans and perspectives, and a learned dissertation'

If the Romans and Danes did not build Stonehenge, who did? There were few other candidates in the 17th century. The Anglo-Saxons, the other known settlers in ancient Britain, were soon promoted by a German antiquary, but the north German monuments compared no better than did the Danish.¹

The invaders exhausted, there remained only exotics like the Phoenicians, the mythical giants (and worse – might it be 'opera diabolica'?²), and the native British. The British case was argued by a native Wiltshireman, John Aubrey. Nowadays Aubrey is known best for his *Brief Lives*, a garrulous gossiping party full of scandal and dottiness. He is seen more fairly as a bigger man, scientist and historian, Fellow of the Royal Society, omnivorous collector of curiosities and learning, pioneer writer on folklore and place-names. His work on the Wiltshire monuments is the great precedent to modern fieldwork.

Aubrey was born in 1626 of a Welsh family that had migrated to west Wiltshire, as he was glad to remember: 'I was inclin'd by my *Genius*, from my Childhood to the Love of Antiquities: and my Fate dropt me in a Countrey most suitable for such Enquiries.' He saw Stonehenge when he was eight, and fourteen years later stumbled on the great stones and earthworks of Avebury, when by chance the hunt took him down from the grey wethers into Avebury village. He was 'wonderfully surprized at the sight of those vast stones: of which I had never heard before: as also at the mighty Bank & graffe about it'. It was 'very strange that so eminent an Antiquitie should lye so long unregarded* by our Chorographers'.³

Avebury is spelt in a number of ways, often Abury and Aubury; it must have been a special joy for John Aubrey to find such a place already named after himself, its would-be discoverer.

Aubrey read Jones's *Stone-Heng Restored* 'with great delight' but 'having compared his Scheme with the Monument it self, I found he had not dealt fairly: but had made a Lesbians rule', ** framing the monument 'to his own Hypothesis, which is much differing from the Thing it self'. Still, it gave Aubrey 'an edge to make further researches'.⁵

Impetus came by royal command of Charles II, the third successive king to take some personal interest in Stonehenge. In 1663, when Walter Charleton was discoursing with the King about Stonehenge, Avebury was mentioned, and what Aubrey said of it, that it 'did as much excell *Stoneheng*, as a Cathedral does a Parish Church'. Aubrey was called to

41 Silbury Hill stands in the Kennet meadows like a grassed-over coal-tip. Broadly contemporary with Stonehenge, it required about the same amount of labour in its construction.

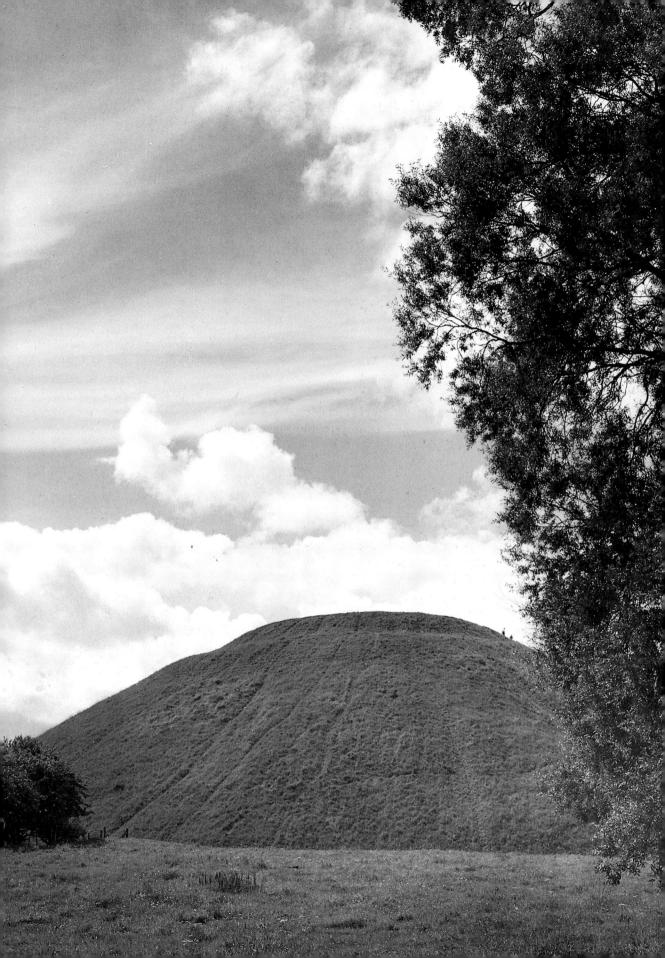

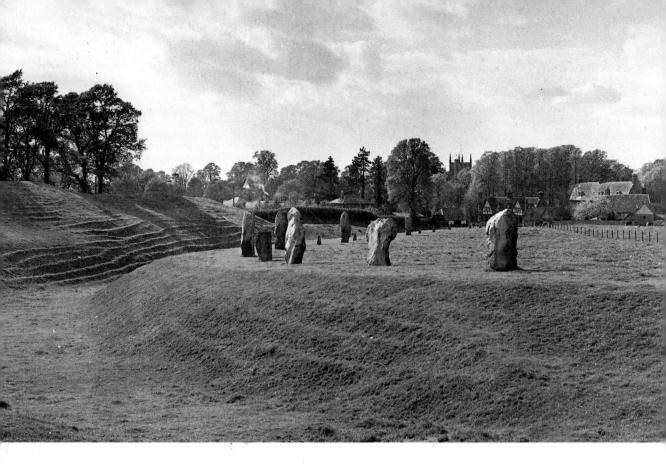

42 Avebury: the bank, ditch and great stone circle are on a far grander scale than Stonehenge.

show 'a draught of it donne by memorie only', and a fortnight later guided the King round 'that stupendious Antiquity'. Climbing to the top of Silbury Hill, the King was diverted by tiny snails in the grass, 'not much bigger, or no bigger than small Pinnes-heads'. When he told his Duchess of them in bed the next morning, her interest was so great that Aubrey was called to Bath to show them to her 'as a Rarity'. On the larger issue, Aubrey was commanded to give a 'Description' of Avebury – and, the Duke of York added, an 'account of the Old Camps and Barrows on the Plaines'.⁶

His plan for an 'Avebury described' grew, as Aubrey's projects tended to do, into a larger scheme, the 'Monumenta Britannica' or 'miscellanye of British antiquities'.⁷ The tired squabble over Romans and Danes at Stonehenge had 'left the world as much in darkness as ever'. Because they concerned only historical peoples, historical individuals like Boadicea, and historical records, 'from all their disputations, no spark was struck, towards a discovery of the real truth'.⁸ Aubrey saw that floundering in the early histories was no use: 'These Antiquities are so exceeding old that no Bookes doe reach them, so that there is no way to retrive them but by comparative antiquitie, which I have writt upon the spott, from the Monuments themselves.' His own inquiry, he admitted, 'is a gropeing in the Dark; but although I have not brought it into a clear light; yet I can affirm that I have brought it from an utter darkness to a thin mist'.⁹ **43** Aubrey's 'wretchedly designed' sketch-plan of Stonehenge, 1666. The dotted lines running out below mark the Avenue, with the Heel Stone to one side. By the entrance causeway are marked three stones, where now there is only one, the Slaughter Stone. The central setting of five trilithons is fairly depicted as a horseshoe, but two more are roughed in to complete a spurious circle of seven.

Just inside the bank are marked (with 'c's) the two Station Stones and (with 'b's) the five extra 'cavities in the ground from whence one may well conjecture the stones...were taken, which stood around the trench as those at Avebury' (as in the illustration opposite).

Explored in 1920, these 'Aubrey holes' (page 181) were found to be regularly spaced pits, rather than stone-holes.

applie of Stone heng a the bank the dites PlateVI - 0

His method then was to be fieldwork; surveys, planning, and observation to sort ancient remains into different classes that could be looked at together. His first and best class was of stone circles, Avebury and Stonehenge of course, and the others in southern England, like the Rollrights and Stanton Drew.

Aubrey began that September of 1663 with a 'plaine table' survey of Avebury, and 'afterwards tooke a Review of Stonehenge'. The Stonehenge plan, dated 1666, is a scrappy thing showing the faults Aubrey cheerfully confessed to in the 'Monumenta' – 'though this be writt, as I rode, a gallop; yet the novelty of it, and the faithfulness of the delivery, may make some amends for the uncorrectness of the Stile'.¹⁰

For all its uniqueness, Stonehenge was an ancient stone circle, to be classed with the other lesser cousins to the cathedral of Avebury. 'By comparative Arguments', Aubrey then tried 'to work-out and restore after a kind of Algebraical method, by comparing them that I have seen, one with another; and reducing them to a kind of Æquation'.

The key equation for the Wiltshire circles was to relate them to stone circles in west and north Britain: in Pembrokeshire, the tip of west Wales, that were noted by Edward Lhwyd; in north-east Scotland, which Aubrey heard of from Professor James Garden of Aberdeen; and in Ireland. The manner of their building, everybody agreed, showed the stone circles were temples, just as the ruins of a monastery immediately show what was there. And the temples in these distant parts of the * This became a placename to treasure, the very word Druid set into the name of the ancient stones. But it is a mistake for Kerig y Druidon, 'Druidon' being Welsh for brave. British Isles, where Romans, Saxons and Danes had penetrated scarcely or not at all, shared 'the same fashion and antique rudenesse'.¹¹ This distribution showed, entirely by proof of the monuments themselves, that stone circles were the temples of the native British.

What is more, it was reasonable to go on to a further 'presumption': 'That the Druids being the most eminent Priests (or Order of Priests) among the Britaines: 'tis odds, but that these ancient Monuments (sc. *Aubury, Stonehenge, Kerrig y Druidd*,* etc.) were Temples of the Priests of the most eminent Order, viz, Druids'. Even this reasonable conclusion was qualified: the 'comparative Arguments' gave 'a clear evidence that these monuments were Pagan-Temples', but it was no more than a 'probability, that they were *Temples* of the *Druids*'.¹²

44 (above) The 'Hebridean Stonehenge', Callanish on the island of Lewis, exemplifies the northern and western aspect of the distribution of stone rings. The 'tide marks' on the stones mark its submergence under peat. This drawing of it by Col. Sir Henry Iames, head of the Ordnance Survey in 1866, was intended as a model for surveyors in recording ancient monuments (page 135). 45 (right) The distribution of stone rings confirms Aubrey's belief that they were concentrated away from the Roman-occupied south and east of England.

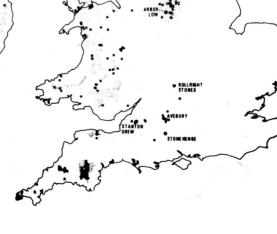

Like almost everything Aubrey started, the 'Monumenta Britannica' was never finished, nor did he dig at Stonehenge, as the King had asked, 'to try if I could find any human bones' below the stones. In the 1690s, the ageing Aubrey, feeling 'like the Ghost of one of these Druids', picked it up again 'after many years lying dormant' and talked desperately of putting it in the press. But even the best part, the section on stone circles now entitled 'Templa Druidum', was too confused to be published.¹³

If Aubrey had been organized by a determined secretary or her 17th-century equivalent - 'some Ingeniose and publick-spirited young Man, to polish and compleat, what I have delivered rough hewen'14 – and the book finished and printed, perhaps it would impress us less than it does when with hindsight we can find among its confusions the premonitions of ideas and perceptions of our own time. There is in it a clear proof that Stonehenge was an early temple of native Britons, a view that has not been overthrown in the three centuries since. But the argument is distracted by all kinds of quaintness and 'beautiful Aubreyisms',¹⁵ and the supporting evidence for a Druid Stonehenge is slight and dotty. The mysterious tablet that no one could read 'might be made by the Druides, who though they used the Greeke character, it might be as much disguised and different from what is now in use as it is in the Sclavonique by the Russians, which a critick in Greeke is not able to read'. And the stares [starlings] that nested* in the gaps between the sarsen uprights and lintels 'did put me in mind, that in Wales, they do call Stares Adar y Drudwy, sc: Aves Druidum, and in the singular number Aderin v Drudwy, sc: Avis Druidum. The Druids might make these holes purposely for their birds to nest in. They are loquacious Birds and Pliny lib: Hist. Nat. tells us of a stare that could speak Greeke.' (Aubrey's Druids were keen on birds: possibly they 'did converse with Eagles, and could understand their Language'.)¹⁶

On Aubrey's death, the 'Monumenta' neither perished nor was sold off at auction, as he had feared. Edmund Gibson put part into the 1695 edition of the *Britannia*, and copies of it circulated.

By the turn of the 18th century, the elegant Roman and Danish Stonehenges were in decline, and the rude British was rising, as we see from Samuel Gale's tour in 1705, when Stonehenge seemed 'a surprizing uniform structure, and even at a distance strikes the spectator with an awful idea': 'from the rudeness and barbarity of the structure, I conclude it to be a British monument, the Romans always leaving indisputable marks of their grandeur, elegance, and particular genius, of any of which our Stone-henge has not the least resemblance'.¹⁷

The style of fieldwork, of travelling, measuring and observing on the ground, that Aubrey had begun was carried on by a young Lincolnshire doctor, William Stukeley. On his first topographic tours, the stone circles excited him wonderfully. The Rollright Stones, on a bare ridge-top above Chipping Norton in Oxfordshire, were the 'greatest Antiquity' seen during his 1710 tour. The stones, 'corroded like wormeaten wood by the harsh Jaws of Time', were 'a very noble, rustic,

• By the 1970s reduced to sparrows, but now there are jackdaws nesting in the holes. sight, and strike an odd terror upon the spectators, and admiration at the design of 'em'. He could not but suppose they formed 'an heathen temple of our Ancestors, perhaps in the Druids' time'.¹⁸ And in 1716, thrown into a 'Set of thoughts about Stonehenge' by a sight of the David Loggan prints (ill. 39), Stukeley undertook to make an 'exact Model' of it, from thence 'the groundplot of its present ruins', a 'view of it in its pristine State', and finally 'the original Architectonic Scheme by which it was erected, together with its design, use, Founders etc.' It made an ambitious plan for a man who had not been to Stonehenge himself; when at last he went, on 18 May 1719 with his friends Samuel and Roger Gale, 'it surprized me beyond measure'. He drew a first plan, and worked on it during the summer, thanks to Lord Pembroke who took and sent him the accurate measurements that he had not found time to make for himself.¹⁹

Over the years 1721-4, Stukeley found time each summer from his busy life as physician, antiquary and first secretary of the Society of Antiquaries in London to work each summer at Avebury and at Stonehenge, surveying, measuring and drawing, so as to put together 'a most accurate description', 'with nice plans and perspectives, and a learned dissertation upon these sorts of Circular Antiquitys'.²⁰

Little escaped Stukeley's eye as he rode and walked round the 'sacred pile' of Stonehenge on the 'delightful plain'; 'nought can be sweeter than the air that moves o're this hard and dry, chalky plain. Every step you take upon the smooth carpet, (literally) your nose is saluted with the most grateful smell of *serpillum*, and *apium*, which with the short grass continually cropt by the flocks of sheep, composes the softest and most verdant turf, extremely easy to walk on, and which rises as with a spring, under one's feet.' These were glorious, busy times, one day digging in barrows, another setting out early from the Amesbury inn to draw Stonehenge in the early morning light or to ride the twenty miles over to Avebury to catch sight of stones there before Tom Robinson's band of stonebreakers got to them.²¹

The chalky soil round Stonehenge was perfectly dry and hard, crisply holding every mark of ancient earthworks; even 'the infinite numbers of coaches and horses, that thro' so many centuries have been visiting the place every day, have not obliterated the track of the banks and ditches'. The visitors busied themselves, of course, with the 'mighty problem' 'which has so long perplex'd the vulgar', to count the true number of stones; Stukeley cheerfully enjoyed breaking that 'vulgar incogitancy' with an (adjusted) figure of 140. The other 'unaccountable folly of mankind' was in 'breaking pieces off with great hammers', a 'detestable practice' which 'arose from the silly notion of the stones being factitious'. When measuring the fallen stones, the antiquary had to imagine how they 'have doubly suffered, from weather, and from the people every day diminishing all corners and edges, to carry pieces away with them'. The smaller stones resisted: 'They are of a harder kind of stone than the rest, as they are lesser; the better to resist violence.'²²

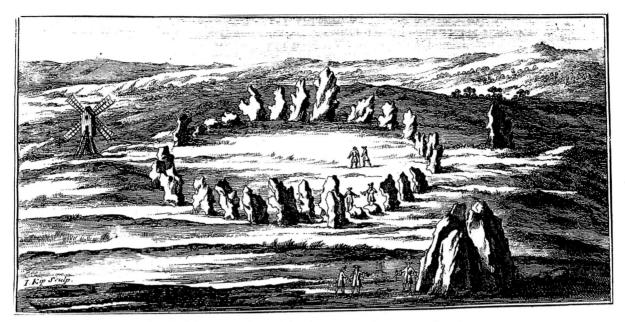

46 The Rollright Stones, Oxfordshire, a perfect circle of untrimmed stones with a single outlier (right, centre) and a ruined megalithic chamber tomb, the Whispering Knights (right, front). Situated on the open ridge-top in the 17th century, the Stones were later enveloped in a gloomy copse of larch trees.

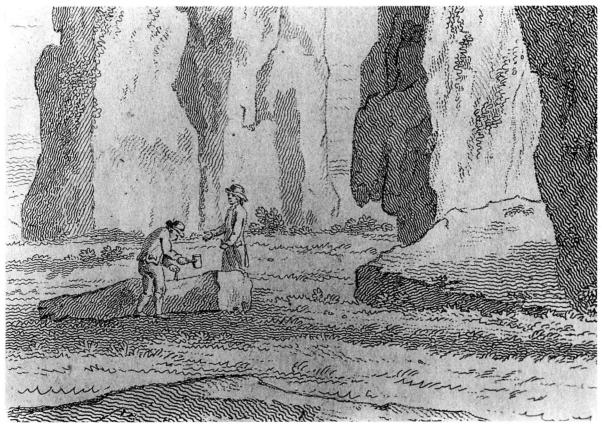

47 The 'unaccountable folly of mankind'. These Stonehenge visitors are trying to hammer off a souvenir they can scarcely hope to be able to carry away with them.

* Not a common feeling; almost everyone then and now is disappointed by how tiny it looks from half a mile away (pages 142-3).

As a temple of ancient Britain, Stonehenge was placed in the quiet of the downs, according to the 'antient notion', that temples are 'in clean and distinct area's, distant from profane buildings and traffic'. Half a mile distant, Stukeley found the appearance 'stately and awful, really august'.* Advancing nearer, 'the greatness of its contour fills the eye in an astonishing manner'. And, 'When you enter the building, whether on foot or horseback and cast your eyes around, upon the yawning ruins, you are struck into an exstatic reverie, which none can describe, and they only can be sensible of it, that feel it. Other buildings fall by piece meal, but here a single stone is a ruin, and lies like the haughty carcase of Goliath. Yet there is as much of it undemolished, as enables us sufficiently to recover its form, when it was in its most perfect state. There is enough of every part to preserve the idea of the whole.' At last you may peep between the sarsens into the holy of holies, the sanctum sanctorum, where 'the dark part of the ponderous imposts over our heads, the chasm of sky between the jambs of the cell, the odd construction of the whole, and the greatness of every part, surprises. We may well cry out in the poet's words

Tantum Relligio potuit!

If you look upon the perfect part, you fancy intire quarries mounted up into the air: if upon the rude havock below, you see as it were the bowels of a mountain turn'd inside outwards.²³

These are grand sentiments and grand words. But Stukeley was as much a man of sense as of sensibility; he noted all kinds of details in the building, for instance the finesse in the sarsen circle referred to on page 12 above. The uprights were turned with their best face inside ('Not as our modern *London* builders,' Stukeley adds, 'who carve every moulding, and crowd every ornament, which they borrow out of books, on the outside of our publick structures, that they may more commodiously gather the dust and smoke.') The artful variation in the spacing at the 'grand entrance' was in accordance with the *Vitruvian* rule of classical architecture to 'relax the intercolumniation just in the middle of the portico', a particular Stukeley is glad to see Webb did not notice. But 'our *British* priests knew nothing of *Vitruvius*; they deduc'd this knack from an authority much ancienter than him, *viz*. from pure natural reason, and good sense'.²⁴

There were other ways to discomfit Webb's Roman pretensions. One was to measure Stonehenge accurately, 'for whoever makes any eminent buildings, most certainly forms it upon the common measure in use, among the people of that place. Therefore if the proportions of *Stonehenge* fall into fractions and uncouth numbers, when measur'd by the *English, French, Roman* or *Grecian* foot, we may assuredly conclude the architects were neither *English, French, Roman* or *Greeks.*' A Roman Stonehenge would measure in Roman feet, which Stukeley had worked out at $11\frac{1}{2}$ English inches. So in 1723, with his friend and patron Lord Winchelsea, he spent at Stonehenge 'compleatly two days and a

half with great pleasure', taking 2000 measurements and settling the groundplot 'upon its true basis'. As the rough stones had suffered in all dimensions, it was 'not practical to take their true measure, without necessary judgment, and relation had to symmetry'. That allowed, the artifice showed itself 'exceedingly pretty, every thing being done truly geometrical, and as would best answer every purpose, from plain and simple principles'. The measures were perfectly agreeable to a unit of 204/5 English inches, the Egyptian cubit in Stukeley's reckoning,* with every dimension convenient 'in round and full numbers, not trifling fractions'. But 'if we collate the numbers given, with the *Roman* scale, the measures appear very ridiculous and without design; and that is a sure way of confuting the opinion, of its being a *Roman* work'.²⁵

Stukeley and Lord Winchelsea went up on the lintel of a trilithon with a ladder, and took 'a considerable walk on the top' (in a space, it may be noted, only 15 ft by 5 ft), but 'it was a frightful situation'. Till that moment, Stukeley thought, he 'knew not half the wonder of that stupendous pile'.

Years later, Stukeley remembered it as large enough 'for a steady head and nimble heels to dance a minuet on'; his company had 'dined at the Place, and left their Tobacco Pipes upon it', and, he supposed, the pipes must still have been there.²⁶

The following day, recovered from the awful walk, the minuet and the dinner, Stukeley dug 'by Lord *Pembroke*'s direction' within Stonehenge. The Rev. Thomas Hayward, into whose possession Stonehenge had come from the Washington family, had already grubbed about, finding 'heads of oxen and other beasts bones, and nothing else'; he had also let loose a colony of rabbits, which were burrowing under the stones. Stukeley, conscious of the 'indiscretion probably, of some body digging there' which had brought down the great trilithon 'from its airy feat', himself 'had too much regard to the work, to dig any where near the stones'. Instead, his men dug 'on the inside of the altar about the middle: 4 feet along the edge of the stone, 6 feet forward'. There, at a foot deep, the solid chalk 'which had never been stir'd' showed how the stones had been put up: 'They dug holes in the solid chalk, which would of itself keep up the stones, as firm as if a wall was built around them. And no doubt they ramm'd up the interstices with flints.'²⁷

Going away from Stonehenge after these strenuous days was a sadness: 'Lord Winchelsea has workt very hard, and was ravisht with Stonehenge, it was a great strife between us, which should talk of leaving it first.'²⁸

Each of those summers at Stonehenge, new wonders showed themselves. In August 1721, Stukeley and Roger Gale spotted an avenue running from the entrance past the Heel Stone and down the hillside 'where abouts the sun rises, when the days are longest'. But it was not an avenue of stones, like those at Avebury and Stanton Drew. Instead, two parallel ditches had been dug, and the earth thrown in to make an avenue raised a little above the ground. It ran straight down to

 It is rather on the short side, by the modern reckoning of an Egyptian cubit. Stonehenge Bottom, where in the dip it was 'much obscur'd by the wheels of carriages going over it' on the Lavington road. Another year Stukeley could track it further and into two branches. One went eastwards, up the hill and between the groups of barrows called the Old and the New King's Graves. There it was 'unfortunately broke off by the plow'd ground' of the Amesbury farms.²⁹

The other branch, turning north and west, led to another new and 'noble monument of antiquity', which he discovered on 6 August 1723. A pair of ditches, 200 of his cubits apart (about 350 ft), ran east and west in parallel for 6000 cubits (just on 2 miles). The earth from the ditches was thrown inwards, and the turf from adjacent ground had been thrown between, to build it higher in level, 'a fine design for the purpose of running'. He called it the 'cursus', as it seemed a hippodrom, a running track for the 'games, feasts, exercises and sports' of the ancient holy days. 'To render this more convenient for sight, it is projected on the side of rising ground, chiefly looking southward toward Stonehenge. A delightful prospect from the temple, when this vast plain was crouded with chariots, horsemen and foot, attending these solemnities, with innumerable multitudes!' At the east end, a 'huge body of earth, a bank or long barrow' across the whole breadth of the cursus seemed 'the plain of session, for the judges of the prizes, and chief of the spectators'. It made 'the finest piece of ground that can be imagin'd for the purpose of a horse-race', where the 'British charioteer may have a good opportunity of showing that dexterity spoken off by Caesar' and the 'exquisite softness of the turf prevents any great damage by a fall'.³⁰

In 1722 and 1723 Stukeley and Lord Pembroke looked into the barrows, the 'artificial ornaments of this vast and open plain' that were set 'upon elevated ground, and in sight of the temple'. That showed their true nature, not 'tumultuary burials of the slain' from great battles, but 'the single sepulchres of kings, and great personages, buried during a considerable space of time, and that in peace'.³¹

Lord Pembroke chose first the double barrow of the Normanton group, on the ridge south of Stonehenge, cutting a 'section from the top to the bottom, an intire segment, from center to circumference'. It was neatly built. A central stack made 'of the turf for a great space around' was covered with a coat of chalk two feet thick 'dug out of the environing ditch' to powder it with a white layer of sanctity. Three feet below the centre, was 'the skeleton of the interr'd; perfect, of a reasonable size, the head lying toward *Stonehenge*'.³²

When he himself dug in the double barrow north of Stonehenge, Stukeley found the same care in construction, layers of chalk, of 'fine garden mould', of flints 'humouring the convexity of the barrow', and of 'soft mould' again. At the bottom was a 'rudely wrought' urn of dark red clay, which crumbled to pieces, full of burnt bones 'crouded all together in a little heap, not so much as a hat crown would contain'. From their size Stukeley judged the bones to be of a girl of 14, whose ornaments were mixed with the bones; a bronze bodkin, the head of her javelin, and Three of William Stukeley's incomparable views of the Stonehenge landscape, and the earthworks he discovered in it.

48 (right) Bush Barrow, where Stukeley found nothing and Cunnington his finest treasure. Stonehenge in the distance.

49 (right) View up the Avenue to Stonehenge, which Stukeley has tidied into symmetrical completeness. On the right is the supposed northern branch of the Avenue.

50 (below) The Cursus, the ancient hippodrome, seen like a broad road running between parallel banks among the foreground barrows. A long barrow blocks its eastern end (left).

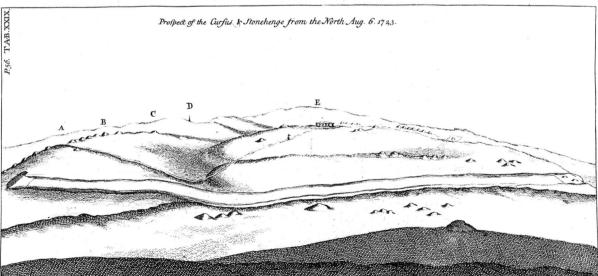

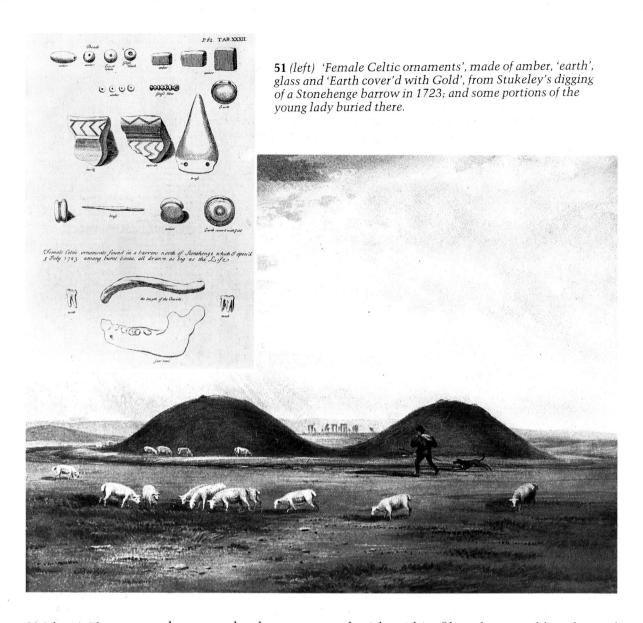

52 (above) The Normanton double barrow – two mounds within a single ditch – opened by Lord Pembroke; the break left by his holes in the smooth double profile is detectable in this later painting, which includes the stock figures of sheep and a lonely traveller. her many beads, one covered with a 'thin film of pure gold', others of glass coloured yellow, black, and blue (these in long pieces notched between), of amber, and of earth. Much was burnt half through by the fire, and 'what would easily consume fell to pieces as soon as handled'. Stukeley reverently 'recompos'd the ashes of the illustrious defunct' and covered her again with earth, 'leaving visible marks at top, of the barrow having been open'd, to dissuade any other from again disturbing them'.³³

In other barrows were 'large burnt bones of horses and dogs, along with human', and of other animals, 'fowl, hares, boars, deers, goats or the like'. And in 'a great and very flat old fashion'd barrow' (Stukeley thought to distinguish older from more recent barrows by their shape) a little west of Stonehenge 'bits of red and blue marble, chippings of the stones of the temple. So that probably the interr'd was one of the builders.'³⁴

Of the date of the barrows, of their builders, of Stonehenge itself, natural philosophy provided two independent clues. In 1720 Dr Halley showed at the Royal Society a piece of Stonehenge sarsen, broken off and polished, which showed under the microscope a 'composition of crystals of red, green and white colours, cemented together by nature's art'. And, Dr Halley observed, 'from the general wear of the weather upon the stones', the work must be of an 'extraordinary antiquity', and, for ought he knew, '2 or 3000 years old'. The smaller stones were of a different, harder rock 'brought somewhere from the west'; and the central stone, which Jones had christened the Altar, was 'a kind of blue coarse marble, such as comes from *Derbyshire*, and laid upon tombs in our churches'.³⁵

The second clue was in orientation. There was 'a greater exactness' in the ancient British sites 'with regard to the quarters of the heavens, than one would expect. in works seemingly so rude; and in so remote an age'. As well, there was 'a certain variation from cardinal points, which I observed regular and uniform, in the works of one place'. The Avebury monuments aligned 9 or 10 degrees anti-clockwise of major points of the compass. Those about Stonehenge varied 6 or 7 degrees clockwise of major points.* The 'principal diameter or groundline', the axis, that is, of Stonehenge lies 'about that quantity southward' (clockwise) of exactly north-east. The 'intent of the founders', thought Stukeley, had been 'to set the entrance full north-east, being the point where the sun rises, or nearly, at the summer solstice'. But not exactly to the solstice sunrise. The ancient British were 'too good astronomers and mathematicians to need so mean an artifice: nor does it correspond to the quantity precisely enough'. This ruled out the obvious but 'superficial' idea that 'it was owing to their observing the sun's rising on the longest day of the year' and setting the line by it.³⁶

Besides, the same degree of variation appeared in the western branch of the avenue, the cursus, and the great long barrow 'exactly at right angles' across it.** This regular and systematic error appeared 'no otherwise to be accounted for' but by the use of a magnetic compass to lay out the works, the needle varying so much, at that time, from true north. Halley and Stukeley plotted the change in the magnetic variation from north in England as far back as they could (about 200 years), and found it seemed to move to and fro over a period of 700 years. Stonehenge, they reckoned, had been built at a time when the variation was the same as it had been in AD 1620; on the regular cycle, that could be AD 920 or AD 220, or about 460 BC, which Stukeley chose as the likely date of the building of Stonehenge.***³⁷

One embarrassment in the dating evidence had to be explained. In 1724 Richard Hayns, an old man Stukeley employed to dig in barrows, found 'some little worn-out *Roman* coins' in the earth rooted up within Stonehenge by Mr Hayward's colony of rabbits. The year before, Hayns had worked as a clay-digger on Harradon Hill, the other side of Amesbury, where Roman coins were often found. Stukeley saw a Mr Merril of Golden Square pay Hayns half a crown for one of them, and

- In 1985, when Stonehenge astronomy was again in fashion, it was shown that Stukeley's compass was in error by about 1½ degrees because its pivot was worn or rusty.
- Stukeley is wrong here. The cursus is angled a few degrees from due east-west, but a few degrees anticlockwise not clockwise as he has it. The long barrow is not quite at right angles, and aligns just clockwise from due north-south.
- Nothing was amiss in the basic reasoning. In Stukeley's time the magnetic declination did have a regular annual change. But over longer periods, the declination has wandered in a complex way according to no recurrent pattern, and on no repeating cycle.³⁸

53 (above) The Wansdyke, running from the right foreground across and over the distant hill-top, in an Edwardian pen and wash drawing.

> 54 (left) Distant views of Stonehenge, like this one 'taken at the distance of a mile' in 1781, invariably exaggerate its size.

guessed he only pretended they came from Stonehenge 'for the sake of the reward'. And he remembered a friend of his, the late Dr Harwood, coming to Stonehenge with Roman coins in his pockets; one of his companions 'would have persuaded him, to throw some of them into the rabbit-holes: but the Doctor was more ingenuous'. Stray coins could not be material: 'were never so many such coins found in *Stonehenge*, they would prove nothing more, than that the work was in being, when the *Romans* were here; and which we are assured of already'.³⁹

Sound evidence for a pre-Roman date of the British barrows came from Woodyates, on the Dorset border of Wiltshire, where the Roman *via Iceniana* cut directly over and through a disc barrow, 'which luckily affords us a demonstration, of the road being made since those barrows'. Near Avebury, the Roman road from Bath to Marlborough cut across another barrow in the same way. Only a mile and a half from Stonehenge, the hilltop fortification called Vespasian's Camp^{*} enclosed within it a barrow 'which doubtless was one of those belonging to the plain, and to the temple of *Stonehenge*, before this camp was made'.⁴⁰

Another insight came from Wansdyke, the boundary earthwork that cuts east-west through Wiltshire, running a little north of Devizes and across towards Marlborough. It must have been dug before the *pax romana* was imposed, 'after that time, the *Roman* power swallowing up all divisions', and 'not improbably' (thought Stukeley) by the Belgae, the last pre-Roman rulers of Britain, as they 'conquer'd the country by degrees, from the aboriginal inhabitants'. Its likely architect was Diviaticus, a Belgic chief mentioned by Caesar, the Wansdyke's size 'suiting so potent a chief'. It cuts Stonehenge off from the sarsen deposits above Avebury, and the stones were 'fetcht from beyond that boundary, consequently *then* an enemies country'. Stonehenge must be earlier than Wansdyke, than the Belgic settlements, than Diviaticus, therefore by Stukeley's reckoning, built before 650 BC.* *⁴¹

The Gale brothers pressed William Stukeley to work up his drawings and notes on Stonehenge and Avebury.⁴² That field study, described in this chapter, was better than anything that was to be done at Stonehenge for the next century and a half. As we read today the books that eventually came out, *Stonehenge* in 1740 and *Abury* in 1743, what seems to be such good fieldwork is increasingly mixed up, especially in *Abury*, with fantastical Druidic vapourings. Filled with these religious speculations, Stukeley was transforming himself into some kind of an Ancient Druid. In Stukeley's time, this univallate hillfort of the Iron Age, set on a bluff above the river Avon, was universally agreed to be a Roman army camp of Vespasian's day.

* Again, Stukeley's reasoning is sound. The Wansdyke is still undated, but belongs with other boundary ditches to the centuries *after* the Roman withdrawal, and therefore has no bearing on whether Stonehenge is Roman or is not pre-Roman.

Two 18th-century models of Stonehenge.

55 (left) Restored in mahogany, conveniently portable inside a hat-box. **56** (right) Unrestored in cork, with the great leaning stone 56 (left) prominent as it should be.

'The origin and progress of true religion, and of idolatry'

Dr Stukeley had long had an affection for the Druids. It was seeing a copy of Aubrey's 'Templa Druidum' that had first sent him to look at Avebury. In 1722, during his Stonehenge fieldwork, he formed with antiquarian friends a 'Society of Roman Knights', dedicated to the saving of Roman remains from destruction by 'time, Goths, and barbarians'. Each member took a suitable Roman or Celtic name, Lord Winchelsea becoming the Belgic prince Cingetorix, Roger Gale the ruler of the Brigantes, Venutius. Stukeley chose a different fancy, to call himself a Druid. Alas! no Druid in England was named in the classical authors, but a little old book, written by a doctor in Dijon, gave him a French Druid – Chyndonax, 'prince des Vacies, Druides, Celtiques, Dijonnois' – according to a supposed Greek inscription. Stukeley was able gratefully to take his place among the Roman Knights as Chyndonax the Druid.¹

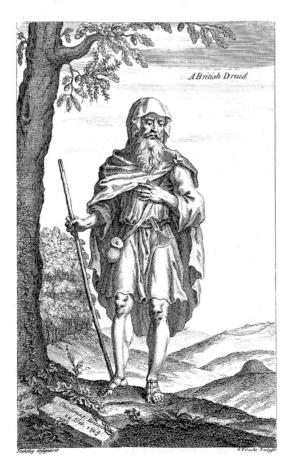

57 (left) A British Druid in Stukeley's original version: an Old Testament figure in cloak and sandals, set in an English landscape (with barrow and distant hill-fort), and ready with a brass axe in his belt to cut the mistletoe overhead.

58 (above) The game of delusion: Stukeley self-portrait as Chyndonax, 'prince des Druides'.

The incident is illuminating. Even Stukeley, who recognized under the enclosures and open fields the existence of a pre-Danish, pre-Saxon, pre-Roman landscape, thought in terms of historical nations and historical individuals. An ancient Druid could not be anonymous, a nameless figure in a shadowy world: historical reference must be found, somewhere, to make of him a real individual with a real name. In the same way, the Wansdyke he found to be built by a named tribe of ancient Britons under a named leader.

Druids of a certain kind, then, were in his mind as he planned and traced the great temples, the parish church of Stonehenge, the cathedral of Avebury, imagining the solemn rites of ancient Britons on the springing downland turf, the crowds cheering the chariots round the cursus race-track, the sober processions up the avenue, the mysteries of the white-surpliced priests at the Altar Stone, the gentle carrying of heroes and heroines, with their jewels and trophies, to be laid to sleep in those most elegant of memorials, the barrow-tombs.

There was in the 18th century, as now, only one direct authority for what the ancient Druids of Britain were really like. That source is the Roman historian Tacitus, and his description is not pleasant. As Suetonius Paulinus, in AD 60, advanced into Wales, the British retreated on to the island of Anglesey. There (in the words of a translation of Stukeley's time) 'the Enemy was rang'd upon the Shore, intermixed with Women, running to and fro, drest in the Habit of Furies, their Hair dischevel'd, Torches in their Hands, and encompast with Druids, who lifted up their Hands to Heaven, pouring forth most terrible Execrations. The Horrour of this Spectacle astonished our Men, and made them stand like Statues to receive the Enemies Assault.' Animated by their general, the Romans 'grew ashamed of fearing a Trup of Women and Enthusiasts', defeated the British, and cut down their groves 'dedicated to their Superstitions'.

When the fighting was done, Tacitus says, 'this inhuman people were accustom'd to shed the Blood of their Prisoners on their Altars, and consult their Gods over the reeking Bowels of Men'.² And Caesar found the Druids of Gaul as sinister; besides judging and settling disputes, they were the priests of human sacrifice – 'unless for a man's life a man's life may be paid, the majesty of the immortal gods may not be appeased'. The gods especially preferred criminals to be sacrificed, but when that supply failed, 'they resort to the execution even of the innocent'. Sometimes they 'used figures of immense size, whose limbs, woven out of twigs, they fill with living men and set on fire, and the men perish in a sheet of flame'.³ Or, according to the historian Diodorus Siculus, they 'kill a man by a knife-stab in the region above the midriff, and after his fall they foretell the future by the convulsions of his limbs, and the pouring of his blood'.⁴*

Pliny's *Natural History* described more civil ceremonies, centring on the sacred oak tree; 'they solemnize no sacrifice, nor perform any sacred ceremonies without branches and leaves thereof'. If they find mistletoe

Mention must also be made of a famous passage of Diodorus, not about the Druids, which has been taken to refer to Stonehenge. Copying the lost history, of the 6th-5th century BC, by Hecataeus, Diodorus talks of the land of the Hyperboreans, 'an island no smaller than Sicily' set in the ocean 'in the regions beyond the land of the Celts'. On the island are 'a magnificent sacred precinct of Apollo and a notable temple which is adorned with many votive offerings and is spherical in shape'. This *might* be Stonehenge, the island *might* be Britain; but the description is short and vague, and there are discrepancies - the climate of the Hyperboreans is so mild they grow two crops a vear.

growing on an oak [extremely rare, though mistletoe on apple or poplar is common enough], the Druids gather it 'devoutly and with many ceremonies' when the moon is six days old: 'after they have well and duly prepared their sacrifices and festivall cheare under the said tree, they bring thither two young bullocks milke white, such as never drew in yoke at plough or waine, & whose heads were then and not before bound, by the horne: which done, the priests arraied in a surplesse or white vesture, climbeth up into the tree, and with a golden hook or bill cutteth it off, and they beneath receive it in a white souldiours cassocke or coat of armes: then fall they to kill the beasts aforesaid for sacrifice, mumbling many oraisons & praying devoutly'.⁶

That was about everything that was known about the Druids. It was discouraging. Nothing fitted Stonehenge, impudently artificial, in the middle of an empty plain, with scarcely a single tree in sight. But the Druids were the priests of the ancient Britons. Stonehenge was an ancient British temple. A reconciliation between the two had to be effected somehow.

The curious workings of orthodox history in the 18th century made accommodation possible. The Old Testament still provided the fixed framework and literal chronology for early history and for archaeology. whose purpose was to provide an 'account of the Origin of Nations after the Universal Deluge'. The earliest part was known in the Bible, from the Creation as far as Mount Ararat. The middle part, bridging from Noah's family to the nations of the classical world, was obscure. In 'these dark recesses of time' illumination came from the Bible, the classical authors and what could be projected back from later sources. Those written sources were the 'solar rays, where-ever they shine, there is pure and perfect light'. Elsewhere, a flickering light came from candles - the analogy of ancient names and words, laws and customs, coins, 'erections, monuments and ruins', inscriptions, place-names - 'little streaming lights to be cautiously and warily made use of' which might 'fill up and enlighten those obscure chasms and interlineary spaces of time' between the brighter strokes provided by records.⁷

There was nothing new in these ideas. The very early histories, including Geoffrey of Monmouth's, had been, like the books of the Old Testament, annotated pedigrees, tracing descent and recording the great events of each reign. It was the natural model for a monarchical and aristocratic world. But by the 18th century, so many suppositions, forgeries and false etymologies were mixed in with historical truths that authorities could be found in the bran-tub of early history to support almost any proposition.

Place-names and language were especially malleable, as the example of the Rollright Stones shows. In the Danish phase, they were 'the *Monument* of some *Victory*, and happily erected by Rollo the Dane'. When fashion changed, and the Somerset circles of Stanton Drew became Stanton Druid, the Rollrights became a corruption of 'Rowl-Drwg', yet another self-announced Druidical temple.⁸ The archaeologist, working from the ancient Britons, that is, the Druids, back towards Noah, found his best lead in Welsh, the relict language of ancient Britain. The sons and grandsons of Noah spoke Hebrew, of course, and Hebrew seemed, or could be made to seem, the same language as Welsh. *Cymry*, the Welsh word for Wales, was easily traceable to the name Gomer, brother of Magog, son of Japhet, grandson of Noah. (An alternative pedigree took *Cymry* back to *Cimbri*, the Cimbrians or Cimmerians of Asia Minor in the Greek authors; and from them again to the Bible.)⁹

The name Stonehenge was more resistant than most to being made Druid, but it did succumb in the end to a pedant who found it 'pure Hebrew-Welsh', as '(Hebrew) *Shiovang*, (Welsh) *Sionge*, the stone seat of Honour or Reverence'.¹⁰ And once Stonehenge and the Druids had been hauled back from outer heathen darkness, into a decent descent from the Old Testament patriarchs, new and benign possibilities opened up. The Druids could be direct descendants of Abraham, in fact and in spirit: 'tho' left in the extremest west to the improvement of their own thoughts, yet advanc'd their inquiries, under all disadvantages, to such heights, as should make our moderns asham'd, to wink in the sun-shine of learning and religion'.¹¹

That was Stukeley's view. It was not the only one. John Aubrey, who we may remember brought the Druids to Stonehenge in the first place, had a harder view of ancient Britons, 'almost as salvage [savage] as the beasts whose skins were their only rayment' and '2 or 3 degrees I suppose lesse salvage than the Americans'.¹² John Toland, an alarming religious theorist of the 1720s, took a cynical view: his Druids are masters of deceit and of 'the art of managing the mob, which is vulgarly called *leading the people by the nose*'.¹³ But, since it was Stukeley's view of the Druids that prevailed, his is the one we must follow.

In 1726 Stukeley left London to live in the country, and in 1729 took holy orders. His old friend and fellow Roman Knight, Sir John Clerk, found him in 1733 'a little Enthusiastick' and 'busy on a book in which he was to describe the Religion of the Druids and all their Temples and monuments, particularly Stonehenge'. Even as he joined the Church, Stukeley began to take Druids for religious reality; when his wife miscarried, he buried the embryo ('about as big as a filberd') 'with ceremonys proper to the occasion' in the 'chapel of my hermitage vineyard', a kind of Druidical folly in his garden.¹⁴

While friends like Samuel Gale waited with impatience, Stukeley's 'Curious Dissertation' on Stonehenge metamorphosed, from a 'History of the Ancient Celts', to 'The History of the Religion and Temples of the DRUIDS' (note the capital letters), and finally to volume seven of a vast religious polemic, 'a chronological history of the origin and progress of true religion, and of idolatry'. In this, when it finally was published in 1740, 'preserving the memory of these extraordinary monuments' took second place to a greater cause, the promotion of the ancient and true Christian religion that was embodied in the Church of England and held

on that median line 'between ignorant superstition and learned free-thinking, between slovenly fanaticism and popish pageantry'.¹⁵

It made for a curious book. There is a full record of the superb fieldwork of 1719-24, which I have quoted at length in the last chapter. But the book begins with Druids, the author's portrait as Chyndonax and then a portrait of a British Druid, a noble patriarch, under the mistletoe and oaken bough. The whole book is made Druidical; Druidical cubits are used to measure Stonehenge; Mr Hayward, the owner, is become 'the Archdruid of this isle'. The Phoenicians pop up as intermediaries to carry the 'reform'd patriarchal religion' of Abraham to the British aborigines. Settled in Albion, the Druids kept pure religion (''till perhaps corrupted by incursions from the continent'). Crucifixion and human sacrifice were an admitted failing, 'a most extravagant act of superstition', but forgivable as 'deriv'd from some extraordinary notice they had of mankind's redemption; and perhaps from *Abraham*'s example misunderstood'.¹⁶

Stonehenge has never entirely recovered from the Reverend Stukeley's vision, although he wrote no more of it, for 'unless a man that writes can be a bookseller, too, he must be a loser by publishing: which has discouraged me from trading with booksellers, who are sure to get all the profit'.¹⁷ He set Stonehenge under a fog-bank of mystification which lasted a century. The modern-day Druids, acting out weakly para-Christian ceremonial in a slacker version of his Druidic garb, are the last vestige of it.

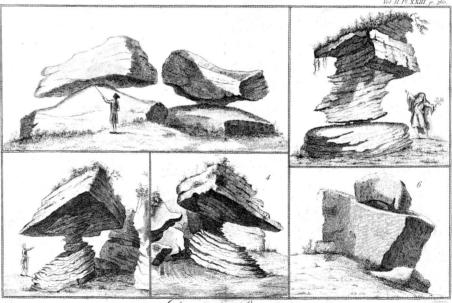

Druidical O Remains

60 (opposite above) Stonehenge fantasy at its Druidical ripest: great glow of fire and smoke of sacrifice, ravines, oak forests, vast crowds of devotees, ivy-covered pillars. The whole performance appears to be choreographed by the foreground conductor with his oversize baton and makes one regret that Cecil B. de Mille never tackled the theme.

61 (opposite below) 'Grand Conventional Festival of the Britons', as Meyrick and Smith saw it in the late 18th century. The snakes come from Stukeley, the arks of the covenant (foreground) from the Old Testament, the costumes from medieval Europe, and the rest from the imagination.

59 A collection of suitable lairs, all in fact natural rock formations but on nicely desolate moors, from a learned paper on Druid habits.

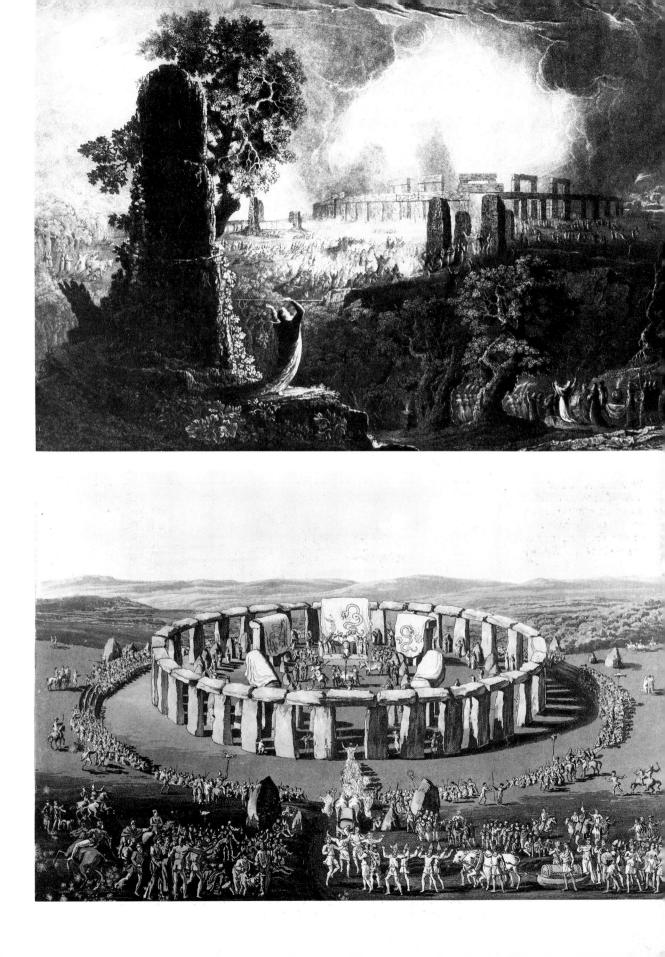

As the Romantic image of the Druid took hold, new places were found for Druids to inhabit. Any rude stone structure, natural or artificial, and preferably on a blasted heath or moor, became Druidic – cromlechs, dolmens, menhirs equally with naturally eroded crags. The Brimham Rocks in Yorkshire were imagined as a kind of provincial Stonehenge for northern Druids; they are actually gritstone blocks, naturally cut into strange shapes by wind and weather, but as late as the end of the 19th century were the subject of earnest enquiry as to whether Druid-built. And chauvinist Yorkshiremen were able to flatter themselves that 'Brimham, could it be transported to Salisbury Plain, would reduce Stonehenge itself to a poor and pigmy miniature.'¹⁸

If no Druidic remains were to hand, they could always be built; various country houses were embellished with Stonehenges as alternatives to the conventional fake ruins or grottoes. There is an early Victorian Stonehenge at The Quinta in Shropshire, and at Alton Towers – now a theme-park – a 'Druid's sideboard', which is an odd transformation of Stonehenge ('very much an abridged version', as Pevsner says).¹⁹ Park Place near Henley was between 1750 and 1790 made variously beautiful by its owner, General Marshall Conway, with obelisks, a grotto, a Cyclopic bridge, and – best of all – 'a little master Stonehenge'. It is actually a chambered megalithic tomb from Jersey, where Conway had once been governor, brought across by barge to make a 'very high-priestly' Druidic Temple.²⁰

Most grandiose of all these false Stonehenges is the full-blooded fantasy on the Stonehenge theme, built in the 1820s by William Danby of Swinton Hall, near Masham in north Yorkshire. It had no particular purpose, save to justify Mr Danby's principles that the local unemployed should receive a dole only if they did some useful work. The Masham Stonehenge stands in a wood high on the hillside, with outlying mock dolmens scattered about. (One of them, which now stands at a road junction, forms the only megalithic roundabout known to me.)²¹

A hermit was for a time installed in the mock Stonehenge near Masham to complete the picture, on the model of the ancients sometimes placed to make authentic the follies and grottoes.

If a complete Stonehenge was too ambitious, a single sarsen stone in the *arboretum*, like the one at Wimpole Hall, near Cambridge, would divert the ladies during an afternoon stroll. Another single sarsen, blackened by smoke, stands in Hyde Park just east of the Serpentine, a forgotten relic of a 19th-century bridge of sarsens.

Stonehenge itself decided to fall in with the idea of Druids. Rocking stones, boulders which lay naturally poised and easily moved by a visitor's weight, were quintessentially Druidic. Around 1740, the fallen lintel of the great trilithon, stone 156, shifted into balance across the altar, 'so exactly counterpoised as to be put in Motion by the force of a Man's hand', for a few years – until the Druidic fervour faded, and it rocked no more.²²

62 (opposite) The 'Stonehenge' at Masham is not a direct copy, but an essay in the Romantic fancies: monoliths and pillars, trilithon gateways, megalithic cells for hermits, a Slaughter Stone for sacrifice, an inner sanctuary with Altar Stone (for dissection), and a corbelled vault to hold any leftovers.

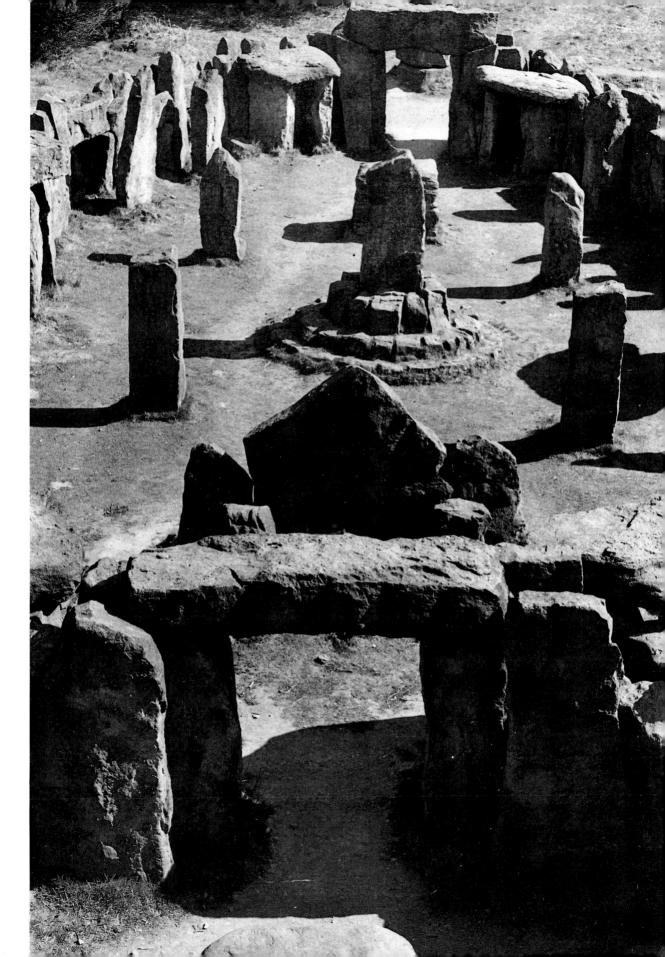

Convenient details from the classics helped in appreciating Druidiana. The Druids were judges, so the 'lesser temples' of Rollright and Stanton Drew were provincial assizes. The annual supreme court of ancient Druids must have been Stonehenge, 'built, as it is, upon an extensive plain, where the surrounding multitude might easily be assembled together'.²³

The Druids gave a new *frisson* and an encouragement to the traveller to visit Stonehenge. It was about this time (or perhaps a little earlier) that the pressure of numbers, visitors, their horses and their droppings, made enough of a muddy mess that a quantity of flints and stone was laid down to give a cleaner surface.²⁴ It had long been 'the greatest gimcrack hereabouts'²⁵ for anyone visiting Salisbury, who could wonder that

Even modern art, which every science owns, Confounded scans the ungovernable stones; Knows not if nature form'd, or art had made, But guits the ponderous theme enwrapt in shade.

To these old thoughts, and the game of counting the stones, Dr Stukeley added a new joy for the sensitive, to dream of Stonehenge in Bardic times:

Lo, there those sons with tawny wolve-skins bound, With thongs from hides of bulls encompass'd round, The temper'd skin of seals a helmet spreads, The raven's plumage nodding o'er their heads. Each tribe its Chief an eagle's plume allows, The hostile pounce projecting o'er his brows. With spears revers'd and daggers sheath'd they come, And file their silent squadrons round the dome.

Seated on the sacred Altar Stone, under the massy columns, even a lady could dare to dream of the 'painted males of many a varied hue', and 'their social wives with fruitage boughs entwin'd', until the 'regal Pontiff' saw the sacred mistletoe 'cut by th'empyreal bill now borne to view'. At last a dread address sent the warriors off to far battles, and the visitor could rise to the world again:²⁶

Naught of my waking vision now remains, But these heav'd catacombs that swell the plains. There slumber there, O Henge, who rais'd their brow, To look disdain on arts we boast to know.

If such a vision did not come easily, there was now a Stonehenge drinks stall to help. An enterprising old carpenter from Amesbury, Gaffer Hunt, built a 'smoaky hut' against the sole standing upright of the north-west trilithon, and 'attended there daily with liquors, to entertain the traveller, and show him the stones'. A cellar dug out under the other, fallen upright kept the drink cool. If it rained you could retire inside the cottage to talk with old Gaffer, while your horses sheltered under the shed at one end. All Stukeley's disputations had set the fashion to measuring the stones; Gaffer would lend you a set of measuring rods so you could work it out for yourself.²⁷

Another occupation was to bang off a souvenir piece for yourself, although no longer – after Dr Stukeley's complaints – with a clear conscience, as Mrs Powys from Oxford found on an August Saturday in 1759. After 'endeavouring with some tools our servants had, to carry some pieces of it with us, which with great difficulty we at last accomplished,' she was 'rather wounded' by reading Stukeley's remarks that ''tis an absurd curiosity for people to wish the remains of this temple further ruinated, but, however, we have the comfort to think that the very small bits we took could not greatly endanger the work'. Also, 'tho' our party were chiefly female, we had not more curiosity' than those learned gentlemen of the Royal Society who had peered at Dr Halley's souvenirs through a microscope.²⁸

(This became the customary excuse. You tut-tutted at the vandals, and showed yourself to be a person of education and learning by taking your own scientific and measured sample – 'I was Obliged with a Hammer to labour hard three Quarters of an Hour to get but one Ounce and a half' – or conducting the scientific experiment of testing which stones effervesced under drops of acid.²⁹)

Mrs Powys, of course, was 'highly entertained' at Stonehenge, 'by the sight of what in the same moment gave one sensations pleasingly awful', just as the good Dr Stukeley prescribed. And of course, she was able herself to give 'but an incoherent account of this noble work',³⁰ and copied *verbatim* the Doctor's glorious prose. There was any quantity like this to quarry from: 'For tho' the contrivance that put this massy frame together, must have been exquisite, yet the founders endeavour'd to hide it, by the seeming rudeness of the work. The bulk of the constituent parts is so very great,' etc, etc.³¹ All the hack guidebooks, 'pitiful abstracts' of the Doctor's great work pushed out by the Salisbury booksellers, copied Stukeley, and so did the visitors;³² no copyright law prevented it, and his ecstatic reveries make still the finest written image of Stonehenge.

As Stukeley's ecstasy came to define the right attitude to Stonehenge, so Stukeley's theories defined its understanding. Every aspect of ancient Britain could be made Druidic, and in particular anything ancient in the way of a knife or cutting tool. No golden sickle was ever found, nor could mistletoe have been cut with one, gold being so soft and mistletoe stems pretty tough. In any case, as Pliny's text clearly says, mistletoe growing on oak is vanishingly rare: a Wiltshire timber surveyor of the 19th century, after a lifetime judging and valuing trees, could remember seeing it only twice. Archaeologists today are used to innocent visitors to excavations expecting every bone visible in the sections of the trenches actually to be human, not animal, and (sometimes) asking what the battle was they died in, as if no one ever died of disease, decay or old age. In the same way, every bronze axe or knife unearthed, like the 'brass' piece ploughed up east of Stonehenge in 1754, might preserve the '(supposed) original shape of a hatchet', 'by which it is conjectured' that the skeleton with it was 'a British Druid, and that the piece of brass was an instrument with which they used to cut misletoe for their religious services'.³³

'Reasonable conjecture' was the guide, and a reasonable man could conjecture almost anything. Why was there no roof over Stonehenge? 'The multitude and nature of their Sacrifices requir'd such Fires as could not admit of Roof or Coverture.' Why was Stonehenge round? 'The Druids were extreamly addicted to Magick, in which Art the circle was esteem'd essentially necessary.' Why were the stones of the inner horseshoe at irregular spacings? To allow for the different sizes of the musical instruments played by the Bards standing at them.³⁴ And so on.

Stukeley's *Stonehenge*, published in 1740, was written only just in time. In the companion volume on Avebury, written just after it, the fieldwork is further buried by religious fantasy, with Druids, Phoenicians and true Christians gathered in mystical serpentine temples to await the Messiah. Even the objective record of fieldwork is interfered with, the circular plan of the site known as the Sanctuary stretched into an oval to suit Stukeley's idea that it symbolized a snake's head.³⁵

But nothing better was written about Avebury or Stonehenge in the rest of the 18th century. Instead there were more vapourings, mostly with hints of eastern promise, for Stukeley had brought the Druids from the east, and the equation of Welsh and Hebrew was mixed up with Indo-European philology. Stonehenge became 'a structure agreeable to the Magi and Ghaurs', a stupendous Asiatic solar temple, or one of 'the 'temples of Boodh', and the Druids were Chaldeans, Hindoos or Brahmins.³⁶

Another style of worthless erudition was invented by Dr John Smith, inoculator of the smallpox, and a worthy successor to Stukeley as the eccentric Medicine-Man of Stonehenge. His version of ancient Druids inclined towards heaven. Their Stonehenge is a 'grand orrery', a 'tropical temple' to watch the skies; the trilithons are the sun, moon and planets; the bluestones of the inner horseshoe are for the twelve signs of the zodiac, plus the Arch-Druid's stall where the high priest watches the sun rise at the summer-solstice dawn directly* over the Heel Stone. Dr Smith, another experimental philosopher, did not believe in burning sacrifices on the Altar Stone: 'I tried a fragment of it in a crucible; it soon changed its bluish to an ash colour, and, in a stronger fire, was reduced to powder. Very unfit surely for burnt offerings.' The Druids must have managed with 'the blood only of their sacrifices'.³⁷ (This claim set off more experiment, the antiquary Hen Wansey announcing a little later, 'I have tried it in the strongest heat, and find it will bear fire.'³⁸)

For a last Druidomaniac, we may take the architect John Wood, designer of the neo-classical terraces and crescents of Bath. His strange vision of Stonehenge, like that of his predecessor in Palladianism, Inigo

In fact *not* directly, as Stukeley had noted (page 79).

Iones, did have unexpected and very practical consequences in his building. And, as an architect, he did appreciate the importance of detailed plans. For all the wrangles over the exact geometry of Stonehenge, no good plan had been published.³⁹ So Wood set out, on Michaelmas Day 1740, 'prepared with proper Instruments, and proper Assistants, to take a correct Plan', in brave disregard for 'all the Inconveniences attending the wild Situation I was to make my Survey in'. At Stanton Drew, the demons had sent storms and lightning when he tried to survey the stone circles; the Stonehenge demons did as well, driving him with a wild wind and showers of snow to shelter inside Gaffer Hunt's hut. Stonehenge had living demons too, 'idle people returning from Weyhill Fair', and 'particularly a Couple of lusty young Fellows who bore the Marks of a late Fray'. They seemed to admire not only the shape of Wood's horses, 'but the Colour of my Watch, which I had inadvertently taken out of my pocket to tell them the hour of the day'. So he kept them 'disagreeably employed at a proper distance from us, under the Notion of their standing for Objects to direct my Instruments to'.

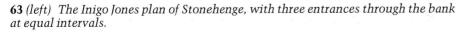

64 (right) John Wood's Circus at Bath, inspired by Jones's plan.

65 A size 11 gum-boot shows the size of the friar's heel, imprinted into stone 14, an upright of the sarsen circle. In the original legend, the Devil threw the stone at a friar, whose foot left this mark. Later the story was attached to the outlier, at first again named the 'Friar's Heel' and to this day called the 'Heel Stone'; 'Heel' was later wrongly derived from helios, the Greek for sun. in honour of the summer sunrise.

66 Megalithic students sit in a stone ring at John Wood's Stanton Drew Druidical University.

Wood's scheme of Druids was even grander than his plans to re-shape Bath, which had been in his version of ancient Britain the 'Metropolitan Seat of the Druids'. (This was proved by its hot-water springs, which showed the sun's inspiration, and by – as usual – phoney etymology: its Saxon name, Achmanchester, meant 'oak men's city'.) Stanton Drew was 'the Ruins of the UNIVERSITY, or great SCHOOL of LEARNING'. The cave of Okeyhole (Wookey Hole) in Cheddar Gorge was the 'DEN, wherein a SECT of PRIESTS', the British Druids, 'INITIATED their Disciples into the Mysteries of their RELIGION and LEARNING'. Stonehenge was a Druidical college, 'the great sanctuary of the ARCH-PROPHET of Britain', where the Divines pretended to raise up the informed Deities from below. (The other colleges were at Avebury for philosophers, on Exmoor for prophets to view the victims' entrails, and for bards at Harptree in the Mendips, another so fortunate place-name that proved the Druid harp was plucked under the boughs of the old oak tree.)

There was naturally a date for Stonehenge (100 BC), and a founder to be named, King Bladud. The whole scheme followed Wood's prejudices; as a neo-classical architect, he looked for origins in the classical world. The Romans ruled themselves out by persecuting Druids, and he chose in their place the ancient Greek sages fleeing Athens when Xerxes sacked the city in 480 BC. They were installed at Stanton Drew to 'instruct the *Britons* in the Liberal Sciences'. Stonehenge was adapted from Stanton Drew, in a plan of Pythagorean geometry. Its outline imaged the world, with north and south pits finely expressing 'Artick and Antartick Circles'. The thirty sarsen uprights were for the thirty days of the month, the thirty lintels for 'an age' of thirty years, and so on. All these schemes combined, every 19th revolution of the Sun and every 235th of the Moon, in the perfect harmony of the celestial spheres. Stonehenge, in short, was a classical temple of the Moon, dedicated to the goddess Diana.⁴⁰

William Stukeley, who as the Druid fantasy engulfed him believed himself more and more actually to be an Arch-Druid, was appalled. Dragging pagan moon-worship 'into this sacred enclosure seems to me like Satan breaking over the hallowed mound of Paradise with no other than a murderous intent'. Wood's whole tract was stuffed with 'fabulous whimsys of his own crackt imaginations, wild extravagancys concerning the Druids, without the least foundation and knowledge concerning

67 The most popular postcard, right up to the First World War, was of the 'Druidical remains', drawn in dark shades of purple and brown.

them . . . the whole of this *wooden* performance is no more than the fermented dregs and settlement of the dullest, and most inveterate mixture of ignorance, malice, and malevolence'.⁴¹ But this is just the biter bit, one 'crackt imagination' fermenting the 'wild extravagancys' of another.

Enough: 'with all due respect for the learning and imagination of the author, however we may *presume* to demur to the corruscations of his lively and fervid *imagination'*, as a more sensible man remarked in dismissing yet another Stonehenge fantasist.⁴²

Phoney history is tiresome in the end. There are no real facts to be ordered or explained, nor the different discipline of admitted fiction. It is time to leave the Druids of Stonehenge, at least until the 20th century, when they make an entrance once more.

Phoney or not, the Druids did not easily go away, especially as the 19th century produced no clear understanding of Stonehenge to take their place. Right up to the First World War, the favourite postcard of Stonehenge was entitled 'Druidical remains' and showed suitably Gothicked and wobbling stones under a brown, green and purple misty sky.

And of the rival varieties of ancient Druid, it was fire, blood and human sacrifice that prevailed over Stukeley's amiable sages, Smith's studied astronomers and Wood's Athenian philosophers. The image that lingered was of the sweet maiden, expired on the altar slab with her guts pulled across the grass, with the Druid priests crowded round in metaphorical darkness like a Wright of Derby painting.

The standing outlier to the north-east became the Heel Stone, pointer to the midsummer sunrise. The fallen outlier by the causeway was made the Slaughter Stone, its various pocks and holes convenient containers for bodily fluids as the victim's corpse was dressed for the final ceremonies, with or without fire as your taste in history preferred, upon the Altar Stone.

STONEHENGE COMPLETE STONEHENGE COMPLETE ST IEHENGE COMPLETE STONEHENGE COMPLETE STONEH IGE COMPLE 6 **The Sublime and the Romantic** Ehenge Omplete Stonehenge Complete Stonehenge Com ETE STONEHENGE COMPLETE STONEHENGE COMPLET

'A wondrous pyle of rugged mountaynes'

Men of the 18th century of a robuster sense, like Daniel Defoe, had no time for the theories of the antiquaries: 'the making so many Conjectures at the Reality, when they know they can but Guess at it, and above all the insisting so long, and warmly on their private Opinions, is but amusing themselves and us with a Doubt, which perhaps lyes the deeper for their Search into it.' As Dr Johnson declared, 'All that is really known of the ancient state of Britain is contained in a few pages.'¹

But ignorance, especially admitted ignorance, was no barrier to appreciation. A full theoretical basis for the appreciation of Stonehenge was laid down by Edmund Burke, the orator and statesman, as a very young man in Ireland, in a study of the two classes of feeling, the beautiful and the sublime. Beauty encompasses the delicate qualities. smallness, smoothness, pale colours. The sublime - which equals beauty in its virtue – relates other properties: obscurity, power, privation (vacuity, darkness, solitude, silence), vastness and infinity, both natural and artificial. In sum, 'whatever is fitted in any sort to excite ideas of pain, and danger, that is to say, whatever is in any sort terrible, or is analogous to terror is a source of the *sublime*; that is, it is productive of the strongest emotions which the mind is capable of feeling.' The sublime properties – intolerable stenches and bitter tastes excepting – show themselves in Stonehenge; above all, difficulty, which Burke defines in these terms: 'When any work seems to have required immense force and labour to effect it, the idea is grand. Stonehenge, neither for disposition nor ornament, has anything admirable; but those huge rude masses of stone, set on end, and piled on each other, turn the mind on the immense force necessary for such a work. Nay the rudeness of the work increases this cause of grandeur, as it excludes the idea of art, and contrivance; for dexterity produces another sort of effect which is different enough from this.²

Dexterity and contrivance were splendidly displayed by Salisbury Cathedral. Visiting the cathedral in the morning and Stonehenge in the afternoon became a philosophical unity, as Dr Johnson found when – thirty years after Burke had written with such authority on Stonehenge – the two of them actually saw it for the first time: 'Salisbury Cathedral and its Neighbour Stonehenge, are two eminent models of art and rudeness, and may show the first essay, and the last perfection in architecture.'³

68 (opposite) Stonehenge in Arcadia, 1836. Thomas Cole's series. 'The Course of Empire', narrates a landscape history from its rural calm into a great city, and then into ruin and decay. The second painting, of the Pastoral State, casts an air of peace and happiness over the scene. with the peasants cheerfully labouring or engaged in simple amusements. At its centre stands the nymphs' and shepherds' temple, a Stonehenge so they may worship under the open sky.

Views of the Stonehenge landscape changed with the change in attitude. In the 1680s, Celia Fiennes thought it 'most champion and open, pleasant for recreations'. To Daniel Defoe in the 1720s, Salisbury Plain was 'a vast continu'd Body of high Chalky Hill, whose Tops spread themselves into fruitful and pleasant Downs and Plains upon which great Flocks of Sheep are fed'. To a farmer, Arthur Young, in the 1760s, the downs were profitable land, sensibly settled: 'I never saw such good sheepwalks as all this country; the verdure is good, and the grass, in general, fine pasture. . . . In twenty miles I met with only one habitation, which was a hut.'⁴

As the taste for the sublime took hold, more violent emotions were searched out. The excursionist from Bath in 1801 was warned to expect 'a wide expanse of sterility', 'a boundless extent of downs, tenanted only by the listless shepherd, his faithful dog, and their fleecy care. In vain the eye looks round for some object to relieve the uniformity of the scene; all is flat, barren and desolate, nothing interposing between it and the distant horizon.' The tourist could feel himself a lonely mariner on 'a rolling ocean continuously heaving in large swells', 'waste after waste rising out of each new horizon', and the edge of the plain seeming 'like land at a distance, horses, trees, and villages; but all around is waste'. A region like this, come down to us rude and untouched, from the beginning of time, will 'fill the mind with grand conceptions'.⁵

Riding up from Salisbury, the imaginative tourist could frighten himself a little: 'I never beheld a more comfortless extension of uncouth, barren, unpicturesque subject in my life.' At the new inn, the Druid's Head, well situated on the way to refresh the weary traveller, he 'noticed the great size and venerable appearance of the landlady, who appeared rather to belong to the ancients than the moderns'. At first sight of Stonehenge itself, the 'distant effect of this stupendous fabric' was not striking, for 'every impression of its greatness is swallowed up and overwhelmed in that idea of immensity which the prospect on every side presents to the mind'. Closer, the effect is heightened, 'for the mind, not being interrupted or distracted by neighbouring objects, bends its undivided attention to the solitary wonder before it', estimating the labour and the toil of its building, 'as these particulars may serve to prove the immense exertions to which men can be stimulated, when under the united influence of superstition and vanity'. (The body, meanwhile, was finding the stones 'almost impenetrable to the chissel and mallet'.)

Another help to the mood was the mystery of its builders; in Wordsworth's verse,

Pile of Stone-henge! so proud to hint yet keep Thy secrets, thou that lov'st to stand and hear The Plain resounding to the whirlwind's sweep, Inmate of lonesome Nature's endless year; . . .

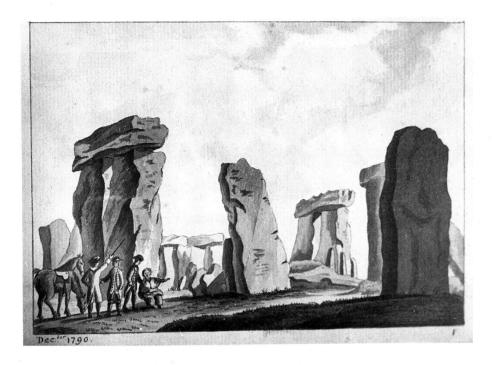

69 Trippers arrive, 1790. The sitting figure is not, as one hopes, a fat lady tourist overcome with sublimity, but the shepherd-guide wearing a smock.

On a wet, stormy day, the whirlwind drove among the stones a shepherd 'whose appearance was almost as antiquated, and rather more defaced by time' than Stonehenge itself. 'Care sat upon his brow, accompanied by Humility, for he very submissively begged to hold our horses, while we surveyed the enormous fabric.' Mercifully, the ancient's life and sorrows, his fifty years' work without a day off for three-and-six a week, his hardships and lost youthful sincerity, made a tale 'too long to be related in such a blusterous hour', and the travellers could escape through the gale, 'tying down our hats with our handkerchiefs'. There was no relief if you chose the Warminster road and headed for Shrewton, the first village, for 'this wretched hamlet affords no other refreshment than bad beer, and worse bread and cheese, is extremely dirty, and equal in nastiness to a Hottentot Kraal'. At last, coming off the waste of the downs into a fruitful valley, 'good accommodation at a decent inn' was found in Heytesbury.⁶

The real purist, once the principles of the picturesque view had been established, would find fault with Stonehenge as an essay in composition, but no one doubted the sublimity of its impact. Rev. William Gilpin, prebendary of Salisbury and priest of the cult of the picturesque, found Stonehenge, on first arrival, 'astonishing beyond conception'. Then he 'walked round it, examined it on every side, and endeavoured to take a perspective view of it, but in vain; the stones are so uncouthly shaped' that it is 'impossible to form them, from any stand, into a pleasing shape'. His judgement had to be severe: 'Wonderful, however, as Stonehenge is, and plainly discovering that the mind, which conceived it, was familiar with great ideas, it is totally void, though in a ruinous state, of every idea of picturesque beauty: and I should suppose was still more so in its perfect one.⁷

For Stonehenge at the turn of the 19th century, we must follow Burke's prescription, and feel the understanding that comes from the senses, directly experienced and mediated through painting, in the finest age of English landscape watercolours.

Stonehenge has an interest, too, in the 'uncouth placing' of its stones as a technical challenge to the painter. There are three problems. Firstly, it is confused: the stones clump together, and you cannot see the organization of the building from the ground. Only in an artificial perspective view, or by walking within the ruin, does its order show itself. Secondly, Stonehenge has little depth of perspective. The stones huddle in a group, with an empty foreground, and an empty background. Thirdly, Stonehenge needs scale, to show off the immense bulk of the stones.

The working-out of these problems, with human figures, sheep, and weather as the means of solution, is the thread running through the pictures that follow.

Three fraudulent solutions to the technical problems of depicting Stonehenge.

70 (below) Mr Pugh squares Stonehenge off to fill his picture and simplify its shape.
71 (opposite above) Mr Hassell, an enthusiast for the Picturesque, constructs a mountain landscape out of clouds to provide a more aesthetic setting.
72 (opposite below) Mr Hogg makes the stones grossly out of proportion to the human figures.

STONE HENGE, in WILTSHIRE.

73 Engraving after Thomas Hearne's watercolour of 1779. The 1797 trilithon is in the left foreground. Stonehenge is a standard item in the great repertoire of English watercolours,⁸ along with other favourites like the view from Richmond Hill, scenes in the Welsh hills, and the more shapely of ruined abbeys. There are any number of careful and restrained paintings of Stonehenge, by amateurs and the best professionals, such as James Malton and Paul Sandby.⁹ The viewpoint is usually from the south or south-west, where the outer sarsen circle is broken and the impressive inner trilithons can well be seen.

The 'irrepressibly genial illustrator' Thomas Rowlandson chose a more flamboyant style; the stones are simplified, moved together and made to undulate exuberantly. The effect is to weaken, the decorative being preferred to the sublime.¹⁰

Without actual falsification, how is the force of the scene to be conveyed? All is so static:¹¹

. . . the spacious plain Of Sarum, spread like ocean's boundless round, Where solitary Stonehenge, grey with moss, Ruin of ages, nods. . . .

The greatest single objects at Stonehenge, to fill and astonish the eye, are the stately trilithons or a single stone, seen close-up; these are the items Thomas Hearne chose in his 1779 watercolour.¹² He took the usual south-west view, but moved closer in. There are no foreground figures; instead a single shapely monolith (an upright of the outer circle) holds the fore. Behind range the three trilithons, and the great leaning stone. (Hearne has the advantage over the 19th-century painters of having the western trilithon available as focus. Its fall in 1797 fatally weakened Stonehenge as a painterly composition, as the centre was occupied no longer by sublime upstanding pillars; instead there was just a mass of lumpen rocks like an abandoned stone quarry.) The sky is a moving background, the sun pouring through breaks in the clouds.

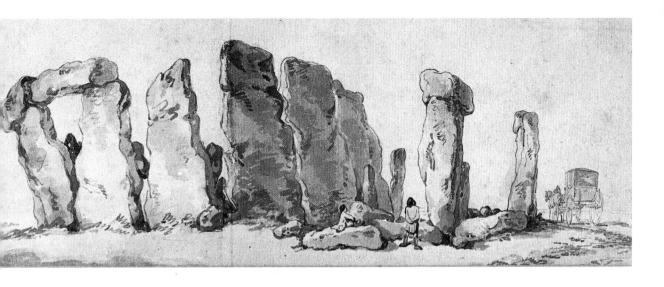

The best-known of the Stonehenge paintings is by John Constable, the 'most ambitious' watercolour of his career,¹³ in which the beige stones lie under a sky of purple-blue clouds, under the arcs of a double rainbow. Fortunately, there survive the original drawing and three intermediate sketches, through which the bare record of the stones, made on the spot, is transformed into the finished composition.

Constable drew Stonehenge in pencil on 15 July 1820 (ill. 75), his only recorded visit. Like Hearne, he chose a close-up, southern viewpoint. With the western trilithon fallen, he moved round to the east a little to make the eastern pair of standing trilithons the focus and high point of the composition. It is a 'typically forthright record of what the artist saw before him, with no discernible, arbitrary editing'.¹⁴ For once there are no sheep, just two figures between the stones, and in the background at the extreme right, a distant covered wagon.

About fifteen years later, Constable took up this sketch (ill. 76), making first a draft of the outlines only of the stones, giving a little more space to left and right, and leaving half the paper free for a skyscape to be worked out in the studio.

Two watercolour versions follow. The stones do not change; the work here is to experiment in the sky, to vary its storminess and to adjust the positioning and separation of the double rainbows (ill. 77).

The final version was complete by September 1835, and shown at the Royal Academy in 1836 (col. ill. VII). It follows the watercolour sketches, but is enlarged again, with extra space to the left and in the foreground. More than half the painting is sky, and power, force, mass, conflict are in the sky. The stones are reduced by the space around them; they begin to be lesser solitaries in an overwhelmed landscape, their immensity slightened by a dominant sky. To a late-20th-century eye, familiar with the mushroom cloud of a nuclear bomb, the great central bank of cloud broadening in blue and mauve behind the double rainbows, has extra and sinister associations.*

74 Thomas Rowlandson's Stonehenge, about 1784.

It may in time become a literal forecast. Constable's viewpoint places the mushroom cloud over the modern military installations at Larkhill, a likely priority target in a nuclear war.

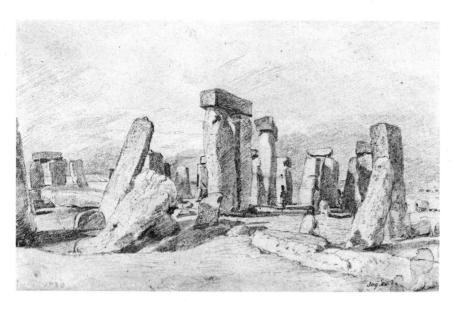

The evolution of Constable's 'Stonehenge'.

75 The original sketch of 15 July 1820.

76 Second sketch, drawn in the studio years later.

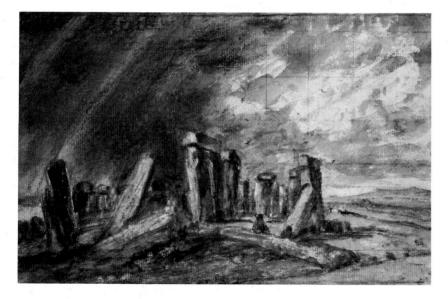

77 One of two preliminary watercolours. The final exhibited version is colour ill. VII.

The covered wagon and figures remain from the first sketch. A new detail is a running hare, in the left foreground, which has been taken as injecting an element of fleeting transience to contrast with the immobility of the stones.¹⁵

At the Academy, Constable appended this caption to the painting: 'The mysterious monument of Stonehenge, standing remote on a bare and boundless heath, as much unconnected with the events of past ages as it is with the uses of the present, carries you back beyond all historical recall into the obscurity of a totally unknown period.'¹⁶ It is an obscurity in which the greatest works of man are weak under nature's power.

The most direct sign of nature's power is lightning, as it strikes down on to or behind the stones. A tiny watercolour by Thomas Girtin (ill. 78). of before 1797, silhouettes Stonehenge against lightning and a storm sky. The same device, on a cataclysmic scale, is exploited by J. M. W. Turner's astonishing watercolour of 1828 (col. ill. VIII). No sketch is known, so it appears first in full and theatrical completeness. As a topographic record it is hopeless – the sarsens are thinned and squared, lintels are added on the right, and extra outliers left and right – but it is a stirring vision. The lightning hits in the centre, a symbol, thought John Ruskin in his later years, of the fall of the Druidical religion. The temple is illuminated by the lightning glow within. The electricity has struck lifeless half the flock and their guardian shepherd, whose loyal dog howls despair. The contrivance of it all did not worry contemporary critics, and the published engraving (ill. 79), in which the lightning is sharper and more explicit, was much admired. Ruskin declared the watercolour to be 'the standard of storm-drawing, both for the overwhelming power and gigantic proportions and spaces of its cloud forms. and for the tremendous qualities of lurid and sulphurous colours which are gained in them'.¹⁷ To 20th-century tastes, it may rather seem lurid in the pejorative sense.

After Constable's and Turner's pyrotechnics – even if they are less pictures of Stonehenge than of fantastical storms – almost any image is liable to seem weak. A lesser picture by far is the first original oil painting of Stonehenge (ill. 80), which is ascribed to William Marlow.¹⁸ The shepherd guides his flock by the stones (as is customary), while eager tourists ride up to the stones (as is customary). The artist has chosen a viewpoint on the south-east which maximizes the number of lintels that can be seen. The 1797 trilithon is still standing, which helps. and he has painted the leaning stone 56 as if it formed a ladder up on to a trilithon. One visitor clings to it on his hands and knees, while his friends who have made it to the top take the awful walk along the lintel. The painting is not exactly realistic (the proportions are adjusted, the trilithons made squarer and rather Italianate; the human figures are reduced; the bluestones are shaped into more perfect pyramids), but it makes a very fair image of the sublime Stonehenge that the visitor would expect to find, after reading in his guidebook the reveries of Stukeley or the mock-medieval verse of Thomas Chatterton:19

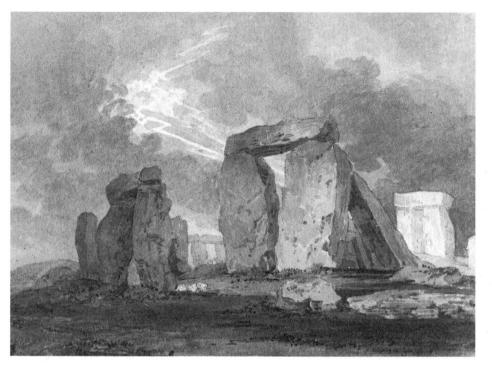

78 (left) Thomas Girtin 'Stonehenge with a Stormy Sky', c.1794.

79 (below) Turner's drama made a popular print. The watercolour original is colour plate VIII.

80 (opposite) The oil painting, perhaps by William Marlow, encapsulates the Sublime experience of Stonehenge.

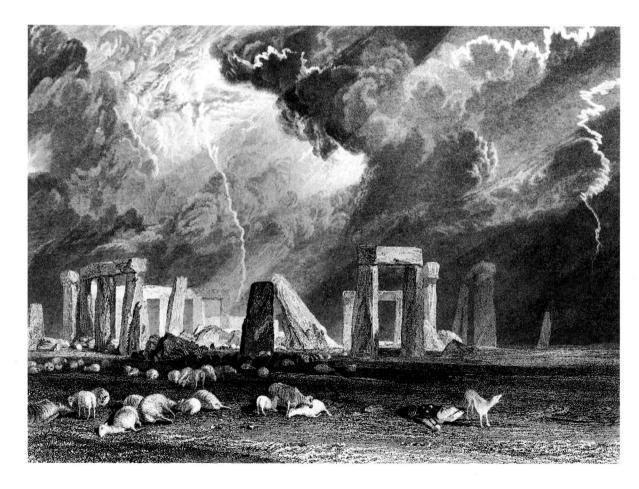

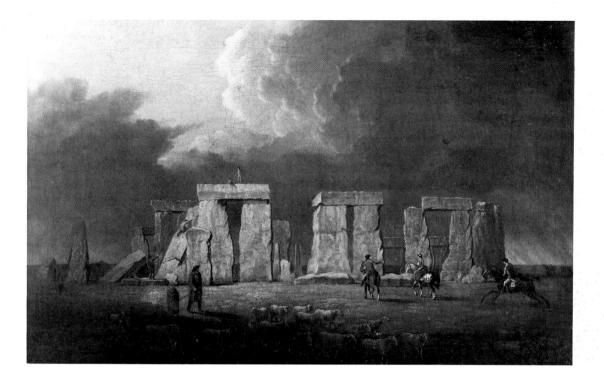

A wondrous pyle of rugged mountaynes standes, Placed on eche other in a dreare arraie, It ne could be the worke of human handes, It ne was reared up by men of claie. Here did the Britons adoration paie. To the false god whom they did Tauran name, Dightynge hys altarre with greete fyres in Maie, Roastynge theyr vyctualle round aboute the flame...

We have seen that favourite mental image of Salisbury Plain for the traveller in search of the picturesque was of a great sea, the downs rolling and dipping like the slow ocean swell. Its visual equivalent is a little watercolour where the ground is painted as if gently heaving, and the stones move with the groundswell, like the heavy hulls of laden ships (ill. 84).

Turner also sketched, in 1811 or 1813, the distant view of Stonehenge from the Amesbury road as it rises over the ridge by the King Barrows, and the traveller first glimpses it (ill. 81). He worked this up as an evening view and, in a monochrome version, with a coach silhouetted on the Exeter road to balance a rather schematic Stonehenge (ill. 83).

For his distant image, Constable chose the same viewpoint as Turner, in conscious imitation, or following the Philip Crocker view published in *Ancient Wiltshire*, or simply because it makes the best viewpoint, with the roads in the foreground leading the eye on to the monument (ill. 82). Constable meant this as a 'poetical' view, 'Its literal representation as a "stone quarry" has been done enough'; he silhouetted the Heel Stone against the setting sun, and added a crescent moon.²⁰

81 Turner: the view from the ridge top on the Amesbury road as Stonehenge comes into sight.

82 The same view sketched by Constable. The sun sets behind the Heel Stone. (For a recent photograph see ill. 164.)

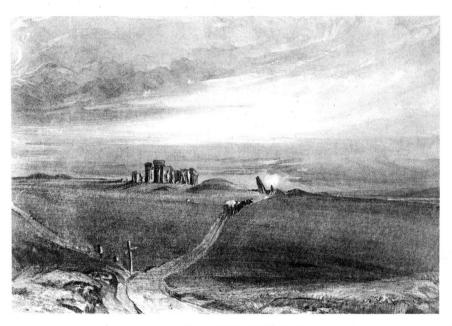

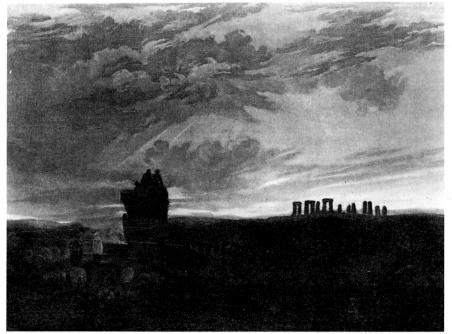

83 Turner: the Exeter stage-coach hurries past Stonehenge on what is now the A303 and still a main route to the West Country. 84 The stones sway on the deep ocean swell of the Plain. Other watercolours are illustrated in col. ills IV-VIII.

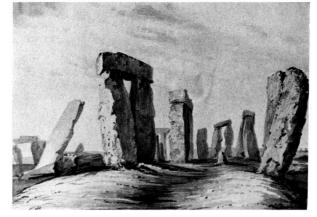

The most striking of the evening views are by a lesser watercolourist, James Bridges. A half-distant view finds the perfect foreground feature in a round barrow, which provides a smooth-rounded shape to offset the jagged stones and makes an evocative reminder of the ancient British dead (col. ill. IV). A close view is less successful, the stones rather squat and cushion-shaped, in front of a full moon. A rosier view of the evening is Copley Fielding's (col. ill. VI).

In a different *genre* are three big oil paintings which bring Stonehenge into the setting of tragic dramas. The first of these is *The Bard* (ill. 88), which Thomas Jones painted in 1774. It now hangs most appropriately in the National Museum of Wales, for it sums up the romantic view of Welsh medieval history. The last of the Welsh bards, carrying his harp and ancient book, hesitates on the edge of the precipice, over which he in a moment will throw himself. Behind are the fallen Welsh warriors, and over the distant pass pour the victorious English under the banner of King Edward I. The dying tradition of Welsh Druidism, which will end in a moment when the sage jumps, is depicted by a rustic Stonehenge, centre left, ruined and storm-blasted.

Five years before, Jones had gone to Stonehenge and thought, 'It's situation adds much to it's grandeur and Magnificence, the vast surrounding Void not affording any thing to disturb the Eye, or divert the imagination... Whereas, were this wonderful Mass situated amidst high rocks, lofty mountains and hanging Woods ... [it] would lose much of its own grandeur as a Single Object.' *The Bard*, this experiment tried on canvas, shows he is right.²¹

The second painting, of the mid 1780s, is James Barry's illustration to Shakespeare, *King Lear weeping over the Dead Body of Cordelia* (ill. 86). Its two perfected Stonehenges (one abbreviated to central trilithons, one enlarged with four standing outliers) are a fittingly monumental backcloth to the great tragedy that fills the foreground.

The third, and most consciously sublime in its atmosphere of terror, is Henry Thomson's *Distress by Land* (ill. 85), which shows peasants trapped in a storm on Salisbury Plain. A mother with her two children flees across the waste; behind her is Stonehenge, its cold hostility evoking Druid sacrifices:²²

85 (left) Henry Thomson, 'Distress by Land': peasants defenceless before the Stonehenge storm.

86 (below) James Barry: King Lear mourning Cordelia, with Stonehenges fit for a Shakespearian tragedy.

87 (opposite above) A last lingering Stonehenge in Samuel Palmer's 'The Lonely Tower', as a motif taken from William Blake. The distant trilithons, tiny silhouettes on the horizon against the crescent moon, come and go from one state of the engraving to another.

> 88 (opposite below) Thomas Jones: Stonehenge, Druids and Welsh national feeling.

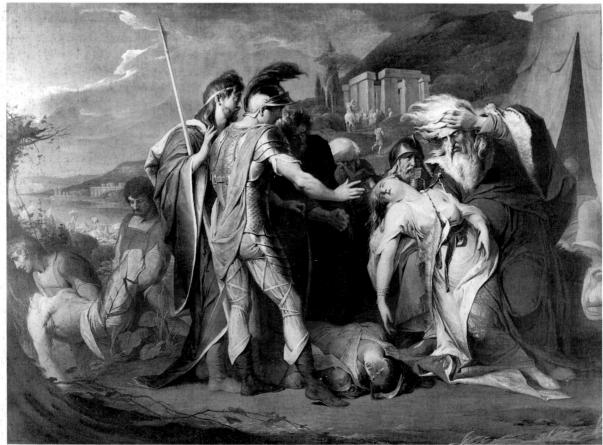

... How sinks her soul! What black despair, what horror fills her heart! Far from the track, and blest abode of man; While round her night resistless closes fast, And every tempest, howling o'er her head, Renders the savage wilderness more wild.

By contrast with the abundance of good Stonehenge paintings, the romantic literature of Stonehenge is very thin. There is a three-volume novel, *Stonehenge, or the Romans in Britain: a Romance of the Days of Nero,* written under the pseudonym 'Malachi Mouldy' by an authority on the celebrities of Newbury. Mrs Craik, author of *John Halifax, Gentleman,* wrote another three-decker, *A Life for a Life,* centring on a death at Stonehenge. And Stonehenge turns up in George Borrow's *Lavengro,* in scattered Victorian stories, and in an improving children's fiction – one of the Magnet stories 'for summer days and winter nights' – in which Caldas the young Druid 'instinctively rejects the gross superstition and false doctrines' and goes over to the Romans.²³

The only enduring novel of Stonehenge is Thomas Hardy's Tess of the d'Urbervilles, written in 1889 but set in rural Wessex years earlier. At its climax, Tess, the 'pure woman' tragically trapped in loveless marriage, kills her husband and flees with her real love, Angel Clare. They pass through Salisbury at midnight, and head north across the open loneliness and black solitude of the Plain, until by chance they strike Stonehenge: 'The wind, playing upon the edifice, produced a booming tune, like the note of some gigantic one-stringed harp.' They feel their way beneath and between the vast architrave and the pillar into this roofless pavilion of the night, till they stand in its midst. Tess flings herself down to rest on an oblong slab, sheltered from the wind by a pillar, and Clare waits until it shall get a little lighter. They talk, obliquely, of what Clare shall do 'if anything happens' to Tess. Dawn nears. In the far north-east sky he can see between the pillars a level streak of light. 'The band of silver paleness along the east horizon made even the distant parts of the Great Plain appear dark and near; and the whole enormous landscape bore that impress of reserve, taciturnity, and hesitation which is usual just before day. The eastward pillars and their architraves stood up blackly against the light, and the great flameshaped Sun-stone beyond them; and the Stone of Sacrifice midway. Presently the night wind died out, and the quivering little pools in the cup-like hollows of the stones lay still. At the same time something seemed to move on the verge of the dip eastward - a mere dot.' It was a man, one of the pursuers closing in on the temple from all round. They let her finish her sleep. 'All waited in the growing light, their faces and hands as if they were silvered, the remainder of their figures dark, the stones glistening green-gray, the Plain still a mass of shade.' The stronger light wakes her, and with a kind of gladness, she goes with the men to Wintoncester, the Assize, and the gaol where 'Justice' is done.*

Even Tess at Stonehenge has its bizarre footnote. Roman Polanski's 1979 film version was shot on location. But Polanski had iumped bail in California after admitting to sexual relations with an underage girl, and could not enter England for fear of extradition. So he filmed in Normandy, and the climax took place not at Stonehenge but in a distinctly unauthentic copy, built of painted blocks of lightweight plastic, and plonked down in the French countryside.

7 THE MAKING OF 'ANCIENT WILTSHIRE'

'HOW GRAND! HOW WONDERFUL! HOW INCOMPREHENSIBLE!'

On 3 January 1797, 'some people employed at the plough, * full half a mile distant from Stonehenge, suddenly felt a considerable concussion, or jarring of the ground, occasioned, as they afterwards perceived, by the fall of two of the largest stones and their impost' – the south-west trilithon (stones 57 and 58, with their lintel, 158). It fell outwards, towards the west, across a bluestone, and the lintel rolled out to hit a sarsen of the outer circle. These are the first stones of Stonehenge whose fall is recorded.

The Wiltshire antiquaries, who saw 'with emotions of peculiar awe and regret such an assault of time and the elements on this venerable structure', were surprised to see how shallow the fallen stone had been set into the ground, 'especially as the Old Stories of such Stones resemble that of the Oak Tree Root, as deep underground as tall above it'. Only 3 to $3\frac{1}{2}$ feet of the stone had been underground, wedged with lumps of sarsen and chalk, to hold in place 60 tons of trilithon rising $21\frac{1}{2}$ feet above ground.

The trilithon had long been leaning. The immediate cause of its collapse was a sudden and very rapid thaw after very deep snow. Gypsies were in the habit of camping at Stonehenge before the Wiltshire fairs, and it was said they dug a hole in 1796 the better to shelter beside the trilithon. Water gathering in the scoop had done the rest.¹

Among the antiquaries come to see the damage was William Cunnington, a wool merchant from Heytesbury at the western edge of the Plain. Woodforde's portrait shows Cunnington to have been a man of exceptionally strong and heavy features. These are among the symptoms of acromegaly, a disorder of the pituitary gland, together with recurrent fearful headaches and intermittent depression. As Cunnington's health declined under the disease, he was told by the doctors, 'I must ride out or die. I preferred the former, and, thank God, that though poorly, I am yet alive.' And his riding-out led him to an interest in fossils and in the antiquities so prominent on the downs.²

John Britton, the topographical writer, was in 1798 still in his twenties, newly released from clerking in a law office to write his first book on *The Beauties of Wiltshire*. While staying at Fonthill with William Beckford, he met Cunnington and asked for news of discoveries. Cunnington told him of his own finds, in a 'Roman station' on Knook Down near Heytesbury, and at Stonehenge, 'where in digging with a This is a sign of the new times, as the arable crept across downland.

89 Decorative border of prehistoric beads, drawn by Philip Crocker for Colt Hoare's 'Ancient Wiltshire', but not used. **90** A gentleman stands on an upright of the trilithon, newly fallen in 1797. His lady, less interested, looks the other way. The mortice holes in the lintel are very apparent, and crushed under the upright is a bluestone.

large Stick under those two very large Stones which fell down . . . I was much surprised to find several pieces of black Pottery similar to those on the above downs [Knook], among which was the bottom of a small Vessell, in form like the bottom of a tumbler Glass, but of the same fine black polished Pottery above – which I used to think was Roman.'

These finds were perplexing, for the Roman Stonehenge was wholly discredited. Instead, Cunnington thought, 'our ancestors (if I may so call them) were not so barbarous nor so ignorant of the Arts as some suppose them when the Romans first invaded this Isle'.³ Only Britton, who had swallowed the strange ideas of William Owen 'the profound Welsh Antiquary', wanted to give Stonehenge a late date, 'some point of time in the fifth century'. In his *Beauties*, he took Cunnington's finds as proof: 'Several pieces of pottery, evidently of Roman manufacture, or made from their models, were discovered (after the fall of the large stones in the year 1797) in the soil which served for their foundation.' Other experts were cautious, Thomas Leman wanting 'to know very accurately the particulars of it as it is by no means a trifling circumstance whether it lay at the *foundation* or was scattered about the outside edge and so thrown up merely by the stones falling'. Cunnington was sure the pottery was later; 'they might have been fragments left on the ground as are Glass Bottles &c in the present day, & works in the earth by Rabbits, and soon after the fall of the Trilithon the adjacent earth containing the Pottery might fall into the excavation'.^{4*}

H. P. Wyndham, the Member of Parliament for Wiltshire, had earlier engaged Cunnington for his expertise to expose a mosaic in the Roman villa at Pitmead. But barrows, the most conspicuous of all the ancient monuments, were the most promising subjects for the excavator; their burials promised grave goods, and Stukeley's barrow types would be a useful guide to research. Cunnington and Wyndham's first long barrow

The pottery, like all earlier finds from Stonehenge, has since been lost. proved a great labour: 'A section was made from the eastern-side to the centre; and on a level with the adjoining ground we found a stratum of very black mould . . . we worked longitudinally for several feet to the right and left, and still continued to find the black earth at the bottom; yet, after all our researches, found only three or four small pieces of bone, some small bits of pottery, and a piece of a stag's horn, five inches and a half in length.'

The first round barrow was more productive. A trench cut right through the middle uncovered a smashed urn made of half-burnt clay. Among the burnt human and animal bones inside it, which crumbled to dust when handled, was the point of a bronze sword or dagger.⁵

By 1801, Cunnington had opened 24 barrows, and gained confidence: 'I now begin to flatter myself that with a little more experience I shall be able to say on first sight of the Tumulus what interment it contains – I think I can already point out the Barrow under which Cremation has been practiced: but the grand difficulty will be to ascertain the contents of the *large* Campaniform Barrows; and those British Pyramids, the long barrows: the opening these is attended with much expence.'⁶

Among Wyndham's friends was Rev. William Coxe, newly appointed as Rector of Stourton. During 1800 he collected a subscription of £50 to re-erect the fallen Stonehenge trilithon, and decided to open some barrows also. He asked Cunnington to recommend 'some careful labourer who has been accustomed to such business to superintend and assist' - to superintend and assist, that is, the inexperienced local men who would do the actual digging. The owner's consent was needed, and that meant tackling 'Q', the notoriously mean and unpredictable 4th Marquess of Queensberry, into whose ownership Stonehenge and the Amesbury Estate had come in 1778. (He cared zealously for those parts of the land that produced income, but so neglected John Webb's Amesbury House that on his death it was beyond repair.) Coxe tried his connections, and 'when Lord Pembroke forgot to apply to the Duke of Queensberry about opening the barrows', asked through Wyndham for the Marquess's consent, 'which is not very easy'. Permission to put the trilithon back in place was refused, but barrow-digging was allowed. 'He is such an extraordinary man,' Coxe wrote to Cunnington, 'that I begin to be apprehensive lest he should retract the permission ... you had better bring 3 or 4 men with you from Heytesbury and I will pay their expenses . . . we had better confine ourselves to the low Barrows.'⁷

The low barrows were productive, especially one a little way west of Stonehenge close to the Shrewton road. This held a cremation under the immense 'Stonehenge urn', $22\frac{1}{2}$ inches high and 15 inches in diameter – quite the finest prize the Wiltshire barrows had yielded. Later in June a long barrow near Stonehenge was opened, and more of the 'Druid's Barrows' (Stukeley's name for disc-barrows), 'that we may ascertain them if possible to be burial places for the ladies'. In July, Coxe declared it was too hot to dig barrows, and suspended the campaign until the autumn.⁸

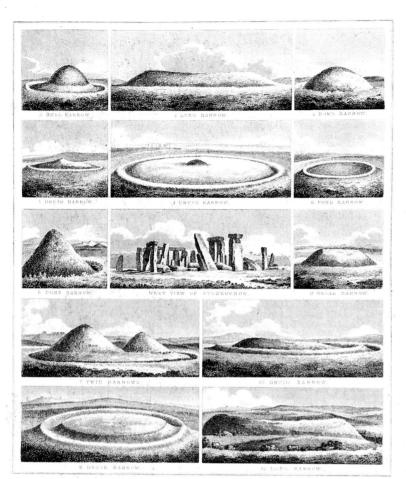

91 (left) Barrows of every type, long, broad, short, round, high, low, single, double, to defeat the most conscientious digger.

92 (bottom) Barrow-diggers at work; which means, as Crocker's watercolour records, the labourers labour and the gentlemen wait to see what they find.

Group of Barrons, South of Stone Hence.

In 1802 Cunnington tried Stonehenge itself. 'I have this summer,' he wrote in November, 'dug in several places in the Area and neighbourhood of Stonehenge* & particularly at the front of the Altar, where I dug to the depth of 5 feet or more & found charred Wood, Animal Bones, & Pottery, of the latter there were several pieces similar to the rude Urns found in the Barrows – also some pieces of Roman Pottery.' He had already poked around under a trilithon in 1798.

And if fragments of barrow urns, the coarse straight-sided and bucket-shaped containers for cremations, were actually *under* the structure of Stonehenge, then Stonehenge belonged to their pre-Roman era. Cunnington also found 'Stag's horns', and noted that the Altar Stone was neatly chiselled into an oblong block. He also dug by the Slaughter Stone, finding a hole under it 'by which it plainly appears that this Stone stood erect'.⁹ **93,94** The antiquary, Mr Cunnington, bowls home (above left) with his daughter clutching the day's prize, the Stonehenge urn (above right), a vessel so large and magnificent that Colt Hoare had a Wedgwood replica made of it.

 'Taking care not to go too near the Stones' [Cunnington's original footnote].

Urn, found in Barron No. 1.

The value of Cunnington's work was recognized in 1801 by his election to the Society of Antiquaries. But there were tensions, too. Coxe planned to write an account of Wiltshire antiquities and history, for which he reserved all discoveries made at his expense. So Cunnington was requested not to communicate his barrow finds to anyone; and Coxe was upset when a model of the Stonehenge urn was shown to an Antiquaries' meeting.¹⁰

In the end, *The Ancient History of Wiltshire* was written not by Britton, nor by Wyndham or Coxe, but by Sir Richard Colt Hoare, who took over the sponsorship of Cunnington's fieldwork when Coxe lost interest. Of the Wiltshire gentlemen-antiquaries, Colt Hoare was the most prosperous and the most travelled. Born into a banking family, he inherited his father's baronetcy and the west-country estates of his grandfather, Henry Hoare. About 20 miles south-west of Stonehenge, and just off the edge of the Plain, is his house, Stourhead, which Colen Campbell designed about 1720 in the Palladian style perfected by Inigo Jones and John Webb. Henry Hoare's landscape garden, with an artificial lake, little classical temples, a grotto adorned by nymph and river god, made 'one of the most picturesque scenes in the world'.¹¹

In 1785, both Colt Hoare's wife, after only two years of marriage, and his father died; and he was free to distract himself for the next years by travelling, in Switzerland, Germany, Spain, Malta, but mostly in Italy, studying the remains of classical antiquity. He returned to England in 1791, and the uncertainties of the French revolution and the wars prevented further European tours. Confined at home, he put his energies into Stourhead, adjusting the layout of the gardens to better Italianate taste, and then enlarging the house with a pair of matching wings, one a picture gallery, the other a library.

Colt Hoare first met Cunnington at Heytesbury in 1801, when Coxe took him to see the Pitmead mosaic; they took to each other, and Colt Hoare also grew to be 'barrow-mad'.¹²

Cunnington's digging team was unchanged under the new patron: Cunnington himself to record and collect the finds; Stephen and John Parker as labourers; and Philip Crocker as draughtsman, surveyor, and map-maker. Colt Hoare financed, organized, encouraged, and engaged in the searches for new ditches and earthworks, but he did not care to excavate.¹³

Archaeological excavation, though taken to be an intellectual pursuit, necessarily concerns the shifting of earth, a combination which presented real difficulties in the 19th century. Simple earth-moving was work for the ignorant and illiterate, the province of the landless casual labourer, the lowest class of society outside the workhouse. Cunnington's team of the Parkers, father and son, was exceptional, firstly for being a regular team, and secondly for their ability to notice the slight changes in a barrow's composition that warned they were close to the burial. And when pressure of work grew, they were even required to search out earthworks on their own.

On their first encounter, Colt Hoare noted in his diary meeting 'Mr Cunnington, an ingenious inhabitant and tradesman'. None of the other antiquaries were in trade; they were gentlemen of learning, of property and of society. When Cunnington was digging under Coxe's patronage, 'peculiar circumstances' generally prevented the patron attending; on a rare appearance during the Stonehenge barrow campaign of 1802, Coxe was mostly concerned with arranging for 'a tent and cold meat, as he expects a party of gentlemen to be there, which will render it unnecessary to go to Amesbury to dine'. But there is no hint of social or commercial distraction for Cunnington, save for an annual trip to London. His business survived, somehow.¹⁴

Colt Hoare's books on Italy were set aside. The library, newly furnished by Thomas Chippendale the Younger, was filled also with Wiltshire books, a collection planned to be so complete that the county history could be written from the sources in that single room – except for the earliest times: those would have to depend on Mr Cunnington.

Among the influential men of Colt Hoare's circle was Thomas Leman of Bath, a renowned expert on Roman roads; he did not care for fieldwork, and when lured away from his home comforts was more interested in warm beds and comfortable inns than looking for earthworks in the rain. He stuck instead to theory, and his constant search for system and pattern was a valuable counterbalance to Cunnington's zest for digging and new discovery. Every single find, Leman insisted, must be recorded: he wrote to Cunnington, 'You will excuse me I am sure when I take the liberty of pointing out to you the necessity of *immediately pasting a small piece of paper on every piece of pottery*, or *coin* that you may hereafter find, describing with accuracy the very spot in which you find them. The people who succeed us, may probably know more about these things than we do, (or else I am confident that they will know but little) but we ought to . . . afford them the Information we can, with clearness.'¹⁵

A frequent visitor to Stourhead was Richard Fenton, a barrister turned travel-writer. His three sonnets dedicated to Cunnington give the flavour of the expeditions to plunder the barrows, this one celebrating the first barrows dug with their owner, Rev. Edward Duke, in the Lake group a couple of miles south-west of Stonehenge:¹⁶

Auspicious morn, by prophets long foretold,

To Sarum's plain once more that calls my friend,

The dark sepulchral mysteries to unfold,

And DUKE's initiation to attend.

Oh! let the young noviciate for his guide

Look up to thee, in mind thy precepts bear,

That when thy mantle thou shalt throw aside,

The mystic robe he may deserve to wear . . .

The Rev. Duke took a personal interest in his barrows. Other landowners left Cunnington free to work alone, and there were certainly **95** (left) Rev. Duke's barrows on Lake Down, numbered for dissection. Oblique perspective views, as if taken from a low-flying aircraft, show handsomely the shapes as well as the positions of the barrows.

96 (right) Daggers and bone mounts from the Stonehenge barrows.

no fences to mark off fields on the plain. On the autumn morning of Duke's initiation, Cunnington had ridden the 13 miles from Heytesbury over to Lake 'through a fog with no other guide but the different barrows I passed by; when within half a furlong of our group, the sun burst out all at once and disclosed such a scene that few excepting poets could enjoy. Stonehenge never looked more grand.'¹⁷

There were evening gatherings to celebrate finds. Philip Crocker wrote after one: 'Such a feast of reason, and flow of sense I have seldom, if ever, enjoyed, nor perhaps ever shall again. The establishment was – as Sir Richard humorously expressed, – "the most compleat he has yet had". – no less so, than a Priest to grant us absolution – a Poet to immortalize, and raise in living verse, the ashes of the Britons – a Bard (the younger Mr Fenton, who amused us with some secret Welsh airs on the flute) to still the souls of departed heroes – an Artist to restore the costume of two thousand years, and, a Patron of all that is good and great, to show the world thro' the dark labyrinth of long lost ages. – Such a group might well inspire the Bard with a striking fire of Fancy, nor is it easily forgot with what ecstasy he used to exclaim

"Bring the *Urn* – the relicks in; Now the Mystic rites begin"

and amidst the desert of fruit the sparkling glasses, stood the rude relicks of 2000 years: – The "Britons" given as a toast, and drank with all the enthusiasm of true antiquaries.¹⁸

97 (above) Colt Hoare's linen bag of brass tokens, ready for the next day's plunder.
98 (above right) Chevrons of tiny gold pins decorating the dagger-hilt from Bush Barrow, as they survived John Parker's trowel.
99 (right) Miniature cup from a Normanton barrow, which Mr Fenton thought distinctly to resemble Stonehenge.

Cunnington's team opened more than 600 Wiltshire barrows, including nearly 200 in the immediate area of Stonehenge. Only those planted with trees or under standing crops were spared. A trench was cut across the middle of the ground, or a pit sunk in the centre if the barrow was especially large. Two or three could be dealt with in a day, if they were not too high. Typical of Cunnington's records, careful but brief, is this, the full record of the big bell barrow immediately east of Stonehenge (number 23 in ill. 101, and the barrow making the foreground feature of col. ill. IV):¹⁹

'5 June 1807. No. 13.* a fine Bell shaped tumulus, adjoining Stonehenge.

'Base diameter – 116 feet.

'Depth to the floor – 8 feet 9 [inches].

'Soil – a deep clingy loam.

'Mr Cunnington had made a prior attempt on this barrow with Mr Coxe, but had failed in discovering the interment, though the signs of cremation were very apparent – our second attempts were more successful. An interment of burnt bones was contained within an urn, very rudely formed, ornamented and baked; but the only article deposited with them was a pair of ivory tweezers – by far the best formed we have ever found, but resembling others in its pattern.

'Deposited a lead token – '

* As then numbered. When the sequence was revised, it became 23. In each barrow Cunnington left a lead or brass token, marked with the year and his or Colt Hoare's initials, to show any later explorers who had opened it.

Finding the burial was easy, if it was in the centre. But it might not be: 'No. 10 a fine bell shaped barrow – but notwithstanding a great deal of labour we missed the interment. In digging within this Barrow the men discovered the skeleton of a Dog & head of a Deer.' Sometimes: 'No. 11. Is no barrow.' And often '. . . had experienced a prior investigation'.²⁰

Several barrows close to Stonehenge contained chippings of both sarsens and bluestones; the chippings were not worn or rounded but freshly 'chipped off similar (I am sorry to say) to those that are now daily chipped off the fallen trilithon'. 'The most natural conclusion,' Cunnington thought, 'will be that the pieces were scattered about on the plain, before the erection of the Tumuli under which they have been found. If this conclusion is just, it gives higher antiquity to our British Temple than many Antiquaries are disposed to allow.' Leman did not see the point; 'Why should it be thought remarkable to find chippings of the Stones of which Stonehenge is formed, near the place...?' Cunnington retorted, rightly: 'This is a childish note – if they prove that the Barrows are subsequent, we get an important piece of information.'²¹

At Stonehenge itself, more holes 'within the area' produced 'parts of the heads and horns of Deer & other animals, & a large barbed Arrow head of Iron'; in the ditch were found 'both roman, British pottery, and animal bones'. 'The only conclusion,' decided Cunnington, 'we can draw from the circumstances of finding Roman pottery on this ground is, that this work was in existence at the period when that species of earthenware was made use of by the Britons in our island.'²²

Stonehenge, then, was pre-Roman and of the same age as the barrows. This was the conclusion Stukeley had come to eighty years before, and in truth Cunnington and Colt Hoare progressed no further. Their men came to be very adept at quarrying out the burials with the minimum of effort, and at spotting hints in the make-up of the barrow mound, but Cunnington neither took especial interest in, nor drew sections of, the barrows themselves, as Stukeley had begun to do.

Cunnington's early optimism about understanding the pattern in the barrows faded. The more they were dug, the greater the inconsistency and confusion. He worked out that only the lowermost and central burial, the 'primary', referred to the building of the barrow; secondary burials higher up were subsequent. Distinguishing primaries and secondaries helped, but not much.

The tiniest barrow, he found, might cover a rich grave, whilst under the finest might be only a bare skeleton: 'after immense labour in excavating the earth to the depth of 15 feet we found only a simple interment unaccompanied with urn, arms or Trinkets. I have no recollection of ever being so sanguine in my expectations therefore of course was much disappointed.' The ancient Britons, he had to admit, 'had no regular system in regard to the form of the tumulus, nor many other things practised at the interment of their dead; but appear to have been influenced by caprice than by established rules'. The only pattern was that the long barrows, for all their size and the number of bodies in them, held singularly few grave goods; 'so uniform in their modes of sepulture, and so very unproductive in articles of curiosity', they were soon abandoned for the surer spoils from the round barrows.²³

Gold objects, treasure indeed, came from barrows, including those at Woodyates that Stukeley had noted were cut by the Roman road. The richest of all came from the barrows which lie in an east-west line across Normanton Down, a mile south of Stonehenge, and make the finest barrow-group in England. At their second attempt on Bush Barrow, a very large bowl barrow which had defeated Stukeley, Cunnington's men literally struck gold: a single skeleton buried with two metal daggers, a bronze axe and lance-head, two decorated lozenges of sheet gold and a gold belt-hook, a stone mace-head and zigzag bone mounts. A quantity of bronze rivets mixed with wood and bronze fragments were perhaps a shield. The handle of one of the daggers was set with a chevron pattern made of thousands of tiny gold pins, 'but unfortunately John [Parker] with his trowell had scattered them in every direction before I had examined them with a glass'.²⁴

The finds from the Bush Barrow joined the others piling up on the shelves of the Moss House in Cunnington's garden: fine and coarse pottery vessels in great variety, flint arrowheads, beads and buttons in glass, amber and bone, bronze axes and daggers, rusted iron spearheads, whetstones, and all kinds of novel curiosities – bone tokens, tiny 'grape cups', the incisor teeth of a beaver, and the entire skeleton of a goose.

Leman thought to 'distinguish three great eras by the arms of offence found in our barrows', the first of bone and stone 'belonging to the primeval inhabitants in the savage state', the second of bronze,* the third of iron 'introduced but a little while before the invasions of the Romans'. Cunnington, who once complained of Leman 'it is very easy to say how these things should be in the closet', was not impressed. His reply was practical, pointing to all those times he had found 'in the same tumulus instruments of bone, stone hatchets, curious articles in brass, etc, etc'. He wished he could agree to an organizing scheme, but 'when I have attempted to draw conclusions towards forming a system, I have always found something that has knocked my new building down'.²⁵

Without a three-age system to organize prehistoric times into successive epochs of stone, of bronze, and of iron, Cunnington and Colt Hoare could make no advance on Stukeley's proof that Stonehenge was pre-Roman. *Ancient Wiltshire*, after many pages devoted to the age and builders of Stonehenge, declares it finally 'HOW GRAND! HOW WONDERFUL! HOW INCOMPREHENSIBLE!' The same goes for the barrows; for all the wonders that came out of them, their age, their order and their sequence was still incomprehensible.²⁶

Leman, in one of his excited letters, told Colt Hoare: 'I *accidentally* heard of Remains exactly resembling the Trilithons at Stonehenge in a

Which Leman, as was then usual, called brass.

part of the world where I did not exactly hope to find them, but which has overpower'd my mind with Joy. & I hope to be able at some future day to procure drawings & descriptions of them – this you must allow is a DISCOVERY indeed!'²⁷

But he wrote no more of this discovery. Instead, he looked at Stonehenge in search of one of his systems. Since the stones were of two different kinds, might the circles be of two different ages? Cunnington, after consulting the geologist James Sowerby and (perhaps) William Smith, agreed: 'How came the Britons in erecting Stonehenge to make use of two kinds of Stone which are totally dissimilar to each other? Any person versed in Mineralogy will perceive that the Stones without the Work, those composing the outer Circle and it's Imposts, & the five Trilithons, are all raised from Sarsen Stones . . . whereas the inner Circle of small upright Stones & the interior oval of upright Stones, are composed of a variety of Granite, Hornstone &c, most likely brought from some part of Devonshire or Cornwall as I do not know where such Stone could be procured nearer than the latter places.'

The original work, then, was in sarsen – the outer lintelled circle, trilithons and Altar. The smaller stones were 'a later addition, & add no more to the grandeur of the Temple than many of the modern improvements (so called) in our Cathedrals, – indeed it gives a littleness to the whole'. Colt Hoare agreed, thinking it 'if not true, is well imagined'.²⁸

In spring 1810, Cunnington dug at Stonehenge a third time, to confirm his earlier discovery that the Slaughter Stone had originally stood upright: 'I now have Sir R Hoare, Mr Crocker and an Irish Gentleman to attest the fact, that the aforesaid Stone was place originally in an erect position – that part of the Stone which stood in the ground was rough, but those parts which were exposed were chipped like the others. – The hollow in which the Stone now lies was occasioned by digging often to see what was under.' This expedition to Stonehenge was Cunnington's last field trip before his death on the last day of the year.²⁹

He lived just long enough to see the first portion of *Ancient Wiltshire* published. Woodforde's portrait of him had been engraved, as a surprise, to form the frontispiece, and the book 'most gratefully and appropriately dedicated' to him. The paper in Cunnington's hand, blank in the original painting, bears a view of Stonehenge in the engraving, in honour of his achievement.

Colt Hoare had intended to write a conventional county history, like that of Leicestershire by John Nichols, who published the first part of *Ancient Wiltshire*. Cunnington's energies diverted it into a unique form, an original account of the shire richest in prehistory and Roman remains, written anew from field study and observation. Its half-title is bordered with prehistoric flints and beads; inside is a sketch of an ancient British cremation urn, and the words 'Auncient Wiltescire' in wobbly archaic letters. That is all that shows of the romantic fancy so fashionable and so handsomely celebrated by Colt Hoare's circle in

100 The engraved portrait of William Cunnington, Stonehenge in hand.

relaxed evenings at Stourhead. The first words of the introduction announce 'We speak from facts, not theory.' The Druids appear, soberly, sensibly as ancient British priests. The finds from hundred upon hundred of barrows are listed. All that is missing is that sense of time, of sequence and order within the ancient history of pre-Roman Britain, that Stukeley was starting to work out when he was deflected into Druidomania. Although 'Cunnington and Colt Hoare may very properly be called the fathers of archaeological excavation in England',³⁰ they were still in the pre-scientific world: the antiquary as collector of delightful, but random, curiosities. Colt Hoare's own final words on William Cunnington, quite the most vigorous fieldworker the archaeology of Wiltshire has ever experienced, record a friend 'who, from ill health, being recommended to breathe the salutary air of our Wiltshire downs, there found, in an apparently barren region, food for his intelligent mind; and to him alone, the discovery of the numerous settlements of the Britons dispersed over our hills, must be justly attributed'.31

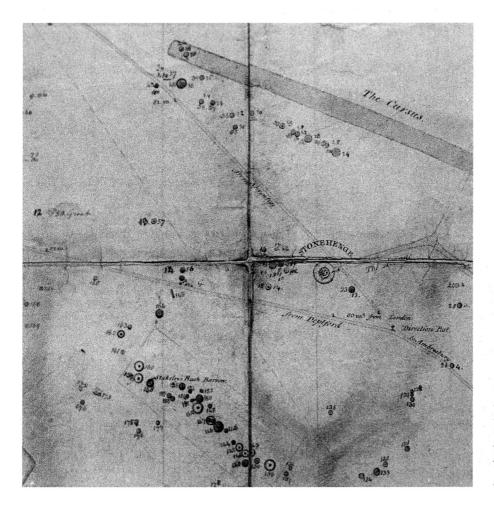

101 The working map of the Stonehenge barrows, surveyed and drawn by Philip Crocker, with the barrows numbered and re-numbered, and the folds broken with use. The broad diagonal line at the top is the Cursus.

STONEHENGE COMPLETE STONEHENGE COMPLETE ST IEHENGE COMPLETE STONEHENGE COMPLETE STONEH IGE COMPLE **8 of Age, evolution and astronomy** 1G Omplete stonehenge complete stonehenge coi ete stonehenge complete stonehenge complet

'What is now necessary is careful digging'

For all Cunnington's practical energies and Colt Hoare's scholarship, the true history of Stonehenge remained 'in obscurity and oblivion', whilst conjecture might 'wander over its wild and spacious Remains'.¹ The date of Stonehenge depended on the date of the barrows, and the barrows seemed undatable.

In 1818 the young Danish antiquary Christian Jürgen Thomsen proposed a three-age division of the prehistoric past, exactly as Leman had theorized. His sequence of a primeval period of stone tools, succeeded by an age of bronze, and then by an age of iron was accepted first in Scandinavia. In England, the most telling evidence for the three-age system was found to come from systematic analysis of the barrow-diggers' finds (or rather, of the finds of which records were kept and preserved). The best records were Bateman's for the northern counties, and Colt Hoare's for Wiltshire. So Sir John Lubbock, in his epoch-making Prehistoric Times of 1865, was able to show that most of the 151 Stonehenge barrows contained cremations, the characteristic burial of the age of bronze. Only 2 contained iron objects (and these were in secondary burials inserted into existing, much older mounds), 39 contained bronze objects, and the balance - the great majority contained no metal at all. Stonehenge accordingly was now proven to be older than the Roman period, older than the last prehistoric phase, the age of iron. At latest, it belonged in the age of bronze, 'an expression of the religious sentiment of the bronze age ... to be viewed as the Westminster Abbey of that time, around which rest the ashes of the great in tumuli which cluster thickly on the neighbouring chalk down'. In confirmation, the fresh bluestone chips in the near-by barrow, key evidence in equating the dates of Stonehenge and the barrows, were accompanied by a bronze pin and spearhead.²

The argument from the principle of the three ages could be taken a step further. Since 110 of Lubbock's 151 barrows contained nothing of metal at all, they – and in some sense Stonehenge with them – could be referred back beyond the Bronze Age; it really belonged 'to a more ancient period than even our most imaginative antiquaries have yet ventured to suggest'.³

The infant science of prehistory could, in the 1860s, come to no clearer conclusion. Beyond this it was safe only to argue, as Colt Hoare had, that Avebury, larger and grander in plan but without bluestones,

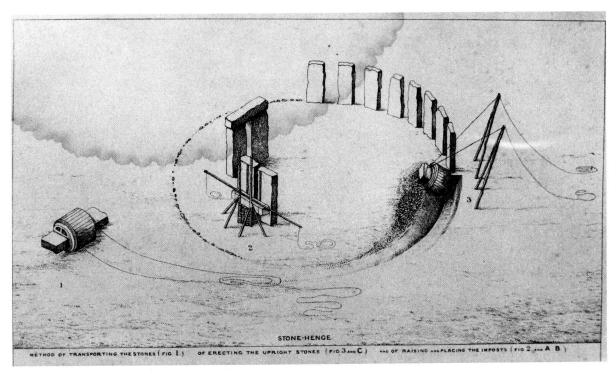

TO REPRESENT THE FORMATION OF STONEHENGE, ONE HALF OF THE MOUND OF EARTH REMOVED, ALSO ONE STONE DROPPING INTO A HOLE AND TIPPING UP FROM OFF THE ROLLERS_ALSO MODE OF CONVEYANCE.

There have been any number of speculations as to how Stonehenge was built.

102 (top) Encased in timber, rolled into a ditch and hauled up with sheerlegs. **103** (above) Dropped into holes in the ground and dug out again. This idea, sketched by a fox-hunting man at the Bishop of Salisbury's dinner table, is as sensible as some by more professional antiquaries. shaped sarsens, or lintels, required less ingenuity and skill in the building. It should therefore belong to an earlier, more primitive phase, so Avebury was perhaps of the early Bronze Age, and Stonehenge of the late Bronze Age.⁴ But what in calendar years 'early' or 'late' might mean was beyond human knowledge.

Still, the dating of Stonehenge, or at least of the Stonehenge that has survived, to the dawn of a Bronze Age is an early and classic example of the method of prehistory. Naturally, it took a while to be understood. For years the insistence lingered that, in a country without really ancient literature, ancient history was forever lost. For example, in the 1880s the delegates of the Suburban Institutes Union were told by their president, Sir Stafford Northcote MP, that on going to Stonehenge and musing as to the history and meaning of the 'marvellous pile', the answer you received was 'entirely blank'. Yet in the noble world of classical Greece, everything could be identified: you could trace in the ruins of Syracuse every point in its famous battle with Athens.⁵

Blinkered classicists were not the only sceptics. The massive collection of excavated finds, and the organization of objects and structures into the compartments of the three ages, were the particular forms taken in archaeology by the Victorian passions for accumulating facts and classifying by evolutionary schemes. Darwin's system for biology (The Origin of Species, published in 1859) was the one fought over in public, but the three-age system of prehistory was, in its own sphere and rather quietly, just as subversive. Good scholars, like John Thurnam, the expert on Bronze Age and older barrows, and Sir Daniel Wilson, the Scottish antiquary who introduced the word 'prehistoric' into the language, resisted the new date for Stonehenge. It was archaeologically unacceptable to suggest Bronze Age barbarians could make anything so great and perfect as Stonehenge: 'Rude as its vast monoliths are, they differ essentially from the unhewn columns of Avebury or Stennis,* and are characterized by a degree of regularity and uniformity of design, which mark them to belong to an era when the temple-builders had acquired the mastery of tools with which to hew them into shape.... [Stonehenge] is certainly not a work of the Stone Period, and probably not of the Bronze Period, with the exception of its little central circle of unhewn monoliths, which may date back to a very remote era, and have formed the nucleus round which the veneration of a later and more civilized age reared the gigantic columns."⁶ By this argument, most of Stonehenge could only belong to a late period, of advanced learning and political stability, perhaps after the Belgic invasions from France in the final centuries BC.

Another influential school, under James Fergusson and Hodder Westropp, took a gloomier view of the savage Celts. The British were still lost in some backward age (of stone, most likely) when Caesar landed, or could only manage Stonehenge when irradiated by the occupying Romans with a real civilization's skill in masonry work. At best, only the small uprights were British-built; all the tricky parts could

* Stenness, one of the great circles of unshaped stones in the Orkneys. only have been managed 'under the supervision of scientific Roman instructors'. In the most dismal view of all, Stonehenge was a failed attempt to build in the Roman manner; it dated from the perilous years after the Roman withdrawal, when the British tribes were left in their natural state with no better pastime than cutting each other's throats.⁷ There was 'no reason' to believe the Britons capable of moving such masses, of 'fashioning them with such art', or of arranging them with such architectural effect. By the 5th century, they had learnt all these things, 'for its reputed founder [Aurelius Ambrosius, if you took Geoffrey of Monmouth's tale as literal true history, as no one had for several centuries] was by descent a Roman and having been educated as such he naturally strove to instil some of the art of his ancestors into the works of his subjects, while Avebury, and other buildings of purely British origin, still retained the impress of the rude conceptions of uncivilized races.'⁸

The evidence actually pointed the other way, towards a stone age Stonehenge. In the mid 19th century Cunnington's Wiltshire barrows were ransacked again by John Thurnam, in search not of grave goods but bones. He was by profession a doctor. His working hours were spent nursing the minds of the modern insane in the county asylum. His leisure was devoted to the heads of their ancestors, in studying the skeletons, and especially the skulls, of the ancient Britons. Out of respect for the dead, and because he could learn nothing from them, Cunnington had left skeletons in barrows where he found them. With Ancient Wiltshire as his guide, Thurnam could quarry the barrows for the material he wanted. He found the skulls divided into two classes, in obedience to the shapes of the mounds that sheltered them. Those from the long barrows were dolicocephalic, long in relation to their width; those from the round barrows were brachycephalic, tending to a round shape.9 Evidently the long barrows, with multiple inhumations, long skulls, scant grave goods and no metal at all, belonged to a stone age population; the round barrows, with single inhumations or cremations, round skulls, burial offerings sometimes of bronze, were of later peoples of the Bronze Age. And as long barrows congregated round Stonehenge equally with round barrows, its location showed it to be a Bronze Age temple on a site previously selected as a burial-ground for the chieftains of the Neolithic tribes.¹⁰

All the factions were handicapped by the difficulty of finding specific analogues for Stonehenge. There were standing stones, circles, cruder megalithic buildings, everywhere, but the lintels and shaping of the stone remained unique. Arbor Low (ill. 106), the great circle of recumbent stones in the Peak district of Derbyshire, was called 'The Stonehenge of the North'; it is actually a plain ring of unshaped boulders. A few miles from Arbor Low, the churchyard at Bolsterstone held a couple of shaped stones, claimed as the fragments of a great trilithon standing on the village green; but nothing suggested they were ancient. The 'Irish Stonehenge', at Magheraghanrush near the Carrow-

105, 106 'Stonehenges' in Africa and Derbyshire. (Above) The Tripoli 'senams' turned out to be Roman olive-presses. (Below) Arbor Low, the 'Stonehenge of the North', is prehistoric.

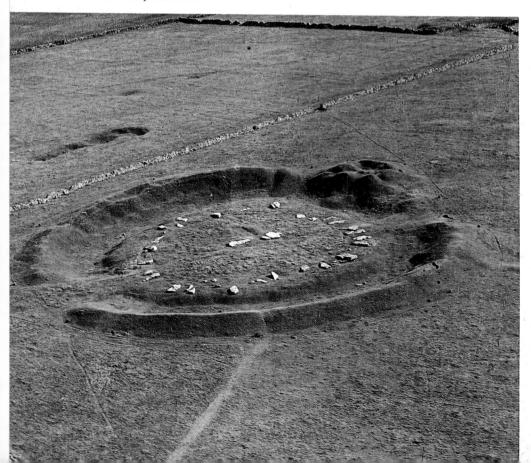

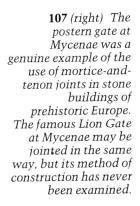

108 (below) Drawing by J.D. Hooker of a Khasia landscape with native and megaliths.

Only in two places were found trilithons of shaped, squared stones, which seemed to resemble Stonehenge in the particular. The first to be noticed, years before Schliemann found any treasure there, was in the pre-classical Greek citadel at Mycenae. For the most part its walls are of cyclopean masonry, that is, walling of very large blocks, but laid otherwise as more-or-less conventional coursed masonry (whereas megalithic building uses single great slabs set on their edges as walls). But one entrance, the Postern Gate, was made of three single stones, two vertical jambs and a single lintel across the top. The proportions and the details were different, but here at last was a structure on the mainland of Europe built the same way as Stonehenge.¹⁸

On the other side of the Mediterranean, in the Tripoli region of Libya, the German explorer Henry Barth found something much better: genuine, free-standing trilithons of megalithic blocks. They were just like Stonehenge, save for having square holes cut through the uprights. He saw at once that the structure was 'a rude kind of sun-dial, combining the vertical with the horizontal principle'. The gap between the uprights was too narrow for a doorway, unless it served 'as a sort of penitential or purgatory passage in consecrating and preparing the worshippers, previous to their offering sacrifices, by obliging them to squeeze themselves through this narrow passage, the inconvenience of which was increased by the awful character attributed to this cromlech'. And channels in the flat stones by the trilithons could only have been for carrying off the blood of the victim, a plain example which showed the purpose of the flat stone at Stonehenge.¹⁹

Since Libya fell in the known area of Phoenician colonies, the Tripoli Stonehenges revived the idea of a Phoenician Stonehenge. Not a single object had been found at Stonehenge or elsewhere in Britain which was incontrovertibly Phoenician, but that did not worry the partisans: 'Phoenician trade with Britain seems entirely to have been confined to barter, since no traces of their presence in the country have as yet been discovered.' The merchant fleet must have sailed into the bay below St Michael's Mount, distributed precious but perishable imports among the crowds of British traders in their bum-boat coracles, lifted the Cornish tin aboard, and sailed away without ever touching land. That explained why no Phoenician objects survived, but it also raised the problem of how they managed to build Stonehenge by remote control from anchorages 180 miles away.²⁰ At the end of the 19th century, J. L. Myres and Arthur Evans were sent to Libya to look again at the 'Tripoli Phoenician Stonehenges'. They proved them to be the frames of olive presses, relics of plantation agriculture in the Roman period, and nothing at all to do with sun-dials, idols, sacrifices, or penitential and purgatory passages.²¹

Many other exotics were linked with Stonehenge – the inhabitants of the lost continent of Atlantis (nothing was known about their architecture, so everything about Stonehenge naturally fitted); the ancient Egyptians, whose mariners sailed up the Hampshire Avon; and the dwarves or little folk, who dug souterrains and built chambered tombs.²²

Some deluded scholar proved the sarsens were actually blocks of pure white marble, exactly like those from Michelangelo's favourite quarry at Carrara, and the surface colour only superficial; another that Stonehenge was 'an arena in which wild animals were collected and destroyed', the gaps between the stones blocked off with hurdles, the spectators on the lintel-galleries above, and the umpire perched on the central stone.²³

But the prevailing opinion among antiquaries, as successive editions of an orthodox reference book like the *Encyclopaedia Britannica* declared, remained that Stonehenge was Druidic. The most stolid and down-to-earth of men became animated when Druid theories could be elaborated. A notable victim was Sir Henry James, colonel in the Royal Engineers and head of the Ordnance Survey. In 1867 he issued a model guide for his surveyors, large descriptive photographs and plans of Stonehenge and of Callanish, 'circulated for the information of the Officers on the Ordnance Survey, in the hope that it may stimulate them to make Plans and Sketches, and to give Descriptive Remarks of such Objects of Antiquity as they may meet with during the progress of the Survey of the Kingdom'. His photographic records are years ahead of his time, but the Colonel's text is as many decades behind, full of learned and false Druidic lore and prefaced by a picture, in the Colonel's own hand, of the 'Druidical Sacrifice'.²⁴

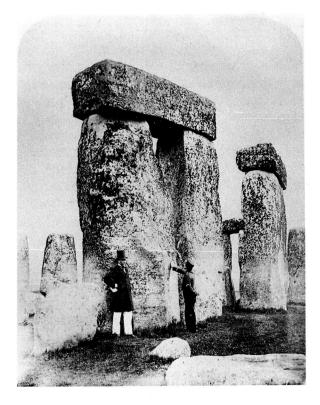

109 (*left*) Ordnance Survey photograph of Stonehenge, 1867, from Sir Henry James's pioneering photographic survey.

110 (below) 'Time bowling out the Druids', an early Stonehenge cartoon. Notice the trilithon wicket, an aid to speculation as to the prehistoric origins of cricket.

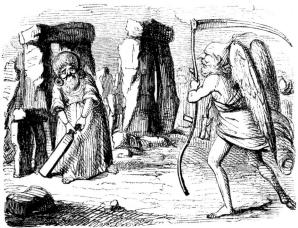

Time Bowling out the Druids.

While Stonehenge was being fitted – or could not be made to fit – into the evolutionary schemes of prehistory, the great panjandrum of evolution, Charles Darwin himself, went to examine it. As a young scientist, before the voyage of the *Beagle* and the idea of the *Origin*, he had studied the action of earthworms in turning over the soil. In old age he returned to studying them again, especially the rate at which the worms bring up fine silt in their casts, so that objects small and large sink slowly through the soil. Roman remains were a good test. Darwin's sons were sent to Chedworth and other villas to measure how far they had sunk, and the excavation superintendent at Silchester had many trenches dug especially for Darwin's inspection. The most challenging trial to the worms would be the fallen stones of Stonehenge.

Accordingly, Darwin travelled to measure Stonehenge in June 1877. He was aged sixty-eight, and his wife Emma was apprehensive as to how, after so many years dedicated to ill-health, he would manage the journey by train and carriage, from their son's house at Southampton. But after a 6.45 a.m. start, the day went well. She knew what to expect from the little sketch of Stonehenge printed on her friend Lady Lubbock's notepaper. From a distance the stones looked just as tiny as they should; close to, they gave no feeling of grandeur. The guardian, grateful they had not brought a sledgehammer, was 'quite agreeable to any amount of digging'. Little pits were hollowed out by three stones, and iron pegs poked about underneath to see how far they had settled into the soil. Emma thought 'They did not find much good about the worms, who seem to be very idle out there'; idle or not, the Stonehenge worms had an important place in Darwin's last 'curious little book', The Formation of Vegetable Mould, through the Action of Worms, which came out in 1881, the year of his death, and sold rather faster than had The Origin of Species.²⁵ It is the most charming of all the Victorian Stonehenge books, with sections that range from their 'Mental qualities' to 'Summary of the part which worms have played in the history of the world' and 'Gigantic castings on the Nilgiri Mountains'.

A couple of years before Darwin, the Egyptian archaeologist Flinders Petrie had also been measuring at Stonehenge. He was trying to arrive at the unit of length adopted by its builders, working on the same simple principle Stukeley had followed – that they used 'whole numbers in preference to fractions, and round numbers in convenience to uneven ones'. The method had worked well on the neat stone buildings of Egypt,

111 The earthworms' accomplishment. Crosssection by Charles Darwin of a fallen stone at Stonehenge. to establish the length of the ancient cubit there. Petrie now tried thirty or forty sites in Britain and France, where the uncertainties in measuring the dimensions of eroded earthworks and of rough stone circles were a difficulty. At Stonehenge, he found Stukeley's 'Druidical cubit' to fail utterly, but there were dimensions of 40, 50, 80 and 100 Roman feet.²⁶

Dissatisfied with his first plan, Petrie measured Stonehenge in June 1877 (the same month as Darwin's visit) and in September. Using a specially made chain, he plotted the stones to the nearest tenth of an inch. A published version of this plan, reduced to about 10 inches square, claims to be accurate to $\frac{1}{2000}$ of an inch.* By re-working the new survey, he found two different units had been used at Stonehenge. A measure of about 224.8 inches, about ten of the known Phoenician units of 22.51 inches, served for the earthworks and the Station Stones. The building itself followed the Roman foot of 11.68 inches.

This puzzling result meant Stonehenge was both pre- and post-Roman. Its resolution, thought Petrie, was only possible through excavation: 'what is now necessary, to settle this much-disputed subject, is careful digging. By having a timber frame to carry the weight of a stone, clamped by its middle, it would be possible to remove the whole of the disturbed layer from underneath each of the still erect stones, leaving the stones suspended; the earth being replaced and rammed, the stone would undergo no perceptible change, and could not be upset during the operations.'²⁷

Petrie also was interested in Stonehenge astronomy. Since Stukeley's time the significance of the orientation of the axis to the midsummer sun had been accepted. 'What can be more probable, and what can better be supported by facts, than that unlettered man in his first worship and reverence, would direct his attention to that glorious luminary the Sun? – the generator of his daily blessings, – the unifying power of the earth, and plants, and fruits – the source of his own subsistence.' This common-sense hypothesis was supported by the known traditions of sun-worship in the East, and the evidence of goldwork and rock-engravings of the European Bronze Age.²⁸

Stukeley had pointed out that the Heel Stone, as seen from the centre of Stonehenge, was not *exactly* in line with the midsummer sunrise. If you stand at the centre and look through the middle of the wider entrance-gap between sarsens 30 and 1 of the outer circle, the first glimpse of the sun's disc is distinctly to the *left*, that is to the north, of the Heel Stone. But as the sun is also moving rapidly to the east, it is in a very few minutes over the Heel Stone. (The many photographs, including mine in this book, which seem to show half the sun's disc sitting neatly on top of the Heel Stone are all 'adjusted': as the sun begins to come up, the photographer moves to one side – a foot or two is ample – to align the sun over the Heel Stone, and stands up straighter or crouches a little to get them exactly into the vertical relation he wants.)

The sun's annual movement, as seen from Stonehenge, is straightforward enough. At the spring equinox, always within a day or two of 21

* It is not; the lines are too thick, and the differential movement of paper with varying temperature and humidity upsets the accuracy of the scale. March, it rises almost exactly in the east and sets almost exactly in the west. Through the spring months, it rises each day further north and sets further north, and the days become longer. As spring moves into summer, its rising and setting points move less each day, reaching their northern limits on the solstice day, within a day or two of 21 June. For a few days before and after the solstice, the points of rising and setting scarcely move, and the days are almost the same length. Then the points of rising and setting begin perceptibly to move south, and the motion increases to the autumn equinox, on about 23 September. The sun continues south, and the days become shorter than the nights, until it reaches its southernmost limit at the winter solstice, about 21 December; there it seems to hesitate, as it did at the summer solstice, before moving north again to complete the annual cycle at the spring equinox once more.

For prehistoric men, one can conjecture, the vital points in the cycle were the two solstices. At midwinter the life-giving sun, whose warmth and light has been slipping away in shorter and shorter days, at last begins to come back; though the worst of the winter is yet to come, the sun has given its first hint of spring. At the midsummer solstice the sun's generosity shows the first signs of declining, the days begin to grow shorter, the return of winter is heralded. A third point, of less obvious value and less easy observation, is given by the equinoxes.

There are therefore four – perhaps six – directions in the sun's annual movements as seen from Stonehenge, which might be of interest: sunrise and sunset at the winter solstice; sunrise and sunset at the summer solstice; also sunrise and sunset at the equinoxes. These fall almost exactly opposite each other in three pairs: winter sunset in the south-west opposite summer sunrise in the north-east; summer sunset

112 Sir John Soane's students measuring Stonehenge early in the 19th century. Architectural historians generally begin with Greece. Soane, like Inigo Jones recognizing its elegance of design and proportion, also took notice of Stonehenge.

in the north-west opposite winter sunrise in the south-east; equinoctial sunrise in the east opposite equinoctial sunset in the west.

The orientation of Stonehenge – as it is indicated by the axis of symmetry of the building and by the Avenue – is on the midsummer sunrise/midwinter sunset line. Since the horseshoe settings face the midsummer sunrise and the Avenue runs out that side, it is usually assumed the axis worked that way, and midsummer sunrise is what mattered. But equally the midwinter sunset could be indicated. The analogy of Christian churches, orientated to the east and with the main entrance to the west, supports this, with the faithful, as they walk up the Avenue to the sanctuary, facing the object of their devotion.^{*29}

Victorian researchers also noticed an indication of the other major direction, midwinter sunrise/midsummer sunset, in a line drawn from Station Stone 93 at right angles to the axis and through the site of the missing Station Stone 92.³⁰ (Modern workers discount this claim as erroneous.)

From one year to the next, the sun's annual cycle seems exactly to repeat itself. But over a long period it is affected by a slow change in the tilt of the earth's axis, i.e. in what astronomers call the obliquity of the ecliptic; and this variation makes the position of the midsummer sunrise move along the horizon. But the change is very slow indeed, only one-seventieth of a degree per century, whereas the sun's disc has an apparent diameter of half a degree. (And it is certainly not the reason for the displacement of the Heel Stone, because in the past the sunrise was even farther away. It will not be until many centuries in the future that the change in the obliquity of the ecliptic will bring the sunrise round to the point marked by the Heel Stone.)

If the builders of Stonehenge aligned it *precisely* towards the exact point of midsummer sunrise, it would in theory be possible to date Stonehenge by the change in the obliquity of the ecliptic. But we do not know what the builders took as the moment of sunrise; it could be, for instance, the first gleam of light (the upper limb), the centre of the sun's disc, or the lower limb (when the sun is tangential to the horizon as it finishes rising). And there is a practical difficulty. A precise measurement of the axis of the Stonehenge building requires an exact location of two points on the axis. One safely survives, the midpoint of the extra-wide gap between sarsen uprights 30 and 1. Another would be the middle of the gap between the uprights of the great trilithon. But as one of these has fallen and the other in Petrie's time leaned wildly, that point cannot be fixed with accuracy. An alternative way to define the axis is by the centre-line of the Avenue, on the reasonable assumption that this coincides with the axis of the building.

Petrie in the end chose to use the first glimpse of the sun as seen over the Heel Stone from between the uprights of the great trilithon. From this he extracted (with, it was said, defective arithmetic) a date of AD 730. It fitted his Roman foot, as well as the idea he held that Stonehenge really was the burial ground of English kings after the Roman

* Photographers sent to Stonehenge to take the moody views of sun and stones that are so fashionable nowadays prefer the midwinter sunset. To catch the summer dawn is tiresome; you have to arrange special access and get up there by half past four in the morning. Too often, cloud or groundmist hides the sun. The winter sunset is more convenient - it means a gentle outing at a sensible time of day – and very few people can tell the difference between the results.

113 Two Lockyer oddities. (Top) Stonehenge as one corner of an equilateral triangle drawn between ancient sites on the Plain. Two of these lines were later adopted as leys (pages 240–1). (Above) The 'oldest crossroads' on Salisbury Plain (whatever that means) lies at the centre of the triangle.

So many earthworks survive in Wiltshire that it is easy, as Lockyer did, to find that geometrical figures can be drawn between them. withdrawal. But it fitted with nothing else, and scarcely anyone believed it.³¹ The sounder view, as expressed by such authorities as Arthur Evans, was that Stonehenge was late Bronze Age or Iron Age, and most emphatically pre-Roman.³²

A second attempt to date Stonehenge by its orientation was made at the very end of the century by the astronomer Sir Norman Lockver. After studying the orientations of ancient Egyptian temples on the sun and on stars, he turned to the ancient British sites, especially Stonehenge. He chose as indicator the first gleam of the rising sun. As substitute for the unknowable axis of the building, he used a straight line down the centre of the Stonehenge Avenue, as judged by estimated points on its midline, at an azimuth (compass direction) of 49° 35' 51". This azimuth, if projected to the north-east, passed close to Sidbury Hill (not to be confused with Silbury Hill) about 8 miles north-east of Stonehenge, on which there is an earthwork. There was no reason whatever to link Stonehenge with the Sidbury earthwork: they are not even intervisible. Nevertheless, Lockyer substituted, in place of his estimated Avenue axis, the line made by joining Stonehenge to a 19th-century Ordnance Survey benchmark on Sidbury Hill. This line, azimuth 49° 34' 18", gave a date of about 1680 BC, but Lockyer's bizarre method of arriving at it rendered it meaningless.³³

At other megalithic sites, Lockyer found indications of orientations to various conspicuous stars. Since the observed position of stars also changes, he could arrive at dates of building by calculating when the appropriate star was in the indicated position. (This method had been used on the Stonehenge Heel Stone, before either Petrie's or Lockyer's solar estimates, and had given a date of 977 BC, when the star Sirius had risen over it, as the supposed date of building.³⁴)

Critics of Lockyer found in his general approach a flaw as devastating as his 'adjustment' of the Stonehenge azimuth. The sun's various positions during the year, at its solstice, equinoctial and various intermediate points, taken with the orientations of several stars during several centuries accepted by Lockyer as possible building dates, gave 'significance' to a great many azimuths. It was embarrassingly clear that Lockyer was prepared to switch from one 'indicated' star to another, if the first would not fit the alignment he was trying to prove.³⁵

Lockyer's uncritical methods discouraged archaeologists from taking alignments in general very seriously. His naive willingness to find significance in chance coincidences, like the equilateral Groveley triangle on Salisbury Plain, and to take local folk-festivals at Mayday or Beltane as certain relics of ancient astronomical studies, meant that whatever genuine discoveries existed in his work were mixed up with all kinds of worthless speculations. Although work continued in the directions he had laid out for the study of archaeoastronomy, it was not until half a century later that the astronomical factor was once again to play a major role in the study of Stonehenge and other megalithic monuments.

'Where folks who came to scoff, would stay and muse'

Let us begin in Salisbury on 28 December 1832.¹ A German traveller, Prince Pueckler-Muskau, is on a tour through Britain, remarking on the manners and customs of the inhabitants. We should take notice of what he has to say about Stonehenge, for his words are prefaced by some exceedingly complimentary remarks by Goethe; and who are we to question the greatest philosopher of the age?

ORS

It was a wet morning, and the Prince stayed in, reading. About three o'clock the sky cleared, and he 'jumped into the bespoken gig, and drove as hard as an old hunter would carry me to Stonehenge, the great druidical temple, burial place, or sacrificial altar. . . . The orange disk of the cloudless sky touched the horizon just as, astounded at the inexplicable monument before me, I approached the nearest stone, with the setting beams tinged with rose-colour. . . .

'I was not the only spectator. A solitary stranger was visible from time to time, who, without seeming to perceive me, had been going round and round among the stones incessantly for the last quarter of an hour. He was evidently counting, and seemed very impatient at something. The next time he emerged, I took the liberty to ask him the cause of his singular demeanour; on which he politely answered, "that he had been told no one could count these stones aright; that every time the number was different; and that this was a trick which Satan, the author of the work, played the curious: that he had within the last two hours confirmed the truth of this statement seven times, and that he should inevitably lose his senses if he tried again." I advised him to leave off, and go home, as it was growing dark, and Satan might play him a worse trick than this. He fixed his eyes upon me sarcastically, and with what the Scotch call a very "uncanny" expression, looked about him as if for somebody; then suddenly exclaiming "Good-bye, Sir!" strode off, like Peter Schlemil, casting no shadow, ('tis true the sun was set,) with seven-league steps across the down, where he disappeared behind the hill. I now likewise hastened to depart, and trotted on towards the high tower of Salisbury Cathedral, which was just visible in the twilight. Scarcely had I gone a mile, when the high crazy gig broke, and the driver and I were thrown, not very softly, on the turf. The old horse ran off with the shafts, neighing merrily, towards the city. While we were crawling up, we heard the trotting of a horse behind us; it was the stranger, who galloped by on a fine black horse, and cried out to me, "The Devil sends his best compliments to you, sir, 'au revoir';" and darted off like a whirlwind. This jest was really provoking. "O, you untimely jester!" exclaimed I, "give us help, instead of your 'fadaises'." But the echo of his horse's hoofs alone answered me through the darkness. The driver ran almost a mile after our horse, but came back without any tidings of him. As there was not even a hut near, we were obliged to make up our minds to walk the remaining six miles. Never did a road seem to me more tedious; and I found little compensation in the wonders which the driver related of his hunter, when, twenty years ago, he was the "leader of the Salisbury hunt".'

The Prince, so really provoked, spent the next day indoors, reading, with a violent headache, and then departed.² If the point of the Stonehenge excursion was to experience the terror and privation of the sublime, he actually did rather well.

And he had chosen to go in December, when the high open spaces of the Plain may seem unusually wet, windy and cold. As a traveller complained, stuck in an inn on the Plain waiting for the weather to improve:³

England! thy weather's like a modish *wife* – Thy winds and showers for ever are at strife. To gain her art by every end she tries, And when she can no longer scold – she cries: So shifts thy climate round these chilling plains, For when it can no longer blow – it rains.

The favourite excursion was still Salisbury to Stonehenge via Old Sarum, in a hired carriage, one horse 15 shillings, two horses a guinea. (Public transport was minimal; the direct London-Exeter stage through Amesbury, or the coach from the Three Swans in Salisbury to Amesbury at 3 p.m. on Tuesday, Thursday or Saturday.⁴) With your own driver you could go in the morning to Old Sarum, which had a new fame as the rottenest of pocket boroughs before the Great Reform, its resident population of zero returning two Members to Parliament. After a picnic at Stonehenge, you came back through Wilton to see the Pembrokes' splendid house, or by the quick route through the water-meadows of the Avon valley.

The Cunnington family kept up a tradition established by William, to avoid the customary disappointment, 'that on this extended plain at such a distance it appears nothing, and by the time you are at it all astonishment ceases'. Richard Fenton had enjoyed the trick at its beginning, his 'Cicerone from Heytesbury' insisting 'he must stipulate every stage' of the excursion. After a few miles, the blinds of their post-chaise were pulled up. 'Thus in darkness and durance we travelled rapidly for a few miles, till our captain, with a most majestic tone, issued the word of command, "Stop, down with the blinds"; when lo! we found ourselves within the area of the gigantic peristyle of Stonehenge.' The effect, for once, was 'wonderful' as the sight burst 'suddenly and all at once on the eye, as it did on us, not familiarized by a graduated approximation'.⁵

You would expect to meet at Stonehenge the 'Shepherd of Salisbury Plain', Wiltshire's original contribution to the cult of the romantic rustic. The shepherd by the stones is a stock figure in the paintings and written accounts of Stonehenge as far back as Pepys. He (rarely she) is a solitary and weather-beaten figure, gathering true wisdom from a life-time of lonely navigation of the Plain's rolling oceans, where you see 'lving at anchor in a hollow, or steering across the plain like a flock of white sails, whose course you can track for miles, what you know must be a flock of sheep'.6 The pamphlets of the Religious Tract Society introduced the Salisbury shepherd in an impossibly sentimental tract as the exemplar of the poor and humble turning to God. Linked as it were with the Holy Evangel, he was translated into 'nearly all the alphabetted languages of the earth' - including Turkish, Russian and, twice, Romansch - and millions speaking multifarious tongues in remote continents, who had never heard of Stonehenge, found its shepherd one of the permanent guide-lights to a better being.⁷

A more real version of him awaited you by the stones, to hold your horses and assist the intelligence of your visit, whether you wanted him or not: 'The "Shepherd of Salisbury Plain" was represented by an old man who told all he knew and a good deal more about the great stones, and sheared a living, not from sheep, but from visitors, in the shape of shillings and sixpences.'⁸

There were genuine shepherds, but Henry Browne, 'the first custodian of Stonehenge', did not think of himself as a rude rustic. He came to Amesbury in 1822 and installed himself at Stonehenge as resident 'Lecturer on Ancient and Modern History'. He was not employed by the Marquis of Queensberry, but he was empowered to call himself the official guide and to collect tips, provided he was there whenever there were visitors, to see no damage was done. His living was precarious, 'sometimes obtaining sufficient sustenance, sometimes reduced, with his family, to the greatest distress'.⁹

Mr Browne's lectures on ancient history were exceptionally strange, although he believed them to be 'the unprejudiced, authentic and highly interesting account' that Stonehenge 'is found to give of itself'.¹⁰ His account was inspired by Dean William Buckland, the Oxford geologist who was the last champion of the Catastrophic hypothesis, which sought to accommodate the evidence of fossils and their geological deposit with the short chronology of the Bible, in which all geological events had to be crammed into the years since the Creation in 4004 BC. Browne had the bad luck to embrace Catastrophism just as it was being swept away by a flood of evidence associating human remains and artefacts with the bones of long-extinct creatures, often sealed under feet of stalagmite deposits. And he had the bad judgement to go further than Buckland, who had never risked assigning buildings, however rude, to an antediluvian age.

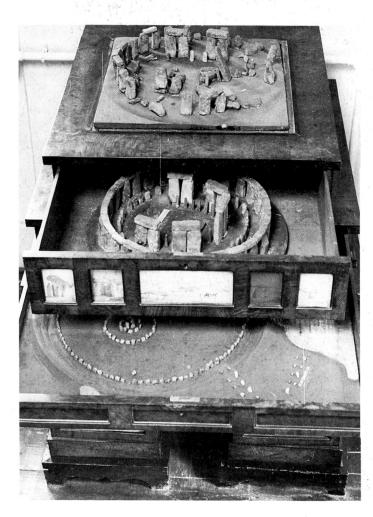

114 (*left*) In Johannesburg, South Africa, hotel visitors were greeted by the gentle shepherd of Salisbury Plain, painted on its sign with this doggerel in Latin, English, Afrikaans and French:

Multum in parvo pro bono publico Entertainment for men and beast all of a row.

Lekker Kost as much as you please Excellent beds without any fleas.

Nos patriam fugimus, now we are here Viramus, let us live by selling beer. On donne à boire et à manger ici, Come in \mathfrak{O} try it, who ever you be.

115 (above) Souvenir sweet-basket in porcelain with printed picture.

116 (left) Antiquary's cabinet, incorporating Henry Browne models of Stonehenge (As It Is and As It Was) and Avebury. Underneath are drawers for the collection of curiosities.

117 (opposite) Victorian melodrama at the old stones. The novel's title, 'A Life for a Life', tells all.

Browne persuaded himself that Stonehenge was the last surviving building from the age before Noah's flood. Its size and craft were a new proof of the skills of the fair and noble Antediluvians. The battered south-western side showed that the flood, in Wiltshire at least, engulfed the world from the south-west. Avebury was also, he said, antediluvian, built by Adam himself as a reminder of the origin of sin, with serpentine stone avenues and apple-shaped stone circles.¹¹

Browne was an observant man, and he found empirical evidence for his deluge in the raised lips on the top of the Stonehenge uprights, which make a shallow cup to hold the lintel firm. On the trilithon falling in 1797 these pans were, he was informed 'on sufficient authority', 'completely glazed by some coagulated matter which had insinuated itself into it. What this could have been but the remains of the waters of the Deluge I am wholly at a loss to conceive.¹²

One of Browne's sidelines was making cork models of Stonehenge ('As it is' and 'As it was', 7 guineas the pair¹³); Colt Hoare was an early patron. John Britton had respect for Browne, though he could not for a moment entertain his 'daring and very eccentric hypotheses', which he had formed 'in his closet, and gone abroad to confirm'. He wanted to turn Browne's abilities and experience to some account, 'whereby he might be personally benefited, and laudable curiosity be gratified'. If 100 gentlemen each subscribed £5, a new company to make Browne's models could be floated under the title 'The Druidical Antiquarian Company', a name admittedly risky in an age of stock-broking bubbles. If they succeeded, Britton would go on to a 'novel plan for exhibiting models, pictures to be elucidated by lectures. This plan would combine something of the principles of the Cosmorama, Diorama, Panorama, and Eiduphusicon [contemporary variants of the magic lantern], and I am persuaded that a very interesting exhibition might be formed of Celtic or Druidical Antiquities, whereby amusement and instruction might be united, and where "fools who came to scoff", would stay and muse.'14 The 100 gentlemen-subscribers were not found, and the imminent opening of an instructive museum in Amesbury, which Browne constantly announced, ¹⁵ did not take place either.

Hen Browne was a great tramper, wandering all over southern England in search of antediluvian evidences, and a great reader, too. Wherever he walked, he preached a unified grand theory of fundamental Christianity and diluvial geology, encapsulated in the title of his *magnum opus*, *The Geology of Scripture*. This combined 'the operation of the Deluge, and the effects of which it is productive', 'Scripture history in reference to Stonehenge', and 'the caves of Elephanta and Salsette, and the Wonders of Elora, in Hindoostan' with 'an interesting tour along the banks of the Avon from Christchurch to Abury'. He dedicated it, respectfully and with passionate fellow-feeling, to Buckland 'in admiration of your unshaken fidelity, in the maintenance of what appears to be true on the authority of Scripture, even in the face of the most formidable resistance which the world can oppose to it'.¹⁶ The little money Hen Browne could spare went on apocalyptic pamphlets. My favourite shows that one town in England gave him a friendly welcome: The critical state of England, at the present time; from a consideration of the circumstances connected with the death of our late Sovereign, George the Fourth, with the capture of Algiers by the French, and with the resignation of the Crown of France by Charles the Tenth: Addressed to the people of Kent in general, and to the honest and manly inhabitants of Dover in particular.¹⁷ In old age he made a last long tramp, pushing a handcart bearing two of his Stonehenge models from Amesbury to London. The journey took two days and nights. On the third day, he reached the steps of the British Museum, unannounced, to present his Stonehenge. The doorkeepers turned him away,* and he walked sadly home. Soon after, in 1839, he died after walking from Amesbury to lecture in Winchester.

Hen Browne's son, Joseph, took over at the stones, selling the old guidebook and his own paintings as 'attending illustrator' of Stonehenge for the next forty-one years. Before long, his inherited diluvial geology was so ancient as to be quite absurd, and its proponent more of an oddity than ever. This is how he was encountered about 1860, a great character who startled tourists with his apparition and enlightened them with his discourse: 'We saw, half a mile off, winding slowly across the Plains towards us, a mysterious machine, half-wheelbarrow, half-peepshow, with a man behind it - at least a big hat, which indicated a man underneath.' Mr Browne stopped the machine, laid out his sketchbook, plans and curiosities in a sheltered nook, and began to lecture, in the most intelligent fashion. 'All visitors to Stonehenge', thought his audience, 'will miss a great treat if they do not invest a shilling in the guide-book, and one or two more in the acute explanations of the guide. We did so: left him beaming with satisfaction, and bowing till the big hat nearly touched his knees - in manners, at least, our friend might have taken lessons from our favourite antediluvians.'¹⁹

Joseph Browne's sister Caroline kept up the religious works, addressing especially the ungrateful inhabitants of Winchester, for whose salvation her father had died. She ran a school in Amesbury ('a sound English education is all I attempt') and in old age became, like the rest of the family, a fine oddity to amuse the visitor: 'Quaint old miss Brown, the greatest curiosity of Amesbury, will tell you "It is antediluvian, sir" – a remnant of the serpent worship of which she shows you traces at Ellora, and ever so many other spots; and the flints of wonderful forms which are found lying about she believes to have been fruit, lizards, and fir cones – anything, in fact, except the sponges which we know they were.'²⁰

The next guardian, William Judd of Maddington, brought the profession of 'attending illustrator' up to date by investing in an extremely modern photographer's van, which stood with its white horse close by the stones. Like the Brownes, he was unpaid, but earned a handsome living, for having your likeness taken in front of a great stone was just In a happier version of the story, the models are gratefully accepted by the Trustees. As the British Museum accessions lists have no record of receiving his models, I fear the gloomy story is the true one.¹⁸ the thing. On a quiet day he might borrow a ladder and shin up on to the lintels to collect the coppers thrown up by visitors, and if you were lucky you might be allowed up on the highest impost, for the purpose of examination and understanding.²¹

The final 19th-century guardian was an old soldier named Smeeth, called 'Sikher' for his tales of Indian Army life, and famed for the chestful of medals he sported to help con the visitors. He had a gammy leg, but as a young man had been a noted runner. Soldiers, down from Bulford on their off-duty day, would find him sitting by the milestone which stands on the Shrewton road just by the Heel Stone. After reminding them of his youthful speed, he would point down the Amesbury road, and challenge one of them to a race as far as 'the nearest milestone' with two conditions. The stake must be lodged with a neutral bystander, and the young soldier must take a hundred yards' start over Sikher. Once the challenger had been watched safely away eastwards down the Amesbury road, Sikher would hobble south past the stones to the other milestone close by Stonehenge on the Winterbourne Stoke road – he had specified 'the nearest milestone' – and claim his winnings.²²

The direct railway from London reached Salisbury in 1857, and it was possible to reach Stonehenge from the metropolis on a day excursion. On a summer Saturday, the Baedeker advised, you should save the cost of a hired coach and join the excursion brake from the station for just 5 shillings return. If you stayed in Salisbury a few days, the Old Sarum and Stonehenge outing was inescapable. A would-be nonconformist protested that a man who stayed a week in Salisbury without going near Old Sarum or Stonehenge was surely an especially interesting person. Maybe, but his party dragged him on the outing anyway, grumbling the while: 'sometimes we went up, sometimes we went down'; 'sometimes we saw a gentleman's country seat, sometimes we didn't'; and when the carriage stopped, it invariably chose to do so outside a public-house, where 'man and beast, in collusion, appeared utterly and theatrically distressed'. Stonehenge was reached at last, looking at a distance like paltry chips from a stone-mason's yard or 'an ornament discarded from the drawing-room table of a Druid dissenter's semi-detached villa at Balham'. Disillusion was completed by the guide, not the ancient Shepherd of the Plain, but respectable Mr Judd, middle-aged and middle class, propped against a stone and reading the local paper.²³

If Stonehenge did honestly disappoint, you were not to be upset. That Victorian parlour sage, Elihu Burritt, 'the learned American blacksmith', had reassurance: the most remarkable sights everywhere in the world, even Niagara Falls (which English authorities said could *never* disappoint), were well-known to let down the eager and dilated imagination.²⁴

For some, scepticism was all and the guidebook's clichés just extra provocation: "Do not we gaze with awe upon these massive stones?" asks the high-falutin guide-book compiler. No indeed we don't. It is a

118 *Mr Judd, waiting for business, is drawn from life as an 'Interesting fossil found at Stonehenge July 4 1885 AD' by a Devizes schoolmaster.*

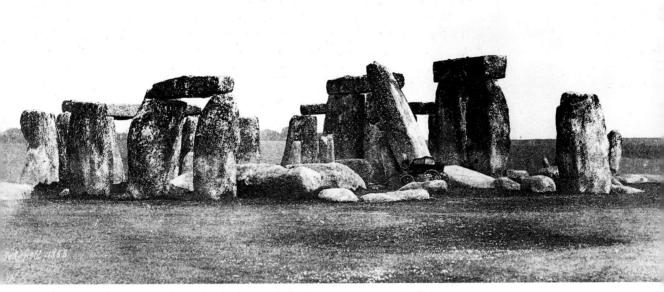

The first photograph of Stonehenge, a calotype taken by R. Sedgfield in 1853. This print is from Prince Albert's personal photograph album.

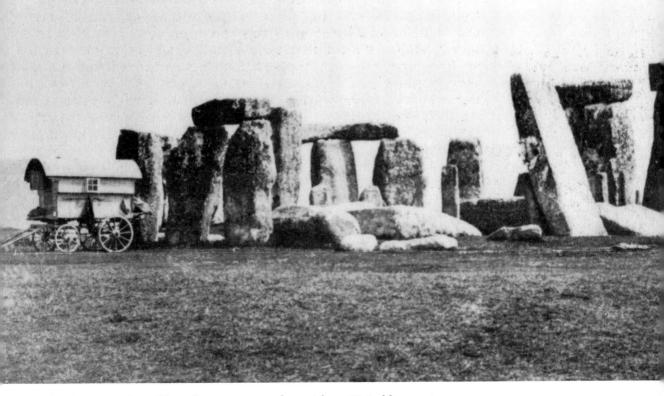

Later, no view of Stonehenge was complete without Mr Judd's smart - white-painted darkroom on wheels.

121 The 'Leisure Hour' indicates the correct way to enjoy Stonehenge: a picnic, a sketch, a little verse perhaps – though, since it was a Christian journal, not Lord Byron's effort:

'The Druids' groves are gone – so much the better: Stone-Henge is not – but what the devil is it?' pity, but it can't be done, and the average description of Stonehenge which sets forth the grandeur and stupendous size of these stones, is pumped up fudge and flapdoodle of the damnablest kind, which takes in no one. It is not merely the Philistine who thinks thus, but even the would-be marvellers, and those of light and learning are disquieted by secret thoughts that, had we a mind to it, and if there was money in it, we could build a better and a bigger Stonehenge by a long way.²⁵

The front cover of an issue of *The Leisure Hour*, 'a family journal of instruction and recreation', in 1853²⁶ shows how the respectable mid-Victorian party spends its Stonehenge excursion. The ladies sit round the picnic cloth, while the senior gentleman educates them in the intricacies of the monument; the guide-book, with fifteen theories concisely set out and the sure conclusion Stonehenge really was Druidic, will have been a useful crib. A younger gentleman squats on a folding stool to sketch the view. Stonehenge is a godsend to the nervous artist, presenting just the right degree of challenge and nothing actually difficult. The stones are rectilinear and mostly upright, but not precisely squared off, so a little uncertainty in the line does not come amiss. And they are set in bare surroundings, which presents none of the technical problems of foliage or landscape. People, and horses with carriages, are optional extras for the ambitious amateur.

The other gentleman has wandered off among the stones, which may inspire him to the composition of verse, for Stonehenge brings poetry to male hearts of every class:²⁷

A voiceless vision of a vanished age, These solemn triliths of a temple stand On the unquestioning plain – a hoary band And mystery of ev'ry modern sage.

Or:28

Such have they stood, till dim Tradition's eye Looks vainly back on their obscurity. Through the wild echoes of their maze have roll'd Fierce harpings fit to rouse the slumbering bold: And many a song which check'd the starry train, And bade the Moon her spell-bound car restrain.

The Stonehenge verse – and there is a great deal of it – must have given more pleasure in the writing than it does in the reciting. It begins with conventional wonderment, and when that palls or the rhymes run out, turns towards Druids. The formula is heard at its rare best in the poem which won Thomas Stokes Salmon the £20 Newdigate Poetry Prize at Oxford University in 1823:²⁹

Wrap't in the veil of time's unbroken gloom, Obscure as death, and silent as the tomb, Where cold oblivion holds her dusky reign, Frowns the dark pile on Sarum's lonely plain.

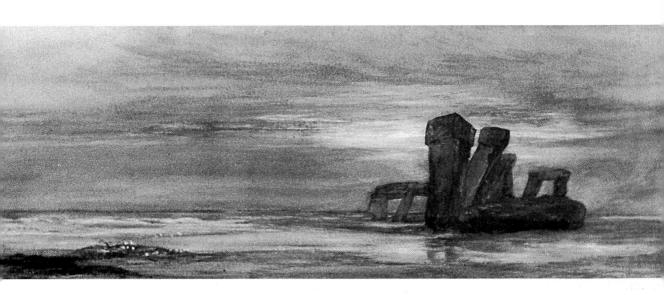

Yet think not here with classic eye to trace Corinthian beauty, or Ionian grace: No pillar'd lines with sculptur'd foliage crown'd, No fluted remnants deck the hallow'd ground; Firm, as implanted by some Titan's might, Each rugged stone uprears its giant height, Whence the poised fragment seems to throw A tumbling shadow on the plain below.

Here oft, when Evening sheds her twilight ray, And gilds with fainter beam departing day, With breathless gaze, and cheek with terror pale, The lingering shepherd startles at the tale, How, at deep midnight, by the moon's chill glance, Unearthly forms prolong the viewless dance; While on each whisp'ring breeze that murmurs by, His busied fancy hears the hollow sigh.

Rise, from thy haunt, dread genius of the clime, Rise, magic spirit of forgotten time! 'Tis thine to burst the mantling clouds of age, And fling new radiance on Tradition's page: See! at thy call, from Fable's varied store, In shadowy train the mingled visions pour. . . .

Mr Salmon continues with a tour of Stonehenges past, the wild Briton, the Druid priest, the Bardic lyre, until – and this is absolutely conventional – the Christian dawn drives paganism away:

On wings of light Hope's angel form appears, Smiles on the past, and points to happier years; Points, with uplifted hand, and raptur'd eye, To yon pure dawn that floods the opening sky; **122** There are any number of attempts at realistic paintings of Stonehenge, but this is something different, a smaller version set by the sea and washed by the rising tide. Watercolour by the lady artist Barbara Boudochon. And views, at length, the Sun of Judah pour One cloudless noon o'er Albion's rescued shore. More often, deliberately or not, the supposed grandeur failed:³⁰

Can I not fancy all these stones upright; Thy surpliced priests, with mistletoe *bedight*, With open mouths to catch the morning air, And crowds on crowds with *open mouths* too, stare! List, where the anthems semiquaver'd rise From G to G, and echo to the skies!...

The most vital element in the apparatus of the Stonehenge excursionist, even the royal Stonehenge excursionist, was the picnic hamper, for the guardian was forbidden to sell refreshment, even lemonade. Without one, you had to trek down to Amesbury for a drink, or go across to Lake and the Druid's Head (where Mrs Woolcot's early breakfast was known for 'coffee, comfort, eggs, ham, and moderate charges', and you could admire a large and barbaric painting of the Druid's head). How much more agreeable to lie back on the downland turf, the sun on your face, the sound of bumble-bees in your ears, and the glass in your hand, surrounded by the majestic relic your schoolbooks had called 'the frontispiece to British history'.³¹ The pictures always show a bottle centrally on the picnic cloth, though we can be sure the one on the cover of *The Leisure Hour* held nothing stronger than ginger beer, for that estimable journal was another emanation from the presses of the Religious Tract Society.

English and foreign royalty naturally took the Stonehenge excursion like everyone else, and even the Empress-Queen herself, or so Mr Judd would tell: one day, a lady and two gentlemen drove up, in the same manner as any Salisbury tourists. At the suggestion of the lady, Mr Judd photographed them by the stones, one of the men giving an address in the London West-End for the prints to be sent to. The party left unrecognized, but 'it subsequently transpired' that the lady was no other than the Queen. He kept the negative, until by accident it was broken; and it brought him an annual revenue of fifty pounds in prints for the curious.³²

Gladstone, the Queen's least favourite prime minister, really did go to Stonehenge and found it, conventionally, 'a noble, and an awful relic, telling much and telling that it conceals more'.³³

Americans were as attracted to Stonehenge then as they are now. Ralph Waldo Emerson went with his old friend Thomas Carlyle, 'in a bringing together of extreme points, to visit the oldest religious monument in Britain in the company of her latest thinker', and was impressed by both.³⁴ On the other hand when Thomas Moore, a popular poet and song-writer, took an American (in the best way – making him keep his eyes tight shut until right inside the circle), the visitor saw nothing wonderful about it; accustomed to *nature* on the grandest scale – back home he had sailed in a tall ship through a natural arch of stone –

Juliance Mock Farthe Confish . Joles Sweetbreads Spinach Chicken Kissolete, For Quarter of Samuel Ducklings & Culles Plours & Soufflie Solatoris Custard Farthets Brazilian Sudding . Sears & Cream Constantion There Atranos

123 (above) Stonehenge at supper.

124 (right) A royal picnic party. Prince Leopold, youngest son of Queen Victoria, and friends. The Prince, an unmistakable brother to the future King Edward VII, is seated fourth from right.

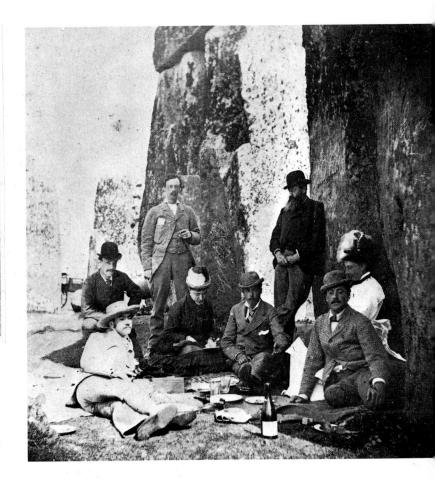

he found Stonehenge too close to nature on the domestic scale. Yet at Salisbury Cathedral he had been overcome with admiration and astonishment because, as Moore noted, Americans are wholly unaccustomed to *art*.³⁵

Throughout the 19th century, Stonehenge Down was a favourite resort for a Sunday school or holiday outing, in horse-drawn brakes or with a traction engine from the further villages. The fairs continued, and Stonehenge was also the place for special events, like the matinee concert presented in 1896 by a travelling company, The Magpie Musicians. A company of more than a thousand gathered in the finest of weather to give the five players a most enthusiastic reception. The leader, Mr Collard, played flute 'rushes' and variations to the piano accompaniment of his daughter, Miss Gwendolyn Stanhope, who also performed exercises with Indian clubs. Miss Allington sang solos with great taste and expression, and Miss Erroll Stanhope was a notable *siffleuse* and *comedienne*. Mr Scott's quaint singing and dancing was novel, ingenious and humorous. A London photographer took views of the scene, and the afternoon concluded with hearty cheers for Mr Collard and his company.³⁶

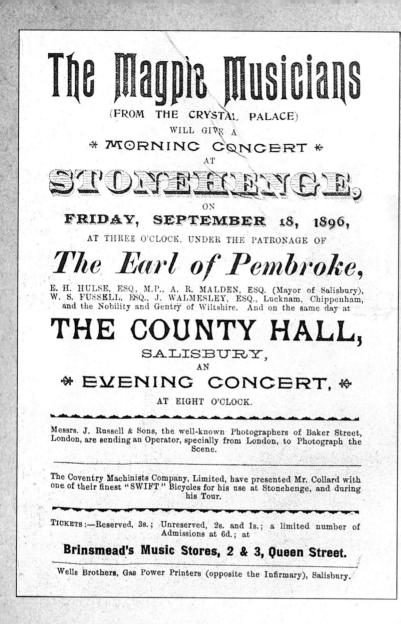

Stonehenge, the complete Victorian resort – music, coursing, excursions, cricket, even antiquities.

125 (left) Wells Brothers, 'Gas Power Printers' of Salisbury, found no fewer than ten different typefaces to make up the Magpie Musicians' poster.

126 (opposite above) The Wiltshire notables, all in top hats and with Sir Edmund Antrobus among their crowd, assemble for the great Stonehenge coursing meeting, c. 1854. In the foreground are two winning greyhounds and a losing hare. This fine large oil by the Barraud brothers, the prize given that year to the most successful owner, is still in the possession of the winning owner's family. The artists unwisely painted the favourite dog and its owner prominently into the foreground and had to revise the composition when an outsider won.

127 (opposite below) Village outing towards the end of the century.

128 (both pages) Gentlemen of the Stonehenge Cricket Club play a home match, 1830. Top hats again, also underarm bowling, fourteen fielders, and a large refreshment tent. Stonehenge, to judge from the numbers, is almost an equal attraction. Cricketers used the Stonehenge ground until the 1920s.

A.A.S

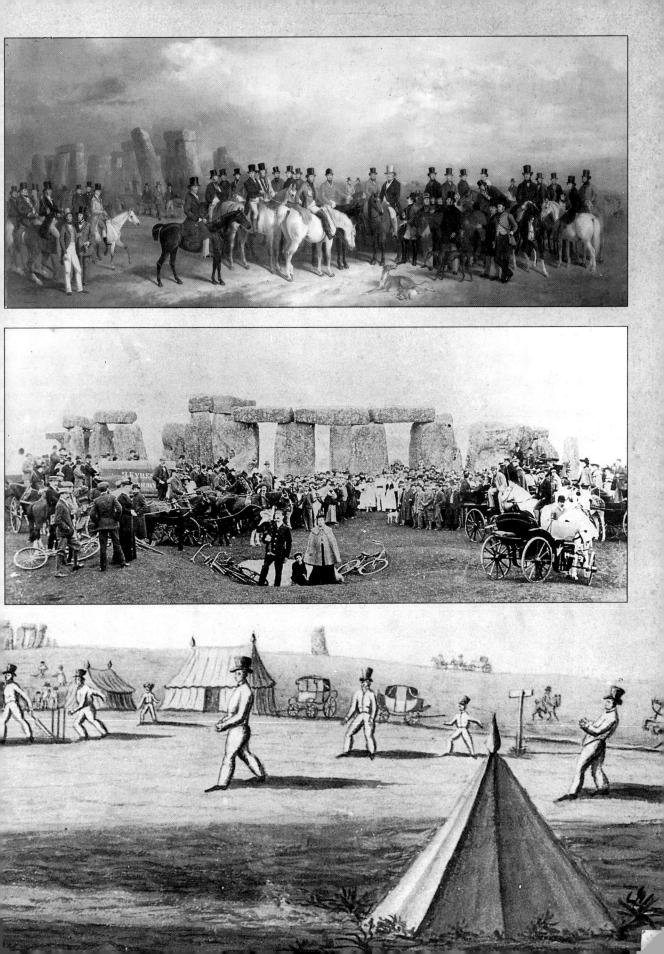

Since the later 19th century, the principal annual event at Stonehenge has been going to watch the solstice sunrise. John Thurnam watched a clear dawn in 1858, and in 1860 Lord Carnarvon was 'impressed with all the desolation and solemnity of the scene', as he watched for the sun to rise. A crow 'of more than normal size' and 'very prophetic aspect, perched on the index-stone; and, presso ter gutture, uttered three distinct and, I doubt not, encouraging caws'. At 4 a.m., all was favourable, 'the sky was clear, bright fleecy clouds caught the reflection of the coming dawn', but 'even as we watched, there rose a bank of leaden cloud and vapour'. But Carnarvon was lucky: the sun cut through the mist and 'shone out in all his brightness and in full and certain relation to the index-stone, exactly as we had hoped and expected'.³⁷ By the later 1870s the summer solstice was a popular attraction. The Devizes cycling club made it the occasion for an annual outing. In the late evening, the brave velocipedists were sent off from the market-place by a large crowd, to face the stony road on their silent steeds.

By the end of the century the solstice had become a well-organized affair. The Amesbury pubs stayed open all night – but only, as the licensing laws specified, for bona fide travellers. Accordingly, a policeman was posted by each inn door in order to ensure that every 'traveller' was out again and on his way within ten minutes – though nothing was to stop him going to the next pub in the street. Towards three o'clock the cycles and carriages climbed the dim road to Stonehenge, making a crowd of two or three thousand if the night was clear. Some authority, such as the Headmaster of Dauntsey Agricultural School, would discourse from the top of a brake; and there would be three cheers for the lecturer, three for his family, and three for the Royal Family; and *God Save the Queen* would be sung. No wonder the schoolboys at Marlborough College took to creeping out of their dormitories to cycle illicitly over for the occasion, even though they had to leave before the dawn so as to be back in time for morning roll-call.

It was not a reverent crowd. 'Reverence is not a characteristic of the age,' a visitor from London complained, 'nor are cyclists as a rule, or agricultural folks, or provincials generally, inclined greatly to worship the immeasurably old.' A few constables would be on hand to keep the peace, but it was to be expected that rowdies would break bottles on the stones, or clamber up wherever they could.³⁸

The summer dawn at Stonehenge is an extraordinary and moving sight, when the two miles of low ground between the Heel Stone and the Larkhill horizon are filled with mist; then, only the delicate line of trees silhouetted, with exact clarity, against the sun's disc tells you where in the emptiness the horizon actually is. But in the 1890s – and ever since – the one morning not to watch the sunrise was the solstice day itself, when the quiet is broken not by the song of larks, but by the sound of a big crowd and the noise of its vehicles.

ENGE COMPLETE STONEHENGE The proprietor and his public

'Ringed with a cordon of waggonettes and flecked with the light foam of summer blouses'

Travellers in the early 1800s were shocked to find Salisbury Plain uncultivated and unproductive. In an improving age, such an affront to Adam Smith's laws of prosperity verged on the immoral. But it is thanks to that neglect that some barrows and earthworks near Stonehenge still stand. Closer to Amesbury, in the area cultivated since medieval times, everything has been flattened.¹

Through the 19th century, the plough crept across the down, and in dips and hollows grew spick-and-span new farms, roofed with bright red tiles or dark Welsh slates. The sheep remained, but fed on swedes – 'all our mutton now-a-days is, alas! mere animated turnip, mere colossal lamb' – grown by the progressive farmer where the old barrows had stood: 'It is a shame, for under culture they will soon cease to be barrows; but still the black earth of the "burning"* must be very tempting to the farmer. What a contrast between you and him! He thinks of rent and crops, and the excellence of the artificial soil. All you think of is the dead chieftain lying in rude state upon the heath, with his arms and little trinkets round him.'²

Another casualty of the new agriculture was the great bustard, the largest land bird of the British Isles. Salisbury Plain, and the area round Stonehenge especially, was one of its last strongholds, for it is shy and nests only in grassland which is entirely undisturbed. In their time, of course, these great lumbering birds had been an extra element in the sublime experience, when the homeward shepherd might disturb a bustard, which³

... outsent a mournful shriek And half upon the ground, with strange affright, Forced hard against the wind a thick unwieldy flight.

The 4th Duke of Queensberry, who had forbidden Coxe to put up the fallen trilithon, died a bachelor. The estate was bought by Sir Edmund Antrobus in 1824, and stayed in the family through the rest of the century. Queensberry had not been a man to squander money on tidying away earthworks to improve marginally a tenant's land. Sir Edmund was more generous (on first arriving, he spent £189 on 'a pair of very handsome stoves' for Amesbury church), but the Antrobuses had the same views about Stonehenge. The baronet was proud to have in his care the premier relic of antiquity in the land, and to call himself 'the proprietor of Stonehenge', but he was not going to 'improve' it.⁴

* The turf stack within barrows decays to a loam sometimes so rich and dark it looks burnt.

129 A great bustard at home.

By 1823, 100 acres of the land north-east of Stonehenge was in arable, and by 1850 the land on the north also, bringing much of the Cursus into ploughland. Normanton Down, to the south, stayed in pasture longer. A new farm, Fargo Cottages, was built in 1847 a quarter-mile west of Stonehenge, the first and for a half a century the only building in sight, and a couple of mounds there were levelled. They were 'in great measure formed of the chippings and fragments of the stones of Stonehenge'. Ploughing closed in on the temple itself; and the barrow-group to the west vanished by degrees.⁵

In time, the railway, the quintessence of Victorian progress, was bound to move from Salisbury closer to Stonehenge. *Punch* had anticipated the results when new lines were being cut ruthlessly through south London: 'The Lord of the Manor of Stonehenge begs to inform archaeologists and others that he has transferred his rights to the London, Chatham, and Dover Railway, and that this famous Druidical remain will be on view until the 1st of April, when it will be put into thorough repair, and converted into an engine-house for the above company.'⁶

Salisbury Plain is poor country for a railway promoter. There must be major engineering to take the line up on to it from the valleys, and there are no settlements of a size to generate traffic. But it lay in border country between the rival empires of the Great Western (GWR) and London & South Western (L&SWR) companies. The first scheme, put forward in 1886, would have taken a L&SWR branch diagonally across the Stonehenge Cursus on its push towards the GWR stronghold of Bristol. Opposition from Sir John Lubbock, the chief spokesman for archaeological interests in Parliament, had it diverted, and then the scheme was dropped. Ten years later, the GWR countered with a planned line from Pewsey, close to Stonehenge on the east with a 'Stonehenge & Amesbury' station to serve tourists and locals, the aim being to break the L&SWR monopoly of traffic from Salisbury. This

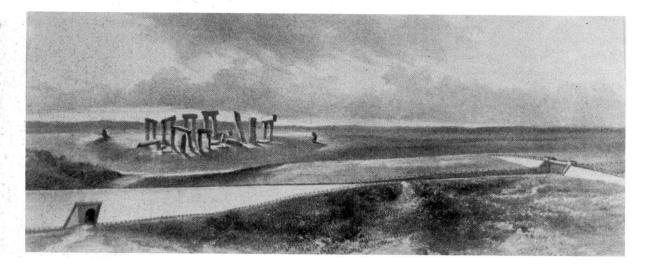

130 The clean straight line of the railway, in an 'artist's impression', shows up Stonehenge for the obsolete antiquarian crotchet the railway promoters thought it to be. scheme failed, too, and the railway only reached Amesbury at the turn of the century, when military needs, rather than railway empire-building, justified a short branch line.⁷

Railway excursion trains were not needed; without them, the streams of visitors were trouble enough. The guardian had a long list of transgressions to prevent: 'To see no damage is done to the stones and the grass. To ascertain the names and addresses of any persons so doing and not to allow visitors to picnic inside the stones, nor light fires inside the ditch. Visitors are requested not to put marks or names on the Stones. No picketing or feeding of horses allowed between the Stones and the Ditch. Visitors not to leave rubbish.'⁸ For all the guardians, moreover, there was the distraction of having to earn a living – the Brownes with their guides, their models, and their Catastrophic evangelism, Mr Judd by taking and developing souvenir photographs.

The better class of tourist resented the 'odious omnibuses, sordid shandrydans from Salisbury' – 'Waggonette parties are the bane of Stonehenge. To avoid them you must be up with the dawn, or you must wait for the evening shadows. Unfortunately I had stumbled upon the early afternoon, and long before I reached the stones I could see that they were ringed with a cordon of waggonettes and flecked with the light foam of summer blouses.' On arriving, you found a good scatter of picnic remains, broken bottles, dirty papers, chicken and chop bones, and what the Victorians called 'litter', horse dung and straw soaked in horse piss.⁹

Names were scribbled on the stones. Children used the fallen stones for slides and games, while their parents busied themselves with acquiring a souvenir chunk of stone. On a summer day, 'a constant chipping of stone broke the solitude of the place'. One party found their carpenter's hammer was good only for making small chips, and wished they had brought a geological hammer instead. Another, expecting the place to be guarded, had brought no hammer at all, and so were unable to benefit from their luck on finding it unattended. The better-equipped visitor would, Sir Edmund Antrobus admitted, get his souvenir anyway 'notwithstanding the remonstrance' of the guardian.

What if the 'responsible visitor' saw hammering? He was counselled to 'offer one of those good-natured remonstrances which will carry weight with the offender, and are sure to enlist the sympathy and assistance of the great body of bystanders'. Sir Edmund himself requested a 'respectable paterfamilias in a well-appointed barouche' to desist when he heard him asking for the hammer and chisel. When Sir Edmund announced himself as the proprietor, the visitor said he thought Stonehenge was public property (and, therefore, one may guess, a little part of it belonged to anyone who came to collect his share). Sir Edmund fared no better when three young men tried to carry off part of a sarsen for a relative, 'a distinguished archaeologist', to whom he protested. The archaeologist denied any relative of his would do such a thing; and there was no point, 'as he had already had part of the stone in question given to him by a friend'. **131** Deep carving in sarsen is a slow business. Mr Bridger's name, the year, and his town (Chichester, abbreviated) must have occupied most of his day-trip.

Up to the 1850s, 'a rustic' (or was it the guardian himself?) would often loiter by the stones, offering to sell little chunks from his pockets for a few pence. These probably came from near-by fields, where every ploughing would throw up quantities of stone chippings. But his presence encouraged the 'conscientious' visitor to break off pieces for himself – and so be sure they were genuine.¹⁰

If you did not care to make the day-trip to Wiltshire, it was - briefly possible to visit Stonehenge in the West London suburb of Shepherds Bush. A new pleasure garden, Woodhouse Park, opened in 1894 'to create a select and refined resort at Kensington for afternoon tea'. For 6d admission you could view the Majestic, the largest captive balloon in the world, ascending with 12 passengers to a height of 1000 feet. There were lectures, recitals, lovely gardens, refreshments by the Oriental Association, and the unique attraction, Stonehenge As It Was, the oldest monument of man's labour, in full-size reproduction. Woodhouse Park did not prosper. The planned partner, Stonehenge As It Is, was not built. and within a couple of years the Stonehenge of Shepherds Bush had become the site of a power station for a new underground railway.¹¹ A more confused idea was given by an exhibition in Southampton, where the 'Unique Exhibition of Stonehenge Druidic Temple' (above Mr Dibben's ironmongery store) would tell you its masonic secrets, with exoteric drawing-room lectures in camera every Wednesday.¹²

In 1882, after years of rebuffs, a weakened version of Sir John Lubbock's Ancient Monuments Bill became law. Its assertion of some national claim to ancient remains cut across the absolute rights of land-ownership, and had been fiercely fought by the landed interests. Thanks to their resistance, it was voluntary only; an owner could ask for state protection for a monument or sell it to the State, but he could not be coerced. Stonehenge was listed in the schedule of twenty-six English monuments it was expected to protect.

General Pitt-Rivers, the leading field archaeologist of the day and himself a Dorset landowner, was appointed as first Inspector of Ancient Monuments. He wrote to Sir Edmund, several times. Sir Edmund declined. He was the proprietor, and that was the end of it. He provided a guardian. When rabbits had dug under the stones, Eli Volckins, under-gamekeeper to Sir Edmund, had been set to digging them out. When there were fears for the safety of some stones, an architect was engaged, and the unstable ones were propped with stout timbers. He was looking after the monument, properly and in his own way: no government 'inspector' was going to tell him what to do.

In 1893 Pitt-Rivers tried again. He made a new inspection, and reported that not much had changed in ten years. No stones had been seriously broken or removed, but names were still being scratched into them, though fewer and less deeply, and the rats and mice that lived on picnic scraps still burrowed. It was 'to some extent in charge of a Photographer' (Mr Judd), who was generally present in summer but not in winter. A policeman was needed as a better guard, every day at least in

132 A secure fence round Stonehenge, in Victorian times, would have meant something like this which protects (and disfigures) the Whispering Knights at the Rollright Stones. The favoured design was the 'unclimbable' Crump's Improved Angle-Iron Frame Vertical Bar e⁹ Hurdle no. 31 with its excellent spikes.

the summer, and he needed to live in a cottage within sight of Stonehenge. Some stones were sure to fall, 'more probably soon than later'; the only remedy was to raise the leaning stones to the perpendicular, and to set them in new foundations of concrete or masonry.

Sir Edmund's response was vigorous: 'What steps can be taken to prevent visitors leaving a crumb from a sandwich in too great a proximity to the Monument would, I think, puzzle the General.' He had for years been pestered by advice from lunatics; one had suggested a close ring of iron palings, another a moat 'on a down plain which is nearly as thirsty as the Sahara', and now the government's Inspector was saying a cottage must be built in sight of the place. The Commissioner of Works did not pursue the matter.¹³

Sir Edmund's policy was to protect Stonehenge, given limited resources, from new damage, but otherwise to leave it alone. Years before (about 1839), a Captain Beamish from Devonport had been allowed to dig 'in order to satisfy a society in Sweden there was no interment in the centre of Stonehenge'. (He went down six feet in the usual patch, just in front of the Altar, over an area 8 feet square, and found nothing more thrilling than 'a considerable quantity of the bones of rabbits'.)14 He was the last explorer allowed to go grubbing. Sir Edmund resisted all the later requests to explore, notably those of the Wiltshire archaeological society in 1864, and of the British Association in 1880. He would not allow fallen stones to be raised or new foundations to be put in. He ignored all reports and committees urging this or that. He refused to dig a ha-ha to regulate access. He took no notice of the four (contradictory) reports issued by the Society of Antiquaries on its preservation. When Henry Cunnington, another member of that archaeological family, cut away the turf round the bluestone lintel to see its shape better, he was forced to agree to a humiliating apology inserted in the local papers.* All these measures – whatever the motives for his obstinacy – had the most valuable result: they protected Stonehenge from wholesale excavation and restoration which would have destroyed much of its archaeology.

* The only 'vandal' formal action was ever taken against.

133 Stonehenge as the county emblem on the Wiltshire County Council seal.

But the mere press of numbers was defeating benign *laissez-faire*. Stonehenge was, thought *The Times*, 'in danger of being vulgarized out of all knowledge and certainly out of all its venerable charms. To continue to allow this marvellous relic of prehistoric ages to be ruthlessly disfigured and perish inch by inch would be an eternal disgrace.' On the other side was also the fear that, whatever state Stonehenge was in already, Her Majesty's Commissioners of Works might be worse than tourists and rabbits together.

In 1898, Sir Edmund Antrobus, 3rd Baronet, died, and was succeeded by his nephew of the same name. The 4th Baronet felt Stonehenge was a dubious asset to the estate: it yielded no income, only trouble and bad feeling. If the Government wanted to interfere, they should buy it. So he offered to sell to the nation Stonehenge, plus 1300 acres of downland, for \pounds 125,000, retaining for himself shooting and grazing rights (there was precious little else to be done over unploughed down). His price took account of the historical associations, which he valued at a minimum \pounds 37,000, a sum comparable with the 'very large sums which are given nowadays for works of art and other memorials of the past'. Hostile estimates reckoned downland to be worth \pounds 10 an acre, so the real price for Stonehenge itself was monstrous, about \pounds 110,000. It was pointed out that the family had paid very little more for the entire 5000-acre estate. The Chancellor of the Exchequer said the price was 'absolutely impossible for any purchaser to consider'.

If the government did not buy, might someone else? It was a matter, in effect, of putting up a notice 'STONEHENGE FOR SALE', even though 'in any other country, so grotesque-looking an announcement as the above would hardly come within the scope of practical possibilities'. Heavyhanded hints were put about that 'the owner might be tempted by some American millionaire who may be inclined to bid for notoriety by transporting the relic bodily across the Atlantic'; after all, 'one only has to threaten the Government with a rich American, and the price might be raised indefinitely'. Years later, Sir Edmund's widow said the American story had just been a joke, but it was taken seriously at the time, and anxious MPs reassured themselves they could rush through a law to prevent the summary export of Stonehenge to the New World.

Perhaps a showman would buy Stonehenge as a commercial undertaking, walling it off, charging for admission, and providing sideshows to encourage custom. An advertising contractor might be interested – the 'Pear's Soap Stone', and the 'Little Liver and Beechams Trilithons', say. Or a syndicate, running Stonehenge as a joint-stock concern, might remove it from the empty Salisbury Plain 'to some more convenient place, if not to the metropolis itself'.¹⁵ The Government declined. No other buyer materialized. As the 19th century ended, the pressures on Stonehenge grew. The workmen building the military camp at Bulford and the Amesbury railway came on their days off, and behaved even worse than the tourists. Soon soldiers from the new camps and excursionists from the branch-line trains would swell the crowds.

PUNCH, OR THE LONDON CHARIVARI.

[AUGUST 30, 1899.

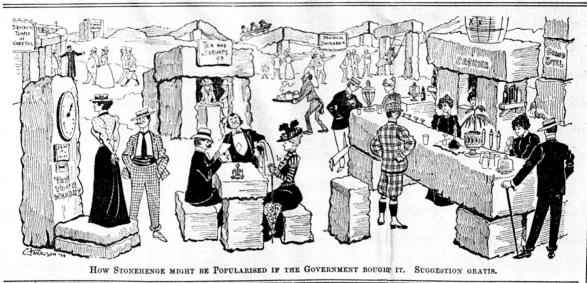

134 (above) Punch's view of how the tourist potential of Stonehenge might be put to useful profit, 1899.

100

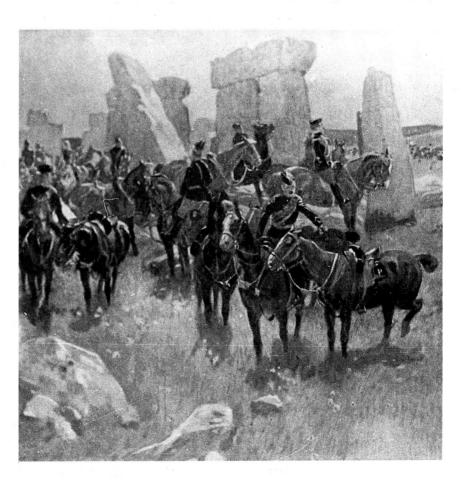

135 (right) The men of the mounted infantry storm Stonehenge, during the annual Salisbury Plain manoeuvres, 1896.

STONEHENGE COMPLETE STONEHENGE COMPLETE ST IEHENGE COMPLETE STONEHENGE COMPLETE STONEH IGE COMPLE**11 1900 AND AFTER** COMPLETE STONEHENGE COMPLETE STONEHENGE COMPLETE STONEHENGE COM ETE STONEHENGE COMPLETE STONEHENGE COMPLET

'In fact at all times private property'

On the last night of the 19th century, 31 December 1900, a gale blew down stone 22, a sarsen upright on the west side of the outer circle. With it went its lintel, stone 122, which broke in half with such a shock that a fragment was thrown 81 ft away. These were the first stones to fall since 1797. The guardian being ill, Sir Edmund paid for a police constable to keep sightseers in order.

Something now would have to be done. Sir Edmund decided to fence Stonehenge off, to charge admission, and have its safety checked.¹ Tree-trunks were put across the various cart-tracks between the stones. His plans for a permanent wire fence were blessed by an advisory committee of local and national archaeological societies. The fence went up in May 1901, and by October of that year 3770 visitors had paid their shillings to see Stonehenge under the amiable supervision of a resident police constable.

Sir Edmund declined assistance offered by the county council under the Ancient Monuments Acts. He would accept help only 'on the distinct understanding that it in no way affected my rights as absolute owner or interfered with my right of sale should I deem that advisable'.² That was where the trouble lay. Sir John Lubbock (Lord Avebury) had resigned from the advisory committee, thinking it 'not sufficiently insistent on the rights of access of the public'.³ For years Lubbock had argued the case that ancient monuments were held in trust for the nation as a whole; they were not just the private concern of the owner in whose care time and chance had happened temporarily to place them. Sir Edmund was protecting Stonehenge, conscientiously and carefully; but he was also asserting a right to keep out the public if he chose, and to charge them to look at something that seemed rightfully theirs. Nor had the threats to sell Stonehenge to America been forgotten.

Formal opposition came from three groups. The Amesbury parish council asserted the local tradition of free access to the downland. The National Trust led a group of amenity societies insistent on public rights to a national monument. Flinders Petrie and other eminent archaeologists were fearful of damage through over-eager restoration. The objectors found a basis for legal resistance in the claim that the various tracks wandering across the downs and between the stones were public rights of way, unlawfully obstructed by the new fence. Processes of law were pursued, each side stayed resolute, and mutual bitterness set in. The county council, trapped in the middle, tried to mediate. Sir Edmund

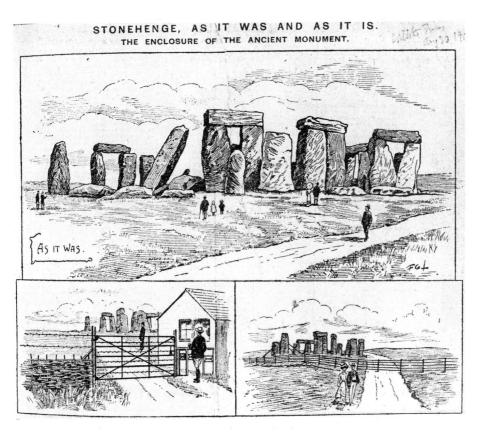

136 Before, and after the stone-fall, with pay-box and policeman installed. At least the fence was comparatively inconspicuous.

made a new offer to sell, this time for \$50,000 with 8 acres of land; which did not help, as it made clear just how much was asked for Stonehenge itself. He refused a counter offer to purchase for \$10,000 plus the cost of fencing.

By pressing a claim to a legal right of free passage, the objectors insisted, in effect, that Stonehenge should be uncared for and unprotected, an absurd idea after the disorder and decay of the previous thirty years. Sir Edmund was encouraged to cling on to an absolute sovereignty over Stonehenge, lest he give an inch and lose a mile; actually he went to the best authorities and exactly followed the advice they gave. Since neither side would shift, the courts had to decide. Four years after the fencing, the case reached the High Court. Barristers for both sides had constructed their legal fictions. The protestors declared, 'Stonehenge is subject to a trust created by a grant or declaration of trust which if in writing [and this for a prehistoric monument!] has been lost or by a statute which has been lost for the free use by the public of Stonehenge as a place of resort. . . .' Sir Edmund's side countered with, 'Stonehenge is and has been from time immemorial and in fact at all times private property and not national or public property. . . .' Both propositions were unproveable and irrelevant. All that the law required was for Sir Edmund to show that the public used the tracks, by his permission, to reach a place that was his own private property. This was done, and Mr Justice

137 The Stonehenge Inn, Durrington, 2 miles north-east of Stonehenge, was put up to cater for the soldiers coming to the new camps early in the century. The brewery artist shows the stones standing in mud, with a few tufts of grass.

Farwell ruled for Sir Edmund: 'The action accordingly fails and ought never to have been brought. ... I desire to give the relators [the protestors] credit for wishing only to preserve this unique record of a former age for the benefit of the public, but I fail to appreciate their method of attaining this.'⁴

More reasoned worries had been made public by Flinders Petrie. Writing to *The Times* from his excavation camp at Arabah in Upper Egypt, immediately word of the stone-fall reached him in January 1901, he declared three concerns.

The first was artistic: 'To do anything to break the marvellous effect of the lonely plain and great masses of stone would be cruel. The sight is the most impressive in England, and on no account should it be destroyed by a hideous iron railing.' It was not. The fence was of wire, strong but unobtrusive, and set a good way back from the stones; it did less damage and obtruded less than Petrie's alternative of a sunken ditch would have done.

His second fear was of over-eager restoration. In the end nothing was restored that had fallen, and the work restricted to safeguarding what still stood.

Petrie's third concern was for a proper standard of excavation. He laid down four essential rules, which are sadly revealing of how the average excavation at the turn of the century was run: '1. Not a handful of soil must be moved except under the instant inspection of a good archaeologist, who must live in a shed on the site. There must be no fooling about driving up each day from an hotel in Salisbury to find that workmen have wiped out historical evidences before breakfast. 2. The workmen must be trained hands, and full local value must be paid to them for everything they find; there must be no chance tales a year or two later about so-and-so having got prizes from the excavations. 3. A perfect record of every scrap, even of pottery, must be kept, and the ground cut away in such measured slices that the place of every object is known to an inch. 4. The public must be kept out from all interference from the portion being worked, and no festive luncheons and notabilities must be allowed to distract the recorder for a moment.'⁵

As before, contradictory advice had poured in; there was a call for complete restoration of every stone 'but those hopelessly broken' in a bed of concrete topped with asphalte; the sensible reminder that 'Restoration is often something worse than ruin, which at least has a melancholy grandeur of its own'; and even a last romantic fancy: 'Surely this thing unknowably old, of whose very form and purpose we have no sort of certainty, belongs to Time and Nature, and should be left to the pious operation of natural decay.'⁶ Several stones were propped with wood, but no fallen stones were put up again. The only restoration was to pull upright the leaning stone no. 56, the sole standing upright of the great trilithon. Its lean had increased over the years to an angle of 60°, and threatened the safety also of bluestone 68, which it was pushing over. A crack on its exposed face showed where it might break in two. The advisory committee approved its being pulled straight and its base being set in concrete. In September and October 1901, this was done under the direction of Mr Detmar Blow, a noted Wiltshire architect, and of Professor William Gowland, of the School of Mines at South Kensington, nominated by the Society of Antiquaries as supervising archaeologist.

Gowland was a Fellow of the Society and an expert on early metal-working, but Stonehenge seems to have been his first attempt at excavation.⁷ Perhaps that explains why his work was so good. Certainly, the intricate and delicate stratigraphy of Stonehenge – where a tiny depth of deposit holds traces of a complex and long sequence of buildings – could not have been understood if it had been attacked by armies of pick-and-shovel men, even if they had been under the direction of Pitt-Rivers himself. (He had firmly advocated, so very few years earlier, total excavation.)⁸ And behind Flinders Petrie's reasoned worries, there must have been a wish to do the job himself.

The only ground opened by Gowland was the small patch around the base of stone 56 which the engineer needed to disturb, a space no more than 17 by 13 ft in all. This had to be dug in small segments, each to be filled with concrete before the next was started, so the forty-plus tons of the stone's weight should not be undermined all at once.

A timber cradle was built round the leaning stone and connected to two stout winches. Slowly and cautiously it was hauled up, two or three inches at a time, then propped on larch poles before it was next moved; it was finally brought upright before a large crowd on 19 September.

Gowland made a point of being at the excavation before the day's work began and after it finished, and a watchman ensured there was no tampering during the night.

In two important ways, Gowland's work maintained new and rare standards. He planned each trench with a rectangular measuring frame, marked off in 6-inch intervals, and measured the depth of each find from a fixed datum; so the exact location of every object within each trench was recorded to an accuracy of a few inches. And all the material dug out was sifted through meshes of 1, $\frac{1}{2}$, $\frac{1}{4}$ and $\frac{1}{8}$ inch, in order that no object, however small, might be lost.

There was no immediate word of treasure, nor were there any dramatic discoveries. But the Professor's final excavation report, which he read to a large company in London on 19 December 1901,⁹ scarcely two months after he finished digging, revealed more about Stonehenge than all the previous century of theoretical hypothesis. From the evidence of a month's work in less than 18 square yards, he showed how the stone-holes had been dug, and how the sarsens were trimmed, shaped and put up; he proved both bluestone and sarsen settings were of the same date, and he made a good estimate of what that date was.

All over the excavated area he found the upper 'Stonehenge layer' of debris, just under the turf – abundant stone chips and flint fragments, clay-pipe stems, pieces of broken crockery, bottles and glass, together

with pins, buttons and other rubbish of obviously recent date. In these upper layers were ten coins spanning the period from a Roman sestertius of Antonia to a penny of George III. Clearly all this was the litter of visitors, sightseeing, souvenir-hunting or quarrying from the stones, in centuries after Stonehenge was completed.

Beneath this layer were the original stone-holes for the leaning upright, stone 56, and its fallen and broken partner, stone 55. In the chalk rubble packed around their bases were the tools of the builders of Stonehenge. They were all of stone. Flint axes and hammerstones showed in the roughness of their breaks how hard the work of trimming had been. Small round hammerstones of sarsen and huge sarsen mauls, weighing from 40 to 60 lb, had been the main tools in shaping the sarsens. The mauls were then reused as blocking stones to wedge the bases of the uprights securely in place. Of the tools for digging out chalk, there remained splinters of deer antler, and a pick of deer antler jammed close to the bottom of a hole. Nothing of metal was found below the upper levels, but a stain of bright green, the unmistakable colour of corroded bronze, marked a sarsen block seven feet down. Chemical analysis showed it was copper carbonate, the last trace of some copper or bronze scrap.

Of the first stage of construction, the bringing of the sarsens from the Marlborough Downs to the site, no direct evidence was found, but Gowland's reasoned conjecture has not since been challenged. He took as his models the moving of great stones in ancient Egypt and in recent Japan, where building with vast blocks was commonplace into the 19th century. Each sarsen had been levered up from its natural resting place on the downs with long poles, and packed with timber supports as it was raised. A frame of massive timbers was manoeuvred into place underneath, and the sarsen lowered on to this sledge. Then teams of men pulling animal hide ropes could drag the sledge across country, a moving bed of wooden rollers most likely easing its passage.

The rough dressing of the sarsens must have taken place at their find-spots. But all the final trimming, and the shaping of the mortiseand-tenon joints was done on-site. The natural tabular shape of a sarsen gives the beginnings of two parallel faces. Often, the two longer sides are vaguely parallel. Nevertheless, a great deal of rock must have been trimmed off many, or most, sarsens. The roughest shaping might have been done with fire and water, the method Avebury villagers used in Stukeley's time. Fires are lit along the line of the intended break; when it is good and hot, the ashes are swept off, cold water is poured over, and the stone is snapped by beating at it with heavy stones.

The finer shaping must have been done with sarsen mauls – as a diamond must be cut with a diamond – for no other available stone is tough enough to work sarsen. Flint will shatter against sarsen without seeming to affect its surface, and even pounding with a great maul breaks off, not chips, but tiny fragments and sandy dust. Some of the stones still show how an area was worked down, first by making long

parallel grooves, then by working at right angles to break down the ridges left between the grooves. The exactness of the curves on stone 56 show how perfectly this laborious work could be done.

The surface finish, once an area was at the right level, was a smooth, uniform pecking, made with the small quartzite hammerstones. This has largely weathered away, and survives only where protected. (The high polish on some fallen stones is not an original finish, but the result of scuffing by thousands of visitors' shoes in recent times.) The tenons were shaped with the same small hammerstones, and the mortices cut by boring with a small stone, using a cutting paste of sand and water.

Gowland also found exact evidence, from the cuttings and packings into the chalk rock, of how stones 55 and 56, the largest of the sarsens, had been put up. The two are of quite different lengths, although they share a lintel. Stone 56 is just short of 30 ft long. More than 8 ft was embedded, and it carried the lintel 21 ft above the ground. A deep hole had been dug, with antler picks and perhaps flint tools also, down into the chalk, straight-sided on the outer face, where the stone was to stand, sloping on the inside to make an inclined ramp. The trimmed stone was slid down this ramp into the hole, then levered and roped upright against the vertical face. Two blocks of sarsen were wedged under its base, and the hole tamped full with chalk rubble.*

Stone 55 had presented the builders with a problem, as it was only 25 ft long. It had to be held in place by not much more than 4 ft of its base set into the chalk. To give extra stability and weight at the bottom, the lower end had been left untrimmed as a kind of club-foot. Understandably, the foundations had failed and the stone fallen, while the footing of stone 56 was strong enough to hold it even when it was leaning at 60 degrees.

The lintels would have been raised on timber packing. First one end and then the other was levered up, and logs pushed in, so the stone gradually rose to the height of the uprights and was slid across into place.

Gowland's two sarsen uprights were put up from the inside, that is, the area where the inner bluestone horseshoe stands. Bluestone 68 was actually set into the rubble filling the ramp of stone 56. So the bluestones must have gone up after the sarsens, not - as many 19th-century experts had thought - the reverse.

The technology of building was entirely Neolithic, the tools having been of stone, of wood and of antler: 'had bronze been in general or even moderately extensive use when the stones were set up, it is in the highest degree probable that some implement of that metal would have been lost within the area of the excavations'. But the tiny green copper stain showed bronze had been present in minuscule quantity. Stonehenge, therefore, was built 'during the latter part of the Neolithic age, or the period of transition from stone to bronze, and before that metal had passed into general practical use'. Gowland estimated that date at around 1800 BC.

* Professor Richard Atkinson in 1958 uncovered more of the ramp of stone 56. Its position showed the stone had either been put up lying on its narrow face or was put upright on its broad face, then turned through a right angle when upright.¹⁰

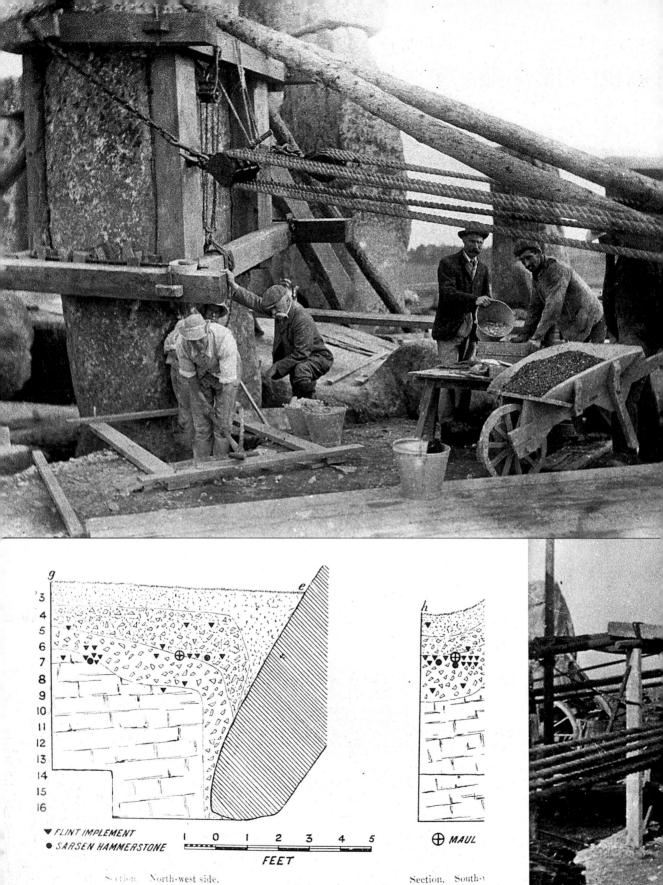

Figure 10. Excavation III.

Section. South-1

COPYRIGHT.

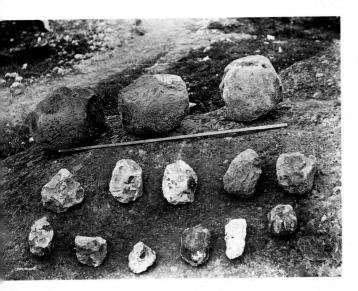

Gowland's 1901 excavations round the leaning stone 56.

138 (opposite above) With 56 safely upright, Gowland (in cap, second from left) supervises digging inside the wooden measuring frame. Sieving in progress on the right.
139 (opposite below) Section through deposits in 56's stone-hole.
140 (left) Sarsen mauls and flint hammerstones from the trench.
141 (below) Gowland stands proudly amid his lifting tackle. The constable is conspicuously on duty (right). The purpose of Stonehenge? All the evidence of the lay-out – the horseshoe open to the north-east, the central trilithon and Altar, the Heel Stone and Avenue to the midsummer sun – implied worship of, or reverence for, the sun.

And its origin? Gowland discounted exotic inferences. Megalithic buildings round the world had independent origins; they were 'the outcome of a similar development of the human mind'. Of a foreign origin for Stonehenge, 'there is, in fact, no proof, and its plan and execution alike can be ascribed to none other than our rude forefathers, the men of the neolithic or, it may be, of the early bronze age'.

The logic of these cautious and sober conclusions swept away all the extravagances of Phoenicians, of Brahmins, and of Britons irradiated by Rome. Especially, it removed the Druids from Stonehenge. It made the time-gap between Stonehenge and the Druids of the Classical world as great as the gap between the Druids and the modern world.

But at the very time the real and ancient Druids made their exit from the Stonehenge stage, the modern would-be Druids made their first entrance on the scene, to take up the prominent place centre-stage that they have held ever since.

The Ancient Order of Druids, founded in 1781 as a secret society rather on the model of freemasonry, was at the turn of the 20th century a flourishing friendly society, its aims 'convivial, fraternal, and philanthropic'. A new member, once welcomed into his local lodge with a suitably dramatic ceremony, could receive the benefits of the Brotherhood ('Have you tried a Druidical Hair Cut? If not – call upon Bro. Oscar Wediell' – 'Estimates given for Druidical beards'), could buy his Druid's harp from Bro. G. Tancock, and enjoy fraternal outings to visit other lodges.

The Grand Lodge visited Stonehenge for the first time on 24 August 1905, for a mass initiation. 650 or 700 Brothers were present, the metropolitan lodges coming down with all the paraphernalia of their mystery on the early train from Waterloo station. Waggons had conveyed tremendous piles of food and barrels of liquid refreshment to a marquee put up close by the stones. A fierce-eyed Druid stopped anyone who did not know the Druidic Password from getting too close, but sightseers could watch from a distance. A great many notables had been invited to come and be initiated, but of these only Sir Edmund Antrobus and a Japanese gentleman turned up.

They joined 256 other novices, and a journalist who had resorted to monetary persuasion on the Druid guarding the gate. The rites began with a banquet in the marquee, to music from the band of the 4th Volunteer Battalion Queen's Royal West Surrey Regiment, and many speeches and toasts. The initiates were hustled out into the marquee's kitchen and blindfolded with tight-wrapped handkerchiefs, while the Brothers changed into their ceremonial outfits, white cowled robes and white Father Christmas beards, and collected their poles, each with a sickle (for the mistletoe) on top. There was a pause while the police steered the huge crowd of on-lookers back from the stones; then the line of initiates wobbled out of the tent. The band played 'The March of the Druids', specially composed by Bro. Hain for the occasion, while the blindfolded procession stumbled into the circle. There the Most Noble Grand Arch Brother G. A. Lardner stood with his ceremonial battle-axe in front of an altar on which a mysterious blue fire burned fitfully, fed by saltpetre and methylated spirits. He administered an Oath, 'as binding as sealing-wax, and twice as lasting', the blindfolds were taken off, and the new Brothers were welcomed with a chorus:¹¹

See, see the flames arise!! Brothers now your songs prepare! And ere their vigour droops and dies Our mysteries let him share!

In later years the Ancient Order has sometimes visited Stonehenge again – 350 strong for their 150th congress in 1935 – and still continues as a friendly society. (You used to find it under 'Druids' in the London telephone directory.)

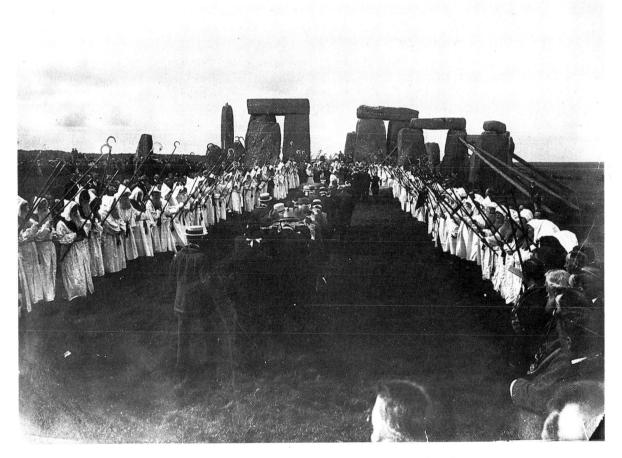

142 March of the Druids, August 1905: blindfolds, sickles, Father Christmas beards.

143 Print of Stonehenge in the eastern manner, published in London early in the century.

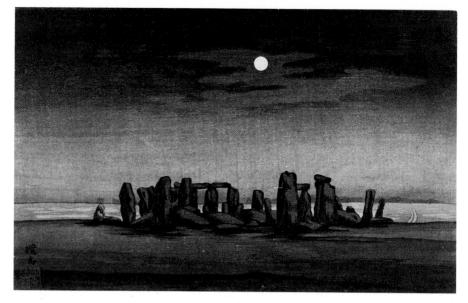

The Ancient Order was not the only band of modern Druids to perform at Stonehenge in 1905. A group called An Druidk Uileach Braithreachas in their native language (a kind of mock-medieval Welsh) and the Church of the Universal Bond in English, had been celebrating its quasi-religious rites for some years. There was friction with Sir Edmund when these Druids objected to paying for admission to a temple they claimed as their own, and open confrontation in 1905 when they were caught burying the ashes of one of their dead. (Druid ritual divided the ashes into seven portions, one to each quarter of the compass, one to the Place of Earth Memory, one to the Air, and the last portion to be buried at Stonehenge in *'talamti cupan'*.) The Druids challenged Sir Edmund to have them arrested. They were not.¹²

There matters rested through the Edwardian years. Stonehenge was fenced and looked after at the owner's discretion, after the old rule that 'a man may do as he likes with his own'. The proprietor's contempt for 'the Ancient Monuments Act or Board of Works or any other hateful government office' seemed to rule out any kind of national ownership. The American philanthropist John Jacob Astor offered to buy Stonehenge for the British Museum, but talks stuck on the usual issues of price (down to £25,000 now) and of suspicion. Sir Edmund feared the British Museum would pass it on to a hated government department; Astor resented the control Sir Edmund wanted even after he had sold the place.¹³

In the end, the Ancient Monuments Act won. A new Act brought in compulsory scheduling, and by Order in Council of 1913, Stonehenge was at last legally and formally protected against summary demolition or export. Prompted perhaps by the Order, Sir Edmund renewed his concern for the stability of the stones, which needed £2000 worth of propping. (The Church of Universal Bond, asked to contribute, suggested instead Stonehenge be transferred to a public company of 'Druids and Antiquarians'.)¹⁴

The fence, the ploughing-up of the grasslands, and the new military camps were quickly changing the Stonehenge landscape. The northern horizon sprouted buildings for the Royal Artillery at Larkhill, and military observation balloons drifted across the Plain. From one of these were taken, in 1906, the first aerial photographs of Stonehenge (or of any archaeological site) (ill. 147).¹⁵ As early as the summer of 1900, the Rev. John Bacon had tried to photograph Stonehenge from a civilian balloon, but from too high up. The stones were 'practically invisible' against the short dry grass, and 'the camera refused to distinguish them at all'.¹⁶

Aeroplanes flew very early over Stonehenge. The War Office allowed flying at Larkhill from 1910. Hangars were erected for military and civilian craft, separated by a 'solstice gap' because, it was said, placed side by side they would have blocked the midsummer sunrise seen from Stonehenge. One of the first machines to fly from Larkhill was the ASL monoplane. Its designer, Horatio Barber, volunteered his chauffeur to pilot it – 'You drive my cars, you can drive my aeroplane'. 'Driving' the aeroplane proved more difficult. The ASL crashed close by Stonehenge in the summer, landing in a heap upside down near the stones.¹⁷

With the First World War, the Stonehenge landscape was transformed. Larkhill camp spilled down the hill towards Stonehenge as far as the cursus, which was smashed beyond recovery at its eastern end. A Horse Isolation Hospital was built at Fargo, and just west of Stonehenge itself sprouted the hangars of the new grass field, the Stonehenge Aerodrome. A light railway wandering over the down from Larkhill to the Winterbourne Stoke crossroads threw off a Stonehenge branch-line. The Fargo cottages, occupied by Sergeant Drew, the resident policeman of Stonehenge, and by the guardian, were in the way of the fliers, so they were torn down. (A persistent rumour, both in Amesbury and among former members of the Royal Flying Corps, insists that the military wanted to have Stonehenge torn down too, as an impediment to low-flying aircraft.¹⁸)

All the roads round Stonehenge now carried heavy military traffic. The north-south road through Stonehenge itself was an admitted public right-of-way and could not be diverted. An alternative track was made a little to the west, but no one could be forced to use it, so motor lorries and the first tracked tanks went bumping and crashing along the old road, only five yards from the stones. When the artillery on the Larkhill ranges was firing, or an experimental mine exploded, the stones themselves could be felt to tremble.¹⁹

The enclosure fence of 1901 had been the beginning of the end for Stonehenge as a lonely temple, and symbol of the vanishing Wessex of Thomas Hardy's novels. The dreadnoughts firing in the English Channel had already metaphorically shaken it:²⁰

Again the guns disturbed the hour, Roaring their readiness to avenge, As far inland as Stourton Tower, And Camelot, and starlit Stonehenge.

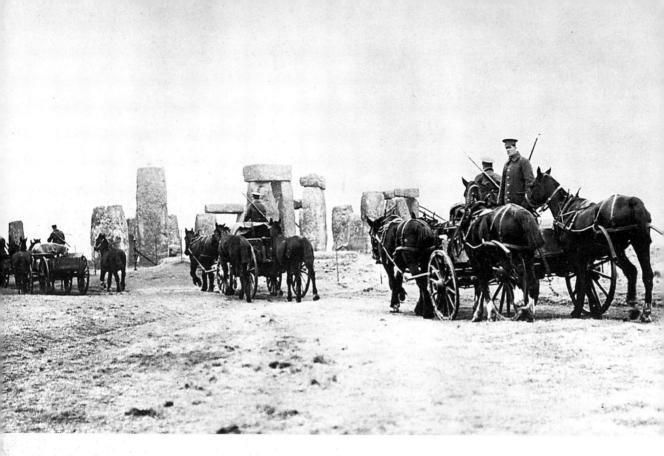

144 Canadian troops march through Stonehenge in 1917 on the weary slog from Southampton Docks to their barracks in Devizes.

145 The Army naturally uses Stonehenge as the emblem of its Salisbury Plain HQ.

HEADQUARTERS SALISBURY PLAIN The First World War finished the job. The Antrobus heir died in action, followed by Sir Edmund himself in 1915. (After more unpleasantness, he had been publicly, ritually and thoroughly cursed by the Church of the Universal Bond, who took his demise as a cheering proof of the efficacy of their religious powers.) Soon it became known that the Amesbury estate was for sale. It was auctioned on 21 September 1915 at the New Theatre, Salisbury. Lot 15 was Stonehenge. In the event none of the menacing buyers who had so long and colourfully threatened materialized – no Americans, no showmen, no advertisers – and the National Trust did not make an offer either. The bidding went up to £6000, stuck for a while, and then Stonehenge was knocked down for £6600 to Mr Cecil Chubb, a local landowner. It was, he said, just an impulse purchase; he simply thought a local man should be the proprietor.

Mr Chubb kept things as before. He tactfully halved the admission charge for serving soldiers, and made his peace with the Church of the Universal Bond. But Antrobus's hated government offices got Stonehenge in the end. In 1918 Chubb offered it to the nation. The Government accepted, and it was formally handed over with much speechifying. In tribute to his generosity, Chubb was knighted by Lloyd George, and found himself locally nicknamed 'Viscount Chubb of Stonehenge'. In truth, Chubb did very well out of Stonehenge; he got a return of $5\frac{1}{2}$ % on his investment while he owned the place and a handle to his name when he gave it away.²¹

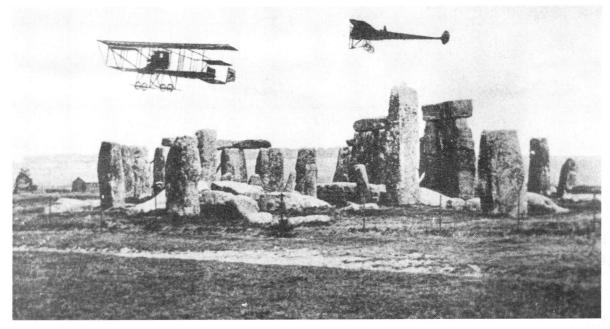

(above) This Edwardian postcard is not what it seems. The Bristol Boxkite biplane and monoplane were cut out of copies of 'Flight' magazine and added to a photograph of Stonehenge.

(below) First air photograph of an archaeological site, from an Army balloon, 1906. Notice the propped stones and the many trackways still in use.

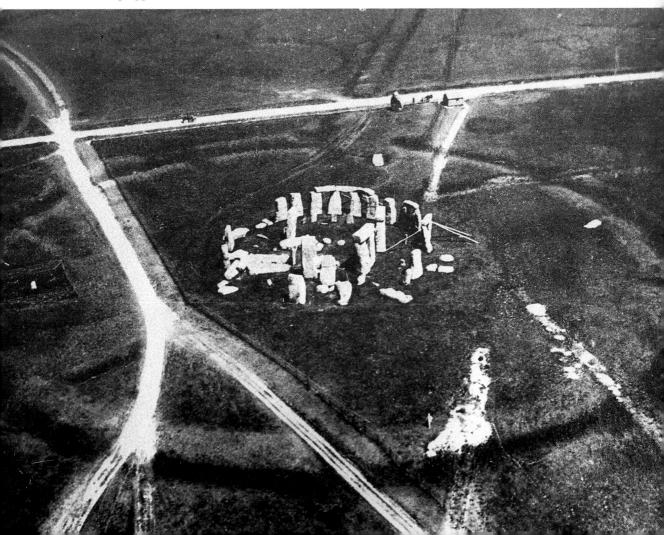

148, 149 William Burroughs Hill (left), looking remarkably like Sigmund Freud, admires the magnificent full-size trilithon he has erected in his Southampton garden, about 1910. In his shrubbery (below) hides a complete model at 1:10 scale.
150 (bottom) It took an American, Col. Samuel Hill (no relation), to do the job properly with his full-size concrete Stonehenge, built by the River Columbia at Maryhill, Washington, in the Pacific USA, 1918–29, as a memorial to the thirteen war dead of Klickitat county.

FONEHENGE COMPLETE STONEHENGE COMPLETE STO Henge complete stonehenge complete stonehe **The destruction of half stonehenge** fonehenge Mplete stonehenge complete stonehenge comi fe stonehenge complete stonehenge complete

'The more we dig, the more the mystery appears to deepen'

When the Great War at last ended, the Office of Works took steps to find out just what state its inheritance was in. Stonehenge certainly looked unsafe, with too many stones at strange angles and propped by timber struts. Their structural engineer's survey confirmed the impression. His checks on the exact angles of leaning stones and of the internal stresses identified those in actual danger. A modest programme of restoration was planned for 1920, on the cautious principle that the 'only safe course is to do as little as possible'. Accordingly, 'stones that are merely leaning, but not dangerously so, should be left where they are, & anything that could possibly be considered as "smartening up" of this venerable monument carefully avoided'.¹

The restoration programme necessarily meant some disturbance of the ground and of the archaeological remains, and that should not be done 'except under the supervision of an expert antiquary'. Like Sir Edmund Antrobus in 1901, the Office turned to the leading national archaeological society, the Society of Antiquaries, for expertise. The Antiquaries' then president was Sir Arthur Evans, the genius of Greek archaeology and discoverer of Minoan Crete, nearing the end of a frustrating five-year term of office. Instead of being able to lead the Society to new distinctions, he had seen its excavations shut down, its attempts to rescue antiquities from towns on the Western Front frustrated, and unpleasant squabbles about expelling its German members break out. The Stonehenge restoration gave him a chance to make his mark with 'a new outlet for the Society's energies'; the small excavations required by the Office of Works would only be preliminaries to a grander scheme, 'an eventual exploration of the whole monument within and including the circular bank and ditch'.²

Work began in November 1919 with those stones of the outer circle that were leaning most. The least stable were 6 and 7, on the east side, and their lintel: 6 leaned in slightly, and 7 out precariously, so that the lintel was twisted right out of position. It was wrapped in felt, cased in a wood frame and lifted off the uprights. Then 7 and 6 were cased up, supported on steel joists, and jacked back to the vertical. Reinforced concrete 3 ft thick was put under as their new foundation, the lintel temporarily replaced to adjust the positioning, and the stones cemented in for good. Finally, on 17 March 1920, in front of the animated-picture cameras of the Gaumont Graphic Co., the lintel was put back safely into place. **151** Photographs of the 1920 restoration were very rare until a whole box of glass negatives of the work was found in the loft of a house in Wales.

This view of the northeast of the sarsen circle shows the three lintels, stones 130, 101, 102, removed while their uprights are concreted.

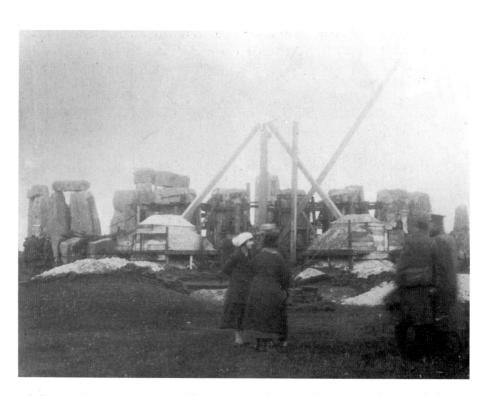

The next stones to be tackled were the three successive lintels by the axis on the north-east. All three and their supporting uprights, 29, 30, 1 and 2, were leaning out together, and were straightened and restored in the same way.³

The obvious choice for expert excavator would have been William Gowland, who had done such a skilful job in 1901. But he was old and in failing health, and the task fell to his intended assistant, Colonel William Hawley. Hawley seemed just the right sort of chap, a respected member of the Society, experienced excavator of Old Sarum, and friendly with the Office of Works (he had been a liaison man during the war, discouraging the military from inflicting careless damage on ancient earthworks on the Plain).

Flinders Petrie was as concerned as ever, quite convinced by now that Stonehenge really was the burial ground of British kings, as Geoffrey of Monmouth had described. He had been cooking up his own scheme to buy Stonehenge from Chubb so that he could dig it as he thought it should be done, when the gift to the nation put the direction in other hands.⁴

Digging round the base of each stone as it was being restored, Hawley found the same deposits as Gowland had excavated at the base of stone 56. The upper layers were full of the 'Stonehenge layer' of stone chippings and modern rubbish, mixed with some Romano-British pottery and some prehistoric material. Even some way down, the deposits were confused: a farthing of George III, more than 3 feet down in stone-hole 7, and an Elizabethan sixpence, 2 feet down in stone-hole 6, showed how little trust could be placed in the evidence of small metal finds. As before, the stones were found to sit in stone-holes in the chalk, wedged with sarsen mauls and packing stones. Some of these were of Chilmark ragstone, the best building stone in Wiltshire – and proof that the builders of Stonehenge did not stick to sarsen from ignorance of more conventional materials. Dark stake holes at the sides of the stone pits showed that all the uprights had been put up from the outside of the circle.⁵

In the intervals between clearing the stone-holes, Hawley started on another part of his commission, the emptying of the ditch. He began on the east side, and found it a clumsy thing, variable in width and in depth, for all the world 'like the outline of a string of very badly made sausages'.⁶ The finds, as Hawley had begun to expect from Stonehenge, were scrappy, mixed and usually 'not of interest', a typical deposit yielding 'two sarsen chips, six of foreign stone, seven of bone, three pieces of Romano-British pottery, one flint flake, and a Lee-Enfield cartridge case'.

The Slaughter Stone was also investigated. It lies flat in the surface of the ground, but under it was a hole in the chalk with a broken piece of sarsen in which the Slaughter Stone seemed once to have stood upright. (Here at least was a more interesting find, the bottle of port left by William Cunnington 'out of consideration for future excavators', but a disappointment, too, for 'the cork had decayed and let out nearly all of the contents'.⁷)

As assistant and draughtsman for the first season, Hawley had R. S. Newall, a Wiltshire archaeologist whose competence was masked by his overwhelming shyness and stutter. Newall persuaded Hawley to follow up a clue from Aubrey's 'Monumenta Britannica' (ill. 43, page 69), the irregular ring of slight 'cavities' Aubrey had marked inside the bank. Nothing could be seen on the surface, but probing with a steel bar located the holes Aubrey had seen. There were 56 in all, spaced 16 ft apart in a regular and complete circle. Newall excavated twenty-one of these 'Aubrey holes', in an arc of the circle from the Slaughter Stone round the eastern side. They proved to be roughly circular pits, straight-sided and flat-bottomed, which seemed once to have contained standing stones. All but four contained cremated bones, often with bone pins and flint artefacts.⁸

This first, very long season – it began in November 1919 and ran until December 1920 – had gone well. The stones most in danger were now safe, and the re-discovered Aubrey holes were only the first of many novelties which could be expected. The man from *The Times* found it hard not to envy 'those lonely discoverers left behind, with their shirt sleeves, their broken nails, their pipes in the open air. Washed by the rains of the plain, burnt by its sun, with minds intent and happy, they sieve and sieve and then sieve again that black and historic earth.'⁹

For 1921, the Office of Works had planned to re-erect the stones which had fallen in 1797 and in 1900. But money was short, and as they were

152 Col. Hawley in jovial mood.

153 In Heywood Sumner's elegant watercolour of Stonehenge restored, the Aubrey holes are shown, following the belief of the 1920s, as holding stones. sure no stone was in actual danger now, the restoration was suspended. That left Colonel Hawley to work alone on the Antiquaries' programme of complete clearance. Since the Society too was short of money, the Colonel was often literally by himself. Sometimes a workman was employed, but Hawley was always fearful there might not 'be sufficient to quite occupy his time'.¹⁰ Newall was there sometimes, and George Engleheart, the local secretary of the Antiquaries, would help occasionally with a delicate job like emptying an Aubrey hole. And from time to time, a few students came for a week or two.

But for most of his long digging seasons, which started in March and ran to November, Hawley was indefatigably alone. His home was in Kent, so while working at Stonehenge he lodged in a draughty wooden hut on the site, an ageing man alternately fried by scorching hot days, drenched by squalls of sleet, and chilled by frosty nights. He was mentally alone too, and in the difficult stratigraphy of Stonehenge quite out of his depth. So he stuck rigidly to his brief, to excavate Stonehenge completely and at the minimum expense, conscientiously and thoroughly stripping the site in patch after patch, sieving and sorting thousands upon thousands of stone chips and the scrappy uninteresting finds, mostly broken flints and little eroded fragments of pottery. By 1923 he was agreeing with Newall that only half should be dug but feared 'they will want it all done & certainly the Ditch'.¹¹

Each summer, Hawley made his report to a meeting of the Antiquaries, exclusively as 'an excavator and recorder of facts' and abstaining from all theories.¹² Occasionally he was driven to interpretation. A shallow, rough grave, only 4 feet long, contained a skeleton, minus its extremities, 'in a very jumbled and broken state'. With it was the iron lever of a padlock. For once even Hawley was driven to a conclusion: the bones were 'of a criminal hung in chains, and what was left of him had been hastily buried'.¹³

The trouble was twofold. Firstly, keeping a neutral, open mind was disastrous as a strategy to excavate Stonehenge. There was no blue-print

in the soil, no prehistoric maker's plate or signature to be found underground. The evidence of the spade was like the evidence of the standing stones, enigmatic, fragmentary, contradictory, in large part lacking – as well as invisible until exposed, and destroyed in the exposing.

And, even if a neutral mind had been desirable, Hawley did not really have one. At first, he had 'little doubt' that the Aubrey holes had held standing stones. Then, when settings of wooden posts were talked about, his mind drifted towards a circle of standing posts. When a retired schoolteacher decided to adjust the design of a model Stonehenge he was building by adding three extra trilithons (surely 'a little imagination is required' when making a restoration?), the colonel approved and promised to look for evidence to support the idea.¹⁴

But for the most part Hawley kept up a patient, self-effacing attitude of ignorance. He could not give 'much information as there was really hardly anything to tell'. Each new feature or find was not an exciting discovery but an obstinate 'puzzle like everything else here'. Each new area was opened up out of simple contractual obligation, so that 'all might be done now that I am about it'.¹⁵ As he told inquisitive journalists, 'The more we dig, the more the mystery appears to deepen.'¹⁶ When work was finally suspended in 1926, an entire half of the site, all that area south-east of the axis, had been cleared (see ill. 183). Hawley by then was finally convinced he knew nothing about Stonehenge at all. Like a Zen master he had achieved complete detachment from his subject. The final words of his last excavation report are: 'so very little is known about the place that what I say [a single paragraph of tentative remarks which formed his conclusions to seven seasons' work is mainly conjecture, and it is to be hoped that future excavators will be able to throw more light upon it than I have done.' 17

The Hawley years, 1919 to 1926, were a disaster. The excavation, rightly said at its beginning to have been 'the most important yet undertaken' in England, was managed on absurdly inadequate resources.¹⁸ Once it was in train, those who saw how badly wrong it was going were too shy or embarrassed to intervene effectively.¹⁹

Of course, there had been important discoveries. As well as the Aubrey holes, two more rings of holes were found running round outside the building. These series of 'Y' and 'Z' holes seemed to be Iron Age and presumably late in any sequence of events (they might even have been to do with the Druids and their 'hocus-pocus'). The Aubrey holes were set in a perfect circle, which could not easily have been measured out when the central standing stones were up, and were perhaps Neolithic. The main building seemed to remain, on the evidence, as before, of bluestone chips in barrows, in the Bronze Age.²⁰

During the Hawley era, in fact, most of the excitement about Stonehenge was not at Stonehenge at all, where a mood of gloomy despair prevailed, but in discoveries made from the air, in the archives and in the rocks.

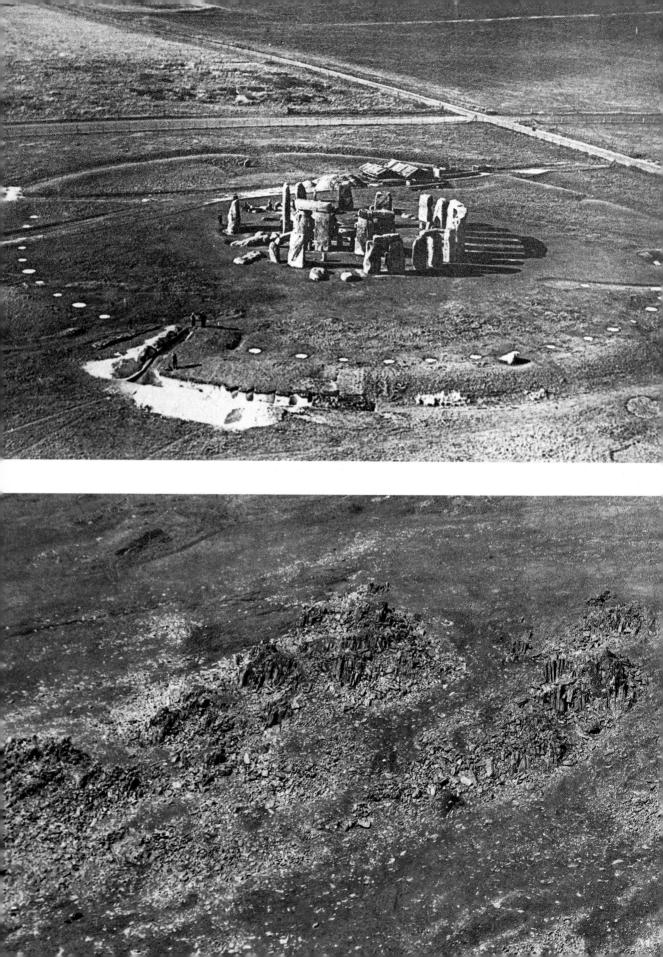

In 1923 Dr H. H. Thomas, petrographer to the Geological Survey, finally solved the mystery of the foreign stones at Stonehenge by tracking down their exact provenance. It was, as had been expected for 150 years, in the deposits of igneous rock lying to the west – but in Wales, not England. In the Preseli Mountains of north Pembrokeshire, a few miles from the Irish Sea coast and by the short sea-route to southern Ireland, Thomas found the three main varieties of Stonehenge bluestone, spotted dolerite (preselite), rhyolite, and volcanic ash, were matched exactly by outcrops.* All three had been brought together by glacial action into a small area on the south-east slopes, near Cil-maenllwyd, which was perhaps the most likely exact source. The Altar Stone was Welsh too, matched most closely in the Cosheston beds of Old Red Sandstone on the shores of Milford Haven, the sea inlet south of Preseli.²²

154 (opposite above) September 1921, Col. Hawley in progress. The Aubrey holes had been excavated the previous year. They are marked by the semi-circle of chalk discs, white against the grass and later made permanent in concrete, running inside the bank. Clearance of the ditch (foreground) had reached the South Barrow, across which a narrow trench has been cut. Running across the photograph at the back is the new track, neatly fenced, that took the place of the old routes across the bank and ditch, whose lines are still marked in the grass. Immediately behind the stones are sheds for timbers and lifting gear.

155 (opposite below) Air view of the Preseli bluestone outcrops, so littered with geometrically shaped blocks that it looks more like a quarry than a natural deposit.

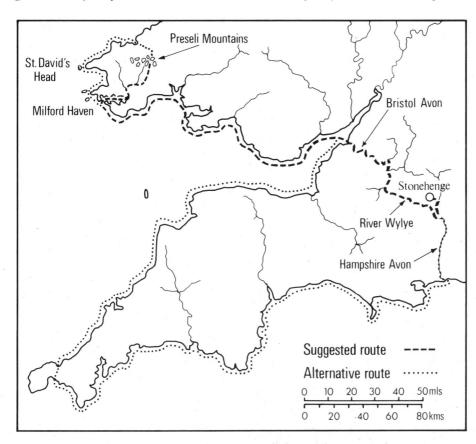

Other foreign stones, known at Stonehenge only in fragments, could also be matched in Preseli. And Professor Atkinson in the 1950s found the fourth main type, unspotted dolerite, outcropping there also.²¹

156 Routes for the bluestones from Preseli. Atkinson's suggested route combines maximum use of water transport with minimum distance. After an overland portage to Milford Haven (likely source of the Altar Stone), the route hugs the Welsh coastline, and strikes across the Severn and up the Bristol Avon: then overland, and close by Boles Barrow; down the River Wylye and up the Hampshire Avon. The alternative, round St David's Head and southwest England, requires less portage but is very much longer and in less sheltered waters. Both routes imply a final approach to Stonehenge by the Avenue, now known (page 271) to be much too recent.

The bluestone lintel, stone 150, reused as an upright in the bluestone circle (and partnered by stone 36, to be identified in 1929 also as a lintel) was proof that the Stonehenge setting of bluestones was rebuilt from some earlier structure. Megalithic structures are known in Pembrokeshire, and Daniel Defoe in the 18th century had seen 'near Kily-maen Ibwyd [llwyd], on a great Mountain, a Circle of mighty Stones, very much like Stone-henge in Wiltshire'.²³ Thomas thought the Stonehenge bluestones were the components of 'a venerated stonecircle' taken in the Bronze Age from Preseli to Salisbury Plain.²⁴ How they were moved has been disputed. The example of the sarsens argues for a land route. The Milford Haven connection suggests water transport, by sea-coast and then river. And why building stone was taken 150 miles in the first place when, as Robert Byron put it in the 1930s, 'a few miles off were lying hundreds of equally useful stones, the builders should have resorted to this heroic effort, is no more explicable than the modern taste for Paris frocks'.²⁵

The bluestone provenance did seem to vindicate Geoffrey of Monmouth to some extent, after centuries of denigration as a worthless romancer. Perhaps there was truth in his history, and the elaborate story of Merlin's magic was the last memory of a portage of sacred stones under the direction of a great leader.²⁶

That same year, a new twist was added to the bluestone evidence, unearthed by digging not in the ground, but in the papers of William Cunnington. Boles Barrow, a long barrow just above Heytesbury, had been an early target, when Cunnington was working with Wyndham in 1801. Ten feet down in the barrow 'we found a floor of Flints regularly laid, on these were the remains of a great many Human Bodies. . . . The Stones that composed so large a part of this ridge over the Bodies are of the same species of Stone as the very large Stones at Stonehenge what the country people call Sarsens.' Ten of the best stones were taken down to Heytesbury and set into a circle round a weeping ash tree in Cunnington's garden. He noticed one was not a sarsen, but 've same to some of the upright Stones in ye inner circle at Stonehenge'.²⁷ His great-grandson, B. H. Cunnington, recognized this reference in the Cunnington manuscripts as indicating a bluestone. The Boles Barrow stone was found safe and well, having migrated across the road into the grounds of Heytesbury House. It was indeed a bluestone, a piece of spotted dolerite weighing about 750 lb. The Ancient Monuments Acts declared that a loose stone could not be an ancient monument, so it could not be scheduled, but when the writer Siegfried Sassoon bought the house in 1934, he presented the stone to Salisbury Museum, where it remains.28

Boles Barrow, a classic earthen long barrow of Neolithic date, thus extended further back the Stonehenge chronology. Its building materials – chalk from the site, Wiltshire sarsen, and Welsh bluestone – were those of the Bronze Age Stonehenge. In particular, it showed that at least one bluestone had come to Wessex centuries before Stonehenge was

157 Boles Barrow in 1979, a seemingly unimpressive earth mound, with its quarry ditches badly smashed up by Army vehicles. Since then, new policies try to ensure that the military respect the archaeology of the Plain.

built; either the Stonehenge bluestones had come then and been in Wessex decades before they were built into Stonehenge, or else there was a tradition of bringing stones from Preseli which was centuries older than Stonehenge.²⁹

The rotting remains of the Stonehenge aerodrome were a constant reminder to Colonel Hawley of flying, and of the potential of aerial observation for archaeology that the First World War had begun to show. Late in 1921 he tried to arrange for Stonehenge to be photographed from aircraft stationed at the aerodrome at Old Sarum, where the skills of observation and army cooperation were taught. The RAF seemed 'very interested in taking Photos of this place especially the Avenue which is just what we want & they say they can trace it a long way across country'.³⁰ But nothing came of this perceptive idea to trace the full course of the Avenue - lost since before Stukeley's day. Actually it had already been photographed, in July 1921, during the ordinary routine of practice flying from Old Sarum. O. G. S. Crawford, looking in 1923 through the files of old negatives there, spotted a pair of thin parallel lines running across country between Stonehenge and Amesbury and recognized them as traces of the Avenue ditches (ill. 158). Stukeley had followed the Avenue eastwards as far as the gap between Old and New King Barrows, where it was lost in the ploughland. The air photos showed it swinging from there south down the valley slope to end close to the bank of the river Avon at West Amesbury. A small excavation confirmed that the marks really were the Avenue ditches, and that they lay, between the King Barrows, exactly where Stukeley had measured them to be in his ancient British measure of cubits.³¹

Two years later, a further astonishing discovery was made from the air, this time of an entire new monument. Squadron-Leader G. S. M. Insall, a distinguished pilot and VC of the First World War, was flying a Sopwith Snipe not far from Stonehenge when he noticed in a ploughed field 'a circle with white chalk marks in the centre'. He was high enough to see Stonehenge and this new site at the same time, and they looked similar. Over the next months he watched the site as the wheat-crop grew, until in June it revealed a perfect crop-mark; the wheat grew darker over disturbed ground, lighter over the solid chalk. Here was a wide round ditch with a single causeway entrance on the north-east side. Inside 'five or six or perhaps seven closely-set rings of spots appeared', the traces of holes for wooden posts cut into the chalk.³²

The plan immediately put archaeologists in mind of Stonehenge: a set of concentric settings, not quite circular and on an axis pointing towards the midsummer solstice, an entrance causeway running through bank and ditch by the axis. At its centre, the excavators found, was not an Altar Stone on the model of Stonehenge, but the crouched skeleton of a child about three-and-a-half years old, its skull split in half. Round it were the post-holes where six ovals of timber posts had stood, in a pattern which suggested the frame of a large timber building.³³

The new site seemed so much like a Stonehenge made of wood that it was soon given the name Woodhenge. While flying in Norfolk, Squadron-Leader Insall found another example, at Arminghall outside Norwich; the post-holes there showed a horseshoe setting of great timbers, like the inner sarsen setting at Stonehenge.³⁴

These wooden monuments seemed to be those cousins to Stonehenge which the Victorian classifiers had been unable to find. A whole class of 'henge' monuments was recognized, so called because they were like Stonehenge without, necessarily, any stones. A central area, more or less circular, was bounded by a bank of material dug from a quarry ditch. usually on the inside. One entrance, or two at opposite sides, was marked by a causeway across the ditch. Inside might be settings of wooden posts (as at Woodhenge and Arminghall), of stones (as at Arbor Low, the 'Stonehenge of the North', or Avebury); or there might seem to be no internal structures as at Durrington Walls, the huge henge close to Woodhenge and only a couple of miles from Stonehenge. The Sanctuary, a henge near Avebury destroyed in Stukeley's day, was located from his notebooks. Stukeley had seen it as a stone circle, but excavation showed this to be only its final form. First the Sanctuary had been a wooden circle, so it linked the traditions of stone and wooden building in one monument. Stonehenge, anomalous to the last, insisted on being an exception even among henges. Its ditch is outside the bank, whereas most henges have the ditch inside; an inner ditch may be a formidable barrier, but it is not thought to be primarily a defence. That, together with the stone and wood settings which could scarcely be houses, seemed proof that the henges were sacred, ritual monuments. And the Stonehenge lintels set it further as an oddity among henges.³⁵

158 (above) The Stonehenge Avenue, as it was spotted on an air photograph. The two dark lines, running parallel and left to right (foreground), mark its ditches.

159 (right) Woodhenge, as discovered by Insall; the circles of dark dots to the right of and below the farm (centre). Each dot marks a post-hole. Further down, closer to the road, smaller circles are ploughed-out barrows.

Through the 1920s, the Office of Works was faced with more practical problems than contemplating just how odd Stonehenge was. An early priority was to arrange the diversion of the last road running through the bank and ditch. Local opposition to its closure was led by John Soul, the leading Stonehenge eccentric of his generation, who had abandoned the mundane business of his grocer's shop to live out a Druidical fantasy-life in a long white beard and a longer white robe. Peace was achieved by offering local residents free admission when the road was closed.³⁶

The organized forces of Druidism, under the formidable leadership of Dr George MacGregor Reid, Chief Druid of the Church of the Universal Bond, were harder to pacify. During his brief ownership, Chubb had let the Druids in free, but the Office of Works would allow no exceptions, and the unfortunate custodian, reinforced by a platoon of four constables, had to withstand the massed wrath of Druidism militant. In 1919 the Druid services were on 21 and 22 June. For 1920 they wanted to include 19 and 20 June: the Office refused to allow the extra days. thinking 'some limit must be set to this absurd and degrading nonsense'. The Druids in affronted protest left the solstice uncelebrated; for the first time, they said, since 1643.* For 1921, by the annual doubling, they demanded eight days at the solstice, and some kind of truce was patched up. But there was trouble a couple of years later, when soldiers from Larkhill camp dressed up in white bedsheets and staged a mock-Druidical parody. And in 1924 word leaked out that the Druids were being allowed to bury the ashes of their dead at Stonehenge, only provided (the Office of Works tried to insist) the hole was very small and made good afterwards. The Druids ingeniously claimed the new-found Aubrev holes were Druidical and excavation of the cremations in them (datable to some 2000 years BC) 'but the sacrilegious handling of the ashes of our recently deceased members'. Under a table in the Clapham headquarters of the Druids were two marble urns filled with Druids' ashes, barred from deserved rest in the ancestral burial ground. There was a huge row, and permission was withdrawn. Outraged by this oppression of his religious freedoms. Dr MacGregor Reid led his forces at the 1926 solstice against the pagan fences, which duly gave way.

Shut out by the officious powers of paganism, the Druids retired from Stonehenge, reserving a special hate for Mr Smith the custodian (he died not long after, another supposed victim of the Druid curse). They settled instead for a fortnight's solstitial Gorsedd, or Camp of Contemplation, on a disc barrow on Normanton Down, about 1¹/₄ miles south of Stonehenge, where they planned to build a full-size Stonehenge replica they would properly control. Once Smith had safely died, the Druids quietly started to use Stonehenge again, paying for admission and publicly laying a curse on no one.³⁷ Druids have made a regular midsummer appearance at Stonehenge ever since; like many a religious brotherhood, they have been prone to schism, and bands of Druid dissenters have gone instead to other sites, like Tower Hill in London, for their worship.

Sticklers for the mundane facts of historical accuracy might notice that 1643 is 150 or so years before any Druid Order had been founded.

160 There is no escaping the Stonehenge Druids, even at this pub in Cambridge.

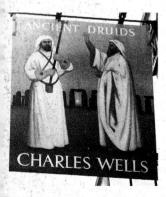

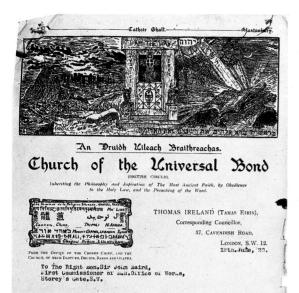

Sir,

Pardon my addressing you in person instead or officia 19.7 am now gasing across the Finin where once the people of my faith held sway, and I cannot a old reflecting upon the great cry that has been raised against the present rulers of Russia by reason of their attac. upon religion. It is now that I see the great wrong that has been done to our people, and, because of this, I am writing to you in order that whate, er takes place in the near suture, you may possess the neeessary facts with which your questions in the house of commons may be answered.

Our Order was never failed in the past to hold its annual meetings within the enclosure of lathoir dails (Stonenenge)a place raised in the make of All sather by our iorbears. Twenty years ago by reason HURRAH, FOR GREAT BRITAIN, THE NEW JERUSALEM !

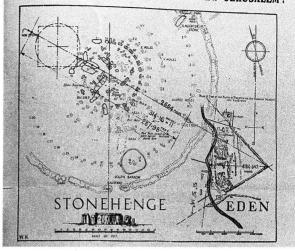

161 (*left*) During their battles, the Office of Works received any quantity of Druidical correspondence. The alarming letterhead is printed, naturally, in bright green.

162 (above) Proof by a Scots visionary of the cosmic identity of Stonehenge and the Garden of Eden, 1943. **163** (below) Dr MacGregor Reid conducts an extremely exclusive Druid service in front of the Stonehenge aerodrome.

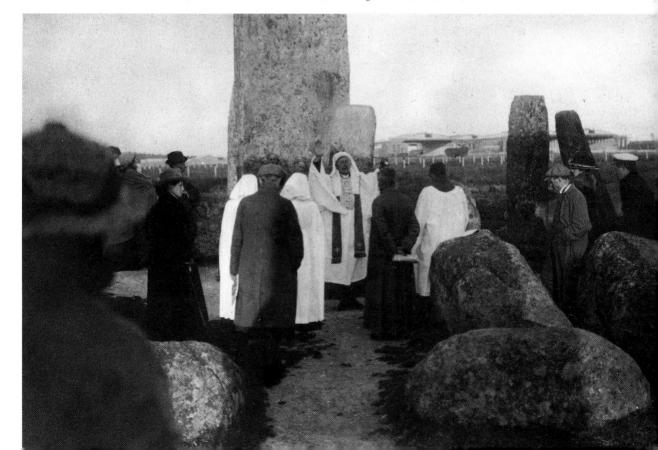

164 Approach to Stonehenge in 1930: custodian's cottages, Mr Billet's Stonehenge Café, AA box, telegraph poles. Compare a century earlier (ill. 81). Another public and pressing matter was the environment of Stonehenge, the downland scattered with rotting relics of the War. The closest buildings were the Ministry's own custodians' cottages, newly built to replace those demolished to make way for the aerodrome. At first the Air Ministry clung on to the aerodrome not, they said, 'in a spirit of thoughtless vandalism' but as a 'military necessity'; then it was used to store a vast quantity of government-surplus building bricks. About 1926 it was handed back to its pre-war owners, who set up a Stonehenge pig-farm. On the other side of the monument the Stonehenge Cafe was built, 'an unpleasing little growth' where visitors refreshed themselves, and there was talk of a colony of holiday bungalows. The Government conceded that the growing disfigurement of Stonehenge was a calamity, but it had no powers to prevent new building or to divert the profit from entry charges into safeguarding the view.³⁸

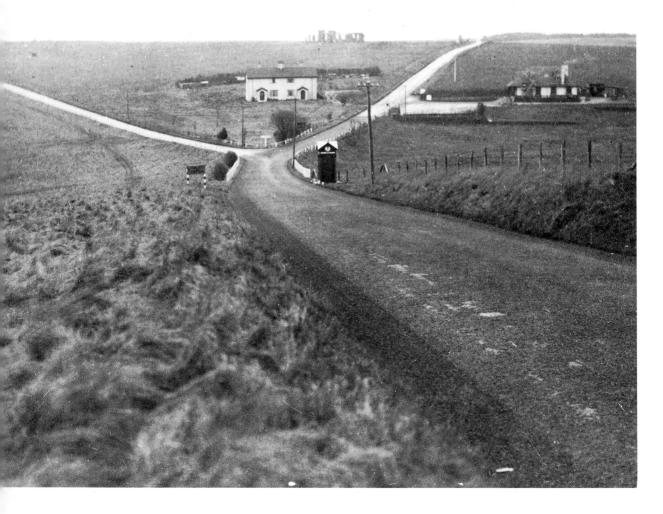

The pig farmers being prepared to sell, private money stepped quickly in to buy the aerodrome from them. In August 1927, a national appeal was launched, its aim to 'restore and preserve the open surroundings' of the frontispiece to British history. The then Prime Minister, Stanley Baldwin, lent support, the King contributed 20 guineas and the Druids 10, and Arnold Bennett headed the signatories when a final appeal was made to complete the purchase in 1929. In all, 1500 acres were bought, saving from development the area to north, west and south which held the cursus and many barrows. The land was vested in the National Trust, so that it would be safeguarded in perpetuity. The aerodrome buildings were pulled down (not an easy job: the water tower alone took 70 pounds of explosives to shift), and there was a general clean-up of huts and hoardings. The Army buildings on the northern horizon remained, but it could now be said of Stonehenge:³⁹

I stand triumphant on this modern day: No lowly huts shall struggle o'er the lea, The builder homeward plods his ugly way, And leaves the downs to darkness, and to me.

After the clean-up there remained, however, two wooden shacks just south of the Stonehenge ditch. One still housed the interesting finds kept from Colonel Hawley's diggings; the other, which had housed the Colonel himself, had been turned into latrines for visitors. From the beginning Hawley had been troubled by his finds, so many, so uninteresting, so tiresome in the space they took up in the hut. He therefore opened 'graves', long shallow trenches by his excavation huts, into which he put any finds that it seemed safe to get rid of. Just what is in the Hawley graves nobody now knows; probably the contents are mostly stone chips. But they may also hold minor mysteries, like the elegant long flint blades – so clean and sharp they could be used to cut the bread at picnic lunches – that are said to have come from the Hawley trenches and are now lost.⁴⁰

Even after Hawley's dedicated winnowing, a large quantity of finds remained. The hut gave them no security, and it was letting the weather in, so R. S. Newall was given 100 sandbags to put them in, and he took them away to his own house at Newton Delamere for temporary safekeeping. But where was their permanent home to be?

Alexander Keiller, who was busy restoring and preserving Avebury at his own expense, thought a special Stonehenge museum was needed, near to but not actually in sight of the stones. He would pay for the building and its curator. But people like O. G. S. Crawford disliked multiplying 'these wretched little museums which are a plague to the student and not much good to the general public', and it seemed perverse to plan a new building just as the old ones were being torn down. In the end Keiller 'bowed to the storm' and withdrew his final proposal, which was for a solid, crouching, one-storey building in Stonehenge Bottom (ill. 166).

165 The sun rises over Stonehenge; and on the Wiltshire Masonic Bowling Association's colourful enamel badge.

166 Keiller's museum design.

Most of the finds went instead to the museum at Salisbury. Newall sorted out sets of typical material for the Ashmolean in Oxford, for Cambridge ('If Oxford have some, I feel bound to suggest that Cambridge should not be left out'), Cardiff, and the British Museum in London. That left as the last residue cluttering the loft over Newall's garage the human cremations and 'nearly a cubic vard' of animal bones. The cremations, probably, were 'decently re-interred at Stonehenge'. The animal bones were sent to Dr W. Jackson of Manchester museum for an expert report; he was told to destroy 'all bones that are of no interest', the cutlet and chicken ones that were just the refuse of modern picnics. The balance, four sandbags full, came back from Manchester in 1934, a last memorial to Colonel Hawley's conscientious labours to be got rid of. Burial seemed the most final solution, and on 28 January 1935 Newall supervised their return back into the soil of Stonehenge, as a new filling for Aubrey hole 7, with a stout lead plaque explaining them.41

A final eyesore to be erased were the recently-built custodians' cottages on the slope east of Stonehenge. These were demolished, and replacements put up by the King Barrows, out of sight. But even before this last item in the great clearance, the newly restored grand sweep of down began to sprout new clutter. At first, policy was robust: just a small hut by the turnstile, no museum, no public lavatories l'after all. the whole Plain is available for the convenience of the public').⁴² The final, and the worst, intrusion on the ancient temple was the main Amesbury to Shrewton and Devizes road, running close by the Heel Stone and right across the Avenue, 'so that the Circle itself seems almost submerged by the congestion, vulgarity, speed and noise'. The only way 'to regain a measure of isolation' for Stonehenge was to close the road, for 'it was the height of incongruity to tolerate big motor coaches and big touring cars and other modern modes of transport, crowded right on the threshold'. It would merely mean parking out of sight in Stonehenge Bottom, and walking up the hill a few hundred

yards. But it seemed impossible to close the road without a special enabling Act of Parliament; the Road Fund declined to pay the cost, and the road remained open.

By the early 1930s, more than 15,000 visitors arrived in a single midsummer month. Their cars blocked the road, and the custodian was overwhelmed at busy times, when 'six charabancs crammed with Oldham mill-operatives' would draw up together by the turnstile. The need for professional security arrangements had already been shown in 1928, when people climbed through the fence and tried to lever the lintel off a trilithon. A telephone was now vital, and the custodian's plump spaniel was far too good-tempered, a nightwatchman with a 'sufficiently savage' dog was needed.⁴³

For the 1935 season, it was decided that managing the hordes was a better policy than pretending they did not exist. A discreet car park was arranged across the Shrewton road, north-west of the stones, where the ground dropped away. This was on land saved by the appeal and vested in the National Trust, who leased it at a peppercorn rent to the Office of Works. A car park on Trust land was clearly in breach of the spirit of the public appeal which had bought it – which was intended precisely to prevent tourist facilities – but the Trust agreed that managed control was a better policy than resistance.⁴⁴

No one used the new car park. It was easier to leave your car on the roadside verge, so that you didn't have to walk so far. But it did make a good pitch for a Wall's ice-cream van and a lemonade stall. The Automobile Association put a scout on duty at the car park to assist members, and the rival RAC replied by providing signposts. The National Trust, scenting the way the wind was blowing, decided it wanted to continue with the Stonehenge Cafe, whose annihilation had been a prime object of the public appeal. But when the lease expired, the Office of Works kept the Trust to its original undertaking to demolish it, for 'to retain a cheap flashy little building like the worst type of bungaloid growth spoils the whole scene and vulgarises unspeakably' what should have been a sublime sweep of empty countryside.⁴⁵

Despite all these new problems, there had been great progress: Stonehenge was physically secure, safe from sale by auction, and its surroundings were much improved. If you chose a quiet time of a quiet day of a quiet season, you could still with Siegfried Sassoon think of stillness and timelessness:⁴⁶

What is Stonehenge? It is the roofless past; Man's ruinous myth; his uninterred adoring Of the unknown in sunrise cold and red; His quest of stars that arch his doomed exploring.

And what is Time but shadows that were cast By these storm-sculptured stones while centuries fled? The stones remain; their stillness can outlast The skies of history hurrying overhead.

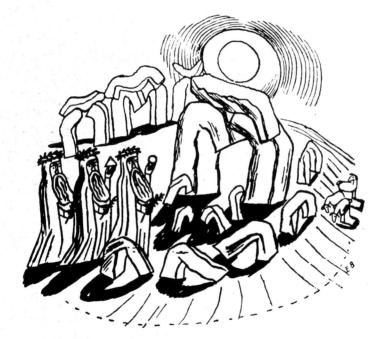

STONEHENGE WILTS. BUT SHELL GOES ON FOR EVER

167 (*left*) Symbols of endurance, and trade-mark for a Wiltshire tyre company.

168, 170 A fearful pun on the county name by Edward Bawden (below left). The three Druidic Wise Men are suitably distressed. (Below right) Lithographed poster by E. McKnight Kauffer of stones and stars. Both advertisements were commissioned by Jack Beddington, promotions manager for Shell petrol in the 1930s and incidentally for much fine art.

169 (right) 'Very Early English' in Osbert Lancaster's cartoon view of English architecture. He commented: 'The earliest mode of building employed in England was one in which everything, including shelter, was sacrificed to obtain an effect of rugged grandeur . . . even then British architects were actuated by a profound faith, which has never subsequently wavered, in the doctrine that the best architecture is that which involves the most trouble'. The foreground is occupied by something more recent.

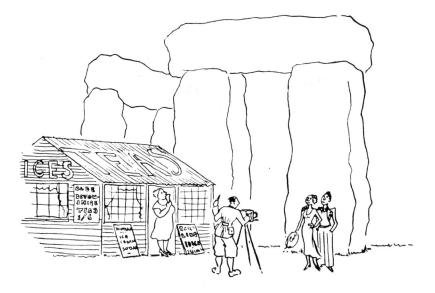

STONEHENGE COMPLETE STONEHENGE COMPLETE ST Nehenge complete stonehenge complete stone NGE comple**13 wessex to mycenae, and back** eheng Complete stonehenge complete stonehenge co Jete stonehenge complete stonehenge complet

'Diffusing culture in all directions'

The Druids were the most conspicuous of all Stonehenge aficionados in the inter-war years, as they have been ever since. But they were by no means alone. Most of the others were as haywire as the American lady heard to declare, after a quick glance round, 'I guess this was the result of an eruption!'; but nothing like so original. Old chestnuts like serpent worship (which was one of Stukeley's greater delusions at Avebury). Atlantis, and antediluvians were recycled along with Egyptians in various guises. And there were a few new recruits. The most enduring were the ley-hunters, whom I shall return to later (Chapter 15). Less staying power was shown by rival theories of a Stonehenge timemachine - Mr Ludovic McLellan Mann's clock-dial or wheel-calendar tangling cogs with Mr Moses B. Cotworth's equal-month Stonehenge for the International Fixed Calendar League - both of which have passed into oblivion. And a man in the comfortable warmth of southern California demonstrated at length and in every detail that the Biblical Eden was actually Salisbury Plain and Stonehenge built there, in 20,000 BC, years and years before Noah's Flood. (Mr Hen Browne and other less eminent Victorians had been down that road before, of course, but the idea is hardly likely to convince anyone who spends winter days at Stonehenge, as any of the present custodians can tell vou. $|^1$

All the same, the archaeologists still faced a number of long-standing problems, chief of which was the exact shaping of the Stonehenge lintels and the seeming use of entasis, the adjustment of their elevation to offset the distorting effect of perspective, a refinement not otherwise known in Europe before Classical Greek architecture.² If this was a 'trick learnt at second-hand from those who had some knowledge of the temple-masonry of Greece and Rome', then Stonehenge had to be very late indeed, certainly of the Iron Age, probably of the last century BC. That date scarcely fitted the Neolithic and Bronze Age affinities of the finds from Stonehenge or the dates of other henges. Conversely, if Stonehenge was of the Bronze Age, was all that skill in its architecture really acquired inside Britain? And if it was early, why were the sets of Y and Z holes dug in the Iron Age, the best part of a thousand years later, and why was the site so scattered with Romano-British pottery?

Either way, it did not make easy sense, though a tortuous amalgam of the dates could be managed, as it had been in the 19th century. Assuming you could bear to bring the Druids back into Stonehenge, it could be argued that the priests, a few decades before the Roman conquest, had taken over an existing sanctified circle with its patriotic attachment and tried to build on it 'as grand a temple as those the refugee druids from Gaul had seen erected by the Greeks and Romans'.³ This was a possibility, but scarcely plausible.

And it was not just Stonehenge itself that needed explaining. There were also all those rich barrow-burials, expecially those clustered round Stonehenge. The gold ornaments of the strong man buried under the Bush barrow, as rich and strange as Stonehenge itself, scarcely seemed an English domestic matter. This was the same problem as had faced Inigo Jones three centuries earlier,⁴ and those 300 years of discovery had still thrown up no monument that looked like a close relation to Stonehenge. The other henge monuments were only a slight help, as they were all in Britain and lacked Stonehenge's sophisticated architecture.

In a significant article published in 1938, Stuart Piggott identified ninety-nine rich 'Wessex' burials of the Early Bronze Age, mostly on the chalklands of Wiltshire and Dorset, with outliers like Rillaton in the West Country with its delicate cup of sheet gold. They seemed to show the sudden flowering of a true Bronze Age in southern England with links all across Europe: amber from the Baltic, gold from Co. Wicklow in Ireland, bronzework of types known in Brittany and in southern Germany, and blue faience glass beads from Egypt - a sea, a continent and a channel away from their final resting places in English graves. This Wessex culture represented the local aggrandisement of an aristocracy able to levy toll on the international trade routes across England: the acquisitions of their profits had been buried with them in the fancy barrows close to their great temple of Stonehenge. After the article was written, Piggott went to Greece on holiday, where he saw the Mycenaean relics and was very struck by their chronological and cultural affinities with Wessex. Both were then dated to about 1700-1400 BC, and they were linked by the amber trade, by similarity in gold-working, and by the position of Greece as a convenient entrepot which could channel Egyptian faience into Europe. Piggott accordingly added a few lines linking the Wessex burials with Mycenae, a modest proposal which was to grow into a view of Stonehenge as 'the individual creation of an architect whose capabilities in design and proportion were far beyond those of barbarian north-west Europe at the time'. The spirit of the Mediterranean world beckoned, as it had to Inigo Jones. It was in the maritime empires of Minoan Crete and Mycenae, rather than the unaided inventiveness of the untutored and barbaric chieftains of Wessex, that the unparalleled architectural refinement of Stonehenge had its source.5

Hard evidence was a little elusive. There were several Mycenaean objects that had been found in north-western Europe, but none was in secure contexts; they could have been brought north in modern times. Amber beads occurred in Wessex and in Mycenae, but that just connected both places to the Baltic without linking them directly. There were similarities in metal-working, but not identity. There was a single faience bead of the Wiltshire segmented type known from Egypt, but it was only one among many thousands of Egyptian beads – and the Scottish star-shaped beads had no parallels anywhere.⁶ Nothing in Mycenaean architecture exactly matched Stonehenge; there was not even proof of entasis in Mycenaean building.

Still, it was an intoxicating vision, of an outpost of Greek learning set down among the willing but uneducated barbarians of England's green and pleasant land:⁷

Now the ancient Wessex hills seize their lost splendour once, Stonehenge-building, their princes proud with their Wicklow gold strode in the sunshine; now earth inherits their dust, who are chalk-graved, dry frail and brittle pale bones under barrows – poor fragments, those great ones.

The Second World War, unlike the First, left Stonehenge unharmed; but archaeology, like everything else, was slow to get going again after 1945.

171 Two symbols of English freedom. Winston Churchill, in Wiltshire to see new tanks being demonstrated, 1944, poses by the Heel Stone. Immediately behind him is US General Marshall.

Research in the Stonehenge area began afresh in June 1947, when a Wiltshire archaeologist, J. F. S. Stone, cut a section across the cursus near the conifers of Fargo Plantation, north and a little west of Stonehenge. The cursus had not been dug into before, and this small cutting was not expected to explain its function. (Stukeley's original idea of a race-track remained as good a guess as the suggestion of a formal processional way comparable to the later Stonehenge Avenue.) But Stone was able to date the cursus. Its ditch, like that at Stonehenge, had been dug with antler picks in irregular sections. A fragment of foreign stone, another type from the Cosheston Beds of Milford Haven, found in the cursus ditch filling matched a piece from Gowland's 1901 trench at Stonehenge. And across the ploughland between the cursus and Stonehenge was a scatter of bluestone fragments with a concentration up by the cursus. Somewhere there, and demonstrably earlier than the bluestone phase at Stonehenge, there had perhaps been a bluestone monument of which the component pieces were later taken away to Stonehenge.⁸

Another cursus had been spotted from the air on the Thames gravels at Dorchester, Oxfordshire, part of a complex of ritual monuments being studied in the late 1940s by Richard Atkinson of the Ashmolean Museum. Also among the Dorchester earthworks were two late Neolithic circular enclosures. Like Stonehenge and unusually for a henge, the bank of each was inside its ditch, and inside the bank was a circle of ritual pits with cremations, on the model of the Aubrey holes. And Piggott, as professor of archaeology at Edinburgh now working in Scotland, found something comparable on Cairnpapple Hill, West Lothian, a semicircular setting of Neolithic ritual pits.⁹

At Stonehenge itself, there was the Hawley legacy to be sorted out. It was agreed that Atkinson, Piggott and Stone would jointly take on responsibility for producing a full and definitive report on Stonehenge in place of Hawley's 'inadequate, often very obscure' interim articles, and for directing a limited programme of such new excavation as was essential to clarify uncertainties.¹⁰

They began with the Aubrey holes; 32 out of the total of 56 had been emptied of their contents in the 1920s, but the records of them were not satisfactory. So two more were investigated at Easter 1950, leaving the last 22 intact for archaeologists of the future. These two holes, A31 and A32 on the south-west side, contained no trace either of packing for standing stones or of post-holes, and it was confirmed that the Aubreys were ritual pits, dug in the later Neolithic, deliberately refilled, and usually containing cremated human remains.

A sample of charcoal from A32 was sent to Professor Willard Libby in Chicago, who applied to it his newly established method of dating by radiocarbon. The figure he gave was 1848 ± 275 years BC, the first absolute dating for Stonehenge. It fitted the conventional chronology, in which the Neolithic in England ran from 2000 to 1500 BC, but was perhaps a little on the early side.¹¹

172 Sections of A31 and A32 show the confused deposits usual in Aubrey holes.

173 (*left*) *Professor R.J.C. Atkinson examines the surface of a fallen sarsen for traces of carving.*

174, 175 (opposite) Prehistoric carvings on stone 53: (left) as discovered and visible only as shadows in oblique sunlight; (right) as black marks after 25 years of touching by grubby fingers. The left-hand carving is the controversial 'Mycenaean dagger', the right-hand a flat axe, haft down, curved blade up.

Since half the archaelogical deposits of Stonehenge had been removed only thirty years earlier, the overriding intention of the excavators was, for once, to avoid further digging. So far as possible, the area north and west of the axis that had survived Colonel Hawley's attentions was to be left for the improved methods of future archaeologists. It was a difficult commission, but the example of the Aubrey holes was encouraging. Very limited excavation in strategic areas, combined with the published and unpublished Hawley records, the recollections of R. S. Newall, and limited re-exploration of Hawley's trenches, promised to explain much while destroying little.

But the discovery that hit the headlines was unexpected and quite accidental. One job for the 1953 season was a photographic survey of the stones. On 10 July Atkinson was to photograph the 17th-century graffito (ill. 20) on stone 53. He waited until the late afternoon, when the sun would shine obliquely across the face of the stone and throw the carving into a sharper contrast of light and shade. As he looked through the camera viewfinder, with his eye and mind concentrated on inscriptions, he spotted more carvings below, not letters or figures but the shape of a short dagger pecked into the surface of the stone. Close to it were carvings of four axes, of the characteristic flat Middle Bronze Age type, set with the blades upright. Two days later, the schoolboy son of one of the excavation helpers found another axe, on the outer face of stone 4. Through the summer, more axes were spotted, at least a dozen more on stone 4, on stone 3 and, again, on stone 53. In August, a visiting archaeologist, Brian Hope-Taylor, saw a second and smaller dagger on the side of 53, and other carvings were spotted that were too faint or weathered to identify easily. One, a worn sub-rectangular shape on stone 57, resembled early carvings in Brittany.

The flat axes were undoubtedly prehistoric, a standard Irish type with a broad cutting edge curved in a crescent and a tapering butt which was known in mainland Britain and dated to about 1600-1400 BC. They were

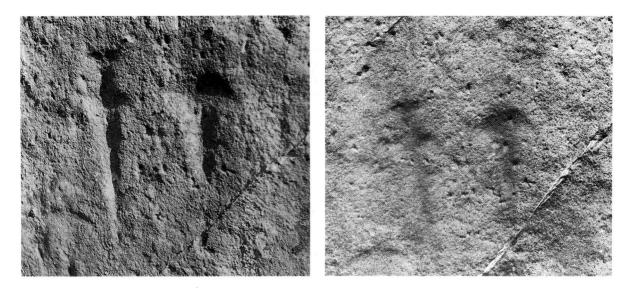

further evidence of the northern aspect of the Wessex aristocracy's trade-routes.

The dagger was more exotic; its appearance – with a straight-sided tapering blade expanding sideways into 'horns' at the base, short hilt and wide pommel - could not be matched anywhere in northern Europe. But there were parallels from Greece, in the rich royal graves of the citadel of Mycenae itself, a dagger from shaft-grave VI and a dagger-carving on a stone over shaft-grave V. To some eyes, it was no more specific than an eroded carving of some kind of dagger. To others, it made a clear statement of direct contact with Mycenae. The Stonehenge carving was that prehistoric equivalent of a maker's plate which had eluded earlier excavators, a signature not squirrelled away in its foundations but boldly scored at chest height into a stone facing on to the central sanctuary. It was a personal record of a Greek master working abroad in the way Homer tells: 'Who, pray, of himself ever seeks out and bids a stranger from abroad unless it be one of those who as masters of some public craft, a prophet or a healer of ills, or a builder, aye, or a divine minstrel, for these men are bidden all over the boundless earth?'

Away in the cold North, 1500 miles from home, at the bidding of the greatest of the Wessex chieftains, the master-builder of Mycenae became the first architect of the men of England. His name could never be known, nor that of his patron. But one guess could safely be made: so bold a chief deserved the greatest burial-ground of all Europe. He was laid to rest 'in the quiet darkness of a sarsen-vault beneath the mountainous pile of Silbury Hill'.¹²

At the least, the Mycenaean dagger gave a good date for the sarsen building; it must have been carved 'within the lifetime of someone who was personally familiar with this type of weapon in its homeland'; and that meant it was no later than about 1470 BC.¹³

Nothing quite so exciting as the Mycenaean carving came to view at Stonehenge later in the 1950s, though there was a thrill of a different kind when an unexploded 13 lb artillery shell turned up in a trench. Instead, there was solid progress in teasing out the chronological sequence, and an entire phase of building discovered of which there was no surface trace. Though the press of inquisitive faces around the trenches made them feel sometimes too much like the inmates of a zoo, the archaeologists got used to working in front of the visitors' gaze. It could even be put to advantage: Lord David Cecil, allowed as a personal friend of Stuart Piggott to slip through the fence into the holy excavation precinct, turned and said in a stage whisper: 'I do enjoy privilege, especially when publicly displayed.'

It was a novelty, also, to suspend work for a few days in June to make way for the Druids, and one year an embarrassment as well. On the solstice eve of 1956, just before the dig was shut down, there had been found under the turf near the north Station Stone mound, fragments of a crushed glass object (reconstructed, it turned out to be a Victorian moulded-glass container in the shape of a pear); with it was some grey dust, and sealed into the neck of the bottle a note saying these were the ashes of a Chief Druid, interred at the solstice some years before 'in the north door by ceremony of BEMA'. The archaeologists, knowing nothing of BEMA but remembering all those victims claimed to have perished under the Druid curse, thought it politic to restore the turf over the spot, so its disturbance was not noticed at the solstice.¹⁴

The strategy of very limited excavation to resolve key points worked well, because the logic, order, precise measurement and symmetry so visible in the standing remains was carried through underground. The Aubrey holes, for instance, although of the earliest phase and irregular in individual form, are placed at standard spacings round an accurate circle. Again, the few blocks of rhyolite among the dolerite in the bluestone circle are not dropped in haphazardly but arranged opposite one another. So, in exploring the traces of the buildings of earlier phases, it was found safe to extrapolate from a restricted area to the whole building. Some features were inexplicable, and some areas like the causeway and entrance had already been destroyed by the work of earlier excavators. But Atkinson was able in 1956 to present, in his masterly book called simply Stonehenge, a summary account of the three phases of the building sequence at the site. Further work since has altered details, and calibrated radiocarbon has altered all the absolute dates, but the essentials of Atkinson's scheme still stand (Chapter 17), and his explanation¹⁵ of the Stonehenge sequence is a classic resolution of a complicated building sequence by excavation and analysis. For 1956 permission was given for Atkinson and Piggott to refine it by exploring in six more small areas 'to facilitate the writing' of the excavation report, in which would be published the evidence on which Atkinson's scheme was based.¹⁶

The idea of restoring Stonehenge, dormant since the Victorians, was revived during the 1950s. R. S. Newall even talked of a benefactor who would pay for wholesale restoration of all the fallen stones, and asked the Inspectorate of Ancient Monuments what that would cost. (In reply the Chief Inspector confessed his own ignorance and referred Newall to a 'Mr Merlin', who would have the costings from when it was last done.)¹⁷ There might be more Mycenaean carvings on the hidden surfaces, and restoration was better for the stones than letting them suffer under the shoes of scrabbling visitors. And was it not a national duty, a patriotic correspondent insisted in *The Times*, to put back up what those nasty foreign Romans had pulled down?¹⁸

In conformity with Ruskin's maxim, 'Restoration is a lie', it was decided to restore only the stones that fell in 1797 and 1900, at a planned cost of just £8500. During the spring of 1958, a protective floor of timbers was laid, the stones were cased in felt-padded steel cages, and a 60-ton mobile crane lifted them. The archaeologists explored their footings, new concrete foundations were laid, and the uprights and lintels safely put back. Stonehenge was now returned, very nearly, to the appearance it has in the earliest paintings (col. ills. I, III). In 1959, three more stones were straightened and given their concrete shoes, and then Stonehenge seemed permanently secure. Unfortunately it wasn't. In March 1963, an upright of the sarsen circle, stone 23, fell without warning, though not necessarily due to natural causes; in the only serious mishap of the restoration work it had been given a hefty blow when stone 22 moved in its cradle. In a final season of work, stone 23 was put back up and more stones concreted, leaving only seven uprights of the sarsen building still in their original chalk-cut sockets. The policy was then confirmed, that excavation should be limited to 'what is required to ensure the safety and good display of the monument'.¹⁹

The Mycenaean Stonehenge did not stand firm for long either. The first radiocarbon dates for prehistoric Europe, like the one for Stonehenge itself, were compatible with the conventional prehistoric chronology, under which the first farmers in Britain, of the Windmill Hill culture, arrived about 2000 BC. But as the dates became more precise and more numerous, a pattern emerged which pushed that date back by up to another millennium. For a while these early dates could be discounted as 'archaeologically unacceptable',²⁰ but their numbers began to tell. Then, in the mid 1960s, a completely new calibration of radiocarbon dates, based on the ancient bristlecone pine trees of the Californian mountains, pushed them back again, so that a date of around 2000 BC moved back to 3500 BC, at the very latest.

Calibrated radiocarbon had an important and direct effect on the Stonehenge chronology, by lengthening the early stages dramatically. The first phase went back from about 1800 to perhaps 2600 BC, while the date for the final form of the building, about 1400 BC, scarcely changed. So developments at Stonehenge took place over not 400 years (about 18 human generations), but 1200 years (some 55 generations).²¹ Its equivalent in our own era is a cathedral founded in Saxon times, rebuilt and reconstructed time and again by medieval, post-medieval and Victorian builders, and still in active use today.

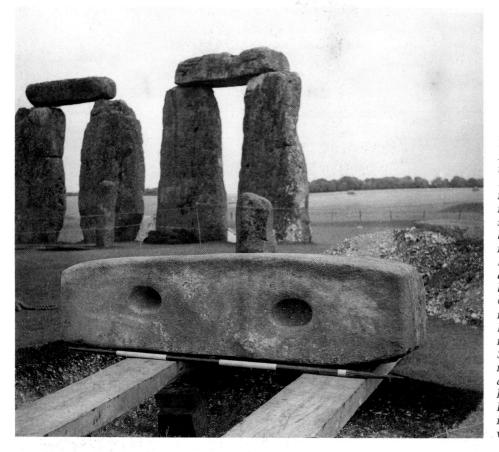

178 (opposite) Raising an upright of the fourth trilithon, 1958. The only mobile cranes able to raise the biggest sarsens were two built years before to rescue the huge Bristol Brabazon aircraft if it did a bellyflop landing. One crane, left rotting on Boscombe Down airfield, was rehabilitated for Stonehenge. After a nasty moment when a sarsen was being lowered over Professor Atkinson, its safety devices were also restored.

176 (above) The lifting of bluestone lintel no. 36, in 1954, showed its full beauty, and the feeling for shape and form its makers must have possessed. By the left-hand mortice is an oval depression to match the top of its upright.

177 (right) Broken stumps and stone-holes in a sector of the bluestone circle where no complete stones survive.

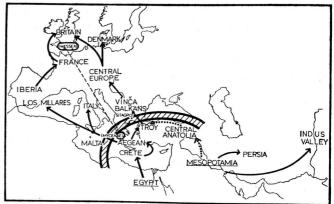

180 (above) Professor Colin Renfrew's diagram of the 'fault-line' opened in south-eastern Europe by calibrated radiocarbon. Aegean events can still, as before, be dated by reference to historical records of Egypt, but the calibration of radiocarbon dates in Europe makes events there much earlier than was once thought, thus breaking traditional links with the Near East.

179 Professor Stuart Piggott's draughtmanship is famous. Here he pauses in his drawing while an assistant takes a measurement. The indirect effects of recalibrated radiocarbon were even more striking. The conventional prehistoric chronology depended on diffusionism, the idea that major innovations and technical advances, such as the skills of building with great stones or working copper, had gradually spread from the more advanced cultures of the Mediterranean, especially the Aegean, to the ruder barbarians of the north and west. Radiocarbon did not upset the Aegean dates, where those were ultimately based on the written records of Egyptian king-lists. Nor were internal relations within central and western Europe called wholly into question, since dates there moved back together and stayed, more or less, in step. But a chronological fault-line opened up on the edge of the Aegean world. Innovations to its north and west turned out to be earlier there than in the Aegean.

Among the scholars unpicking the old chronology was Colin Renfrew, then a young research worker and now Lord Renfrew and professor of archaeology at Cambridge. In examining the most famous trans-European link, that between Wessex and Mycenae, he could not argue directly from radiocarbon, as there were no dates from Wessex itself. Instead he used the dates from related Bronze Age sites in northern Europe to place Wessex in the period 2100-1700 $_{BC}$, whereas Late Helladic I of Greece, the first Mycenaean phase, was known not to have started until 1600 $_{BC}$.

The finds that linked Wessex and Mycenae did not convince Renfrew. Even that architect's mark, the Stonehenge dagger carving, 'if it really is Mycenaean in form, has no more chronological significance than the signature of Byron on one of the marble columns of the Temple of Poseidon at Sounion'.²² If the amber at Mycenae came from the north, from the Baltic or from Wessex itself, then Mycenae was likely to be later not earlier. Some new research supported 'Wessex without Mycenae'. Wessex faience was shown to differ chemically from Egyptian, and there was proof of faience being made in central Europe. A new study of Wessex gold thought it was all made in a single northern workshop. On the other hand, so much of Aegean origin had turned up in northern Europe that it stretched credibility to think that every last object had been dropped by 'exceptionally and singularly careless' private collectors bored with their souvenirs of a Grand Tour.²³

The radiocarbon dates for Wessex graves, when they came, were late – as late as 1500 BC.²⁴ There *was*, after all, an overlap between Mycenae and a Wessex culture that spanned some centuries – but the sarsen building of Stonehenge was seen to fall early within Wessex and before that overlap. It was 'Stonehenge without Mycenae', and the master-builder of Stonehenge was to be taken as a native Briton.²⁵

Chronology, the impetus to the debate, was part of a larger issue, a weariness with the diffusionist model of prehistory, in which external influence is seen as the prime mechanism of change. The remote islands of Britain and Ireland, on the wet edge of the Atlantic, were far from the Mediterranean world where the wheat and barley, the sheep and cattle had been tamed in the Neolithic revolution; and a mature civilization, when it finally reached the northern outposts, had come as the legions of Rome, again a Mediterranean illuminating a backward north. So it had come to be the British prehistorian's customary response, when a new cultural unit was identified, to scan the nearer shores of Europe in search of its port of embarkation.²⁶* Explanation of the rich Wessex graves had followed the 'invasion hypothesis', as tombs of an aristocracy from Brittany that had come into Wessex and lorded it over the native element.²⁸

One element of the old explanation survived into the new, the recognition of a common pattern of burial across Europe, in for instance Brittany and north Germany, during the early centuries of bronzeworking. The new metal was used for making tools, for decorative pins, and above all for daggers, the weapon of hand-to-hand combat. Attractive materials, especially gold and amber, suddenly came into use to make personal ornaments. A few men and women were now buried in single graves with the riches of their special status.

The change, then, is seen as a shift in social structures and social values. Neolithic society had been marked by its community elements – collective burial in chambered and unchambered barrows, the central meeting-places of the causewayed camps and then the great henges like Durrington Walls built in the later Neolithic. It was a society of groups and of group solidarity, the community's works are more prominent in the archaeological record than any striking display by individuals. Bronze manufacture brought in a new form of personal wealth, suited to

* It must also be said that. before radiocarbon, an element of diffusionism was inescapable, since an absolute chronology could only be built for western Europe by reference of some kind to the historically dated civilizations of the East. In the particular case of Wessex, it is noticeable that Gordon Childe, who as the principal architect of the old chronology has tended to go down with it, was sceptical of the idea that the wealth came from the profits of middlemen's trading; instead he thought it the 'beggarly surplus' of 'primitive subsistencefarming' concentrated into the hands of a few chiefs. And he was very cautious when the supposed Mycenae-Stonehenge link was sweeping the field.²⁷

outward display and to armed strife, which is reflected in a shift to individualistic chiefdoms. In a more materialistic, acquisitive, aggrandising society, maintaining the personal property of a chief, its display and its final burial with him, is the dominant motive. In Renfrew's view, the sarsen building at Stonehenge and Silbury Hill were not the first monuments of a new age, but the last of an old, the culmination of the group solidarity of the late Neolithic before it was overtaken by a more competitive and divisive order.²⁹

An epitaph for Mycenaean Wessex has been well written, not by any archaeologist or academic, but by Julian Mitchell in his play *Half-Life*.³⁰ Its central character is Sir Noel Cunliffe, the grand old man of British archaeology, who was played by Sir John Gielgud as a cross between Mortimer Wheeler and Maurice Bowra. Cunliffe has retired to Wiltshire from the mastership of his Oxford college; he sees in a Wessex deprived of Mycenae the destruction of his life's vision. He remembers standing at Stonehenge, that glorious year when Atkinson found the Mycenaean dagger, to look with joy at that spot on the horizon which marked the direction of the sacred inspiration of Greece. Now the half-life of radioactive carbon has shattered that vision, and with it the values of his own life and of the British Empire: 'We thought we'd been the new

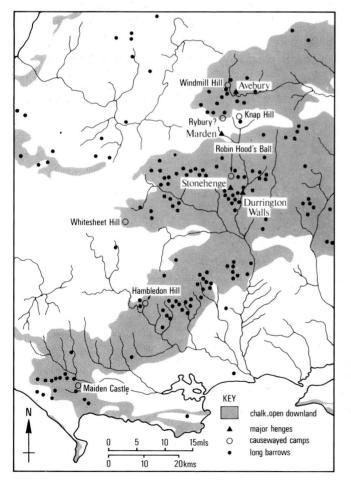

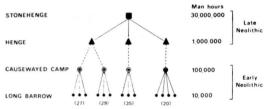

181 (*left*) Wessex territories; clusters of long barrows, with causewayed camps, in the same areas as the later large henges.

182 (above) Hierarchy of Wessex monuments according to the number of man-hours required for their construction. In successive eras monuments are larger and fewer, culminating in the unique Stonehenge. (Silbury Hill, another unique site and requiring a comparable labour input, is of the same period.) Mycenae, sending out law and order, and justice, and the Pax Britannica, diffusing culture in all directions.' If those must go, then everything must go, so he invites (on the evening before the summer solstice) those closest to him – the favourites among his old pupils, the new master of his college, the woman he would have married if he had been of a marrying sort – and shatters their lives too.

Clearest of the many invasions that structured that older view of British prehistory was the one associated with 'beakers', handsome wellfired pots that look to have been drinking vessels. Along with these new pots came a set of other new artefacts, and a supposed new way of life in a shift to mobile pastoralist communities. In the new view, even the physical evidence of different skull-shape – Beaker skulls are round, where the older skulls are long – does not make for a new immigrant population of 'Beaker Folk'. Most of the characteristic 'Beaker assemblage' in fact occurs in Britain before the special pots arrive, and the changing heads are easily to be accounted for by simple population genetics.³¹ At Stonehenge, the Beaker people were thought associated with the bluestone setting of its 'Stonehenge II' phase,³² so a new explanation needs to be sought for this.

In an account of British prehistory without invasions, circular enclosures like Robin Hood's Ball, the 'causewayed camp' 1¹/₄ miles north of Stonehenge, are to be interpreted as settlements where early farming communities practised both the domestic and the ritual of their daily life. Their dead, if not pitched into the ditches that defined the camp, were placed under long barrows, like that at 'Long Barrow Cross-roads' to the west of Stonehenge; in the burial places, the skeletons were moved about and the bones sorted in a manner that denied the integrity of the individual and the differences in death between individuals. This was an egalitarian society, held equal by ancestor cults and community-based ideologies. Already Wessex made a distinct region within which interaction and exchange concentrated, and the people shared common traditions.³³

In the centuries before 2000 _{BC}, new monuments were built: the different kind of round enclosures, the 'henges' that as a group are named after Stonehenge, and the long rectangular structures, again named as a group after that first 'cursus' just north of Stonehenge that Stukeley recognized in the 1720s. They came about from the internal dynamics of social evolution, and the force this gave to change. Sometimes the fighting was physical, sometimes symbolic, using objects as indicators of power. Tim Darvill explains: 'A simple pattern had developed whereby goods were made or acquired for their prestige value until such time as they became debased by copying, faking, and reproduction, at which point new types were taken to symbolize power and the old types became acceptable domestic items in everyday circulation.' Beakers, at first exotic in graves, came to be found also in settlement sites, while a different and new pottery type, the collared urns, took their place in burials, as containers for ashes from the new ritual of cremation.³⁴

183 Beaker from a Stonehenge barrow. Once a certain proof of an immigration of new people with a new idea for Stonehenge, it is now seen by some as a matter of passing ceramic fashion.

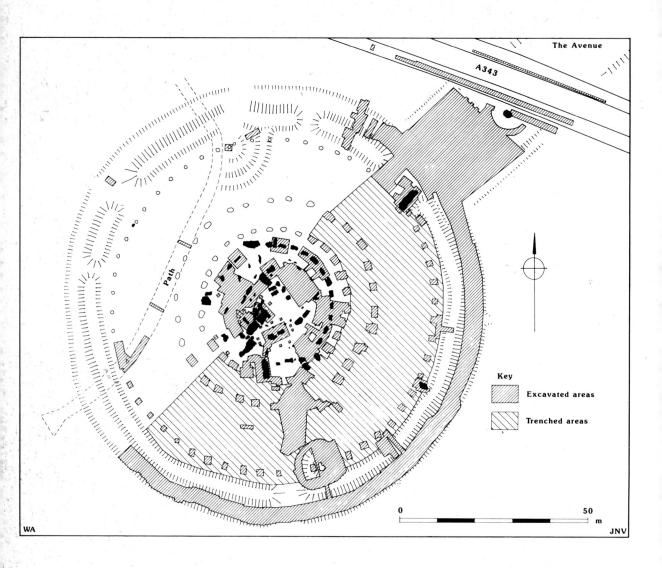

184 (above) Areas of Stonehenge excavated by archaeologists this century. The exact positions of the holes dug in earlier centuries are unrecorded, as are those of the fossickings made by Druids to bury their cremated brethren.

Gowland's 1901 excavation was restricted to a neat hole around stone 56. It makes a sad contrast with Hawley's open areas of trenching. Altogether more than half the site has now been destroyed by archaeological study. The less explored western half is badly damaged by old trackways.

185 (right) The Stonehenge landscape from the air, 1975. From Stonehenge (upper right) the Avenue runs down into Stonehenge Bottom (top left) and turns to the east. The Cursus is in the left foreground, two ditches that run parallel and diagonally, separated by a field. (The white marks in this and other fields are due to the farmer.) The barrows to its right are the Cursus group.

This is the centre of the Stonehenge landscape, as explored by the Stonehenge Environs Project 1980-86.

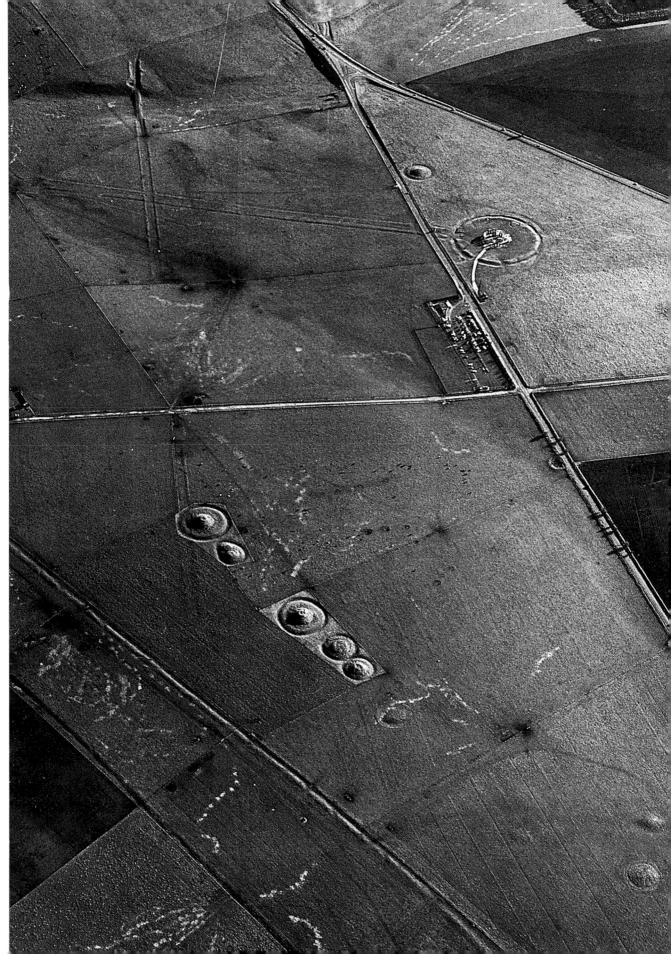

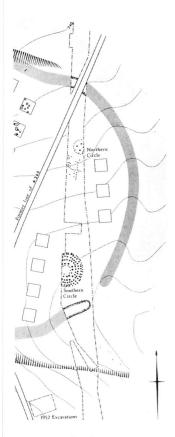

189 In the thin strip cut across Durrington Walls for the new road were portions of two wooden circles resembling Woodhenge. Prospecting without excavation (in the squares top left) showed several others to exist. Stonehenge and immediate rescue work apart, excavation in the vicinity in the post-war years began mostly with barrows in arable land, to rescue information before annual ploughing levelled them completely. Often, Cunnington's labourers had been there before, and their quarry-shafts showed how the grave goods of the primary burial disappeared. A supposed pond-barrow at Wilsford, however, $1^{1/4}$ miles south-west of Stonehenge, proved not to be a slight and surface feature, but the top of a huge shaft, $6^{1/2}$ ft wide and 105 ft deep, dating perhaps to 1500 BC. The Wilsford shaft has a functional explanation, as a well to water the prehistoric flocks. In another view, it has a more human purpose, as a ritual means to communicate with whatever prehistoric spirits or souls existed far underground.³⁹

When a new road was built across Durrington Walls in the late 1960s, rescue work along its track produced massive evidence of occupation, notably two groups of concentric post settings, rather on the Woodhenge model and interpreted as big timber buildings. Remote-sensing survey elsewhere inside Durrington Walls found other major structures, not excavated and therefore of uncertain plan. The radiocarbon dates show that this major site was broadly contemporary with the main period of activity at Stonehenge, though how the two sites relate to each other is a more tricky question.⁴⁰

Stonehenge looks monumental today because its sturdy sarsens have barely been worn down by forty centuries of English weather. At one time the timber structures we know only from the ground-plans of their rotted posts may have been as grand. The earthworks we see as green humps were once great heaps of shining white chalk, the 450 burial mounds of the Stonehenge environs, each one gleaming when new-built.

Research in the 1980s looked out from Stonehenge to its landscape, called the 'Stonehenge Environs' after Colt Hoare's map of his exploration. It began with a review of existing knowledge,⁴¹ and then developed to a new Stonehenge Environs Project, directed by Julian Richards, whose fieldwork spanned the years 1980-86. The high density of ceremonial and burial monuments was clear; did it make this wholly a 'ritual landscape'? Or was there a 'domestic' component also?

In its first years the project concentrated on surface survey, using the old, simple and laborious method of field-walking which in recent years, helped by new ideas in statistics, has become a fundamental method of British archaeology. Richards's team walked over 750 hectares of ploughed fields in the Stonehenge landscape, spaced on an organized grid, picking up or recording all the archaeological objects they found. Most often these were worked flints, altogether 102,175. There was prehistoric pottery too, though a weak prehistoric sherd does not long survive the shock of the plough and the action of frost once it has been pulled to the surface; only 581 pieces were spotted, most of them worn and rolled. Later, special areas were surveyed more intensively and studied by geochemical and geophysical methods. Some sites were excavated in part, including yet another henge monument, 1600 yards away from Stone-

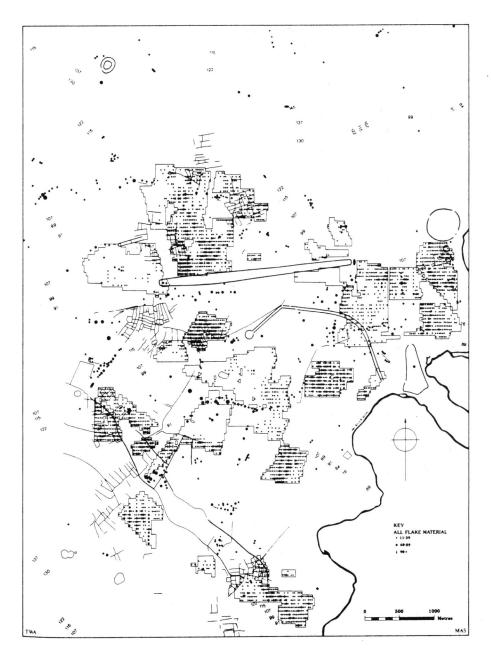

190 Distribution of flint cores from surface collection in the Stonehenge Environs Project.

In the centre, Stonehenge with the Avenue running off to the north-east, and above it the parallel lines of the Cursus.

High-density areas, west of Stonehenge and north of the Cursus, contrast with lowerdensity areas west of the Cursus and south of Stonehenge.

Since flint cores are prehistoric, but not commonly datable with exactness, these patterns show the overall story of intensity of occupation over a long period in the immediate neighbourhood of Stonehenge.

henge on Coneybury Hill and long ploughed quite flat, which had been recognized in 1970 from its plan on an air photograph (ills. 191, 192).

The evidence from field-walking decisively showed that Stonehenge was more than a ritual landscape. There was also the debris of flintworking and occupation right across the zone, with some distinct settlement sites, like those of the Later Bronze Age by the Winterbourne Stoke crossroads, and identified areas with higher and with lower densities of surface finds. The sequence shows a landscape that is more tamed and divided as time passes, from an Early Neolithic of first farmers

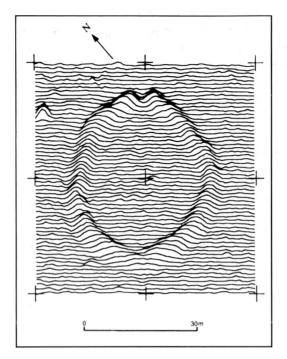

191 Magnetometer survey at Coneybury Hill reveals the plan of the ploughed-out henge. The upward kicks of the lines in fact correspond to deeper ground, so the oval 'bank' they seem to define is actually the ditch.

192 Jane Brayne's reconstruction drawing of the Coneybury Henge sets it in a woodland clearing.

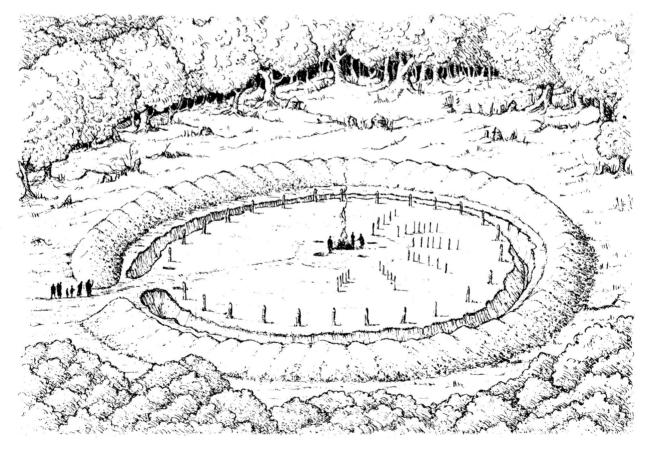

and forest-clearers onwards; just one sherd of pottery from the surface survey stood for this first period. (The bones of beaver and brown trout from a settlement by the Avon east of Durrington make a reminder of the wilder landscape those pioneers chose to occupy.) At the time of the late Stonehenge, a more open, cleared landscape was divided up by Bronze Age linear earthworks, long affairs of bank-and-ditch that are thought of as 'ranch boundaries' which acted as physical boundaries to keep stock apart or as markers on the ground to indicate social boundaries. Finally, areas of small 'Celtic fields' – nearly everywhere ploughed quite or almost flat – mark a final phase of intensive land-use. There *is* a period afterwards of an empty landscape, but this comes *after* Stonehenge has gone wholly or practically out of use, in the Iron Age and Roman periods; not a single piece of Iron Age pottery was found in the entire surface survey.⁴²

Fieldwork in the early 1990s, commissioned to see what archaeological impact a new visitor centre and new roads would have, has further developed this many-coloured picture, in which the complex central site of Stonehenge is surrounded by a landscape of equally complex history, in which domestic occupation and industrial life (for flint-quarrying and knapping is an *industry* in prehistory) went on in and beside the worlds of ritual and of burial ceremony.

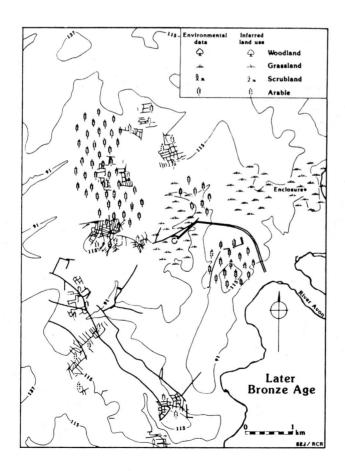

193 The environment of Stonehenge towards the end of its time of active use, in the Later Bronze Age, as inferred by the Stonehenge Environs Project.

Immediately around Stonehenge (marked as a circle with the double lines of the Avenue to its top right) is open grassland, with areas of cereal crops a little distance to east, north and northwest; to the west are networks of Celtic fields.

STONEHENGE COMPLETE STONEHENGE COMPLETE ST HEHENGE COMPLETE STONEHENGE COMPLETE STONEH IGE COMPL **14 THE MOON BEHIND THE MEGALITHS** HENG OMPLETE STONEHENGE COMPLETE STONEHENGE COI ETE STONEHENGE COMPLETE STONEHENGE COMPLET

'If I can see any alignment, general relationship or use for the various parts of Stonehenge then these facts were also known to the builders.'

Anyone bold enough to call his book *Stonehenge Decoded* deserves to cause a stir. That was the title chosen in 1965 by the American-based astronomer Gerald Hawkins in making a claim that promoted a Stonehenge archaeo-astronomy from a total eclipse back into full light. The Victorian visitor wanted to see the Slaughter Stone where the Druid sacrifice was made; the visitor today asks which are the stones of the prehistoric archaeo-astronomers.

Sir Norman Lockyer's work at the turn of the century showed that future students of prehistoric astronomy at the English megaliths ought to watch for two blunders.

First, they would need to take account of the evidence as to what was contemporary with what; sites and structures of quite different dates should not be linked into a single scheme, as Lockyer had done in dragging Sidbury Hill into his Stonehenge scheme. At Stonehenge, two of the four Stations are set over and erase Aubrey holes, so no astronomical account should make the full set of Aubrey holes part of the same apparatus as the Stations, and have it all in use at the same time.

Second, astronomical studies should take note of the reality that alignments that seemed to have astronomical significance would occur by chance. It would not be enough to show that some astronomical alignments exist in the plan of Stonehenge. It would have to be shown they were so numerous or had so much pattern they must have been set up intentionally in the prehistoric period.¹

What are these astronomical alignments? The sun's cycle of movement is a repeated annual round, with the directions of sunrise and sunset varying from the northernmost limit at the summer solstice to the southernmost at the winter solstice. The summer sunrise is opposite the winter sunset, the winter sunrise is opposite the summer sunset. One of those alignments, to the summer sunrise/winter sunset, is followed by the symmetrical axis on which Stonehenge is built, though with what accuracy is unknowable.

The moon, brightest object in the night sky, was important in a prehistoric society without efficient lights, and its rapid waxing and waning the most obvious of changes in the sky night by night. As well as its phases, the moon follows a cycle comparable to the sun's but much faster; the directions of moonrise and moonset swing from northernmost

194 (opposite) The moon behind the megaliths. Analysis of astronomical alignments within Stonehenge has concentrated on the points on the horizon at which the sun and moon rise and set, and especially on the limits of their movement.

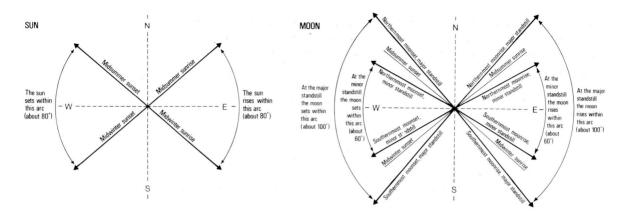

195 The four defining limits of the sun's annual movement, and the two solar directions at the equinoxes.

196 The eight defining directions of the moon's movement over its 18.6-year cycle.

to southernmost and back in a month. For the moon, those limits themselves move. At the 'major standstill' the northernmost limit is at its most northerly, the southernmost at its most southerly. Then the limits close together until they reach the 'minor standstill', begin to separate again and reach the next major standstill after a cycle of 18.6 years. At the major standstill the range of movement of the moon is greater than the sun, at the minor it is less.

These theoretical directions require adjustment for several factors in respect of just what is the direction in which the event is seen from any one place: date (since they drift slowly over time), astronomical parallax, atmospheric refraction, the profile of the local horizon, and whether the first or last glint, the centre, or the bottom limb is taken as the moment of rising or setting. And a small 'wobble' in the moon's path may change its positions a little from standstill to standstill.

In principle, a diligent observer who watches clear skies over several of the sun's 1-year and the moon's 18.6-year cycles will recognize these patterns, and come to understand there are 2 important solar and 4 lunar directions in the east for the rising, and a matching opposite set of 6 in the west for the setting. One can add the 2 directions of the sun at the spring and autumn equinoxes to make, if one wishes, 14 astronomically significant directions.

At Stonehenge, lines drawn between pairs of Station Stones had long been known to indicate midsummer sunrise and midwinter sunset; these alignments follow from the Stations being parallel to the second Stonehenge axis, itself aligned that way. A new Stonehenge astronomy began in the 1960s.² An amateur astronomer, 'Peter' Newham, found an alignment for the equinoxes in a line connecting Station 94 with a hole by the Heel Stone. And he found a lunar alignment: the lines formed by the long sides of the Station Stone quadrilateral indicated moonrise and moonset at the major standstill. The Station Stones are in a poor state; numbers 92 and 94 are missing, 93 is still upright though truncated, 91 is fallen. It is not certain which period of Stonehenge they belong to (page 268). Their locations make an approximate rectangle, and that may be important. It is only near the latitude of Stonehenge that the two astronomical directions of its sides, one to a solar event and one to a lunar event, fall at right angles. Had Stonehenge been built further north or south, and those directions maintained, then they would be set out as a parallelogram.

At much the same time, Professor Gerald Hawkins was tackling the possible Stonehenge alignments with the help of the Harvard-Smithsonian IBM computer. His first results, published in *Nature* in 1963, were astonishing: a whole pattern of alignments in solar and lunar directions that would arise by chance, he claimed, only with a probability of less than one in a million. Hawkins, in touch with Newham, then explored equinox alignments and found Stonehenge also to be a 'Neolithic computer'; his full theory was set out in his 1965 book, *Stonehenge Decoded*, written with J.B. White.³

In Hawkins's study, the positions of 165 key points – stones, stoneholes, other holes, mounds, midpoints – were plotted. Alignments between these fixed points were checked against rising and setting directions, at 1500 BC, first of the planets and bright stars (which they did not match) and then of sun and moon. There was 'total sun correlation' and 'almost total moon correlation too', with a network of 13 solar and 11 lunar alignments (ill. 196).⁴ All these are in features of the early Stonehenge – the holes, rude stones, banks and ditches that occupied the site long before the lintelled building of the later Stonehenge. Hawkins also found alignments that were much *less* precise than in the earlier Stonehenge.⁵

Hawkins's 'Neolithic computer' was a way of using the Aubrey holes as a tally to predict eclipses of the moon, which relates to a recurrent cycle of about one-third of 56 (56 being the number of Aubrey holes). By moving markers from hole to hole round the ring, prehistoric astronomers could have forecast lunar eclipses (ill. 198).

Stonehenge Decoded had the greatest popular success, but archaeologists were uneasy. Atkinson detailed defects in an article entitled 'Moonshine on Stonehenge'.⁶ Sight-lines used holes F, G and H, but these were rough irregular pits not proven to be humanly created features. And sightlines were taken as significant that were 2° or more out of true, enough for the 'sight-line' to miss the sun or moon event completely. Using pencil and paper in place of Hawkins's much-publicized electronic brain, and making different reckonings of which lines should be counted, Atkinson found the probability of alignments occurring by chance was not astoundingly small, but not so far from evens. The evidence from excavating the Aubrey holes, that they had been filled up very soon after being dug, did not square with their having lain open as tally-pits. An eclipse predictor using the Aubrey holes was destroyed in setting out the

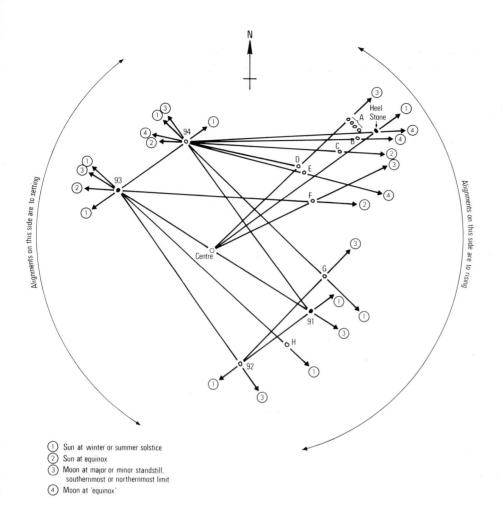

197 Sun and moon alignments in features of Stonehenge I and II, according to Hawkins. He finds many more alignments than Newham, but at some expense: the scheme involves all the holes A to H, plus the geometrical centre, at which no stone or hole is known to have existed; and it introduces moon 'equinoxes'.

Two methods of forecasting eclipses from the Aubrey holes.

198 (left) Hawkins uses six markers (moved by one Aubrey hole a year); three fixed positions; and a moon marker, moved by one stone of the sarsen circle a day.

199 (right) Hoyle uses three markers moving at different rates to model directly the movements of sun, moon, and ascending node.

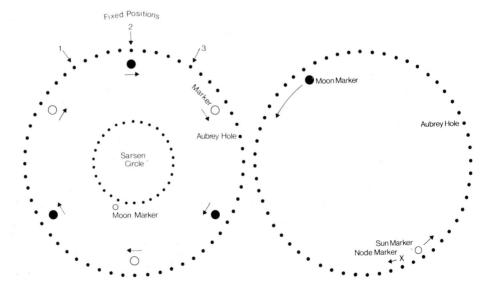

Station Stones, which stand over the filled holes. The two scientific components in Stonehenge, the computer and the observatory, could not have existed at the same time.

Fred Hoyle, the celebrated Cambridge astronomer, was induced to look at Stonehenge. He found a different way to predict eclipses by moving tallies round the Aubrey holes. He thought the discrepancies in sightlines from correct astronomical direction were not errors, but deliberate offsets to make observation more exact. Stonehenge I, thought Hoyle, was an astronomical instrument, showing its builders to have astonishing intellectual powers; Stonehenge III, for all the craft of its construction, showed no great skill in astronomy.⁷

Other expert correspondents to *Nature* in 1966 were not convinced. Eclipses could be forecast by other tallies than 56, doubt was cast on the 56-year cycle, and simpler ways of eclipse forecasting put forward.⁸

Newham, Hawkins and Hoyle had shown ways Stonehenge could have been used to study solar and lunar alignments. Hawkins had adopted as his working hypothesis, 'If I can see any alignment, general relationship or use for the various parts of Stonehenge then these facts were also known to the builders.^{'9} But this approach lacks historical sense. The Stonehenge axis, projected to the north-east, in our age runs through the city of Copenhagen; was that alignment known to its builders? What had not been proved by the modern Stonehenge astronomers was that Stonehenge had actually been used as an astronomical observatory or calculating machine. Nor had it been shown that the observations required could be reliably made in English weather and sighting conditions.¹⁰ The 20th-century astronomers had looked for clues at Stonehenge towards astronomical events that modern science already knew to exist: their work at Stonehenge was much easier than that of the prehistoric researchers who had no cause to know in advance what were the patterns they should be looking for.

This Stonehenge astronomy was a particular, even an anecdotal affair, explaining features of Stonehenge alone. The several objections to it, especially the possibility of chance alignments, left Stonehenge astronomy an open question, with many in the astronomical community inclined to be convinced, and many in the archaeological community not persuaded. The popular vote, if the many visitors to Stonehenge I have talked to over the years make a fair sample, gave a majority to the astronomers which continues more than twenty years later.

Stonehenge, extraordinary though it is, is just one of many henges, stone circles and megalithic structures spread through the British Isles. If there were astronomical alignments and calculating purpose at Stonehenge, would there not be elsewhere? And if the prehistorics were accomplished and exact in their astronomy and eclipse prediction, would they not have matching skills in mathematics and engineering – of the kind so evident in the elegant order of Stonehenge? This larger proposition, of a 'megalithic astronomy' practised at many stone circles and other megalithic sites, was developed in a series of studies by Alexander Thom,

200 '6th Circle' by Bill Vazan, 1977. Along with North American interest in Stonehenge astronomy has gone some remarkable photography.

a Scots mechanical engineer and Oxford professor. Published from 1954 onwards, long before the public rise of Stonehenge astronomy, they explored how solar and lunar explanations could be made with the sightlines from and within megalithic sites.¹¹ And Thom developed a wider scheme of a 'megalithic science', in which exact astronomy was joined by exact geometry and exact systems of measurement. Plotting the plans of stone circles with new and precise field surveys, he found that they were not rough rings, but followed a set of ovals, flattened circles and eggshapes which could be laid out from a developed knowledge of plane geometry. Studying the distances between the stones, and in those geometric plans, he found a pattern consistent with the use of fixed units of length, a 'megalithic yard' of about 2.72 feet, a 'megalithic fathom' of twice the megalithic yard; a small 'megalithic inch' was found by analysing cup-and-ring marks. At first, Thom kept clear of Stonehenge, even at the height of curiosity about its astronomy, preferring to study sites elsewhere in Britain and northern France he thought important.

In 1973 Thom's team went to Stonehenge, and found there the astronomy, the geometry and the units of his integrated megalithic science.

In astronomy, Thom looked at both solar and lunar aspects, as had become customary. Examining the several alignments, not quite the same, to the north-eastern sunrise, Thom thought the main axis of Stonehenge had been oriented on the centre of the solstice sun's disc, when half-risen, at about the date of the sarsen building. He looked at Peter's Mound, a little tump on the distant horizon and at a slightly different azimuth, noticed by and named after Peter Newham, and suggested it belonged to earlier solar observations, made at the time of Stonehenge I.

Thom set aside suggested lunar alignments *within* Stonehenge as inaccurate – the sight-lines were too short to be good – though the lunar element to the Station Stone rectangle was encouraging. He searched instead for long-distance sight-lines in directions corresponding to the eight important directions of the lunar movements, and found for some of these evidence of their use on the far horizon, in the form of surviving earthworks.

In geometry, Thom confirmed that the sarsen ring at Stonehenge was a good and exact circle, and plotted the sarsen trilithons on to an ellipse.

Sarsen dimensions, the spaces between sarsens, and the size of the whole sarsen circle followed the megalithic units of length.¹²

An element missing from the Thom scheme of megalithic science, as it had been from the other Stonehenge astronomies, was evidence for some developed scheme of record-keeping, or for the instruments smaller than the great rocks of the megaliths that would help their work. This was provided by Archibald Thom, son of and collaborator with Alexander Thom, who some years later looked at the shape and markings of the gold plaque from Bush Barrow, and found that these could incorporate a solar and lunar calendar for Stonehenge.¹³ A new and compelling solar alignment was found at Newgrange, the chambered tomb in eastern Ireland, which stands with Stonehenge as among the great megalithic structures of prehistoric Europe. At Newgrange a small chamber within a stone cairn is approached by a long narrow passage facing south-east; at the midwinter solstice, it came to be noticed, the rising sun shone a thin finger of light down the passage to illuminate the decorated back stone of the chamber. While the Stonehenge alignments are in two dimensions alone, from one stone past another to the horizon, the Newgrange alignment is in three dimensions; the passage, as well as pointing in the right direction, must slope at the right angle, lest the light hits floor or

201 Alexander Thom in the midst of a Carnac thicket. Stonehenge was more open country, at least for physical survey. roof before it penetrates the chamber. This extra dimension gives one confidence that the Newgrange alignment really is not a chance affair.

The Thom vision of a prehistoric megalithic science, as it can be extended by the Bush Barrow gold plaque and the Newgrange midwinter alignment, makes an exciting and compelling proposal. It has an internal consistency in a set of skills that go together, and corroborative field evidence; it offers a view of a whole culture, whereas Stonehenge astronomy alone gave a single and an isolated proposition.

If there were prehistoric scientists at Stonehenge, and at other megalithic places, what were they like? They would have needed time and inclination to pursue their researches, social power to have their computer-cum-observatory built, and some means to record astronomical observations over the several or many years needed to calculate the

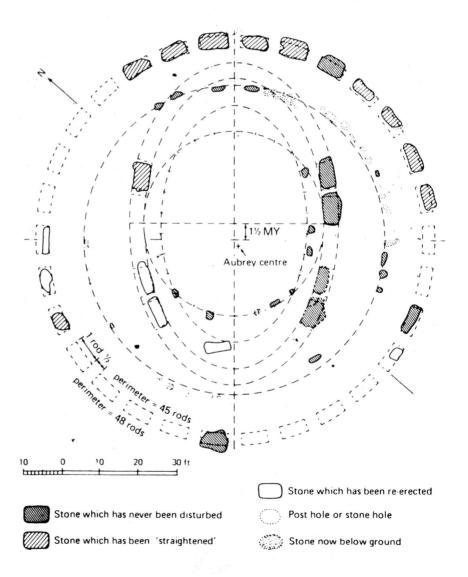

202 Geometry of the sarsen building, as analysed by Thom. Four of the five trilithons stand on an ellipse, but the bluestone horseshoe is intractable. The outer circle follows a simple pattern of megalithic rods.

patterns of eclipse cycles. Euan MacKie, a Scots archaeologist, looked for a trace of these kind of people in the prehistoric record, and maybe found it, he thought, at the henge monument of Durrington Walls, just over the ridge to the north-east of Stonehenge (by the summer solstice alignment). The new excavations there had found big circular timber buildings, a distinctive kind of pottery, and abundant pig and other animal bones. Were these, MacKie wondered, the halls of the astronomers, a distinct caste or class of scientist-sorcerers, who inhabited special houses, used special pots, and lived well on the meat the peasants brought them?¹⁴

MacKie was one of the very few archaeologists convinced by the Thom scheme, which would have upturned long-set views about the nature of societies in the British Isles of 2000 BC. Many difficulties and objections arose from the two fundamentals noticed at the start of this chapter.

The rule of contemporaneity requires elements of a single astronomical observing system to have all been set up during the same period, or at least all to have existed at the same time. Peter's Mound, when investigated, turned out to be a small dump of rubbish, datable from its contents to the early years of the 20th century. It did fall on the midsummer alignment from prehistoric Stonehenge - but it was 4000 years too young! Three massive holes in the chalk north-west of Stonehenge, uncovered when the car-park was extended, were taken into Newham's scheme as marking sight-lines, and into Thom's scheme as supports for a platform to help in distant observations; radiocarbon study of pine charcoal dated them to over 9000 years ago - they are over 4000 years too old! Field evidence for the three earthworks on the long-distance lunar alignments. which Thom thought to be sighting markers or platforms, finds one to be a military earthwork from the time of the English Civil War and no older than John Aubrey's day, one to overlie medieval ridge-and-furrow marks, and the third to be integral to a group of earthworks that may be prehistoric but are certainly much later than Stonehenge III; all three are subsequent to the time of a Stonehenge astronomy.

The chance rule requires one to be sure that the identified pattern of astronomy or other prehistoric science was deliberate and intended, rather than arising by chance or in a simple way. Again, further work has not been kind to the Thom scheme.

At megalithic sites, there are compelling individual alignments to the lunar directions, but not so many or of such repeated pattern that one can be sure of megalithic lunar astronomy.

Further studies, and experiments in setting out buckets of sand to make circles, give a quite different account of the geometry of the stone rings. A good circle – and some stone circles, like the late sarsens at Stonehenge, *are* good circles – is easily laid out by scribing with a rope tied to a single peg. The other, more complex shapes may arise simply from setting out a circle by eye, as it is hard to judge a consistent curve. A ring that is not judged right may have flattened parts, where the curve is too slight, or corners, where the curve is too sharp, that together make it fall by chance into a complex geometry of the Thom scheme.

Statistical studies showed some pattern in megalithic measurements, but this was not strong enough to disprove the other contention, that the measurements were inexact. Any clustering about a postulated megalithic yard, for example, could arise from the simple means of using a human pace, which is indeed about 2.7 feet, as a prehistoric unit when laying out megalithic, wooden or earthen structures.

Neither the particular schemes of Stonehenge astronomy nor the larger vision of megalithic science have found favour with archaeologists. I am not sure they were ever given a really fair consideration, or that they could have been. Although some astronomers tried to grasp the archaeology, and some archaeologists the astronomy, practically no one had or has sufficient grasp of *both* subjects fairly to explore them together. And the statistical issues, far beyond the mathematics of most archaeologists, taxed the methods of first-rate statisticians.

I think - and here I write as an archaeologist with not enough science in my education – that the Thom challenge has tested and improved our knowledge of prehistoric cognition. Solar alignments are accepted, with the Newgrange example more compelling than anything at Stonehenge. Precise lunar alignments are not, although Aubrey Burl has found consistent lunar regularities in the stone circles of north-east Scotland. Precise geometry and measurement have not been proved, but it has importantly - been shown that the simplest methods of craft-workers and rules-of-thumb may create patterns that closely resemble an exact and measured knowledge. All these develop without overturning our image of a prehistoric society in Britain of subsistence farmers, ignorant and superstitious, by the 20th-century ideals of a rational and secular world: knowledge they had, but not that of research scientists in white laboratory coats. The mistake in the astronomers' vision, in my view, is shown by the very word 'astronomer', which comes to the English language from the Greek natural philosophers who mapped the stars at the dawn of our modern science. We should think instead of a prehistoric cosmology, a broader concern with the heavenly bodies, their meaning. their magical powers, their influence on our world below, not at all on the model of a western analytical science which the word astronomy must convey. (And yet: Stonehenge is different, its advanced engineering makes a standing anomaly to the vision of later prehistoric society the archaeological community has chosen to hold to.)

A few decades on, it is interesting to speculate why Stonehenge astronomy, and especially *Stonehenge Decoded*, made such a stir. One can give an account more in terms of the 20th century AD than BC. As Hawkins's book explained things, the IBM computer was central. It was not the scientist but the IBM, helped by its friend 'Oscar' the automatic plotting machine, that did the discovering.¹⁵ Stonehenge the Neolithic computer was the IBM of the ancient world – and it took the intelligence of a modern IBM to understand it. In the 1990s, I write revisions to this book on an inexpensive laptop computer whose technology is far in advance of the clunking antique machinery (in computer terms) that is an

IBM of early 1960s vintage; my laptop is made by one of the new companies, founded after the excitements of a Stonehenge astronomy, which have overtaken the IBM corporation in technology and in business success. The Stonehenge vision of the 1960s astronomers now seems an artefact of its time, that decade when space travel first became a reality, and the magic of computers was promised to solve everything.

Through the centuries explored in this book, onlookers admiring Stonehenge have expressed their respect in metaphor, analogy and explanation. Inigo Jones, neo-classical architect, made Stonehenge great by pretending it was a Roman building. Scientists of our age made Stonehenge great by treating it as a two-purpose scientific instrument, and – at a certain moment in 20th-century technical and commercial history – linked it to what was then the best name in state-of-the-art hightechnology. A very contemporary, and a very transient, way of showing respect.

203 The evening star over Stonehenge – and perhaps over Stonehenge astronomy. Wood engraving from the 1930s.

The Pentax ME Super -leaves the rest standing

Simply hold a Pentax PENTAX JML1= SUPE Advertising designers, always keen to find a new form for an old image, find Stonehenge irresistible. A setting or rising sun is mandatory.

204 Pentax echo the appearance and associations of Stonehenge (strength, endurance, precision?) with 'trilithons' built of SLR camera bodies.

205 Benson & Hedges set a monolithic cigarette packet, in bursting gold, among the sarsens. Their 'Stonehenge' is a studio model, simplified from the original, and superimposed on a stock shot of the sky.

'Conscious initiators of a new sacred and mythopeic world view'

'E VISIONS

TERNATI

The archaeologists and the astronomers, for all their differences in background and in method, share a common approach to Stonehenge, in thinking that it should be studied in a spirit of sceptical and questioning rationality. As earlier chapters have shown, this academic attitude to Stonehenge has been dominant for the past century and a half, ever since the awe of the sublime and the genuine turmoil of the soul it could induce drifted down into a banal and conventional *frisson* to amuse the tourist. Professor Atkinson feels there is beneath the surface appearance of Stonehenge 'an inwardness which is none the less real or significant for being personal and, in part at least, incommunicable'. Professor Thom has an engineer's love for that 'beauty of design' which is hidden in the controlling geometry of a stone ring that looks only to lie casually in a rough circle. But both turn away from these private regards to the proper method of their study, 'the precise and academic discussion of the evidence'.¹

Both of these academic approaches to Stonehenge can be traced back to William Stukeley. As the father of field archaeology, Stukeley explored the earthworks and proved the equal date of the bluestone building and the barrows by methods still accepted as sound today. As a pioneer in measurement and astronomy, he worked out systematic patterns in Stonehenge dimensions and studied its solar alignment.

There is a third element in Stukeley's Stonehenge – that quality of spiritual excitement that showed itself in the awesome ecstasy of the walk upon the trilithon, in his delight in the physical sensation of the place, and in the thrill of taking yourself from the mundane world and becoming, if only when having dinner among friends, a Roman Knight or a Druid Priest of the Ancient Britons. This element, submerged since the 18th century by the cooler conventions of historical research, has blossomed in the last several years into the movement sometimes called 'alternative archaeology' - 'archaeology' because it tries to understand life in ancient times, 'alternative' as in 'alternative society'. The plural 'alternative archaeologies' is a better name, since one of its characteristics is a diversity of thinking, some of it new, much of it old ideas revived. Partly this is conscious, a feeling that the measure of a wonder like Stonehenge is not to be had by the narrow and reductionist mind of a 'rational scientist'. There will not be a single account, not one agreed 'explanation' that will take away the mystery of this place. This impulse, which goes back to the spirit of 1967 and beyond, is still strong.

If the alternative archaeologies have any inspiration in common, it is the mystical vision of the poet and painter William Blake. In Blake's *Jerusalem: The Emanation of the Giant Albion* 'All things Begin & End in Albion's Ancient Druid Rocky Shore,' and the sons and daughters of Albion walk beneath a vast trilithon, twenty times taller than the trees round its base, or measure out a lintelled temple that twists a snake's tail out across the plain. Ancient British Druids, trilithons and serpentine temples were all picked up by Blake from William Stukeley, and so was his vision of those noble Britons who 'derived their origin from Abraham, Heber, Shem and Noah, who were Druids, as the Druid Temples (which are Patriarchal Pillars and Oak Groves) over the whole Earth witness to this day'.

'The Nature of my Work,' wrote Blake, 'is Visionary or Imaginative; it is an endeavour to Restore what the Ancients call'd the Golden Age.³ And that is the endeavour of some alternative archaeologists. The aim is to awaken charismatic Albion from its enchantment: 'just as astronauts of our decadent, materialistic society reach out for the Moon and outer space, a new breed of Britons look to the countryside for a true vision of the past and find themselves also exploring the infinity of the mind's inner space'. The thesis is 'the existence in prehistoric times of an active science of spiritual physics, whereby the functions of mind and body were integrated with currents in the earth and powers from the cosmos'.⁴ New means of enlightenment – such as the direct experience of the ancient powers (which chemical encouragement has been known greatly to assist), the study of landscape geometry, and the seeking-out of hidden figures outlined in marks on the open countryside – combine with the revival of the ideas of forgotten thinkers like Ludovic McLellan Mann⁵ (of the Stonehenge calendar, page 198), who were written off years ago as worthless quacks. Stonehenge has a special appeal, as the British monument most directly showing both the super-ability of the ancient Britons and the failure of mainstream archaeologists - those 'geniuses with trivia and ignoramuses with ideas'⁶ - to grasp its mysteries. -

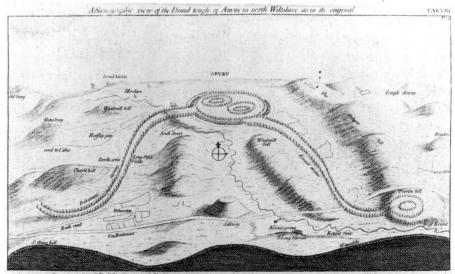

Prehonorabili Dio Dio. Philippo Dio. Hardwich, fummo magne Brittannico Cancellario tabulam. 1.51. D. W. Saukeley.

206 William Stukeley's book on 'Abury' (Avebury) is even stranger than his 'Stonehenge', written earlier. The Avebury avenues became the twisting bodies of great serpents.

207 (above) Several designs of Stonehenge medal exist. One commemorates Stukeley, and others celebrate Druid orders, including one by William Blake.

208 (right) In Blake's 'Jerusalem', a monstrous trilithon rises over 'Three Forms, named Bacon & Newton & Locke, in the Oak Groves of Albion'.

209 (bottom) The 'Serpent Temples' of Salisbury Plain in 'Jerusalem' combine the lintels of Stonehenge with the Avebury serpent plan (opposite).

210 *A mile from*

Stonehenge there used to be this wooden structure, a modern 'woodhenge' whose form, complete with outlying post like a Heel Stone, echoes its prototypes.

On closer look, you see its secular reality: the posts of a stockyard.

Chief among those pastmasters is Alfred Watkins, the miller and photographer from Hereford who in 1921 rediscovered (in the language of heresy) or dreamed up (in the language of orthodoxy) the ancient British system of trackways that he christened 'leys'. From a hill-top in the country, he had a vision in the landscape below him of 'a network of lines, standing out like glowing wires all over the surface of the country, intersecting at the sites of churches, old stones, and other spots of traditional sanctity'. These 'old straight tracks' had been laid out by surveyors or 'dodmen', using staffs like those held by the hill-figure of the Long Man of Wilmington, in perfectly straight lines between the ley-marks – mounds, notches in ridges, beacons, mark-stones, ponds, fords, crossroads, camps, churches, crosses (which had often taken over the older, pagan ley-sites), along earthworks, and so on. A few leys survive as bridle-paths and by-ways; the rest of the lost network is to be found by discovering on the map or on the ground the straight lines that pass through several lev-marks. Running through Stonehenge, for instance, Watkins could draw three leys, one of them Lockyer's axis-line, that linked together burial mounds.⁷ (An obvious precursor of Watkins's Salisbury Plain leys, though not one he acknowledged, was Johnston and Lockyer's equilateral triangle joining 'significant' points, with the oldest crossroads at its centre [ill. 113], which includes both Stonehenge and Old Sarum levs.)

Two of the most famous English leys pass through Stonehenge. The *Stonehenge ley* is Lockyer's south-west/north-east axis line, notorious for his adjustment to make it run through the Sidbury Hill bench-mark. As a ley it starts at Castle Ditches hill-fort, passes through a dew-pond and Grovely Castle hill-fort, over the flank of a bell-barrow on Normanton down, through the centre of Stonehenge and down the Avenue, along the rampart of the hill-fort on Sidbury Hill, over two barrows on Cow Down and across a former crossroads. The known length of this ley – unless further research finds more ley-marks beyond its present ends – is about 22 miles.

Another classic, the *Old Sarum ley*, is a little shorter. It goes north-south, beginning at a barrow on Durrington down, then running over the Cursus, over the Stonehenge bank and ditch (and also across the Stonehenge ley) at the beginning of the Avenue, before passing through

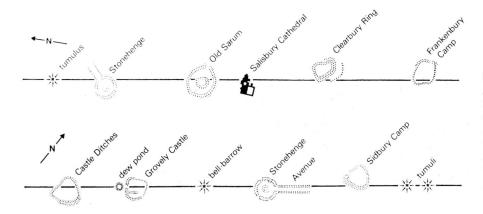

211 Two Stonehenge leys. A ley of a different type is the long-distance alignment between Stonehenge, Avebury, and the 'Stonehenge of the North' at Arbor Low, which is also a major ley focus.

Old Sarum, just by the spire of Salisbury Cathedral, and then by the edge of a hill-fort, Clearbury Ring, a medieval priory and a final hill-fort, Frankenbury Camp.⁸ This again is one of Lockyer's lines, and in another modern version is seen as a long-distance line linking Stonehenge with Avebury and Arbor Low in Derbyshire, which has been taken like Stonehenge to be a major focus of leys.

From the beginning, orthodox archaeologists have derided leys as lunatic fabrications. That in itself can be held as a plus, if you choose to adopt that most useful fallacy of self-justification, the Columbus principle (which goes: they laughed at Christopher Columbus when he said he had found a new continent, instead of taking him seriously – but Columbus was right; they laugh at us instead of taking us seriously . . .). There is also an element of mystical revelation; Watkins, an Alfred on the road to Hereford, was struck in a single moment of imaginative truth by a sudden understanding of the leys. And there is the democratic accessibility of ley-hunting. There are no university professors of ley science to quibble about methods, or tiresome paper qualifications to hold the novice hunter back. All you need is a map, a straight edge, and sufficient patience.

The objections to the whole concept of leys are threefold and echo objections to astronomical views of stone circles. The first is statistical; so many kinds of marks qualify in defining a ley that simple chance will throw up a great many straight lines – especially when a ley is accepted that passes not just through point spots but near sprawling earthworks like hill-forts or large henges. It would be extraordinary, for instance, if many straight lines could not be drawn near Stonehenge that ran through three or more of the many hundred barrows in the area. A second objection resists the inclusion of sites of wildly differing dates, ranging from a Neolithic long barrow to a church some 5,000 years younger, as equal markers in the ley system. And there is the common-sense objection that the quickest route for a trackway between two points is rarely the most direct, especially in an untamed prehistoric landscape. Take, for example, the Old Sarum ley, and accept Stonehenge and Old Sarum as valid points, since a straight line cannot be made without two fixed points. Everything else can easily be dismissed by a hostile critic. The Durrington barrow is a matter of chance, and so is the Cursus (which is so long that *any* straight line drawn at random through Stonehenge is actually more likely to cross the Cursus than not). The reasons for choosing the site for Salisbury Cathedral in medieval times are well documented and have nothing whatever to do with alignments of any kind. The ley does not actually run through Clearbury Ring at all. And as a working trackway the ley would have been a disaster, 'for within eleven miles it crossed four rivers, three times unnecessarily, slurped through a mile of primeval swamp and then waded across another river'.⁹

If leys are not physical trackways, but surface traces of some abstract system, the difficulty of walking them is no objection. Leys then are part of a system of geomancy or landscape geometry, 'a striking network of lines of subtle force across Britain, and elsewhere on spaceship Earth, understood and marked in prehistoric times by men of wisdom and cosmic consciousness'.¹⁰ This idea is the starting-point for all sorts of alternative enquiries; it makes a kind of master ley-mark or intellectual Stonehenge through which run lines of complementary and contradictory exploration in astrology, UFOlogy, numerology, in speculative and psychic archaeology, that can seem as confusing to the outsider as the arcane disagreements within the world of orthodox archaeology.

One or two ideas are so exotic that one wonders if there may be such a thing as 'alternative alternative archaeology'. There is Stonehenge as the setting for a seven-act masonic mystery play, whose performance began on 14 October 3373 BC and is still in progress. Or, in an original variation on the astronomers' speculations as to why there are fifty-six Aubrey holes, an American claims Stonehenge is 'the first accurate sex machine and it still works'. The Aubrey holes represent the menstrual cycle of twice twenty-eight days for each human ovary; the upright (and slightly leaning) Heel Stone is symbolic of the male penis. This is, to be fair, as good an explanation of the Aubrey holes as most; if it had been published like the others as a short paper in Nature, rather than obscurely and privately as a pamphlet, it might have been taken notice of. The author, whose interest in the processes of reproduction is clear. ascribes the personal conviction of his theory to his British ancestry: 'I am reasonably sure that the germ plasm that built Stonehenge is the same as that which wrote this understanding.'11

Orthodox alternative archaeology is usually more straightforward, but there are dangers if you home in too well on ancient forces. One researcher stood on his car roof in the Stonehenge car-park with a home-made aerial. When he pointed it at the stones, from 150 or 200 yards away, an enormous surge of energy seemed to burn his arm. He lost consciousness and was thrown off the car. It was six months before his arm recovered fully.¹²

Another group heard a 'strange clicking sound from the stones'. They started to run, and 'a strange whirring noise shot heavenwards as if a giant catherine wheel had gone spinning upwards'. Later, as they sat at home recovering, the figure of a woman dressed in yellow materialized,

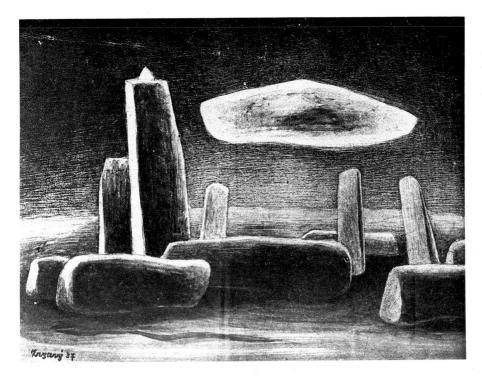

212 Years before alternative archaeology got going, a Czech artist painted Stonehenge under construction using principles of levitation.

wearing long plaited hair and a headdress 'similar to ancient Egyptian', and they had 'the impression there had been some sort of struggle between good and evil that night'.¹³

Levitating great stones by the power of sound, an easy task for an intelligence controlling these kinds of force, must be an obvious alternative to human labour in the building of Stonehenge.¹⁴

Generally, alternative archaeology uses a more oblique approach, combining in modern geomancy elements from Chinese and pre-war German studies as well as refinements of the Watkins ley system. There are the leys themselves, especially the link found by John Michell that joins Stonehenge directly to Glastonbury, holiest of ancient British sites and only some 35 miles away. The axis of the abbey, and of the town of Glastonbury as a whole, runs as a ley over the chapel of St Michael's, Gare Hill, and on to Stonehenge, the other ancient centre of power. Other geometrical constructions in the landscape involve Stonehenge and Glastonbury jointly: a 5-5-3 isosceles triangle, accurate to 1 part in 1000, links them to the significantly named Midsummer Hill; a regular ten-sided polygon can be drawn with vertices at significant places including Stonehenge, Glastonbury, and Llantwit Major, the most famous of the Celtic monastic sites of Wales. (There is a difficulty in this last construction, as the geomancer Michael Behrend admits, 'a slight but definite displacement from the theoretical decagon vertex', which was in all probability a compromise in siting the omphalos made necessary by the number of geometrical conditions Stonehenge must satisfy.)15

Another kind of link is revealed in the dimensions of Stonehenge and of Glastonbury Lady Chapel; in both, the proportion of $\sqrt{3}$ recurs. These geometrical principles are shared also by buildings in Chaldaea and Egypt and by the Gothic cathedrals of Europe (themselves so often built on sites already long sacred as henge monuments).¹⁶

Numerology and gematria, the numerology of letters translated into numbers, also establish links between Stonehenge and Glastonbury (as well as the pyramids of Egypt). Michell has found both places to follow a plan of the number 666, the number of the beast in Revelations, and a sign that both are the New Jerusalem. Recently, Michell has observed that the lintels of the Stonehenge sarsen circle embody in their dimensions 'a synthesis of ancient units of measure, systems of numeration and geodetic standards' in which Stonehenge symbolizes the major dimensions of the earth.¹⁷

The Earth

Stonehenge

Dimension length in ft. \times multiple product in ft. = geodetic constant52.1362275 Outer radius 400.000 20,854,491 polar radius Mean radius 50.4 $207,360 \times 2$ 20.901.888 mean radius 3,000,000/7 Inner radius 48.66048 20.854.491 polar radius Outer radius 52.1362275 2.520.000 131,383,296 meridian circumference Mean radius 50.4 207,360 × ⁸⁸/7 131,383,296 meridian circumference Inner radius 48.66048 2,700,000 131,383,296 meridian circumference Mean circum- 316.8 $207,360 \times 2$ 131,383,296 meridian ference circumference 6,000,000 Width of lintel 3.4757485 20,854,491 — polar radius

The plan of Stonehenge also presents in miniature the distances between the different bodies in the solar system. And the long barrows on Salisbury Plain make up a map of major constellations in the heavens.¹⁸

Michael Dames, who has made many discoveries regarding the meaning of Avebury and Silbury Hill, points out that the lintels of the Stonehenge sarsen circle make a continuous elevated walkway of the same diameter as the flat top of Silbury Hill. Stonehenge is thus 'a megalithic harvest hill with a unique capacity to be nurtured by celestial events', and the importance of its upper surface is shown by the depressions on the upper side of stone 156, conventionally dismissed as failed mortise holes but 'admirably suited to the twin roles of goddess's eyes and libation bowls'.¹⁹

There are patterns underground, too. Work by several dowsers confirms discoveries made by Guy Underwood and published in his *The Patterns of the Past*. Stonehenge, like all the barrows, stands over a spring, one running through the ruin under the Altar, Slaughter and Heel Stones and down the Avenue. As befits a site of such importance, there are all sorts of complexities. Reginald Smith found a hidden spring at its precise centre dividing into three streams; one runs south, the other two

213 John Michell's table demonstrates how the dimensions of the outer sarsen circle of Stonehenge encapsulate the dimensions of the earth.

unite at the north end of the great horseshoe. Underwood tracked more than thirty radiating streams and fissures under Stonehenge.²⁰ And Californian dowsers who have mapped the earth's acupuncture system have naturally found Stonehenge and Glastonbury to be needle-points.

A major element in new discoveries is the link Tony Wedd has shown to exist between ancient power lines and UFOs. Stonehenge, seen from the air, even looks like a classic flying saucer: the bank and ditch are its outer rim, the Aubrey holes its port-holes, the sarsen circle its cabin, the trilithons its raised central cockpit, the bluestones its humanoid passengers; as Michell has said, the whole is 'evidently a sort of cargo cult monument, a pattern of the sacred disc, built to attract this object for which men felt such a yearning'. The Cursus faithfully depicts the larger mother-ship, of elongated cigar shape, often seen to accompany flights of saucers.²¹

Warminster, an otherwise unremarkable town in west Wiltshire, has become famous for its UFOs. Its position, about halfway between Stonehenge and Glastonbury, is significant, and so is its being a garrison centre, hemmed in with military installations.* Warminster UFOs often follow an east-west orbital path, an 'aerial lane' from Stonehenge to Glastonbury. There have been landings, sightings of giant men, the traces and sounds of 'invisible walkers', and exotic floral perfumes that linger when the UFO has gone.²² (That phenomenon is by no means new. John Aubrey records an encounter in 1670: 'not far from *Cirencester* [admitted]y well north of Warminster and just across the Wiltshire boundary], was an Apparition: Being demanded, whether a good Spirit or a bad? Returned no answer, but disappeared with a curious Perfume and most melodious Twang.'²³)

UFOs have been recorded at Stonehenge itself. In 1954, years before alternative archaeology took an interest, a photographer found that on all his photos 'a column of light, like a searchlight beam, can be seen rising into the cloudswept February sky from the very centre of the Trilithon'. There are at least two clear sightings of more recent years. In 1968 Arthur Shuttlewood, an expert on the Warminster UFOs, saw a spacecraft which 'blacked out entirely . . . before becoming a ring of fire that evidently shot from the stones themselves, whereupon the UFO fled upwards from our curious approach'. On an October evening in 1977 glowing lights were seen from Stonehenge moving about in the sky in formations. 'They could hover and change direction instantly; not in a smoothly flowing action, but rather in a swift yet jerky movement. They would change formation, with one object at a time either dematerializing or moving away at terrific speed.' Compasses went awry and a portable TV was erratic, but the UFOs were caught with a cine-camera. The military, not surprisingly, took an interest: 'what appeared to be a strong searchlight, was obviously aimed directly at the aeroforms or UFOs; and it was no use at all. As the beam approached within a certain proximity of the objects it faded away abysmally as if deflected by some subtle force.'24

The association of UFOs and the military has two interpretations. In the benign view, the Ufonauts understand how human existence is threatened by the military's nasty nuclear toys, and make it their business to keep an eye on things. In the sinister alternative, the military and the Ufonauts - if not in active collaboration have at least chosen not to reveal each other's secrets to the rest of us. Note that Stonehenge, though itself still seemingly in civilian hands, is hemmed in by Army and Air Force prohibited areas. Glastonbury they appear to have left alone, at least for the present.

Other researchers, such as Anthony Roberts, have found in folklore and traditional history many memories of the ancient world, with its giants, Atlanteans and flying dragons (most likely the things we call UFOs). The old accounts are often absolutely clear, once you adopt the attitude of the speculative mythologist rather than the hidebound orthodox historian. Geoffrey of Monmouth's history, for example, states in the clearest terms that Merlin the wise shifted the stones that made up the Giants' Round (note the name) by superhuman powers.²⁵

Alternative Stonehenge studies flourish also in California, where Donald Cyr publishes a newspaper, Stonehenge Viewpoint, from Santa Barbara. Partly it is a vehicle for the 'canopy' hypothesis of yet another forgotten thinker, Isaac N. Vail, which postulates a layer or 'canopy' of ice crystals high in the atmosphere in the millennia after the last glaciation. Reflection from the crystals in the canopy would have set up bright 'haloes' at 22 and 44 degrees round sun and moon (such haloes are seen today under certain atmospheric conditions). The Vailian researcher, encouraged by Mr Cyr's example and helped by his mail-order Mark I or Mark II Stonehenge Research Kit, may expect to find circles and angles that show themselves to be hidden haloes all over, not just at Stonehenge and other rings, but in megalithic art, Egyptian pyramids, characters of the Chinese alphabet and, come to that, on the planet Venus. For the rest, Stonehenge Viewpoint is eclectic: there are the perennial attempts by sceptics, armed with anything from pencil and scrap-paper to large computers, to show that 'significant' alignments and haloes are only chance phenomena, and any number of diversions -amap of the world made visible in the markings of a black and white cow, a correspondence on the aerodynamics of the pterosaur, the campaign strategy of the Santa Barbara Pole Sign Ordinance Committee. An early issue ran a cautionary tale of the Santa Barbara Stonehenge Expedition which decided to check the curves in the Stonehenge sarsens. The 'Sagittometer' specially invented for the job passed its 'wring-out' test on the retaining wall of the Santa Barbara Art Museum, but it was less good at Stonehenge. And as they had omitted to ask permission to work at Stonehenge, the intrepid scientists had to work clandestinely. They became too absorbed in their work: the then senior custodian. Len Smith (who had cleaned off graffiti enough times to suspect human huddles by a stone) pounced. But the Expedition was prepared! It moved into protective blocking formation, and young Annette Cyr whipped out a copy of *Stonehenge Viewpoint* to distract the guardian – a good ploy, but not good enough to deflect him. The story has a happy ending: once innocent intentions were proved, Cyr became firm friends with Smith.²⁶

What is to be made of these strange ideas, seemingly contradictory, about Stonehenge? Some are declared personal experience, and cannot be assessed by anyone else. Others are testable, at least in theory: is the number of leys going through Stonehenge actually greater in a statistically significant way than the number to be expected by chance? But such tests miss the point, as the speculative archaeologist Anthony

214 All kinds of elements can be traced in this poster of Merlin summoning sarsens from the vortex. Below is Stonehenge with attendant flying saucers.

215 This amiable ogre, plonking on the lintel without bothering to line up the mortice and tenon joints, decorates the cover of a book on giants.

Roberts has recognized. In commending a 'totally technical treatise' in geomancy for its 'almost bewildering plethora of rigidly scientific analysis', he also noted that it was 'Newtonian not poetic in its outlook and therefore much of the genuine magic is lost'.²⁷ (I have myself seen nothing that begins to approach a proof of 'Newtonian outlook' for any of the speculative and alternative archaeologies of Stonehenge – but Newtonian testing is not what the majority of them are into.)

Of wider interest is the attitude speculative archaeologists adopt, as 'the conscious initiators of a new sacred and mythopeic world view'; they look back to ancient masters, sensitive to earth forces and aware of cosmic vision, who managed technically brilliant works in stone without disturbing ecological balances: 'they lived an immensely simple organic existence which was more related to a "monastic" or "zen" understanding of man's relation to the biosphere and which was dictated by very limited "worldly" ambitions'. That has an attraction as an alternative to consuming materialism, cold science, and shattering of the environment.²⁸

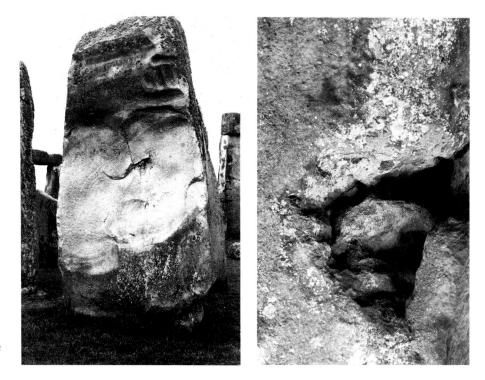

In this view, orthodox archaeologists are not just wrong but dangerous; they are the 'unconscious apologists for industrial civilization', and their careers depend 'upon the maintenance of the myth of the primitive, savage origins of European civilization'.²⁹ The gulf between opposing camps is sure to remain, with the alternative past underpinning present commitments to 'new age' attitudes, while the orthodoxy provides historical authority for the still-dominant framework of social evolution and improvement, from rude primitives upwards and onwards to ourselves.

The alternative learns, grows and develops with new evidence and new ideas. During the 1980s there began each summer to appear 'crop-circles' in fields of English wheat, perfect rings where the corn stalks had been pressed down by some un-understood force. The crop-circles beguiled seekers after the curious, and duly made themselves present at Stonehenge, where one of the most elaborate of them made an 'insectogram' shape in the fields to the south (ill. 225).³⁰ Diverse theories of the circles developed. According to one expert, the circles were made by atmospheric vortices, miniature whirlwinds whose impact would have cast prehistoric people into such awe that they built their sacred places, like Stonehenge, in circular form.³¹ In 1992, some fellows with ropes, broomsticks and a sense of mischief announced themselves as the mysterious powers; human teams in competition tried their hands at replicating an insectogram; and in 1993 crop-circles were less seen in the land.

Feminist thinkers have looked to prehistoric Europe, and found there a gentler and a fairer social order, before 'the Fall' swept men into patriarchal control.³² The proposition of a benign 'mother-goddess' in old

216-219 Four faces in the stones. To the author's eye, these make (this page) a large open human face and a small piggy one; (opposite page) a quizzical bear and (on the Heel Stone) a porpoise.

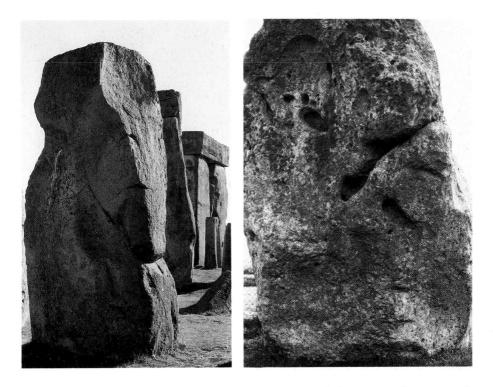

Europe has been revived; the shape of the megalithic mound, a central chamber with entrance-passage deep within the earth, stands for the nurturing womb.³³ Stonehenge finds a place in this vision, though the particulars of the place may encourage male themes. This man might start with the phallic shape of the Heel Stone – large, strong, blunt, crudely unshaped, set erect into the turf at a satisfactorily upright angle.

Stonehenge astronomy has a role in this, for it would demonstrate an out-of-the-ordinary degree of accomplishment and knowledge quite at odds with the dismal vision of the archaeological establishment. I remarked in the previous chapter how claiming Stonehenge as an astronomical observatory-cum-computer seemed to bring it unreasonably into the technology-driven world of the late 20th century, making a prehistoric Britain that too much resembles the ambitions of our own time. In the alternative respect for an accomplished ancient Stonehenge, that same quality is read as a different meaning, touchstone of an antiquity that was, happily, quite *unlike* the world of our own time. The resemblance of long-distance alignments in the Thom schemes to Watkins's network of long-distance leys connects the two worlds of theory, as both set Stonehenge as a node in a system of straight-line geometry.

In 1986 a World Archaeological Congress in Southampton held as one of its themes the empowering of those indigenous peoples and marginal 3rd- and 4th-world communities who look to their history and archaeology for self-respect and self-identity. As power goes with ownership, these issues found expression in the phrase, 'Who owns the past?'³⁴ Europeans in the 1990s have seen a discomforting growth in ethnic and nationalistic intolerance, leading to the civil war in the former Yugoslavia, but in 1986

TO LO MAN IN A INFORM OF IN TALAS ETIO 200

Stonehenge reconstructions are as curious now as they have ever been.

220, 221 In the 1930s (above) roofed with thatch; and (left) in the 1870s, the ground floor of a tower of indefinite height.

222 (below) In the 1970s, oddly reminiscent of the wilder fancies of Meyrick and Smith (ill. 61) and illustrating a textbook on prehistoric Europe. Notice the chevron designs (from passage-grave art), the axeman on a sarsen, and the cosy bullskin outfits.

(above) 20th-century sculpture, in its massive abstract forms, owes much to the megaliths. Haydn Davies's 'Homage', 1974.

(below) As well as fine photographs, there are good modern Stonehenge prints that capture the magic. This is from a set by Norman Stevens.

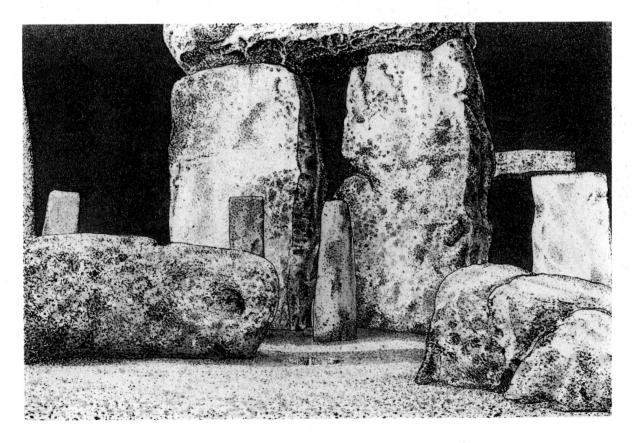

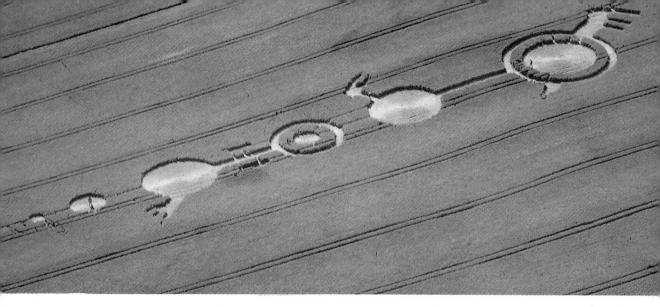

225 'Insectogram' complex crop-circle in the corn to the south of Stonehenge, 1991. the question seemed to apply to other continents, like Australia and America, of divided history. Some of us brought the question home to Europe by asking 'Who owns Stonehenge?' of an earth-mystery researcher, of a native Briton, of the Secular Arch-Druid, and of an orthodox archaeologist. The resulting essays, gathered together as a book,³⁵ showed tolerance, if not much shared and common ground; it began, 'This book is for Stonehenge', in sign of our common respect. Rhys Jones, as a Welsh patriot, created a 'land-claim' to Stonehenge. No part of an 'English heritage' and a sacred place of the ancient Britons, the monument rightly belongs to their Celtic descendants who were dispossessed by in-coming Romans, Saxons and English. Professor Jones, when not a full-time Welshman, is an archaeologist in Australia where he finds 'owning the past' and then an excluding 'control' of the past by its 'owners' helps none of us; so, having created a good claim as a British Aboriginal, he chose not to press it.³⁶

Paul Devereux emphasized the breadth of his 'earth-mystery' studies that enlarge on ideas drawn from Chinese earth-magic, from leys, archaeo-astronomy metrology, and from the old lore of the places. A particular interest has been the rumours of energies at British megalithic sites, explored since 1977 by the Dragon Project. Its work includes both primary direct human sensing, and instrument measuring of electrical and magnetic fields; it has also found anomalies with regard to 'natural radiation, ultrasound, radio propagation and other energetic effects'. Only magnetic studies have been made at Stonehenge (ill. 226), a geomantic centre where access is difficult to obtain and artificial interference may mask electromagnetic fields.³⁷

Tim Sebastian, as Secular Arch-Druid, set out the long history of Druid lore since that ancient period 4000-1500 BC, when a government of Bards ruled Britain by Orphic methods. Many mystics and seers are related to Druidism, or contribute to its perceptions – from John Dee the Elizabethan mystic, through to Madame Blavatsky and the Theosophists, the magician Aleister Crowley and his Hermetic Order of the Golden Dawn, and into our own time, when John Lennon was Arch-Druid of the Silver Beetle. $^{\rm 38}$

Alternative archaeologies are not going to disappear, as one sees in the 'new age' section most bookshops carry. Nominal inspiration of the Stonehenge free festival, the physical powers of ancient Stonehenge are felt to be real even today. What is one to make of a young mother who takes her handicapped child to lie upon the stones of Stonehenge at the solstice, so that the ancient forces may make the child whole? Does she know, I wonder, of the dead archer bundled into the hole in the ditch, the arrows still sticking in his ribs? Or of that other child taken in ancient days to a spot just over the ridge where the summer sun rises, there to have its head chopped in half and be buried at the centre of Woodhenge?

Myself an orthodox archaeologist happy in the other camp, I have an affection and a respect for the alternative visions across the divide. I do not think the alternative archaeologies have produced, or will produce, a better knowledge of prehistoric Stonehenge than can my archaeological colleagues. The Dragon Project reports puzzling effects, but I doubt these will turn into an enduring proof of other-worldly powers at the stones, any more than an eminent engineer has proved a 'megalithic science' there. In principle, and in due time, rational enquiry will resolve all this. Rather I like the alternatives for their irrationality. Modern Stonehenge has become an 'archaeological site', an 'ancient monument', a 'tourist attraction', a 'marketing opportunity'. But prehistoric Stonehenge was never this; it was a sacred place of uncomprehended power on a mysterious earth. The historical authority for the beliefs of the modernday Druids seems to me a mess of misunderstanding and credulity, which has no connection with the religion of prehistoric Britons. More valuable, and most important for Stonehenge as we come to the 21st century AD, is that enduring attitude to the place the alternative beliefs offer, not as an artefact tamed by our own age but as a sacred place. Here there is a resonance with truth of an ancient Stonehenge. This is why I wish good luck to them!

226 Dragon Project volunteers set up magnetic tests at the Stonehenge bluestones, 1987.

227 (right) Not (or not necessarily) a vestal virgin. The Stonehenge Festival in occupation during the solstice afternoon.

228 (left) 'Is this a dagger that I see before me?' BBC TV drama crew filming at Stonehenge, but not 'Macbeth'.

ONEHENGE COMPLETE STONEHENGE COMPLETE STO HENGE COMPLETE STONEHENGE COMPLETE STONEH 6 A FUTURE FOR STONEHENGE NGE COMPLETE STONEH IGE COMPLETE STONEHENGE COMPLETE STONEHENGE C COMPLETE STONEHENGE COMPLETE STONEHENGE C

'Press passes and Druids only permitted'

Over the last thirty years, while archaeologists, astronomers and alternativists have chased their ideas around Stonehenge, the Ministry of Works and its successors, the Department of the Environment and then English Heritage, have been facing the more practical and pressing task of preserving the monument itself.

The vesting of Stonehenge in the State, and of its surroundings in the National Trust, safeguards its physical survival. The immediate danger of the 19th century that Stonehenge would simply cease to exist, whether removed in its entirety or destroyed piecemeal by the chipping of all those little hammers, was safely averted. So was the threat that it might exist only as an anachronism in a suburban sprawl.

The Victorians, we have seen, found Stonehenge infinitely crowded (so had Stukeley early the previous century). In the early 1920s the Board of Works turnstile registered 20,000 or so visitors paying their sixpences each year, but this was as nothing to the post-war boom – 124,000 in the Festival of Britain year, 1951; 337,000 in 1961; 551,000 in 1971; 546,000 in 1981; 615,000 in 1991.¹ Stonehenge, the most visited prehistoric monument in Britain, ranks with the Tower of London as Britain's international celebrity attraction. The numbers vary with the season, so 5000 a day at the summer peak is to be expected.

The building itself is of hard stone (the softer of the bluestones have not survived above ground), but even sarsen wears in the end if enough bodies rub against it and enough shoes climb on it. Far less robust is the grass-covered chalky soil round the stones. No turf can stand the tread of a million and more feet in a year.

During the early 1950s, the numbers were just about manageable; the grass wore away each summer, but recovered in the off season. The only improvement that had seemed necessary was the construction of a range of subterranean lavatories in the car park. (They gave a lot of trouble; preserved among the Stonehenge records in the Public Records Office, but not to be made public until the year 1998 – lest a state secret should be prematurely leaked – is an entire file on 'Underground lavatories: inadequate drainage'.²)

The more visible damage was to the Stonehenge barrow-groups. In 1954 a caterpillar-tracked 'prairie-buster' ploughed over standing barrows in the Normanton Down group that were scheduled under the Ancient Monuments Act. The bailiff and agent were prosecuted, but the Inspector of Ancient Monuments testified that in his opinion no serious

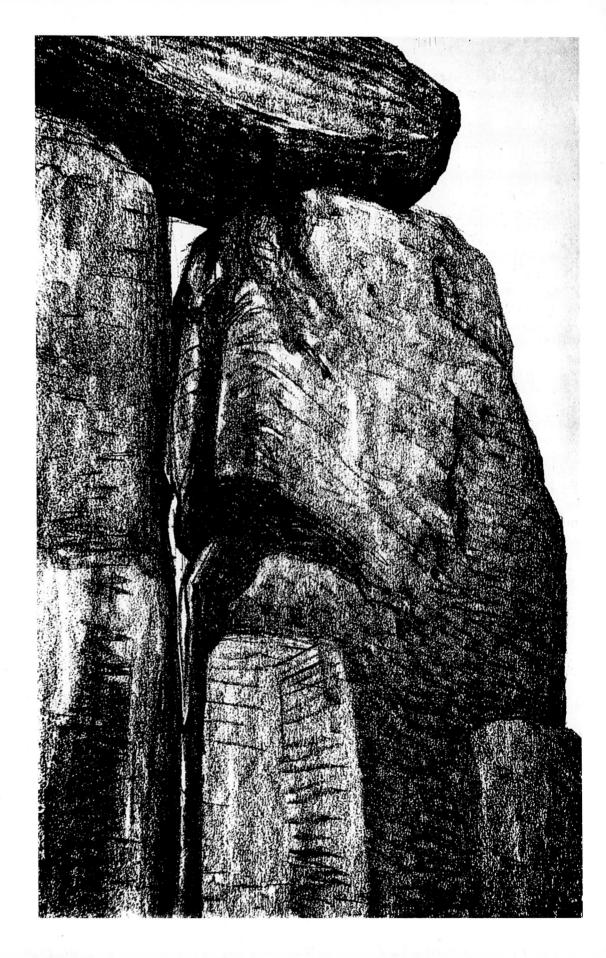

archaeological damage had been done, and the case was dismissed.³ Every year cultivation strips away a little more of the eroded remnants of the many barrows already under the plough.⁴ (The Normanton Down barrows are now safe behind fenced enclosures, but the land around them is arable and they stand out during most winters as little green islands in a desert of ploughed earth. The National Trust policy is to keep its land around Stonehenge under grass, so the barrows there are more seemly in a sea of green.)

Deliberate vandalism was mercifully rare, until the 1960s at least, when there was a rash of paint daubings – 'BAN THE BOMB', 'FREE WALES', for instance – and student rag slogans. Improved security, in particular a microphone system to detect night-time intruders, dealt with that in the end. (The microphones also caught some courting couples, until word got around that Stonehenge was no longer a lovers' haven.) Extra precautions were needed during the excavation and restoration programme, of course, and there were occasional special events. In 1958 the new Southern TV company filmed a four-jet Valiant atom-bomber as it flew at low altitude down the Avenue to Stonehenge in a stunt for one of its first transmissions. And in 1961 the ashes of a former chief custodian were, by his wish, scattered at Stonehenge.⁵

The solstice celebrations continued at least as rowdily as ever, though the pre-war custom of a resident jazz band had lapsed. Instead there were stalls, side-shows, Morris dancers and curiosities like Len Buckland's dancing skeleton that bounced in time to a wind-up gramophone. It made a fantastic scene in the dark, 'a howling mass of people, old, young, children jumping the prostrate stones, teenagers running madly chasing each other and shouting, others sleeping on the ground wrapped in rugs, picnic parties, litter and bottles lying around'.⁶ As dawn neared, the footholds on the stones filled up with climbers, and the Druids pushed a way through the packed crowd to celebrate the solstice as best they could in the embrace of an agnostic congregation. It was unseemly, messy (in 1961 the broken bottles filled eight wheelbarrows), and seriously dangerous - no one really knew whether all the stones were absolutely secure. One year the rhythmic sway of the crowd so alarmed the police that a Southampton university student on a high stone was induced to choreograph their movements with a large stick of rhubarb and conduct them gently to a halt.⁷

From 1962 onwards temporary barbed-wire fences helped keep the crowd under control; in 1969, even these were defeated when a 2,000-strong mob surged over the wire, engulfed the Druids, and conducted its own impromptu ceremonial. The year-round mass of visitors was having its effect, reducing the circle and access path to a sea of mud; so during 1963 Professor Atkinson had the melancholy task of supervising the removal of turf and top soil from the central area, and the filling of all previous excavations within the outer circle of sarsens. In its place went loads of clinker from the Melksham gasworks, and on this a surface of orange gravel.

229 (opposite) Henry Moore, as a student at the Royal College of Art, first saw Stonehenge lit by the moon on a September evening. That first glimpse remained for years his idea of it. In 1971-3 he made a suite of Stonehenge lithographs which progress from sunlit stones to the darker forms that are cloaked inside the stones, like this 'Cyclops'.

(opposite above) At the height of Beatlemania, these five Bogles materialized one morning.

(opposite below) Summer solstice in the 1980s: tents, tepees and cars in the festival field, more cars in the official car-parks, temporary police station, and somewhere behind it all, Stonehenge.

(right) The high point of the solstice celebration, 1966. The crowd chanted, 'Off, off, off, 'but the flowered underpants stayed on.

(below) Summer solstice in the early 1960s. The Druids squeeze with their banners through the crowd. The best vantage point is on top of the stones.

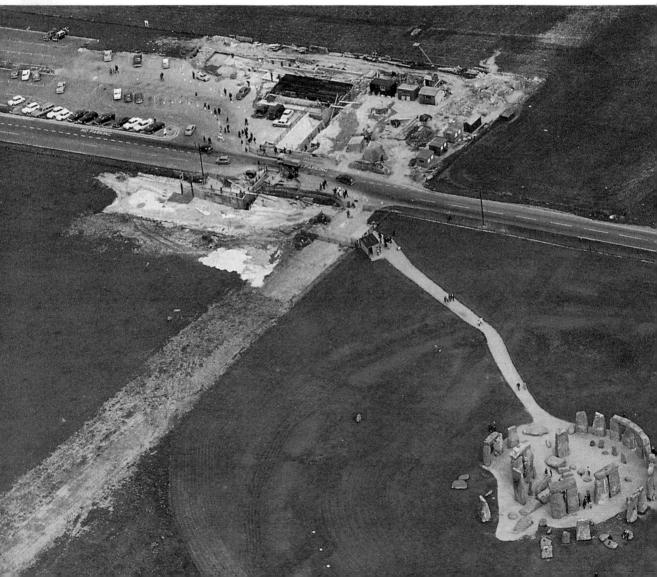

The car-park was too small, and it was dangerous crossing the road from it to get to the entrance. So in 1968 the visitors' facilities were rebuilt, with a larger car-park, new café and bookshop, and a new entrance through a concrete tunnel built under the main road. That has sufficed since, with the addition of an overflow car-park and another range of lavatories (these perched high off the ground as if to counterpoise their subterranean brothers at the other end of the car-park).

The 1974 solstice celebrations were notable for a large contingent from the alternative society, summoned by the pirate station Radio Caroline to a festival of 'love and awareness'. When the crowds drifted away, thirty or so stayed behind, calling themselves the 'Wallies of Wessex', living in makeshift plastic tents, and settling down to community life (smoking strange-smelling substances) and exploration of their theology, an elastic creed that embraced 'the sun, of course, God, Jesus, Buddha, Allah, the earth, the environment, and Oglolala, the mystic poet of the Sioux tribe' (but not Druidism).

234 (opposite, above left) Standard-issue lightweight metal railings to steer visitors make a bizarre contrast with the sarsens, 1972.

235 (opposite, above right) RESCUE, the archaeological pressure group, naturally uses an emblem of Stonehenge bulldozed away to symbolize the threat to Britain's past.

236 (opposite below) Stonehenge dwarfed by construction work for tunnel, facilities bunker and larger car-park. The path and gravel at the centre are conspicuous.

237 (right) RESCUE's bulldozer was intended as a symbol; the GPO's was a reality. The 1979 rescue dig in progress by the Heel Stone (right, behind the midsummer barbed-wire defences). The black 'finger' in the foreground is the trench dug by the machine before it was stopped.

That was the beginning of the Stonehenge free festival, which soon established itself, against all the wishes of the Department of the Environment and the National Trust, as a regular annual event. Since it was unofficial, it had no organizer as such, but each spring posters appeared, reading 'Rumour has it that another free festival will be held close to the site of Stonehenge starting 15th June (so come aid a rumour).' The rumour duly materialized, a crowd several thousand strong taking possession of the field between the Stonehenge car-park and the cursus. The afternoon of the solstice day was the festival's opportunity to go to Stonehenge itself, and all manner of strange celebrations took place among the stones. In the evening, the festival retired once more to its field and perhaps to the serious business of dope-dealing which was rumoured to be its principal *raison d'être*.

The free festival was only one of an unending series of Stonehenge problems its custodians over the years have had to face. One might have thought Stonehenge at least is famous enough not to be dug up accidentally. But no. In May 1979 the Prince of Wales was guest of honour at the celebrations in Amesbury of the town's millennium. Since he had read archaeology at the University of Cambridge and still keeps up his interest in it, the Prince was invited to go on from Amesbury to Stonehenge in the afternoon. The senior civil servants responsible for Stonehenge, coming down from London in the morning to prepare for the royal visit, were greeted by a remarkable sight. A bright yellow machine was busy on the road verge tunnelling its noisy way along a trench towards the Heel Stone. The beast, it turned out, was a GPO cable-layer putting in a new telephone link (called, inevitably, the Stonehenge cable). Somehow, notification of the plan had slipped through the machinery of archaeological liaison. Mercifully, the machine was stopped before it reached the Heel Stone; a reprieve was granted, and Mike Pitts of the Avebury Museum carried out an instant rescue dig (with important results, Chapter 17), but it had been a close shave.

In 1975 the annual number of paying visitors to Stonehenge reached – not for the first time – the figure of two-thirds of a million, and the Department of the Environment (DoE) felt Stonehenge simply could not stand any further growth in popularity. The peak-season admission charge was jacked up as a discouragement, and the DoE began to think about long-term solutions. A working party was set up, and there began an exploration of what was wrong at Stonehenge, and what could be done about it. In 1993, as this edition of the book went to press, that exploration was still in progress, under the personal direction of English Heritage's vigorous chairman, Mr Jocelyn Stevens; his predecessor, Lord Montagu of Beaulieu, had announced a new future for Stonehenge, when English Heritage was born in the 1980s and took over its care – but retired with nothing concrete achieved.

While the long term began to be discussed, the DoE went ahead with interim measures. The gravel among the stones was taken up, the turf restored, and public access to the stones ceased. Instead, visitors were sent along a new green-tarmac path that goes inside the bank and ditch on the west side. It is laid on the line of one of the by-ways closed early this century, so should have made little impact on unbroken ground. Visitors make no impact now on the stones or the ground immediately around them, though they do make an impact outside the bank and ditch where moving the path around is not enough to stop the grass being pounded into summer dust and into winter (and sometimes summer) mud.

In 1985, the authorities' grudging tolerance of the Stonehenge festival came to an end. The A344 road by Stonehenge was closed, the police mobilized, and a convoy of vehicles heading for the festival was halted by a police roadblock. A violent confrontation, the 'Battle of the Beanfield', followed, and there was no festival at Stonehenge. There were confrontations with 'The Convoy' each summer over the next few years, until it was clear no festival would be tolerated. Each year the police prepare with large powers – including the right to stop any procession of more than two people within a few miles of Stonehenge (unless for a funeral) – and with large forces. In some years, some solstice ceremonial has been permitted to Druids, usually on the road outside, rather than in Stonehenge itself.⁸

The routine of summer events during the later years of the Stonehenge Free Festival were so odd they merit description at length; I write this next portion in the present tense, to emphasize this was during these years business at Stonehenge as usual.

They begin with the building of the official fortifications, rolls of razor barbed wire, to prevent the festival seizing the place. Khaki floodlights and loudspeakers go up round the perimeter. The concrete bunker with its slit windows is the HQ of the defending forces; the solemn, darkuniformed guards and the sentry-boxes scattered round the site fit with the military look to this temporary Stonehenge Gulag.

By the evening before the solstice, the Stonehenge free festival is in full swing. At first glance it might be any legitimate camp-site, with new cars, large frame tents and powerful motor-bikes scattered about. But a scatter of big tepees, a van lovingly painted in psychedelic colours with that famous word 'Woodstock', the whiff of joints, the stalls selling wholefood burgers, and the music show we are in the alternative society.

238 Stonehenge on a Suzuki.

At night the Stonehenge area is usually entirely in darkness, but the Gulag has its security lights, so as you come over the hill from Amesbury vou see round Stonehenge - and beautiful it is - a circle. perhaps a quarter of a mile in diameter, outlined in vellow light and seeming to float off the ground like a restless ring of giant candles. By midnight the car-park is full to overflowing (and so are the lavatories). Everyone hurries down the green lane to the disc-barrow on Normanton Down, where the Druids pass their midnight vigil. Towards two o'clock they process back. It is disconcerting to find that a Druid procession leaves – of all things – a strong smell of aftershave in the morning air, and that something so British as a line of Druids should converse among itself with a North American accent. They all wear white robes and most of them white socks and shoes, but a few nonconformists prefer snazzy jogging shoes with bright flashes. They pick their way through the car-park, disrobe and retire to the Druidical coach parked in its usual spot by the mobile police station. (One year the coach bore the memorable slogan, 'Daily services London-Colchester-Clacton', but the services seem to have been the coach company's, not the Druids'.) Come three o'clock, the free festival's music stops for the night. A bus labelled Elim Pentecostal Church roams the official car park (are the Druids about to be evangelized?), but it turns out to belong to the festival and lumbers off into the field.

By about three-fifteen, the light is strong in the morning sky. An advance party of Druids goes through the tunnel into the Stonehenge Gulag to keep brief vigil, then comes out again. Outside the barbed wire, spectators gather.

Inside the administrative bunker, the civil servants of the Facilities Unit of the Information Directorate of the DoE are checking in accredited journalists, who have been allowed to enter past the sign that reads 'Press passes and Druids only permitted'. The press goes through the tunnel into the Gulag, followed by the Druids in procession with the various articles of their faith, a cross, banners, a copper globe hanging from three chains, a small silver cup, and a couple of oak sprigs. The rites begin, and the crowd discovers Druid worship is not diverting to the outsider. There is standing, there is walking in procession, there is more standing. Evidently Druids, like royalty, need to be blessed with sturdy legs and good bladders. Quiet words are quietly spoken. There are police stationed all round the Gulag periphery, but there seems no need of them. The crowd watches, shouts occasionally, 'Where are the vestal virgins?' The north-east sky brightens, the Druids process down to the Heel Stone for further devotions (during which the chief Druid anxiously consults his watch). They then retire into the centre of Stonehenge and form a ring. Above them the photographers crowd together on the remains of the great trilithon; those in the know have put themselves in line to catch the sun just above the Heel Stone. At last, about five-and-a-half minutes before five o'clock, the first glint of the sun comes through the trees on the Larkhill horizon. It is very

239 'Heritage', screen-print by Carry Akroyd, 1985, captures the image of the Stonehenge Gulag.

noticeable how fast it moves *along* the horizon as the complete disc comes into view. The crowd cheers, with restraint. The Druid ceremony drones on. Have they not noticed? At last they acknowledge the dawn, raising long bronze horns and blowing them, quietly. (The horns, far from being yet another age-old element in ancient ritual, were only introduced recently, when an alert off-duty Druid spotted them in a London street-market and snapped them up at a bargain price. They may in fact be Tibetan.) The press scuttles away and out of the Gulag. The Druids process out to their coach. Announcements are made ('dianarchs and pages report to their elements'), banners go away into the coach boot, and the bolder on-lookers try to get the Druids to explain just what they have been worshipping.

At noon the Druids carry out their last ritual inside the Gulag. When they have finished, the festival floods into the sacred space, for amiable hours of empathy with earth magic and leys, feeling the true power of the ancient stones, meditating, chanting mantras and striking bells, dancing, conducting christenings, a wedding and – very nearly – a birth (the St John Ambulance Brigade intervene), and removing some of its clothes.

All that came to an end in the confrontations of the mid 1980s. Since then Stonehenge has been more peaceful, but in surroundings unworthy of so great a place. The designation of Stonehenge and Avebury as a World Heritage Site, the public commitment by English Heritage to make its flagship site a model of the best practice, and continued condemnation of its present state – a House of Commons committee in 1993 called it a 'national disgrace' – mark the pressure that something *must* be done. The passing of so many years show how hard it is actually to do something. A joint English Heritage/National Trust plan, announced in 1992 and withdrawn in 1993 for further development, includes elements that are widely thought essential.

First, the A344 that runs so close by Stonehenge must be closed, so that the monument is re-united with the Avenue that makes the ceremonial approach. The A303, main road from London to the West Country, is an intrusion as well. By coincidence, in 1992 the Department of Transport made it known that the A303 is to be widened and improved; if it is diverted well clear, or dropped into a long tunnel under the Stonehenge environs, then the other highway that intrudes on Stonehenge will go as well.

Second, the visitor facilities need to be moved well away from Stonehenge. Their present site is much too close, and therefore intrusive. They are also much too small and cramped – but facilities cannot be improved there because better and larger provisions would be more unsightly still. The present car-park, café and so on are placed, it must be remembered, on land that was bought by public subscription and vested in the National Trust expressly to prevent car-parks, cafés and so on being set on it.

Combining these two essentials produces a strategy of closing one, preferably both, main roads, and of building new facilities at a good distance. At the edge of or beyond the National Trust holding, they would respect the spirit of its purchase. The distance would permit facilities to be on the large scale needed to cater well for a million visitors and their cars. The 1992 scheme, in the competition-winning design of Edward Cullinan Architects, does this, depending on a closed A344 and using a site at Larkhill about two-thirds of a mile north of Stonehenge. Diverting or tunnelling of the A303 may allow new options for locating the facilities.

The architects explain:

'It would be wonderful if the roads could be closed or moved away and the fences or paths be taken away. This would return the landscape to a rolling sward of sheep-grazed downland and would allow people to walk where they wanted, without paths, on the tough dry grass...'

240 Edward Cullinan Architects' design for a Larkhill visitor centre reconciles demands that it be large yet inconspicuous in the landscape, by placing it largely underground, as this cross-section shows. South facing and turf roofed, it is set into the chalk hillside. A promenade on its rooftop will lead the visitor to a large round grass platform, from which Stonehenge can clearly be seen.

'So a building in a valley on the north side of this landscape should be less a building and more a gateway or portal and that is what our building is.' 9

Working up this plan has taken years. Local people do not want the convenient A344 to be closed at all. Building at Larkhill does not follow planning policy for the area. Access to Larkhill would mean a new road through an archaeologically sensitive landscape, a contrary act if the existing roads are being closed. A distant centre requires visitors to walk to Stonehenge in Wiltshire weather, whereas now they can drive and mostly stay for only half an hour or so. The Stonehenge visit today is 'nasty, brutish and short'; visitors tomorrow will have to invest more time for a better vision.

In 1993, many obstacles stand in the way of this attractive ambition. Will the Department of Transport's new A303 be removed? How is a big new visitor centre to be funded? Private sponsorship, perhaps from overseas, is envisaged, which in many countries would be thought an odd way to celebrate a patriotic symbol that is in public ownership. May the many passionate lobbies block each alternative scheme? Will the members of the National Trust, a democratic organization which owns 99 per cent of the combined English Heritage and National Trust holdings, be persuaded that the English Heritage style is what they want?

Quite different strategies are possible. The preferred and most other plans start from demand: how many people want to visit Stonehenge and what facilities do they expect? A different approach can start from supply. One can define a proper Stonehenge experience; in my view, it is freedom to wander among the stones, on grass, without being conscious of a crowd. Experience through the early 1950s, when the grass crumbled, shows this may be available to no more than 50,000 or so visitors a year just one-twentieth of the approximate million which one now expects. The discrepancy is so large one cannot expect either English Heritage or the tourist industry to think in terms of that 'supply'; they will work to meet a 'demand', and perhaps try to regulate its peaks or growth. Some of the million may go no further than the visitor centre – and this may prompt the erection of a 'Foamhenge' replica there. If a million visitors each with two feet do walk across the rolling sward to the stones, and then walk back again over downland grass which is not that tough and often not dry, they will not be able to walk freely among the stones, and will as today – be obliged to view from a distance.

Barbara Bender, a London University archaeologist, observes that Stonehenge has recently been a 'contested landscape', disputed among different story-tellers, physically fought over. She fears an over-managed, controlled place and thinks instead of openness, for 'Stonehenge belongs to you and me.' Will there be in the new English Heritage landscape of Stonehenge an assured place for Druids, eccentrics and personal visions? Should there be? Will the interpretation go beyond basic facts and archaeological understandings to include astronomers and earth-mystery researchers? Should it?

STONEHENGE COMPLETE STONEHENGE COMPLETE S' Nehenge complete stonehenge complete ston Engenge C **17 Stonehenge: A basis of knowledge** of Lete stonehenge complete stonehenge comple Stonehenge complete stonehenge complete

'The Stonehenge we deserve'

After all these centuries of theory, fieldwork and excavation, how much is actually known of Stonehenge? What is it? Who built it? Why?

Every age, as Jacquetta Hawkes has said, has the Stonehenge it deserves – and desires.¹ Every recent century before our own, for instance, has reflected the formal importance of Christianity in Western culture in the belief that Stonehenge was a temple, a religious bulding of a people whose greatest work naturally was dedicated to a sacred purpose. Now, in a secular century which holds scientific research in high esteem, we find it more fitting to have a Stonehenge that is an astronomical observatory to record the forms and patterns of the natural world.

In our more divided and diverse times, a growing range of views about Stonehenge compete and overlap. One can see in them not just the spirit of a confused age, but the backgrounds and the personalities of the individuals who propagate them. The most precise exposition of a geometrical basis and a megalithic science is by a Scots mechanical engineer. The researcher who postulates that prehistoric Stonehenge astronomers might have belonged to a genetically distinct group with an intellectual level 'higher, and perhaps considerably higher, than the present day norms'² is Sir Fred Hoyle, a famously original scientist with unconventional theories of the origins of ice ages, life and the universe.

Over the last few years it has been the astronomical hypotheses of Stonehenge that have made the running, even though there is inadequate evidence for *any* astronomical alignments beyond the solar orientation of the axis. The rather different claims of alternative archaeologies for Stonehenge are likewise unproven.

Orthodox archaeologists, also susceptible to beguiling ideas, have produced some facts about Stonehenge, on which astronomers and alternativists both depend as the foundation for deduction. Most of these facts are technical and mundane. There are several thousand surviving finds from Stonehenge, beyond the many lost or dumped in earlier years, but they make a dismal collection: hundreds and hundreds of little chips of sarsen and of bluestone, scrappy rough-worked flints, small and abraded fragments of coarse pottery, and miscellaneous rubbish left by recent visitors. One can understand why Colonel Hawley came to be so tired of finding things. The stones of Stonehenge are, by their size and strength, quite well preserved, but their builders have gone; we do not know, for instance, where the army of workers lived while the sarsen building was taking shape, still less the point of the whole enterprise.

So the summary of the known, the certain prehistory of Stonehenge that follows must inevitably be a fairly cautious catalogue of periods and events, lacking the more interesting and speculative views, whether astronomical, archaeological or alternative.³

The conventional division at Stonehenge is into four monumental phases, numbered I, II, III and IV, with important sub-divisions of IIIa, IIIb and IIIc. Our knowledge of I and II is less good than of III, the building of which erased or interfered with older traces. The first Stonehenge was built in a cleared area which soon became much overgrown, the site perhaps abandoned. Much later, the new and very different kinds of structures of phases II-IV were set up on the same spot.

Standing back from that Old Stonehenge and the separate New Stonehenge, looking at the spot in a wider landscape and a wider society, one must think also of a Before Stonehenge, an After Stonehenge, and – many centuries later – a Discovery of Stonehenge. Remembering that the word 'Stonehenge' is not the original lost name, but a creation from the time of Discovery, one might prefer to call this event of which we are ourselves a late part an Invention of Stonehenge.

Before Stonehenge

Of human activity in the environs of Stonehenge during the early post-glacial period there is little sign. The three pits in what is now the Stonehenge car-park contained traces of pine-wood (an indication of the nature of the forest cover); radiocarbon analysis shows that the wood dates from the 8th or 9th millennium BC^* and that therefore these holes precede by many centuries later events at Stonehenge.

From the 4th millennium, evidence of human occupation by farming communities proliferates. A dozen major monuments – ten long barrows for collective burials, a long 'mortuary enclosure' on Normanton Down, and a 'causewayed camp' (circular enclosure) at Robin Hood's Ball (north of Stonehenge and Larkhill, where the artillery ranges now are) – pre-date even the first phase of Stonehenge. Causewayed camps, with their attendant flocks of long barrows, are spaced across the Wessex chalklands; they may show territorial divisions between different social groups, each owing allegiance to the land belonging with their particular causewayed camp.

The Cursus, and the Lesser Cursus to its west, probably were built during the period of long barrow construction and therefore belong with, or even pre-date, activity at Stonehenge.

The first Stonehenge, then, was constructed among other, broadly contemporary monuments, in a landscape already partly grassland. It was part of a complex of ceremonial structures, already several hundred years old when its site was chosen, with a causewayed camp as its central territorial focus.

* These, and other dates in this chapter, are as measured by recalibrated radiocarbon.

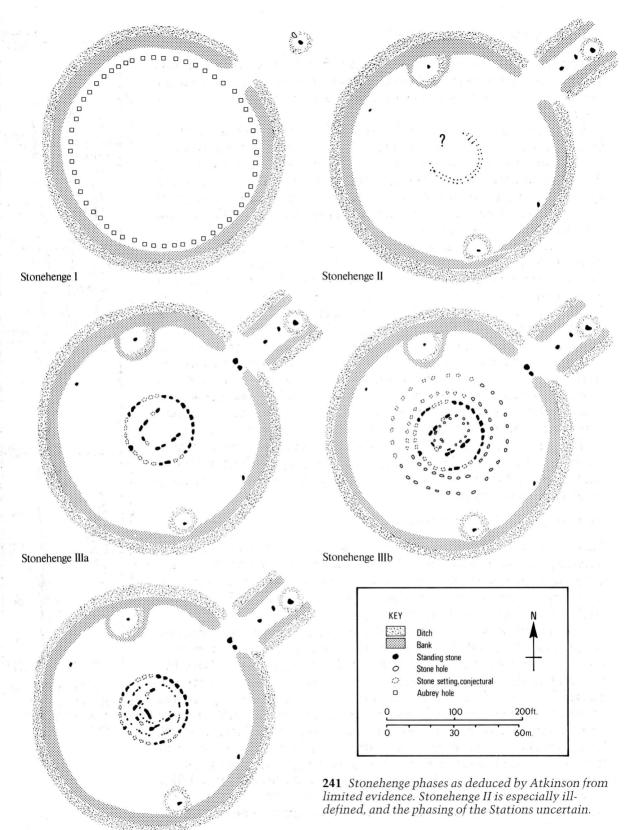

Stonehenge IIIc

Stonehenge I (c. 3100 to c. 2300 BC)

dates BC period 4000 Early Neolithic Lesser Cursus 3500 Robin Hood's Ball L 3000 Coneybury Henge Late Neolithic Cursus I ditch 2500 11 2000 Early Bronze Age Illa IIIb Wilsford Shaft 1500 Middle Bronze Stonehenge Illc Age IV 1000

242 Radiocarbon dating

Stonehenge and in its

of structures at

environs.

Stonehenge – Old Stonehenge – is just one of five 'henges' in the environs. There the ditch was dug with deer-antler picks, and the chalk from it piled into a bank about 6 ft high. A broad entrance-way was left on the northeast side.

Within the bank the circle of fifty-six Aubrey holes was dug, and the holes almost at once filled in again. Their purpose is unknown and perhaps unknowable; they seem never to have held stones or posts, and the evidence only justifies calling them ritual pits, that is, pits which appear to have had no utilitarian purpose. (L.V. Grinsell has, harshly but fairly, defined a ritual pit as 'any pit found by archaeologists, the purpose of which is not evident to them'.)

Two stones were put up in the entrance-way (sarsens, perhaps), and a four-post wooden structure about 65 ft beyond it. The Heel Stone, the first of the surviving sarsens at Stonehenge, was set up as the successor of, or partner to, the stone whose hole was found in 1979. The Heel Stone is unshaped. It might have been found locally, as a few stray sarsens are known in the Stonehenge area, of which the Cuckoo Stone at Durrington is the best known; or it might have been dragged overland from the Marlborough Downs. Boles Barrow, though not radiocarbon dated, is known to belong to this period (or even earlier), and its Welsh bluestone shows that foreign stones were already transported into Wessex well before any known at Stonehenge. A mass of small post-holes in the Stonehenge entrance also belong in this period.

The excavations of the 1950s, on which the sequence is based, were in the early years of the radiocarbon dating technique; few determinations were made, and the values on which the dates of this and other phases depend have large uncertainties.

Stonehenge II (с. 2150 to с. 2000 вс)

This – the start of New Stonehenge – is the first remodelling of the original plan. The axis was shifted round towards the east a little, and part of the bank backfilled into the ditch to widen and re-direct the entrance accordingly. The Avenue was begun, as a parallel pair of banks and ditches, on this axis for about 500 yards.

This new orientation is, to a high degree of accuracy, on the rising sun at the midsummer solstice, a choice of direction held to be deliberate. It may imply an element of sun worship in the religion of its builders, but not necessarily: Christian churches and Moslem mosques come immediately to mind as modern religious buildings whose systematic orientation has causes of a different order. And modern buildings have been given solar orientation with secular purpose or through whim; Brunel is said to have set the line of Box Tunnel on the Great Western Railway so that the dawn sun would shine through it on his birthday.

The two stones at the old entrance were re-set on the Avenue midline between the entrance and the Heel Stone, round which a narrow ditch was dug and soon filled up again. Inside, bluestones were set up in a double circle of Q and R holes, their first appearance on the site. But the circle was not completed, the stones were removed and their holes filled-in, at a date of around 2000 BC. With its extra stones each side of the entrance to the circle (on the new axis), this circle would have needed eighty-two bluestones in all. (The Avenue naturally presents itself as the route by which bluestones, when safely shipped from Wales by raft up the river Avon, would complete their journey to Stonehenge by an easy gradient; but the Avenue is now known not to have been finished until much later, in Phase IV.)

This and the next phase overlap with the building of Durrington Walls – a far larger earthwork but involving no imported materials – together with its large, interior wooden buildings, as well as that at Woodhenge. Durrington has obvious analogies with the older Robin Hood's Ball, as the ceremonial centre for the territory in which Stonehenge lies. The same succession is seen elsewhere; in the north Wiltshire territory, the Windmill Hill causewayed camp is followed by the Avebury henge. In north Wiltshire, too, and round Stonehenge are comparable concentrations of round barrows, but it is noticeable that in both areas these do not press in closely on the henges themselves. This shows that all the apparatus of ceremonial buildings – barrows, earthen henges, wooden settings, stone settings, processional ways – cluster together, not as satellites round a single focus but spread across a zone which forms, as a whole, the sacred ground.

The Station Stones

These must be mentioned separately, because it is not certain which phase they belong to. They are – or rather were – four small sarsens set just inside the bank and making up a rectangular figure. Two of them intersect Aubrey holes, so must be later than early Phase I. They fall in line with the geometry of the revised orientation (Phase II), and of the sarsen building (Phase IIIa). Two stones are missing; the survivors offer contradictory evidence. Stone 91 is barely, if at all, trimmed and might belong to an early phase with the untrimmed Heel Stone. Stone 93 is shaped and might belong with Phase III.

The uncertainty is tiresome, since the Stations have been central to most Stonehenge astronomy. Atkinson believes they belong early in Phase II; the present stone 93 is either an early shaped sarsen or a Phase III replacement for an untrimmed original. But that the Stations belong late in Phase I or early in Phase III cannot be ruled out.

Stonehenge IIIa (c. 2100 to 2000 BC)

This, the lintelled sarsen structure, is what we all think of as the true Stonehenge. Ten great sarsens were trimmed precisely and set up in horseshoe formation as the uprights of the five trilithons; five massive lintels were set upon them. Thirty smaller, but still immense, uprights were so placed as to form the outer circle, with thirty slightly smaller lintels making up a continuous level ring with its surface 16 ft off the ground. Two uprights were set up by the entrance; one, fallen, survives

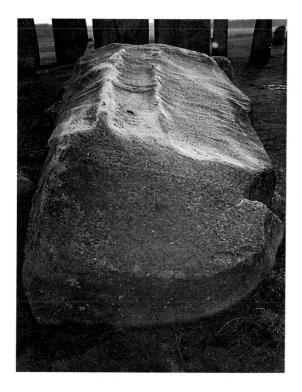

243 (above left) Oblique light across the face of stone 59 shows up the ridges, running both along and across the stone, made during its dressing into shape. The bright polish is the modern result of scuffing by thousands of visitors climbing over the stone with gritty shoes.

244 (above right) A later stage of finishing produced a uniform pocked surface. Protected from weathering, it was very clear when the base of stone 56 was exposed in 1901. The pointed shape of the base, which must have aided its positioning, is also visible.

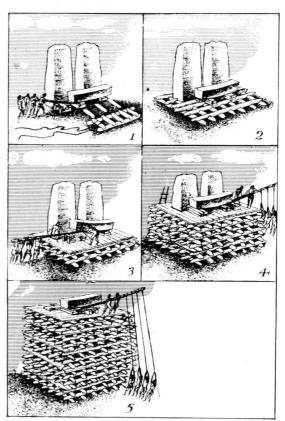

245 (right) The likely method of raising the lintels on wooden scaffolding.

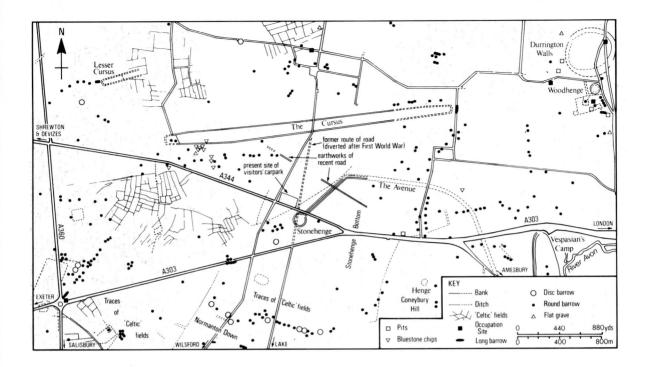

246 Stonehenge and its environs: prehistoric sites, and the modern roads that divide the landscape. Most of the sites survive as earthworks; others, like the round barrows near Amesbury on land that has been cultivated for centuries, have been detected on air photographs. as the Slaughter Stone. Although all the elements of this building are still there (whereas much of Stonehenge I and almost all of Stonehenge II are known from excavation only), to explain structure IIIa is not altogether simple. Stone 11, an upright of the outer sarsen circle, presents a problem: it is thinner and narrower than the others, and stands only half as high. Perhaps it once stood full-height and its use shows that the supply of sarsens wide enough as well as tall enough was running out. Perhaps it never was any taller, the lintel ring never finished. Could it be that Peter Newham was right in assuming that the uprights of the outer circle represent the lunar month of twenty-nine and a half days, one of the thirty uprights being deliberately kept half-size? Or was it perhaps a half-height support for a staircase from the ground up to the lintel ring, which was used as a walkway?

The whereabouts of the bluestones in this phase is unknown.

The date indicated by radiocarbon for the trilithon setting is about 2120 BC, which is actually earlier than the radiocarbon date for Phase II. But the stratigraphic sequence is clear, and the reversal due simply to the statistical uncertainty attached to any radiocarbon date. It is fair to conclude that IIIa followed closely on II, probably about the century 2100-2000 BC. That makes Stonehenge IIIa – what is loosely thought of as Stonehenge proper – 4,000 years old, give or take a few decades.

Stonehenge IIIa marks the end of sarsen-building at Stonehenge. For the rest, there is tinkering with bluestones and the beginning of demolition.

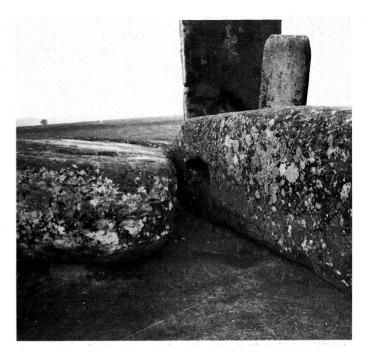

Stonehenge IIIb (c.2000 to c.1550 BC)

About twenty bluestones were dressed into shape and set up within the sarsen horseshoe in an oval structure which included, from the evidence of two bluestone lintels, at least two bluestone trilithons. Later, about 1550 BC, the Y and Z holes were dug outside the sarsen circle, and their number suggests they were to hold the other bluestones. But the circles of holes were never completed, and nothing was set up in them. (The original dating of Y and Z holes to the Iron Age (page 183) is now thought to be mistaken, as a radiocarbon date for an antler from a Y hole shows.)

Stonehenge IIIc (c.1550 to c.1100 BC)

Not long after, the bluestones were re-set in two groups, the bluestone horseshoe within the sarsen horseshoe, and the bluestone circle within the sarsen circle. The Altar Stone was stood on end within the apex of the horseshoe (there is evidence for a single large stone in Phase II, which may be the Altar in its first use), the spot where it has now fallen.

Stonehenge IV (c.1100 BC)

This final phase is represented, not at Stonehenge itself but in the Avenue. Around 1100 BC the Avenue was extended from its original terminus in Stonehenge Bottom for a further $1\frac{1}{2}$ miles as far as the river Avon at West Amesbury.

247 (left) A mortice-hole is visible at the far end of stone 150, one of the two bluestone lintels reused as uprights of the bluestone circle.

248 (right) The Altar Stone once stood on end. Now it lies flat in the grass, hidden under (right) stone 156 and (left) stone 55, fallen fragments of the great trilithon.

After Stonehenge

The ruins that are now collectively called Stonehenge contain elements of different phases, the Heel Stone from Phase I, the Stations perhaps from Phase II, the sarsen building from Phase IIIa, the bluestone settings from Phase IIIc. These phases span, roughly, the years from 3100 to 1500 BC, some 1600 years (more than the interval that separates us from the time England was a Roman province). The range of ideas about Stonehenge explored in this book, by contrast, is contained in only 800 years. Summarized as quickly as they have been in these last few pages, the sequence of Stonehenge phases seems restless, almost irresolute as one half-built scheme is abandoned for another. But if those sixteen centuries are allowed for, it appears in quite a different light: we then see a sacred site that was the focus of ritual and ceremony over sixty or seventy generations – with some long break likely soon after the start.

During the last phases of Stonehenge, a developing agricultural landscape of boundary earthworks, small and square 'Celtic' fields and enclosures grew up around it: its traces, less substantial than the burial mounds, are now mostly visible only by the accumulated record of air photographs. From the succeeding Iron Age, there is Vespasian's Camp, the hill-fort on the natural strongpoint above the River Avon east of Stonehenge, but little else, as if settlement had withdrawn from the open downland and down into the valleys - where the modern settlements are. In Roman times, Stonehenge itself was visited, as the quantity of Romano-British pottery and Roman coins there attest. The landscape around it again seems to have been nearly empty, then and during the early medieval period; the slight and scattered surface finds from the environs survey may mean no more than passing shepherds. It is to this withdrawal from the downland over several centuries that we owe the survival of the earth and chalk structures of the environs, and of Stonehenge itself, which was neither deliberately demolished nor proved worth the labour of quarrying away.

From Stonehenge itself there is the 'pewter tablet' found in Tudor times with writing that the country's best scholars could make no sense of (page 29). Might this have been one of the illiterate curses, written in wobbly and degraded letters rather than proper words, that are known from sanctuary sites of the Roman period?⁴ If so, it might imply that Stonehenge remained a temple of some kind right into the Roman era. This brings us once more to the Druids, the priests of the natives at the moment of contact; did they take up whatever element of sanctity lingered on at Stonehenge, so many hundreds of years after the last grand engineering there? If they did, then they took as sacred a place quite unlike those wooded and watery spots known to be important in Celtic religion.

The discovery, and invention, of Stonehenge

After those still years, the old place was discovered as a forgotten curiosity, named in the new English language by the invented name of Stonehenge, and the story that is told in this book began.

TONEHENGE COMPLETE STONEHENGE COMPLETE STO Chenge complete stonehenge complete stoneh Ge **in conclusion** nehenge complete stonehenge Omplete stonehenge complete stonehenge com Te stonehenge complete stonehenge complete

Even a book of this size has room for only a fraction of *everything* that exists to do with Stonehenge. But perhaps that is as well. Much of what has been written about Stonehenge is derivative, second-rate or plain wrong. (I have read most of it, and do not recommend anyone else to.) Equally, most of the many drawings and paintings are unexceptional. My choice of what to include has been personal, but deliberately kept very broad. I have tried to give room for representative Stonehengiana of every type, and if anything have restricted the space given to wellknown things in favour of people and issues that are forgotten; that is one reason why three chapters and a half are devoted to the Victorians.

Compression, abridgment and selection unbalance any picture, even one of Stonehenge. There are two major consequences. Some ideas and some people have been squeezed out; R. S. Newall is an obvious name in

249 A balanced picture? Stonehenge trilithon in the restrained view of an Ordnance Survey artist. this respect. And the summary sharpens the contrasts in the picture, which is useful but dangerous. There is more to, say, Inigo Jones's Stonehenge than has been given here; taken at length, Jones's idea comes over as more comprehensible and sensible than it does in brief summary. Some people appear in the book on occasions when they were wrong, even though they were more often right. The controversies are strengthened too; when there is space only for a couple of paragraphs, the shriller words of dispute crowd out the quieter common ground.

What is happening to Stonehenge does not reflect the increasing accord that is supposed to come from progress and rationality. In the 18th century those who concerned themselves with Stonehenge were more or less agreed as to its nature and purpose. Today we have a variety of astronomical views, an archaeological view in flux, and a widespread feeling that alternative archaeology, for all its appearance of dottiness, 'must be on to something'. This diversity is sure to continue, though Stonehenge astronomy has come to a major standstill. Archaeologists find unique events, like the building of Stonehenge, as hard as ever to make sense of. If the archaeologists are indeed retreating from Stonehenge, there are others with alternative visions who are ready to move in.

I end with one final, feminist curiosity without which this could not fairly be called *Stonehenge Complete*; it comes from Tom Robbins's novel *Even Cowgirls get the Blues*: 'You will find the Druid women, learned in astronomy and mathematics, engineering Stonehenge, the premium acme apex top-banana clockworks of its time, bar none.' And so it may be.

250 'Bizarro': a Stonehenge for the 1990s?

Visiting Stonehenge

As the later chapters of this book have made clear, Stonehenge is a very popular and busy place in the summer season. Many people find the Stonehenge magic elusive when it is crowded. The worst time to go is in the middle of the day in the middle of the season in middling-to-good weather. Off-season, on a wet day, early or late, you will often be almost by yourself, it is then that the brooding beauty of Stonehenge casts its most potent spell.

As explained (page 260), access is limited. You may walk outside the outer bank and ditch, but not across the beginning of the Avenue, or up to the Heel or Slaughter Stones. You may go inside the ditch only on the tarmac pathway. This takes you within a few yards of the western side of the building, but not right up to or among the stones. It is hard to spot the prehistoric carvings or study the details of the construction, unless you are with someone who knows exactly what to look for and where to look. Stonehenge is open in winter (October to March) 10.00 to 16.00 daily, and in summer (April to September), 10.00 to 18.00 daily; it is closed on Christmas Eve, Christmas Day, Boxing Day and New Year's Day.

Admission costs (1994) \pounds 2.85 for adults (\pounds 2.10 concessions), \pounds 1.45 for children, under fives free. English Heritage and National Trust members are allowed in free on showing their membership cards.

Since Stonehenge is so near the A344 Amesbury to Shrewton road, even when it is closed you have from the road a good near view of the Heel Stone and a distant view of the rest. This, the classic view from the north-east is not at present to be had from inside, as the paying public are not allowed into that zone. The road is so busy that crossing it to see this view is dangerous and is not recommended.

The Stonehenge car-park is free and a good base for walks in the Stonehenge landscape, using the excellent network of waymarked paths on the National Trust land. There is a snack-bar, standup and take-away only, and a book- and souvenir-shop, which you are encouraged to visit after seeing Stonehenge. You do better to go in there first, especially to get Julian Richards's booklet, *Beyond Stonehenge* (National Trust, 1985), as a guide to the landscape and the walks.

The nearest railway station is Salisbury (London services from Waterloo). There are six buses every week-day in high summer from Salisbury city centre and railway station to Stonehenge, plus two as a guided tour, fewer on other days and off-season.

Stonehenge, just off the A303 London to Exeter road, is fast and easy to reach

from London by car. And a car is nearly essential to explore the other prehistoric sites of Wiltshire.

There are two museums within close reach. The Salisbury & South Wiltshire Museum (at the King's House, Salisbury) is in the Cathedral Close facing the west front. Its Stonehenge display, cartoons and curiosities included, is set within a broader account of the archaeology of the region. In Devizes is the Wiltshire Archaeological & Natural History Society's charming museum, which holds the finds from Cunnington's barrow-digging, well displayed in their historic context, which are a large part of perhaps the finest collection of English prehistoric remains outside the British Museum.

If you have a car and a whole day at your disposal, I would recommend a morning at Stonehenge and its neighbouring sites. Woodhenge, Durrington, and the barrows are quiet even on the busiest day at Stonehenge. In the afternoon, go to Devizes museum, and then on to Avebury with its impressive stone circles, settings and avenue, ending with Silbury Hill, and the West Kennet megalithic chambered tomb. Alternatively, if a morning's prehistory seems enough, complete the Stonehenge tour in the way that has been traditional for 400 years, by going to Old Sarum or Wilton House, then on down to Salisbury.

Further reading

A previous writer who tried to summarize ideas about Stonehenge gave no sources at all, declaring: 'I have chose to give the readers my Collections on Credit, rather than everywhere to make a Parade by quoting hard Names, only to shew an Ostentation of Reading.' Without going so far, it seemed useful to give over my limited space to text and illustrations rather than a full bibliography. So here is a brief reading list for anyone who wants to study Stonehenge further.(Detailed sources will be found in the Notes. What has been left out from them is the sources I have used but not directly followed; often a single anecdote could be backed up by several others, none of them mentioned here.)

The geologist W. Jerome Harrison published a Stonehenge bibliography up to the year 1900 (in Wiltshire Archaeological Magazine for 1901). It has nearly 1,000 references but is by no means complete. No systematic bibliography has been published since, which is a pity seeing how many strange Stonehenge publications exist. The oddest of all, I think, is a novelization of an updated Harrison bibliography, written about 1941 by the amateur archaeologist Harold Peake. The plot is thin. An energetic student, commissioned to explore the history of Stonehenge, reports his findings to his patron, Mr Sommit, in a series of letters. Early chapters begin with a single paragraph of fiction, as Mr Sommit breakfasts on tea and toast. The morning post is opened, and the new letter from the student constitutes

the rest of this chapter. (Later chapters abandon even this slight literary device.) Mr Peake's work, with its 1,026 footnotes a curiosity even by the standards of the Stonehenge literature, found no publisher. The manuscript is now in the care of Professor Atkinson.

The central account of the monumental details of Stonehenge and its prehistoric sequence is still R.J.C. Atkinson, *Stonehenge* (Harmondsworth & New York: Penguin). First published in 1956, it presents the findings of the 1950s excavations; recent reprints tack on to this an appendix of 1960 and another of 1979; the main text is obsolete in its background of British prehistory, its account of Stonehenge astronomy, and other ways. Instead, start with Julian Richards, *Stonehenge* in the English Heritage/Batsford series (1991), which

tells more about the landscape than the central specifics. Aubrey Burl, *The Stonehenge People* (London: Dent, 1987) is an imaginative account of Stonehenge prehistory and what it means. The souvenir guidebook sold at Stonehenge is short, good and well illustrated in colour; it is also available by post: English Heritage Postal Sales, PO Box 229, Northampton NN6 9RY.

For the **broader background**: on the British **stone circles** of which Stonehenge is an aberrant example, Aubrey Burl, *The Stone Circles of the British Isles* (London & New Haven: Yale University Press, 1976); on the British '**henges**' of which Stonehenge is an aberrant example, Geoffrey. Wainwright, *The Henge Monuments* (London & New York: Thames & Hudson, 1989); on **British prehistory at the time of Stonehenge** (London: Dent, 1980), thorough, thick and technical; and on **British prehistory as a whole**,

Notes

In the notes that follow, the abbreviation 'WANHS' indicates material in the library of the Wiltshire Archaeological and Natural History Society, Devizes Museum. 'WANHS Jackson' is a scrapbook, mostly of the late 19thand early 20th-century material compiled by Canon Jackson; 'WANHS Manley', a scrapbook of the 1930s compiled by V. S. Manley; 'WAM', the Wiltshire Archaeological Magazine. The publisher, rather than place of publication, is given; almost all the books referred to were published in England, usually in London.

Timothy Darvill, *Prehistoric Britain* (London: Batsford & New Haven: Yale University Press, 1987).

Rodney Legg, Stonehenge Antiquaries (Milborne Port: Dorset Publishing, 1986) reprints long extracts from the early writers, and gives the proper sense of them which the little quotes in this book cannot provide. Lewis Thorpe's is the standard translation of Geoffrey of Monmouth, The History of the Kings of Britain (Harmondsworth & Baltimore: Penguin, 1966). For the antiquaries, there are Stuart Piggott's essays Ruins in a Landscape (Edinburgh: Edinburgh University Press, 1976), Michael Hunter, John Aubrey and the Realm of Learning (London: Duckworth, 1975). Stuart Piggott, William Stukelev (London & New York: Thames & Hudson, 1985), and Kenneth Woodbridge, Landscape and antiquity (Oxford: Clarendon Press, 1970) on Colt Hoare.

PREFACE

- 1 John Britton, *The Beauties of Wiltshire*..., vol. 2, 1801, p. 118.
- 2 Grahame Clark, Archaeology and Society, Methuen, 1939, pp. 111–12.

CHAPTER 1 (pages 20-28)

- 1 Thomas Arnold (ed.), *Henrici Archidiaconi Huntendunensis Historia Anglorum*, Rolls series, Longman & Trübner, 1879, pp. 11–12.
- 2 The lintel of the great trilithon, stone 156, has a pair of shallow holes on its upper side. These seem to be mortise holes left unfinished when it was decided to make the other face of the stone the bottom. This apart, there is nothing that could relate to stonework standing on the lintels.
- 3 J. E. B. Gover, Allen Mawer and F. M. Stenton, *The Place-Names of Wiltshire*, CUP, 1939, pp. 360–1.
- 4 Stuart Piggott, 'The sources of Geoffrey of Monmouth', *Antiquity*, 15, 1941, p. 308.
- 5 Acton Griscom (ed.), *The Historia Regium Britanniae*..., Longman, 1929, pp. 42–98; Richard Howlett (ed.), Robert of Torigni, *Chronicles of the Reigns of Stephen, Henry II, and Richard I*, vol. 4, Rolls series, HMSO, 1887, pp. 65–75.

For consequences of the **radiocarbon revolution** of the early 1970s, as now taken notice of by all researchers, Colin Renfrew, *Before Civilization* (Harmondsworth: Penguin, 1976).

For the **varied claims to Stonehenge** in the 1980s, see Christopher Chippindale and others, *Who owns Stonehenge*? (London: Batsford, 1990).

There is no recent account of Stonehenge **astronomy**. The original book exciting the subject is Gerald Hawkins, *Stonehenge Decoded* (New York: Dell, 1965; London: Fontana, 1970), now a period piece. Hawkins contributed an astronomy update in W.M.F. Petrie, *Stonehenge* (London: 1880, reprinted 1989 by History & Mysteries of Man Ltd, London). The first edition of *Stonehenge Complete* (London: Thames & Hudson, 1983) has more detail on astronomy that is abridged in this edition as no longer a current affair.

- 6 This summary is after, or quoted from the standard translation by Lewis Thorpe, *The History of the Kings of Britain*, Penguin, 1966.
- 7 Thorpe (note 6), p. 51; also his 'Introduction', pp. 14–19. Translation by Thorpe, p. 17, of Thomas Hearne (ed.), *Guilielmi Neubrigensis*..., 1719, Proemium, p. 7.
- 8 He stuck with his own account of Stonehenge. Of the 12th- and 13thcentury chroniclers, only Alfred of Beverley preferred Henry's to Geoffrey's Stonehenge story. Thomas Hearne (ed.), *Aluredi Beverlacensis* ..., 1716, p. 6.
- 9 Such as the English version in National Library of Scotland, Auchinleck MS, Adv. 19.2.1. Also in Ranulf Higden's *Polychronicon*..., Joseph Rawson Lumby (ed.), Rolls series, vol. 5, Longman and Trübner, 1874, pp. 312–13.
- 10 Higden (note 9), p. 337.
- **11** J. S. P. Tatlock, *The Legendary History of Britain*, University of California Press, 1950, p. 41.
- 12 Ludovico Ariosto, transl. Barbara Reynolds, Orlando Furioso, vol. 2, Penguin Classics, 1977, canto XXXIII, verse 4; Ivor Arnold (ed.), *Le roman de Brut de Wace*, vol. 1, Société des Anciens Textes Français, 1938, lines 8175–8.

13 William Caxton, Chronicle of England, 2nd edn., 1482, fo. d₂.

- 14 Henry Ellis (ed.), *Polydore Vergil's* English History..., vol. 1, Camden Society, 1846, p. 29.
- **15** Edmund Spenser, 'The Faerie Queene', in *Poetical Works*, Oxford UP, 1970, book 2, canto X, stanzas 66–7.
- 16 Thomas Rowley (perhaps with Thomas Middleton), ed. A. F. Hopkinson, *The Birth of Merlin*..., Sims, 1901.
- 17 Lewis Theobald, The Vocal Parts of an Entertainment, Call'd Merlin; or, The Devil of Stone-Henge..., 1734. A manuscript score is in Durham Cathedral library. Also Roger Fiske, English Theatre Music in the Eighteenth Century, Oxford UP, 1973, p. 165.
- 18 Salisbury Journal, 26 January 1784. Bournemouth Pavilion concert programme for 15 April 1931; Wiltshire Gazette, 30 April 1931 (which also mentions a full-length Stonehenge opera written years before by a Wiltshireman, but never performed). Bellini's Norma, so often performed on a megalithic set, does not mention Stonehenge as such.
 19 Vergil (note 14), p. 117.
- 20 Hermann Folkerzheimer, letter to Josiah Simler, 13 August 1562, in Hastings Robinson (ed.), The Zurich Letters, (Second Series)..., Parker Society, 1845, letter 39.
- 21 F. J. Furnivall (ed.), Andrew Boorde, The Fyrst Boke of the Introduction of Knowledge, Trübner for Early English Text Society, 1870, p. 120.
- **22** John Rastell, *The Pastyme of People*, 1530.
- **23** James Brome, *Travels over England* . . ., 1700, p. 45.
- 24 W. H. Warn, 'Stonehenge and pyramid erected by giants', 1931, typescript, British Library (press-mark 7710. r.3); Anthony Roberts, Sowers of Thunder, Rider, 1978.
- 25 John Aubrey, *The Natural History of Wiltshire*, Wiltshire Topographical Society, 1847, pp. 97–8.

26 John Lewis, *The History of Great-Britain*..., 1729, pp. 39, 172–3.

27 John Thurnam, Stonehenge . . ., 1860.

CHAPTER 2 (pages 29-42)

1 William Camden, *Britannia*, quoted from the second edition in English, translated by Philemon Holland, 1637, p. 254.

- 2 John Leland, ed. Anthony Hall, Commentarii de Scriptoribus Britannicis, 1709, p. 46.
- 3 John Leland, ed. Thomas Hearne, Antiquarii de Rebus Britannicis Collectanea, [1715], vol. 2, p. 31.
- 4 Leland (note 2), pp. 45–6. He talks of the stone being quarried from pits, so he cannot be thinking of the sarsens lying on the surface of the Marlborough Downs.
- 5 Hermann Folkerzheimer, letter in Hastings Robinson (ed.), *The Zurich Letters (Second Series)*..., Parker Society, 1845, letter 39.
- 6 Chotzen and Draak's introduction to the *Corte Beschrijving* (note 8 below); Frances A. Yates, *The Valois Tapestries*, Warburg Institute, 1959; J. A. Bakker, 'Lucas de Heere's Stonehenge', *Antiquity* 53, 1979, pp. 107–11.
- 7 Leonard Forster, Janus Gunter's English Years, Leiden and Oxford UP, 1967, pp. 46–67.
- 8 Now in the British Library, Add. MS 28330, and printed in Th. M. Chotzen and A. M. E. Draak (eds.), *Beschrijving der Britsche Eilanden door Lucas de Heere*, 1937.
- 9 Forster (note 7), p. 54.
- 10 Translated by Bakker (note 6), p. 108.
- **11** The same hand as the volume of de Heere costume drawings in Ghent.
- 12 Now in the British Library, Sloane MS 2596, and printed in an edition by Henry B. Wheatley and Edmund W. Ashbee, 1879.
- 13 The trees are at OS 128387. Some are being cut down, so the view may return.
- 14 I have traced no better copy than that in the British Library, press-mark 5785(2), which is battered and cut down.
- 15 R. A. Skelton, introduction to reprint of *Civitates Orbis Terrarum*, World Publishing, 1966, pp. xi–xii; A. E. Popham, 'Georg Hoefnagel and the *Civitates Orbis Terrarum', Maso Finiguerra*, vol. 1, 1936, p. 200; Bakker (note 6), p. 110.
- 16 Bakker (note 6) agrees with this conclusion.
- 17 Notably in the version by the Dutch engraver Kip.
- 18 William Camden, transl. Philemon Holland, Britain..., 1600, p. 25; William Stukeley, letter to Maurice Johnson, 6 June 1716, quoted in Stuart Piggott, William Stukeley, Clarendon Press, 1950, p. 37.

- 19 William Lambarde, Angliae Topographicum & Historiarum, 1730 (from manuscript of 1580), pp. 314–15.
- **20** John Harington, Orlando Furioso in English Heroical Verse, [1591], p. 22 (notes to book 3).
- 21 John Aubrey, *The Natural History of Wiltshire*, Wiltshire Topographical Society, 1847, p. 44; William Stukeley, *Stonehenge*, 1730, pp. 5–6; William Marshall, the agricultural writer, in the *Gentleman's Magazine*, quoted in WANHS Jackson, fo. 230.
- **22** R. S. Barron, *The Geology of Wiltshire*, Moonraker Press, 1976, pp. 64–5.
- 23 N. E. King, 'The Kennet Valley sarsen industry', WAM, vol. 63, 1968; Alec Clifton-Taylor, *The Pattern of English Building*, rev. edn., Faber, 1972, pp. 112–13; Stuart Piggott{note 18], pp. 111–12.
- 24 Richard Symonds, Charles Edward Long (ed.), *Diary*..., Camden Society, 1859, p. 151.
- 25 E. Herbert Stone, *The Stones of Stonehenge*, Robert Scott, 1924, p. 51.
- 26 H. C. Bowen and I. F. Smith, 'Sarsen stones in Wessex . . .', *Antiquaries Journal*, vol. 57, 1977, pp. 185–96, and records of the survey in the Society of Antiquaries; Stone (note 25), pp. 69– 74.
- 27 Stone (note 25), pp. 140–5; Edith Olivier and Margaret K. S. Edwards (eds.), *Moonrakings*, [1930], p. 75; John Wood, *Choir Gaure*, 1747, pp. 73–5.
- 28 Harington (note 20), p. 22.
- **29** *Britannia*, first edition of 1586, and White (fittingly, also, growing from Geoffrey and the Brut a whole mess of imaginary history) 1600.
- **30** Samuel Daniel, 'Musophilus', of 1599, in Alexander B. Grosart (ed.), *The Complete Works*..., 1885, vol. 1, pp. 236–7. Another fine lamentation is in Michael Drayton's verse geography of England, *Poly-Olbion*, of 1612.

CHAPTER 3 (pages 43-65)

- 1 William Stukeley, Stonehenge, 1740, p. 2, as misquoted in Concise Account of Stonehenge..., 1768, p. 2.
- 2 John Speed, *The History of Great Britaine*..., 1611, p. 314.
- 3 For the recent Stonehenge landscape, see RCHM, *Stonehenge and its Environs*, Edinburgh UP, 1979, pp. xv–xxiii.
- 4 WANHS, cuttings, vol. 16, fo. 27; John Chandler and Peter Goodhugh,

Amesbury, Amesbury Society, 1979, p. 33.

- 5 Save a single mention in a document of 1379. Ancient earthworks, which were later used as land boundaries, often appear. R. B. Pugh (ed.), *Calendar of Antrobus Deeds before* 1625, WANHS Records series, 1947, pp. xxx-xxxi.
- 6 Pugh (note 5), p. xvi; William Long, Stonehenge and its Barrows, 1876, pp. 237–8.
- 7 James Brome, Travels over England ..., 2nd edn., 1707, p. 44; [John Whittle], An Exact Diary of ... the Prince of Orange ..., 1689, p. 62; John Aubrey, 'Monumenta Britannica', in Long (note 6), p. 35.
- 8 Philip Sidney, 'Seven wonders of England', 1598.
- 9 L. G. Wickham Legg (ed.), A Relation of a Short Survey of 26 Counties..., Robinson, 1904, p. 109; Athenian Mercury, vol. 3, no. 19, 1691; Daniel Defoe, A Tour thro' the Whole Island of Great Britain..., Peter Davies, 1927, pp. 197–8. Leslie V. Grinsell, Folklore of Prehistoric Sites in Britain, David & Charles, 1976, lists other stone circles where the same tale was told.
- 10 E. S. de Beer (ed.), *The Diary of John Evelyn*, vol.-3, Clarendon Press, 1955, p. 115; William Derham, *Select Remains of the Learned John Ray*..., 1760, pp. 302–3; Christopher Morris (ed.), *The Journeys of Celia Fiennes*, 2nd edn., Cresset, 1949, p. 16; Sir John Clerk, Scottish Record Office, Clerk Papers, GD/18/2107, pp. 31–3; F. Elvington Ball, *The Correspondence of Jonathan Swift*, vol. 4, Bell, 1913, p. 174.
- 11 Jones and Webb (see note 17 below), p. 42. Jones's plan of Stonehenge 'as it is' does not help, for it shows fewer stones than survive today. Long (note 6), p. 35, quoting Aubrey; Thomas Fuller, *The Church-History of Britain* ..., 1655, p. 36.
- 12 Evelyn (note 10), p. 115.
- 13 Robert Latham and William Mathews (eds), *The Diary of Samuel Pepys*, vol. 9, Bell, 1976, p. 229.
- 14 William Mathews (ed.), *Charles I's Escape from Worcester*, University of California Press, 1967, p. 68.
- **15** Long (note 6), pp. 237, 36–7, 39, quoting Aubrey.
- 16 John Summerson, *Inigo Jones*, Pelican, 1964; Stephen Orgel, 'Inigo Jones on Stonehenge', *Prose*, vol. 3, 1971, p. 112.

- 17 Inigo Jones and John Webb, The Most Notable Antiquity of Great Britain, Vulgarly Called Stone-Heng, on Salisbury Plain, Restored, 1655.
 Quotations are from the 'omnibus' edition of 1725, which reprints with it Charleton's Chorea Gigantum, Webb's Vindication, and some notes on Jones and the first edition. The first edition was reprinted in facsimile by Scolar Press, 1972, the omnibus by Gregg International, 1971.
- 18 There is no direct evidence, but the lucidity and clarity of Webb with Jones as compared with the dogged pedantry of Webb alone is telling.
- 19 Jones and Webb (note 17).
 20 Barbaro (ed.), *I Dieci Libri* dell'Architettura di M. Vitruvio..., 1567, book 5. Jones's own annotated copy is now in the Chatsworth library, but the notes in it make no reference to Stonehenge.
- 21 Jones and Webb (note 17).
- 22 C. E. and Ruth C. Wright (eds.), *The Diary of Humfrey Wanley*, vol. 1, Bibliographical Society, 1966, p. lxiii; 'Memoirs of the life of Inigo Jones, Esq.', in Jones and Webb, 1725 edition (note 17); John Conyer's diary, British Library MS Sloane 937, fo. 179r...
- 23 Wystan Adams Peach, Stonehenge. A New Theory, 1961; Richard Marsden Twist, Stonehenge. Its Liturgical Background, 1964.
- 24 Notably Rudolf Wittkower, 'Inigo Jones, architect and man of letters', *Journal of the RIBA*, vol. 60, 1953, pp. 1–7; John Summerson, 'Inigo Jones', *Proc. British Academy*, vol. 50, 1964, pp. 169–92.
- 25 Horace Walpole, Anecdotes of Painting in England . . ., 3rd edn., 1782, vol. 2, p. 274 and note; Summerson (note 24), pp. 83–93.
- **26** 'Philanactophil' [Edmund Bolton], Nero Caesar . . ., 1624, pp. 181, 182.
- 27 Jones and Webb (note 17).
- 28 Johan Picardt, Korte Beschryvinghe van eenige Vergetene en Vorbegene Antiquiteten ..., 1660. A letter of the engraver George Vertue, dated 17 April 1753, in a British Library copy (press-mark 154.f.1) refers to a 'quarto pamphlet black letter dated 1601', also about antiquities, in Dutch and by the same 'Picart', which describes and illustrates 'erected stones in the form and manner of those on Salisbury plane'. I have not been able to trace such a pamphlet.
- 29 Olaus Worm, Danicum Monumentorum . . ., 1643; Walter

Charleton, Chorea Gigantum: Or, The Most Famous Antiquity of Great Britain, Vulgarly Called Stone-Heng, Standing on Salisbury-Plain, Restored to the Danes, 1663. An unlikely champion of Charleton, a century and a half later, was Sir Walter Scott, though he chose a different northern nation and thought Stonehenge to be Saxon-built. See his edition of

Dryden's works, Patterson, 1885, vol. 11. **30** Robert Plot, *The Natural History of*

- Staffordshire, 1686, p. 398; William Coxe, Travels into Poland . . ., 1784, p. 598.
- **31** Charleton (note 29); Percy Enderbie, *Britannia Triumphans*..., London, 1661, dedication.
- 32 John Dryden, 'Epistle to Charleton', in Charleton (note 29).
- **33** John Webb, A Vindication of Stone-Heng Restored: In which the Orders and Rules of Architecture Observed by the Ancient Romans, are Discussed, 1665.
- **34** Aylett Sammes, *Britannia Antiqua Illustrata*..., 1676, preface.
- **35** Richard Gough, Anecdotes of British Topography . . . , 1768, p. 530.
- 36 Sammes (note 34), p. 39.
- **37** Brian Fagan, *Antiquity*, 44, 1970, p. 321.
- 38 Anthony à Wood, Athenae Oxoniensis . . ., 1691, col. 537; John Childrey, Britannia Baconica.... 1660, p. 45; Whittle (note 7), Lorenzo Magalotti, Travels of Cosmo the Third, quoted in Henry Hatcher, Modern Wiltshire - Salisbury, 1821, pp. 469-71. There are scattered references right through the 17th century of the curious going to visit Stonehenge, such as Thomas Naish, who gave his sister-in-law a token there, 30 May 1689. Doreen Slatter (ed.), The Diary of Thomas Naish, WANHS Records series, 1964 (1965), p. 24. Also A Fool's Bolt Soon Shott at Stonehenge, in Thomas Hearne (ed.), Peter Langtoft's Chronicle ..., 1725, p. 483.
- 39 Holborn-Drollery . . ., 1673.

CHAPTER 4 (pages 66-81)

- 1 Joh. Giorgio Keysler, Antiquitates Selectae Septentrionales et Celticae ..., 1720, pp. 97ff., 199ff., 230ff.
- 2 Keysler (note 1).
- 3 There is at last a published edition of John Aubrey's *Monumenta Britannica*, edited by John Fowles, annotated by Rodney Legg, Dorset

Publishing, 1980/2, but I have depended more on quotations in: Michael Hunter, John Aubrey and the Realm of Learning, Duckworth, 1975; Oliver Lawson Dick, 'The life and times of John Aubrey', in Aubrey's Brief Lives, Penguin, 1972. These are from Hunter, p. 158; Dick, p. 50.

- 4 Joshua Childrey, *Britannia Baconica* ..., 1660, p. 49. For early mentions of Avebury which do not notice resemblance to Stonehenge: Aubrey Burl, *Prehistoric Avebury*, Yale UP, 1979, pp. 40–2.
- 5 Hunter (note 3), p. 180; Dick (note 3), p. 55. Aubrey thought Charleton's ideas 'a great mistake': William Long, *Stonehenge and Its Barrows*, 1876, p. 39.
- 6 Hunter (note 3), pp. 138, 159; Dick (note 3), pp. 69–70.
- 7 Anthony Powell, *John Aubrey and His Friends*, Heinemann, 1963, pp. 287–8.
- 8 Edward Daniel Clarke, A Tour through the South of England . . ., 1793, p. 33; William Stukeley, Stonehenge (see note 21 below), 1740, p. 3.
- 9 Dick (note 3), p. 70.
- **10** Dick (note 3), p. 70. Long (note 5), opposite p. 32.
- 11 Hunter (note 3), p. 180.
- 12 Hunter (note 3), p. 159.
- 13 Dick (note 3), pp. 70, 89.
- 14 Dick (note 3), p. 18.
- 15 John Fowles, 'Introduction' to Monumenta Britannica (note 3), p. 4.
- **16** Long (note 5), p. 35; Hunter (note 3), p. 198.
- 17 Samuel Gale, 'A tour through several parts of England', in *Bibliotheca Topographica Britannica*, vol. 3, Nicholls, 1790, pp. 24, 26.

18 William Stukeley, Itinerarium Curiosum, 1724.

19 William Stukeley, letter to M. Johnson, 6 June 1716, quoted in Stuart Piggott, William Stukeley, Clarendon Press, 1950, p. 37; William Stukeley, 'Diary', in The Family Memoirs of the Rev. William Stukeley, M.D. and the Antiquarian and Other Correspondence of William Stukeley,

Roger & Samuel Gale, etc., 3 vols, Surtees Society, 1882–7, vol. 3, p. 273.

- **20** Roger Gale, letter to Arthur Charlett, 13 October 1719, quoted by Piggott (note 19), p. 52.
- **21** Stukeley, *Stonehenge*, 1740, p. 9. Exact dates are in Piggott (note 19), pp. 132–5.
- 22 Stukeley (note 21), pp. 10, 30, 5, 26, 21

23 Stukeley (note 21), pp. 10, 10-11, 12.

- 24 Stukeley (note 21), pp. 15-19.
- 25 Piggott (note 19), p. 106.
- 26 Stukeley, letter to Roger Gale, 26 July 1723, *Memoirs* (note 19), vol. 3, p. 250; Stukeley, at the Society of Antiquaries 22 March 1759; Joan Evans, *A History of the Society of Antiquaries*, Society of Antiquaries, 1956, pp. 121–2.
- 27 Stukeley (note 21), p. 32.
- 28 Stukeley, *Memoirs* (note 19), vol. 3, pp. 249–51.
- 29 Stukeley (note 21), pp. 35-6.
- 30 Stukeley (note 21), pp. 41-2.
- **31** Stukeley (note 21), p. 43. Aubrey, *Monumenta Britannica*, ed. Fowles, p. 83, agrees.
- 32 Stukeley (note 21), p. 44.
- 33 Stukeley (note 21), pp. 44-5.
- 34 Stukeley (note 21), pp. 45-6.
- 35 Stukeley (note 21), pp. 5-6, 29, 30.
- 36 Stukeley (note 21), pp. 56.
- 37 Stukeley (note 21), pp. 57, 64-6.
- 38 R. M. Cook, 'Archaeomagnetism', in Don Brothwell and E. S. Higgs (eds.), *Science in Archaeology*, 2nd edn., Thames & Hudson, 1969, p. 83.
- **39** Stukeley (note 21), p. 32.
- **40** Stukeley (note 21), pp. 9–10.
- 41 Stukeley (note 21), pp. 47-8.
- 42 Roger Gale, letters to William Stukeley, *Memoirs* (note 19), vol. 1, e.g. pp. 186, 201.

CHAPTER 5 (pages 82-95)

- Stuart Piggott, William Stukeley, Clarendon Press, 1950, pp. 44, 53–7.
 The Annals and History of C.
- *Cornelius Tacitus*, 1698, vol. 2, pp. 354–5.
- **3** Julius Caesar, *De Bello Gallico*, in H. J. Edwards's Loeb Library translation.
- 4 Diodorus Siculus, *Histories*, V, 31, in C. H. Oldfather's Loeb Library translation.
- 5 Diodorus Siculus (note 4), II, 47.
- 6 Pliny, *Natural History*, XVI, 44. Translated by Philemon Holland as *The Historie of the World*, 1601, p. 497.
- 7 Henry Rowlands, *Mona Antiqua Restaurata*, 2nd edn., 1726, p. vii.
- 8 Robert Plot, *The Natural History of Staffordshire*, 1686; W. Cooke (?), *A Description of Stonehenge, Abiry &c . . .*, Collins & Johnson, 1771.
- 9 Stuart Piggott, *Ruins in a Landscape*, Edinburgh UP, 1976, pp. 59–61.
- 10 In, admittedly, an obscure corner of learning: J. G. Williams, in Salopian

and West Midland Monthly Journal, May 1877.

- 11 William Stukeley, *Stonehenge*, 1740, preface.
- 12 John Aubrey, 'An essay towards the description of the north division of Wiltshire', quoted in Michael Hunter, John Aubrey and the Realm of Learning, Duckworth, 1975, pp. 176, 175.
- **13** John Toland, A Collection of Several Pieces of Mr John Toland..., 1726.
- 14 Sir John Clerk, letter to Roger Gale, 11 June 1733, quoted in Piggott (note 1), p. 138.
- 15 Stukeley (note 11), preface.
- 16 Stukeley (note 11), p. 54.
- 17 William Stukeley, letter to William Borlase, 17 October 1749, in The Family Memoirs of the Rev. William Stukeley, M.D. and the Antiquarian and Other Correspondence of William Stukeley, Roger & Samuel Gale, etc., 3 vols, Surtees Society, 1882–7, vol. 2, p. 55.
- 18 John Palmer, 'Rock temples of the British Druids', Antiquity 38, 1964, pp. 285–7; Hayman Rooke, 'Some account of the Brimham Rocks in Yorkshire', Archaeologia 8, 1787, pp. 209–17; A Descriptive Account of Brimham Rocks, 5th edn., 1845.
- 19 Hugh Casson (ed.), Follies, Chatto & Windus, p. 42n.; Glyn Daniel, Megaliths in History, Thames & Hudson, 1972, p. 41; Nikolaus Pevsner, The Buildings of England – Staffordshire, Penguin, 1974, p. 58.
- 20 Barbara Jones, Follies and Grottoes, Constable, 1953, pp. 121–2; Horace Walpole, quoted in Nikolaus Pevsner, The Buildings of England – Berkshire, Penguin, 1966, p. 193.
- **21** Jones (note 20), pp. 127–9. This pseudo-megalith has acquired a penumbra of pseudo-learning about its meaning, and supposed lore of freemasons hidden in it.
- 22 John Wood, Choir Gaure, Vulgarly called Stonehenge, on Salisbury Plain, Described, Restored, and Explained, 1747, pp. 33–4. The stone rocked in 1739, when Wood surveyed Stonehenge (but is not mentioned by Stukeley, who was there in the 1720s), in 1750 (letter of Richard Woodyeare, in WANHS Jackson, fo. 246), and in 1770 (John Smith, Choir Gaur..., 1771, p. 58), but later only in secondhand accounts.
- 23 Joseph Strutt, The Chronicle of England, 1777, p. 247.
- 24 All around Stonehenge lies, just

under the turf, a 'Stonehenge layer' made up of flints, chips of sarsen and bluestone, and rubbish of all periods, including modern china, bits of broken bottles, etc. The layer is dated by a clay pipe, made in Bristol about 1650/1670, lying at its base. Professor Atkinson believes the layer was laid down as a deliberate surfacing, no later than 1700, of flints picked off the fields around. I think it dates from at least 50 or 60 years later, when there are many signs (the growth of tourism generally, the guidebooks and prints sold in Salisbury, the fashion for Druidical remains, Gaffer Hunt's stall, the turnpiking of the road through Amesbury), of many more visitors and of facilities for them. See R. J. C. Atkinson, Stonehenge, Pelican, 1979, pp. 63-5, 213.

25 WANHS Jackson, fo. 244.

- **26** 'Stone Henge: a poem, inscribed to Edward Jermingham, Esq.', 1742.
- 27 Wood (note 2), pp. 32, 34; Smith (note 22), p. 58.
- 28 Emily J. Climenson, Passages from the Diaries of Mrs Philip Lybbe Powys ..., Longmans, Green, 1899, pp. 52–3. There are many stories of banging at the stones, but I have found no documentary evidence for R. S. Newall's story, often quoted, that you could hire a hammer kept at Amesbury expressly for visitors to use on Stonehenge. (Atkinson, Stonehenge [note 24], p. 191.)
- **29** Robert Townson, *Tracts and Observations in Natural History and Physiology*, 1799, p. 227.
- **30** Climenson (note 28), p. 51.
- 31 Stukeley (note 21), p. 5.
- 32 All the striking passages in books like Benjamin Martin, *The Natural History of England*..., 1759–63, and William Cooke, *An Enquiry into the Patriarchal and Druidical Religion* ..., 1754, are stolen. So are those in the guidebooks, like the one quoted by Atkinson (note 28), p. 191.
- **33** Letter of October 1754, in WANHS Jackson, fo. 226.
- 34 William Borlase, Observations on the Antiquities Historical and Monumental, of the County of Cornwall..., 1754, p. 185; Smith (note 22), p. 67.

35 William Stukeley, Abury, 1743.
36 W. Williams, 'Thoughts on Stonehenge', Gentleman's Magazine, vol. 61, 1791, p. 108; Thomas Maurice, Indian Antiquities, vol. 6, 1796, pp. 152–66; Reuben Burrow, 'Hindoos and the binomial theorem', *Asiatic Researches*, vol. 2, 1790, p. 488; Charles Vallancey, *Oriental Collections*, vol. 2, 1798.

37 Smith (note 22), pp. 68, 53–8, 64, 68. **38** Hen Wansey, 'Stonehenge', 1796, WANHS Wiltshire Tracts no. 19, p. 61n.

- **39** Jones published only geometric
- reconstructions. Aubrey's rough sketch was unpublished, and so was Stukeley's measured plan. **40** Wood (note 22).
- 41 William Stukeley, 'Diary', in Memoirs (note 17), vol. 3, p. 276.
- 42 Unsigned review, by Richard Gough (according to *Gentleman's Magazine*, 1823, p. 127), of Edward King's *Monumenta Antiqua* in *Gentleman's Magazine*, vol. 72, 1802, p. 147.

CHAPTER 6 (pages 96–112)

- Daniel Defoe, A Tour thro' the Whole Island of Great Britain . . ., 1st edn., reprinted, Peter Davies, 1927, p. 198; Samuel Johnson, quoted in Glyn Daniel, A Hundred and Fifty Years of Archaeology, Duckworth, 1975, p. 25.
- 2 Edmund Burke, ed. J. T. Boulton, A Philosophical Enquiry into the Origin of our Ideas of the Sublime and the Beautiful, Routledge & Kegan Paul, 1958, pp. 39, 57.
- 3 R. W. Chapman (ed.), *The Letters of* Samuel Johnson . . ., Clarendon Press, 1952, vol. 3, p. 86.
- 4 Christopher Morris (ed.), *The Journeys of Celia Fiennes*, 2nd edn., Cresset, 1949, p. 15; Defoe (note 1), p. 192; [Arthur Young], A Six Weeks Tour through the Southern Counties of England . . ., 1768, pp. 165, 166.
- 5 Richard Warner, Excursions from Bath, 1801, p. 169, William Gilpin, Observations on the Western Parts of England . . ., 1798, p. 82. For 'Mr Gilpin's errors corrected', see John Britton, The Beauties of Wiltshire . . ., vol. 2, 1801, p. 68.
- 6 I have conflated this account from two of the many accounts in this vein: Warner (note 5), pp. 172–9, and Daniel Carless Webb, Observations and Remarks, during Four Excursions . . ., 1812, pp. 282–95. The verse is from William Wordsworth, 'Guilt and sorrow; or incidents upon Salisbury Plain'; in E. de Selincourt (ed.), The Poetical Works of William Wordsworth, 2nd edn., vol. 1, Clarendon Press, 1952.
- 7 Gilpin (note 5), pp. 77, 81.
- 8 The earliest original oil painting of

Stonehenge itself which is securely dated is by G. R. New, exhibited at the Royal Academy in 1814. It is not at all special (see reproduction in M. H. Grant, *A Chronological History of the Old English Landscape Painters*, vol. 6, Lewis, 1960). Of the other early oils, the 17th- and 18th-century examples are copied from engravings; the Barry, Jones and Thomson include Stonehenge incidentally rather than as the main subject; and the 'Marlow' is undated (though it depicts the 1797 trilithon upright).

- 9 There are, for instance, a fine plain watercolour, very faded now, by Paul Sandby and a set of 4 watercolours by George Engleheart in Salisbury Museum.
- 10 Louis Hawes, Constable's Stonehenge, HMSO, 1975, p. 13.
- 11 John Dyer, 'The Fleece', in his *Poems*, 1761, p. 53.
- **12** Reproduced here from the published engraving, as the present whereabouts of the painting is not known.
- 13 Hawes (note 10), p 2.
- 14 Hawes (note 10), p. 3.
- 15 Hawes (note 10), pp. 2–5.
- 16 Algernon Graves, *The Royal* Academy of Arts, vol. 2, 1905, p. 125.
- 17 John Ruskin, 'Catalogue of Rudimentary Series', in E. T. Cook and Alexander Wedderburn (eds.), *The Works of John Ruskin*, vol. 21, Allen, 1906, p. 223; John Ruskin, *Modern Painters*..., vol. 1, Smith, Elder, 1843, p. 249.
- 18 Michael Liversidge (personal communication) is confident it is not a Marlow, and will omit it from his forthcoming catalogue. It includes the 1797 trilithon upright, so cannot be later than that date (unless, like the Malton, it was painted *after* 1797 from sketches of *before* 1797). Liversidge thinks it dates from the very end of the 18th century, and is perhaps also a Thomas Malton.
- 19 Thomas Chatterton, 'The Battle of Hastings', 1768.
- 20 John Constable, letter to John Britton, in R. B. Beckett (ed.), *John Constable's Correspondence*, vol. 5, Suffolk Record Society, 1967, pp. 84– 5.
- 21 'Memoirs of Thomas Jones', Walpole Society, vol. 32, 1951, p. 21.
- 22 Quotation from James Thomson's 'Winter', attached to the painting's frame, which is adapted from the original to suit the female subject. The picture was bought by Sir Richard

Colt Hoare in 1811 for Stourhead. He also commissioned a watercolour by Francis Nicholson, which rather resembles the Copley Fielding.

23 'Malachi Mouldy', Stonehenge..., Rich & Bentley, 1844; M. D. Mulock, A Life for a Life, 1859; Julia Corner, Caldas: a Story of Stonehenge, Groombridge, 1863.

CHAPTER 7 (pages 113-25)

- 1 Gentleman's Magazine, vol. 67, January 1797, pp. 75–6, also February 1797, p. 116; W. G. Maton, 'Account of the fall of some of the stones of *Stonehenge . . .', Archaeologia* 13, 1880, pp. 103–6; Hen Browne, An *Illustration of Stonehenge and Abury* . . ., 2nd edn., Browne, 1833, p. 18; John Rickman, letter to William Frend, 15 April 1830, British Library Add. MS 24831, fo. 290v.
- 2 William Cunnington, letter to Joseph Cobb, 1804, quoted in Robert Cunnington, From Antiquary to Archaeologist, Shire, 1975, p. 5; Calvin Wells, 'A clinical view of William Cunnington', in Robert Cunnington, pp. 161–2.
- 3 Cunnington, letter to John Britton, dated 25 November 1798 (although it says the stones fell 'about three years ago'), WANHS.
- 4 John Britton, *The Beauties of Wiltshire*..., 1802, p. 131; Thomas Leman, letter to W. Cunnington, 21 September 1802, WANHS; Cunnington, letter to Britton, 9 February 1801, WANHS.
- 5 Cunnington owned copies of Stukeley's *Stonehenge and Abury*: Britton, letter to Cunnington, 9 February 1801, WANHS; Britton (note 4), pp. 110–12.
- 6 Cunnington, letter to Thomas Leman, 17 September 1801, WANHS.
- 7 John Britton, *Memoirs of . . . Henry Hatcher*, 1847, p. 5; William Coxe, letters to Cunnington, 20 April, 27 June 1801, and 17 May, 1 June 1802, WANHS.
- 8 Coxe, letters to Cunnington, 26 June, undated (? July), and 8 August 1802, WANHS.
- 9 Cunnington, letter to Britton, November 1802, WANHS.
- 10 Cunnington, letter to A. B. Lambert, 9 March 1803. There was a notice of the urn in the *Gentleman's Magazine*.
- 11 Horace Walpole, quoted in Kenneth
- Woodbridge, *Landscape and Antiquity*, Clarendon Press, 1970, p. 3.

- 12 Coxe, letter to Cunnington, 1 November 1803, WANHS.
- 13 The only excavation after Cunnington's death was of one barrow-group at Shepherd's Shore.
- 14 Colt Hoare's journal for April 1801, quoted in Woodbridge (note 11), p. 202. Coxe, letter to Cunnington, 19 June 1802.
- **15** Leman, letter to Cunnington, 24 September 1802.
- 16 'A barrister' [Richard Fenton], A Tour in Quest of Genealogy . . ., 1811, p. 286.
- 17 Cunnington, copy of letter to Richard Colt Hoare, 30 October 1806, in the Cunnington Papers, book 13, fo. 3, WANHS.
- 18 Philip Crocker, letter (no. 35) to Cunnington, 1806, WANHS.
- 19 Cunnington, MS 'Collections for Wiltshire', fo. 25, WANHS.
- **20** Cunnington Papers, book 4, fo. 9; Richard Colt Hoare, *The History of Ancient Wiltshire*, vol. 1, 1810–12, p. 208.
- **21** Cunnington Papers, book 12, fos. 10–12.
- **22** Cunnington Papers, book 4, fo. 23; Colt Hoare (note 20), p. 151.
- 23 Cunnington Papers, book 5, fos. 42– 3; Colt Hoare (note 20), p. 209.
- 24 Cunnington Papers, book 10, fo. 9.25 Cunnington, quoted in *From*
- Antiquary to Archaeologist, p. 76. 26 Colt Hoare (note 20), p. 153.
- 27 Leman, letter to Colt Hoare, 30 April 1806. It is hard to guess what he meant: the North African trilithons, perhaps (page 134 above).
- 28 Cunnington Papers, book 3, fos. 53– 5. Colt Hoare (note 20), p. 152. He was right to look for different periods, wrong in his order.
- **29** Cunnington, letter to James Douglas, 1810, WANHS.
- **30** Glyn Daniel, *A Hundred and Fifty Years of Archaeology*, Duckworth, 1975, p. 31.
- 31 Richard Colt Hoare, Ancient Wiltshire: Roman Æra, 1821, p. 126.

CHAPTER 8 (pages 126-40)

- 1 Richard Colt Hoare, *Journal of a Tour in Ireland A.D. 1806*, 1807, p. 257.
- 2 John Lubbock, *Prehistoric Times*, Williams & Norgate, 1865, pp. 52–3; 'Age of bronze', *Edinburgh Review*, vol. 147, 1878, p. 458; 'Secret of the Druidical stones', *Athenaeum*, 1866,

p. 18. His exact figures vary a little from publication to publication.

- 3 Lubbock, 'Secret of the Druidical Stones' (note 2).
- 4 Richard Colt Hoare, *The History of Ancient Wiltshire*, vol. 2, 1812, p. 93; Lubbock, *Prehistoric Times* (note 2), p. 55.
- 5 The Times, 17 November 1883.
- 6 Daniel Wilson, Prehistoric Annals of Scotland, vol. 2, Macmillan, 1863, p.
 9.
- 7 John S. Phené, 'Existing analogues of Stonehenge . . .', Journal of the British Archaeological Association, vol. 18, 1892, p. 276; Charles H. Pearson, The Early & Middle Ages of England, Bell & Daldy, 1861; James Fergusson, A History of Architecture . . ., vol. 2, Murray, 1867, p. 5. Also, notably: John Rickman, 'On the antiquity of Abury and Stonehenge', Archaeologia 28, 1840, pp. 399-419; Thomas Wright, Wanderings of an Antiquary . . ., Nichols, 1854, pp. 304-5; Hodder Westropp, Athenaeum, 1866; A. Hall, 'Avebury and Stonehenge', Athenaeum, 1869.
- 8 [James Fergusson], 'Stonehenge', *Quarterly Review*, vol. 108, 1880, p. 207.
- 9 Joseph Barnard Davis and John Thurnam, *Crania Britannica*..., 1865; John Thurnam, 'Long barrows', *Archaeologia*, vol. 42, 1869, pp. 161– 244; 'Round barrows', *Archaeologia* 43, 1871, pp. 285–544.
- 10 Charles Elton, Origins of English History, 1882. Thurnam himself thought Stonehenge was of Late Bronze/Early Iron Age date.
- 11 Joseph Kenworthy, 'Antiquities of Bolsterstone and neighbourhood', *Reliquary & Illustrated Archaeologist*, vol. 5, 1899, pp. 145– 58; William Copeland Borlase, *The Dolmens of Ireland*..., vol. 1, Chapman & Hall, 1897, p. 134.
- 12 S. Pasfield Oliver, Athenaeum, 1892, p. 295; The Times, 30 August, 26 October 1892. Most vigorously pressed was John Phené's idea that the *talayots* and *taulas* of Minorca were models for Stonehenge.
- 13 William Gifford Palgrave, Narrative of a Year's Journey through Central and Eastern Arabia (1862-63), vol. 1, Macmillan, 1865, p. 251.
- 14 Herbert Meade, A Ride through the Disturbed Districts of New Zealand ..., Murray, 1870, pp. 300–301.
- 15 Joseph Dalton Hooker, *Himalayan Journals*..., vol. 2, Murray, 1854, pp.

273–7, 319–21; C. B. Clarke, 'The stone monuments of the Khasi hills', *Journal of the Anthropological Institute*, vol. 3, 1874, especially p. 490.

16 Thomas A. Wise, *History of Paganism in Caledonia*..., Trübner, 1884, p. 45; cutting of 1852 in WANHS Jackson, fo. 162.

17 Austen Henry Layard, Nineveh and its Remains..., Murray, 1849; Discoveries in the Ruins of Nineveh and Babylon..., Murray, 1853, pp. 114–15; John Hawkshaw, 'Address of the president', in Report of the Forty-Fifth Meeting of the British Association..., Murray, 1876, pp. lxxi–lxxiii.

18 W. Gell, *The Itinerary of Greece*..., 1810, plate 11; Thomas Dudley Fosbroke, *Encyclopaedia of Antiquities*..., vol. 1, 1825, pp. 6–7, 31, 72–4.

19 Henry Barth, *Travels and Discoveries in North and Central Africa*..., vol. 1, Longman, 1857, pp. 51–8.

20 Sven Nilsson, 'Stonehenge . . .', *Transactions of the Ethnological Society*, new series, vol. 4, 1866, pp. 255, 257, quoting John Evans; John Kenrick, *Phoenicia*, Fellowes, 1855, pp. 220–1.

21 J. L. Myres, 'The age and purpose of the megalithic structures of Tripoli and Barbary', *Proceedings of the Society of Antiquaries*, vol. 17, 1897– 9, pp. 290–3; H. Swainson Cooper, 'On the Tripoli senams: idols or oil presses?', pp. 297–300.

22 Atlantis: e.g. W. S. Blackett, Researches into the Lost Histories of America . . . , 1883, p. 193; A. P. Sinnett, 'A new theory of Stonehenge', Black and White, 25 March 1893 (and a pastiche: H. W. Estridge, The Origin of Stonehenge, 1894). Egypt: H. M. Grover, A Voice from Stonehenge, Cleaver, 1847. Little folk: H. N. Hutchinson, Prehistoric Man and Beast, Smith, Elder, 1896.

23 Mr Clarke in *Wiltshire Gazette*, January 1836; Felix Fairly, cutting of 4 February 1857 in WANHS Jackson, fo. 160.

24 Henry James, *Plans and Photographs* of Stonehenge . . ., 1867.

25 Letters of Emma Darwin, Cambridge University Library; partly published in Henrietta Lichfield (ed.), Emma Darwin, a Century of Family Letters, 1792-1896, Murray, 1915, pp. 226–7; Charles Darwin, The Formation of Vegetable Mould, Murray, 1881, pp. 154–6; 'An autobiographical chapter', in Francis Darwin (ed.), *The Life and Letters of Charles Darwin*, Murray, 1887, vol. 3, pp. 216–18; R. B. Freeman, *The Works of Charles Darwin*, 2nd edn., Dawson, 1977, pp. 164–8.

26 W. M. F. Petrie, Inductive Metrology: or, the Recovery of Ancient Measures from the Monuments, Hargrive Saunders, 1877, pp. 118–19.

27 Flinders Petrie, *Stonehenge*, Stanford, 1880, p. 33.

28 G.G.V., 'Present state of Stonehenge', *Gentleman's Magazine*, December 1831, vol. 101, pt 2, p. 519.

29 R. S. Newall thought midwinter sunset was indicated.

30 Edward Duke, *The Druidical Temples of the County of Wiltshire*, Smith, 1846; L. Gidley, 'Notes on Stonehenge', 1874, cuttings in WANHS Jackson, fos. 177–8.

31 Petrie (note 27).

32 Arthur J. Evans, 'Stonehenge', Archaeological Review, vol. 2, 1888-9, pp. 312–30. Also, rather later, T. Rice Holmes, Ancient Britain and the Invasions of Julius Caesar, Clarendon Press, 1907.

33 Norman Lockyer, *Stonehenge and other British Monuments Astronomically Considered*, 2nd edn., Macmillan, 1909, pp. 60ff.

34 [J. H. Broome], 'Astronomical date of Stonehenge', Astronomical Register, vol. 7, 1869, pp. 202–4.

35 E.g. Lockyer's examination of The Hurlers in Cornwall (*Nature*, vol. 71, 1904-5, pp. 536–8), and its criticism in Holmes.

CHAPTER 9 (pages 141–56)

1 Strictly, this is not Victorian at all. But it exactly fulfils the mixture of excitement, delight and danger that Victorians increasingly found to evade them at Stonehenge.

2 Prince Pueckler-Muskau, Tour in England, Ireland, and France, in the Years 1828 ⊕ 1829; with Remarks on the Manners and Customs of the Inhabitants and Anecdotes of Distinguished Public Character, 1832, pp. 221–6.

3 'Lines written at an inn near Salisbury Plain', in WANHS Jackson, fo. 21, which dates it to 1814.

4 The times of the coaches, as printed in the guidebooks, vary, but the

service remains thrice-weekly. These times for 1830 come from the 31st edition of *The Salisbury Guide*, Easton, Salisbury, 1830.

5 'A barrister' [Richard Fenton], A Tour in Quest of Genealogy . . ., 1811, pp. 268–9.

6 'Old Stones', cutting from *Devizes* Gazette in WANHS Jackson, fo. 120.

7 Elihu Burritt, A Walk from London to Land's End and Back, with Notes by the Way, Sampson, Low, 1865, p. 148. The Religious Tract Society's moral tale was written by Mrs Craik, a writer who is still remembered as the author of John Halifax, Gentleman.

8 Oliver Wendell Holmes, Our Hundred Days in Europe, 3rd edn., Sampson, Low, 1887, p. 164.

9 C. Browne, *To the Inhabitants of Winchester*, Browne, Amesbury, 1848.
10 This is the Stonehenge section. His

collected thoughts are in: An Illustration of Stonehenge and Abury, in the County of Wilts, Pointing out their Origin and Character, through Considerations Hitherto Unnoticed, Browne, Amesbury, 1823 (perhaps 1822). A second edition followed in 1833; the ninth and last is of 1871.

11 Henry Browne, Origin and Character of the Serpent and Temple at Avebury, Browne, Devizes, 1823.

12 Browne, An Illustration . . . (note 10).

13 There is a pair surviving in the Ashmolean Museum, Oxford.

14 John Britton in the *Gentleman's Magazine*.

15 In successive editions of his guide.

16 In full, The Geology of Scripture, Illustrating the Operation of the Deluge, and the Effects of which it was Productive: with a Consideration of Scripture History, in Reference to Stonehenge and Abury, in Wiltshire; and to the Caves of Elephanta and Salsette, and the Wonders of Elora, in Hindoostan; a Statement of New and Important Views of Geology. Resulting from Information Contained in Scripture; and an Interesting Tour from Christchurch, along the Banks of the River Avon, and across the Wansdyke to Abury, Browne, Frome, 1832. A book of watercolours by Browne illustrating the tour is in the Red House museum, Christchurch.

17 Browne, Amesbury, 1830.

18 The sad version is in Henry Hatcher, *Memoirs*; the happy is in Joseph Stratford, *Wiltshire and its Worthies*, 1882, pp. 116–17. 19 'Old stones' (note 6).

- 20 'A ramble on Salisbury Plain', *Temple Bar*, vol. 18, 1866, p. 392.
- 21 Contemporary accounts, especially Alice M. Williamson, 'The guardian of Stonehenge', English Illustrated Magazine, November 1895.
- 22 Smeeth is variously spelt, most often otherwise as 'Snaith'. Contemporary reports; and personal information from Mr Jesse Lawrence, who had this story from his father.
- 23 J. F. Muirhead, *Great Britain:* Handbook for Travellers, Karl Baedeker, Leipzig, various editions; 'Stonehenge', *Temple Bar*, vol. 82, 1888, pp. 131–6.

24 Burritt (note 7), p. 148.

- **25** Charles G. Harper, *The Exeter Road*, Chapman & Hall, 1899, p. 200.
- 26 'A visit to Stonehenge', *The Leisure Hour*, 13 October 1853. There are several good mid Victorian accounts of visiting Stonehenge: Walter Thornbury, *Cross Country*, Sampson, Low, 1861; 'Through Wilts', *Temple Bar*, 1865; 'Patricius Walker', *Rambles*, Longmans, Green, 1873; Mortimer Collins (ed. Tom Taylor), *Pen Sketches by a Vanished Hand from the Papers of the Late Mortimer Collins*, Richard Bentley, 1879; as well as those quoted.
- 27 Edward G. Aldridge, 'Stonehenge', cutting in WANHS Jackson.
- 28 Edward Smedley, Prescience: or the Secrets of Divination, John Murray, 1816. For more Stonehenge verse, see elsewhere in this book. Like Stonehenge painting, it drops away after early Victorian times. There is also, for instance: J.H.B. 'Stonehenge', Gentleman's Magazine, vol. 97 (i), 1827, pp. 631-2; C.H., 'Stonehenge', Gentleman's Magazine, vol. 102 (i), 1832, p. 452; Stephen Prentis, 'Stonehenge', 1843; Annie Mountain, 'Lines on visiting Stonehenge at twilight', in her Ballads, Brown, Salisbury, 1862; Oliver Wendell Holmes, 'The broken circle' in his Hundred Days; T. Mayhew, 'Stonehenge', Dublin University Magazine, October 1872. Joseph Browne, the guardian, addressed a poem to foreign tourists in his visitors' book (believed now to be in Salisbury museum).

29 Thomas Stokes Salmon, 'Stonehenge: a Prize poem, recited in the Theatre, Oxford, the Twelfth of June, MDCCCXXIII', Oxford, 1823. Frederick Bowman's Newdigate entry, 'Stonehenge: a poem', Oxford, 1823, is also straight and good.

- **30** 'Sir Oracle', 'Stonehenge: a poem', Oxford, 1823. The rest sends up the competition as well as Stonehenge.
- **31** 'Pleasant trips out of Bristol', second series, no. II, part 2, cutting in WANHS Jackson, fos. 171–2.
- **32** Harold Harries, letter in the *Standard*, September 1893; in WANHS cuttings, vol. 1, fo. 139. Alas, the only part of the story that rings true is Mr Judd's businesslike attitude to the value of his negative. Neither the date (early to mid 1880s), the place (the Queen had no close Wiltshire acquaintance with whom she might stay privately), nor the details seem right for an *incognito* outing.
- **33** William Ewart Gladstone, diary for 31 March 1853, in M. R. D. Foot and H. C. G. Matthews (eds.), *The Gladstone Diaries*, vol. 4, 1848-1854, Clarendon Press, 1974, p. 510.
- 34 Ralph Waldo Emerson, 'Stonehenge', in his *English Traits* (ed. Howard M. Jones), Harvard, 1966, pp. 177–88.
- **35** Thomas Moore, *Memoirs*, Longmans, Green, 1856; quoted in WANHS Jackson, fo. 162.
- **36** Contemporary report in WANHS cuttings vol. 7, fo. 25.
- **37** Fourth Earl of Carnarvon, 'A vigil at Stonehenge', *National Review*, vol. 5, 1885, pp. 540–6; also letter C. E. Long to Canon Jackson in WANHS Jackson, fo. 106.
- **38** Cuttings in WANHS Jackson, fos 26, 51, 106, and in WANHS cuttings, vol. 4, fo. 156; *Devizes Gazette*, 27 June 1895; *Wiltshire Mirror*, 22 June 1894; E. P. L. Brock, 'Sunrise at Stonehenge on the longest day', *Journal of the British Archaeological Association*, vol. 47, 1891, pp. 330–1, and 'Astronomical traditions of Stonehenge', *Leisure Hour*, 1891, pp. 63–5. Harper (note 25), p. 209.

CHAPTER 10 (pages 157-63)

- 1 RCHM, Stonehenge and its Environs, Edinburgh UP, 1979, pp. xv-xviii.
- 2 'A ramble on Salisbury plain', *Temple Bar*, vol. 18, 1866, p. 391.
- 3 William Wordsworth, 'Salisbury Plain', in Stephen Gill (ed.), *The Salisbury Plain Poems of William Wordsworth*, Cornell UP/Harvester, 1975.
- 4 John Chandler and Peter Goodhugh, *Amesbury*, Amesbury Society, 1979.

Sir Edmund (not, as often incorrectly given, Sir Edward) Antrobus's church stoves figure in *The Topographical Dictionary of England*, 1835.

- 5 RCHM (note 1), p. xviii. H. L. Long, Survey of the Early Geography of Western Europe, 1859, p. 109.
- 6 Cutting from *Punch*, probably for 1864, in WANHS Jackson, fo. 44.
- 7 L&SWR: correspondence in WANHS Jackson, fo. 31ff.; newspaper reports of early 1883. GWR: newspaper reports of late 1897.
- 8 This wording conflates the instructions dated 1889 and 1899, which are slightly but not significantly different. Both are in the Wiltshire County Record Office's file of material relating to the 1904 enclosure case.
- 9 'Through Wilts', *Temple Bar*, 1865; Richard le Gallienne, *Travels in England*, Grant Richards, 1900, p. 183.
- **10** Contemporary newspaper accounts, and correspondence copied in the WCRO files (note 8).
- 11 Woodhouse Park: Illustrated Guide to the Grounds, 1894. Kensington News, 26 May 1894.
- 12 Public Record Office, WORK 14/213.
- **13** William Long, *Stonehenge and its Barrows*, 1876, pp. 86–7.
- 14 C. Chippindale, 'The enclosure of Stonehenge', WAM, vols 70–1, 1978, pp. 112–13, and the references noted there, Lady Florence Antrobus, letter, 30 December 1916, in WANHS Jackson, fo. 370.

CHAPTER 11 (pages 164-78)

- 1 Chris Chippindale, 'The enclosure of Stonehenge', WAM, vols 70–1, 1978, pp. 109–23, is a full account.
- 2 Letter of Sir Edmund Antrobus to R. W. Merriman, Clerk of the Wiltshire County Council, 14 February 1901, in the Wiltshire County Record Office file on the enclosure affair.
- 3 Horace G. Hutchinson, *The Life of Sir John Lubbock*, Macmillan, 1914, vol. 2, pp. 136–7.
- 4 Attorney-General v. Antrobus (privately printed), 1905.
- 5 Flinders Petrie, letter in *The Times*, 18 February 1901.
- 6 e.g. *The Times*, letters and editorials, 4 and 14 January 1901.
- 7 Certainly it is the only excavation to appear in Gowland's published work as listed in his obituary in *Proceedings* of the Royal Society, series A, vol.

102, 1922-3, pp. xvi-xix.

- 8 Petrie was another advocate of restoration and new foundations: *The Times*, 10 January 1901.
- 9 Published as: William Gowland, 'Recent excavations at Stonehenge', *Archaeologia* 58, 1902, pp. 37–118. It incorporates a full and expert report on Stonehenge petrology: J. W. Judd, 'Note on the nature and origin of the rock-fragments found in the excavations made at Stonehenge by Mr Gowland in 1901', pp. 106–18.
- **10** R. J. C. Atkinson, *Stonehenge*, Pelican, 1979, p. 207.
- 11 Contemporary newspaper accounts and Druidical documents.
- 12 Contemporary newspaper accounts and scattered references in the Public Record Office Druidical correspondence.
- 13 British Museum records, 615: 'Stonehenge attempted purchase'.
- 14 Order in Council, dated 22 November 1913, London Gazette, 25 November 1913.
- **15** J. E. Capper, 'Photographs of Stonehenge, as seen from a war balloon', *Archaeologia*, 60, 1907, p. 571.
- 16 John M. Bacon, 'Over historic grounds', *Good Words*, November 1902, p. 783.
- 17 Norman Parker, personal communication.
- 18 At least, I can find no record of any formal application. I guess it was talked about in the mess, and perhaps towards the end of a social evening began to seem a serious proposition. If it was ever formally proposed, it did not get very far.
- **19** Public Record Office WORK 14/214. Frank Stevens, *Sphere*, 7 Feb. 1920.
- 20 Thomas Hardy, 'Channel firing', in Collected Poems of Thomas Hardy, Macmillan, 1919, p. 288.
- **21** Contemporary newspaper accounts; Public Record Office files; personal communication from Mr Jesse Matthews.

CHAPTER 12 (pages 179-97)

- 1 Public Record Office WORK 14/485, especially C. R. Peers's memorandum of 29 October 1919. The engineer's report is WORK 14/2464.
- 2 Joan Evans, A History of the Society of Antiquaries, Society of Antiquaries, 1956, pp. 383–7, 398; Joan Evans, Time and Chance, Longmans, Green, 1943, pp. 367–73; 'Excavation of Stonehenge', appeal

leaflet issued by the Society of Antiquaries, April 1919, and signed by Evans as president (a copy is in WANHS cuttings, vol. 11, fo. 41).

- **3** WORK 14/485 and contemporary newspaper reports.
- 4 W. M. Flinders Petrie, 'Neglected British history,' *Proceedings of the British Academy*, 1917-18, pp. 251– 78; Flinders Petrie, letter to B. H. Cunnington, in WANHS Jackson, fo. 373.
- 5 W. Hawley, 'Stonehenge: interim report on the exploration', *Antiquaries Journal*, vol. 1, 1921, pp. 21–30.
- 6 R. J. C. Atkinson, Stonehenge, Pelican, 1979, p. 23.
- 7 Hawley (note 5), pp. 33-6.
- 8 Hawley (note 5), pp. 30-3. As well as the formal reports, there is a good deal of correspondence giving useful detail; for instance, that Newall excavated 21 and George Engleheart with Hawley two, out of the 23 Aubrey holes emptied in the first season. The letters are scattered. Hawley's are in the Society of Antiquaries archives and in Public Record Office files. Correspondence between Newall and Engleheart is in National Monuments Record archives, and in Newall papers in the Alexander Keiller Museum, Avebury. The personal comments in letters fill out the published records and show just how bewildered Hawley became. The published reports are all in the Antiquaries Journal: 'Stonehenge: interim report on the exploration', vol. 1, 1921, pp. 19-41; 'Second report on the excavations at Stonehenge', vol. 2, 1922, pp. 36-52; 'Third report on the excavations at Stonehenge', vol. 3, 1923, pp. 13-20; 'Fourth report on the excavations at Stonehenge', vol. 4, 1924, pp. 30-39; 'Report on the excavations at Stonehenge during the season of 1923', vol. 5, 1925, pp. 21-50; 'Report on the excavations at Stonehenge during 1925 and 1926', vol. 8, 1928, pp. 149-76.
- 9 The Times, 5 April 1920.
- 10 W. Hawley, letter to C. R. Peers, 29 August 1921. Public Record Office, WORK 14/2463. Other letters repeat the worry.
- **11** W. Hawley, letter to R. S. Newall, 21 February 1923.
- 12 G. H. Engleheart in discussion at the Society of Antiquaries, 19 April 1922, in Hawley, 'Fourth report . . .', (note 8), p. 38.

13 Hawley, 'Third report . . .' (note 8), p. 18.

- 14 Hawley, 'Interim report...' (note 8), pp. 30–31; R. J: C. Atkinson (note 6), p. 28; Wiltshire Times, 8 July 1922. I do not place much reliance on details of the schoolteacher's ideas, and Col. Hawley may have done no more than make non-committal acknowledgement to a talkative visitor, but the story fits with other evidence that Hawley was only too receptive to other people's suggestions.
- **15** W. Hawley, letters to C. R. Peers, 15 June 1921, and 29 August 1922, Public Record Office, WORK 14/2463.
- 16 The Times, 5 August 1927.
- 17 Hawley, 'Report on . . . 1925 and 1926' (note 8), p. 176.
- **18** C. R. Peers, memorandum, 24 January 1919 in Public Record Office WORK 14/485; Evans (note 2).
- 19 Newall and Engleheart's correspondence shows how concerned they were, and there are hints in Hawley's letters to Newall that he was aware himself all was not as it should be. A tactful letter was carefully drafted and sent to London. but London took no immediate notice. Years later Newall, acknowledging how bad things had been (and they would have been much worse without Newall), said: 'Colonel Hawley very often complained of the lack of interest shown. No advice was ever offered, and when he read his annual report his careful work was praised." R. S. Newall, 'Stonehenge: a review', Antiquity 30, 1956, p. 140.
- 20 R. S. Newall, 'Stonehenge', Antiquity 3, 1929, pp. 75–88. It is diffident and cautious, but the closest to an analysis of Hawley's work that was made. Identification of pottery from the ditch bottom as of an Early Bronze Age type in 1936 confirmed its early date: Stuart Piggott, 'A potsherd from the Stonehenge ditch', Antiquity 10, 1936, pp. 221–2.
- 21 Atkinson (note 6), p. 49.
- 22 Herbert H. Thomas, 'The source of the stones of Stonehenge', *Antiquaries Journal*, vol. 3, 1923, pp. 239–60. Judd (in Gowland) had thought the bluestones had been transported to Salisbury Plain as erratics by glacial action rather than human agency. This idea was revived by the geologist G. A. Kellaway a few years ago ('Glaciation and the stones of Stonehenge', *Nature*, 3 September

1971, vol. 233, pp. 30–5), but has not found support (C. P. Green, 'Pleistocene river gravels and the Stonehenge problem', *Nature*, 25 May 1973, vol. 243, pp. 214–16).

23 [Daniel Defoe], A Tour thro' the Whole Island of Great Britain, Divided into Circuits of Journies, vol. 2, 1725, p. 84.

24 Thomas (note 22), p. 258.

- **25** Robert Byron (ed.), *Shell Guide to Wiltshire*..., Architectural Press, 1935, p. 15.
- **26** Stuart Piggott, 'The sources of Geoffrey of Monmouth. II. The Stonehenge story', *Antiquity* 15, 1941, pp. 305–19; Lewis Thorpe, Introduction to Geoffrey of Monmouth, *The History of the Kings of Britain*, Penguin Classics, 1966, p. 19.
- 27 William Cunnington to H. P. Wyndham, August 1801. Most of the information in Cunnington's letters appears in *Ancient Wiltshire*, but Colt Hoare omitted some details, such as this.
- 28 B. Howard Cunnington, 'The "blue stone" from Boles barrow', WAM, vol. 42, 1924, pp. 431–7; also M. E. Cunnington, 'Blue stone from Boles barrow', WAM, vol. 47, 1935, p. 267; Wiltshire Gazette, 5 July 1934.
- 29 The discrepancy in date between Boles barrow and Stonehenge was not fully apparent until recent radiocarbon chronologies, and it was long and reasonably held that the Boles barrow stone could have been taken *from* Stonehenge or abandoned in transit overland from Wales. Atkinson (note 6), pp. 110–11, 214.
- **30** W. Hawley, letter to C. R. Peers, 7 November 1921. Public Record Office WORK 14/2463.
- **31** O. G. S. Crawford, *Observer*, 22 July 1923; 'The Stonehenge Avenue', *Antiquaries Journal*, vol. 4, 1924, pp. 57–9; *Archaeology in the Field*, 2nd edn., Phoenix House, 1953, p. 49.
- **32** Squadron-Leader Insall, quoted by O. G. S. Crawford, *Antiquity* 1, pp. 99–100.
- **33** M. E. Cunnington, *Woodhenge*, Simpson, Devizes, 1929.
- 34 Grahame Clark, 'The timber monument at Arminghall and its affinities', *Proceedings of the Prehistoric Society*, vol. 2, 1936, pp. 1–51.
- **35** The word 'henge' was first used by Thomas Kendrick in T. D. Kendrick and C. F. C. Hawkes, *Archaeology in*

England and Wales 1914-1931, Methuen, 1932, pp. 83ff., and the idea refined by Grahame Clark.

- 36 Public Record Office WORK 14/487.
 37 Public Record Office WORK 14/2135 and contemporary newspaper reports.
 38 Public Record Office WORK 14/840.
- **39** Public Record Office WORK 14/488 and contemporary newspaper reports. The verse was an entry in the *Observer* weekly competition no. 158, 1929.
- 40 Richard Atkinson, pers. comm. 41 Public Record Office WORK 14/489, 2463; W. E. V. Young, MS diary, WANHS, January 1935. The fate of the human cremations is not known. R. S. Newall wanted to send them to Sir Arthur Keith at the Royal College of Surgeons for expert opinion. Failing this, they were to be 'decently reinterred at Stonehenge' (memorandum, Office of Works to Newall, 16 October 1931). Keith's detailed diary for the period, now in the RCS archives, does not mention Stonehenge cremations, and it is likely they went straight back into the soil of Stonehenge, in another Aubrey hole perhaps.
- 42 Public Record Office WORK 14/837, 838.
- **43** Public Record Office WORK 14/840, 2463.
- **44** Public Record Office WORK 14/839, 840 (which details the considerable opposition to the development).
- 45 Public Record Office WORK 14/837.
- **46** Siegfried Sassoon, 'The heart's journey', IX, in his *Collected Poems 1908-1956*, Faber, 1961, p. 179.

CHAPTER 13 (pages 198-215)

- 1 WANHS Jackson, fos. 372, 408–9, 478; WANHS Manley. George H. Cooper, Ancient Britain, the Cradle of Civilization, Hillis-Murgotten, San José, Ca.
- 2 Thomas Hardy, as reported in a cutting of about 1901 in the National Monument Record archives.
- 3 T. D. Kendrick, *The Druids*, Methuen, 1927, pp. 154–5; T. D. Kendrick and C. F. C. Hawkes, *Archaeology in England and Wales* 1914-1931, Methuen, 1932, pp. 83ff.; R. H. Cunnington, *Stonehenge and Its Date*, Methuen, 1935, pp. 127–31.
- 4 And see Stuart Piggott, "Vast perennial memorials", in J. D. Evans *et al.* (ed.), *Antiquity and Man*, Thames & Hudson, 1981, p. 23.

- 5 Stuart Piggott, 'The early bronze age in Wessex', Proceedings of the Prehistoric Society, vol. 4, 1938, pp, 52–106; 'New light on the story of Stonehenge', The Times, 4 August 1954 (and Antiquity 28, 1954, pp. 221–4); R. J. C. Atkinson, lecture as reported in The Times, 6 September 1955.
- 6 H. C. Beck and J. F. S. Stone, 'Faience beads of the British Bronze Age', *Archaeologia* 85, 1936, pp. 203–52.
- 7 Stuart Piggott, 'Wessex harvest', in Fire among the Ruins (1942-1945), Oxford UP, 1948.
- 8 J. F. S. Stone, 'The Stonehenge cursus and its affinities', *Archaeological Journal*, vol. 104, 1948, pp. 7–19.
- 9 R. J. C. Atkinson, C. M. Piggott and N. K. Sandars, Excavations at Dorchester, Oxon., First Report, Ashmolean Museum, 1951; Stuart Piggott, 'The excavations at Cairnpapple Hill, West Lothian, 1947-48', Proceedings of the Society of Antiquaries of Scotland, vol. 82, 1947-8, pp. 68–123.
- 10 R. J. C. Atkinson, Stonehenge, Pelican, 1979, pp. 197–8; S. Piggott, 'Stonehenge reviewed', in W. F. Grimes (ed.), Aspects of Archaeology in Britain and Beyond, H. W. Edwards, 1951, p. 274.
- 11 R. J. C. Atkinson, Stuart Piggott and J. F. S. Stone, 'The excavation of two additional holes at Stonehenge, 1950, and new evidence for the date of the monument', *Antiquaries Journal*, vol. 32, 1952, pp. 14–20.
- 12 R. J. C. Atkinson, 'The date of Stonehenge', Proceedings of the Prehistoric Society, vol. 18, 1952
 [1953], pp. 236–7; O. G. S. Crawford, 'The symbols carved at Stonehenge', Antiquity 28, 1954, pp. 25–31; Atkinson, Stonehenge (note 10), pp. 43–7, 166–7; Homer, as quoted in J. H. Cheetham and John Piper, Wiltshire. A Shell Guide, 3rd edn., Faber, 1968, p. 161.
- 13 Atkinson, 'The date of Stonehenge' (note 12), p. 236.
- 14 Stuart Piggott and R. J. C. Atkinson, personal communication.
- **15** Atkinson, *Stonehenge* (note 10), especially chapter 3.
- **16** Ancient Monuments Board for England, *Report for 1956*, HMSO, 1957.
- 17 Correspondence between R. S. Newall and B. St J. O'Neil in Public Record Office WORK 14/1464, which

also contains other proposals for restoration.

- **18** *The Times*, especially 15 December 1954 and 28 February 1958.
- **19** Ancient Monuments Board for England, *Report for 1963*, HMSO, 1964, pp. 3–4.
- 20 This famous phrase, used by Piggott to discount an early date for Durrington Walls, had some special justification in that instance, as the date turned out to refer not to the henge but to an earlier settlement under its bank. Royal Commission on Historical Monuments (England), *Stonehenge and its Environs*, Edinburgh UP, 1979, p. 17.
- **21** Compare for instance Atkinson's 1956 chronology (*Stonehenge*, p. 101) and its radiocarbon re-casting of 1979 (*Stonehenge*, pp. 215–16).
- 22 Colin Renfrew, 'Wessex without Mycenae' (1969), reprinted in his Problems in European Prehistory, Edinburgh UP, 1979, pp. 281–92.
- 23 R. G. Newton and Colin Renfrew, 'British faience beads reconsidered', *Antiquity* 44, 1970, pp. 199–206; Anthony Harding and Stanley E. Warren, 'Early bronze age faience beads from central Europe', *Antiquity* 47, 1973, pp. 64–6; John Coles and Joan Taylor, 'The Wessex culture: a minimal view', *Antiquity* 45, 1971, pp. 6–14, Keith Branigan, 'Wessex and
- Mycenae: some evidence reviewed',
 WAM, vol. 65, 1972, pp. 89-107.
 24 Colin Renfrew, 'Wessex as a social
- question,' in *Problems* . . . (note 22), pp. 306-7.
- 25 Colin Burgess, *The Age of Stonehenge*, Dent, 1980, pp. 108-9.
- 26 Grahame Clark, 'The invasion hypothesis in British archaeology', *Antiquity* 40, 1966, pp. 172–89.
- 27 V. Gordon Childe, *Prehistoric Communities of the British Isles*, 2nd edn., W. and R. Chambers, 1947, pp. 145–6; *The Times*, 20 and 25 July 1953; *The Dawn of European Civilization*, 6th edn., Routledge & Kegan Paul, 1957, p. 336.

28 Piggott (note 5), p. 94.

- 29 Colin Renfrew, 'Wessex as a social question' (note 23), p. 307; Renfrew *Before Civilization*, Pelican edn., 1976, pp. 265–8.
- **30** Julian Mitchell, *Half-Life*, Heinemann, 1979; first performed at the National Theatre, London, in 1977 before transferring to the West End in 1978.
- 31 Timothy Darvill, Prehistoric Britain,

Batsford, 1987, pp. 88-9.

- 32 R.J.C. Atkinson, *Stonehenge*, Hamish Hamilton, 1956, pp. 154-8.
- **33** Darvill (note 31); M. Shanks and C. Tilley, 'Ideology, symbolic power and ritual communication: a reinterpretation of Neolithic mortuary practices', in I. Hodder (ed.), *Symbolic* and Structural Archaeology (Cambridge UP, 1982).
- 34 Darvill (note 31), p. 98.
- 35 C. Chippindale, 'Ambition, deference, discrepancy, consumption: the intellectual background to a postprocessual archaeology', in A. Sherratt & N. Yoffee (eds.), Archaeological theory: who sets the agendal: 27-36. Cambridge University Press, 1993.
- **36** A. Lawson, 'Stonehenge: creating a definitive account', *Antiquity* 66 (1992), 934-41.
- **37** M.W. Pitts, 'On the road to Stonehenge: report on the investigations beside the A344 in 1968, 1979 and 1980', *Proceedings of the Prehistoric Society*, vol. 48, 1982, pp. 75-132.
- **38** J.G. Evans et al, 'Stonehenge: the environment in the late Neolithic and early Bronze Age and a Beaker Age burial', WAM vol. 78, 1984, pp. 7-30.
- **39** P. Ashbee, M. Bell and E. Proudfoot. *Wilsford shaft*. English Heritage, 1989.
- **40** G.J. Wainwright and I.H. Longworth. *Durrington Walls: excavations 1966-*68. Society of Antiquaries Research Report 29, 1971. G.J. Wainwright, *The Henge Monuments*, Thames & Hudson, 1989, pp. 50-61.
- **41** RCHM(E), Stonehenge and its Environs. Edinburgh University Press, 1979.
- **42** J. Richards. *Stonehenge Environs Project*. English Heritage, 1990.

CHAPTER 14 (pages 220-31)

- 1 Douglas C. Heggie, *Megalithic Science*, Thames & Hudson, 1981, pp. 19-22.
- 2 Some of Newham's and Hawkins's observations were anticipated by G. Charrière, 'Stonehenge: rythmes architectureaux et orientation', *Bulletin de la Société Préhistorique Française*, vol. 58, 1961, pp. 276-9; R.J.C. Atkinson, 'The Stonehenge Stations', *Journal for the History of Astronomy*, vol. 7, 1976, pp. 142-4.
- 3 Gerald S. Hawkins, 'Stonehenge decoded', *Nature*, 1963; reprinted as an appendix to Gerald S. Hawkins with John B. White, *Stonehenge Decoded*,

Souvenir Press, 1965 (Fontana, 1970), pp. 209-14.

- 4 Hawkins with White (note 3), pp. 136-44, 168-72.
- 5 Hawkins with White (note 3), pp. 141, 143.
- 6 R.J.C. Atkinson, 'Moonshine on Stonehenge', Antiquity, vol. 40, 1966, pp. 212-16; also, 'Decoder misled', Nature, 1966, vol. 210, p. 1302.
- 7 Fred Hoyle, 'Stonehenge an eclipse predictor', *Nature*, 1966, vol. 211, pp. 454-6; 'Speculations on Stonehenge', *Antiquity*, vol. 40, 1966, pp. 262-74.
- 8 D.H. Sadler, 'Prediction of eclipses', *Nature*, vol. 211, 1966, p. 1119; R. Colton and R.L. Martin, 'Eclipse cycles and eclipses at Stonehenge', *Nature*, vol. 213, 1966, p. 476.
- 9 Hawkins with White (note 3), pp. 15, 180.
- **10** G. Moir, 'Hoyle on Stonehenge', *Antiquity*, vol. 53, 1979, pp. 124-9.
- 11 E.g. A. Thom, *Megalithic Sites in Britain*, Oxford, Clarendon, 1967, and *Megalithic Lunar Observatories*, Oxford, Clarendon, 1971.
- 12 A. and A.S. Thom, *Megalithic Remains in Britain and Brittany*, Oxford, Clarendon, 1978.
- 13 A.S. Thom, J.M.D. Ker and T.R. Burrows, 'The Bush Barrow gold lozenge', *Antiquity*, vol. 62, 1988, pp. 492-502.
- 14 Euan W.MacKie, *Science and Society in Prehistoric Britain*, Elek, 1977, pp. 2, 168.
- 15 Hawkins with White (note 3), p. 172.

CHAPTER 15 (pages 237-52)

- 1 R. J. C. Atkinson, *Stonehenge*, Pelican, 1979, p. 20; A. Thom, *Megalithic Sites in Britain*, Clarendon Press, 1967, pp. 164–5.
- 2 Since alternative archaeology has no single doctrine or founder, it has no formal date of beginning. 1967 was the year in particular of John Michell's first writing (in *International Times*), of his first book, and of course of the Californian counter-culture.
- 3 William Blake, *Jerusalem*, Trianon, 1952, plates 70, 100; Stuart Piggott, *The Druids*, Thames & Hudson, 1968, pp. 173–4.
- 4 Paul Screeton, *Quicksilver Heritage*, Thorsons, 1974, pp. 13–14.
- 5 A Forgotten Researcher: Ludovic McLellan Mann, Institute of Geomantic Research Occasional Paper no. 7, 1977.
- 6 William Irwin Thompson, 'The

future as image of the past', *Quest*, 1978, vol. 2, pp. 54–8.

- 7 Alfred Watkins, *The Ley Hunter's Manual*, Watkins Meter and Simpkin, Marshall, 1927, pp. 7–10, 54; John Michell, introductory note to new edition of Alfred Watkins, *The Old Straight Track*, Garnstone, 1970.
- 8 Paul Devereux and Ian Thomson, The Ley Hunter's Companion, Thames & Hudson, 1979, leys SW7 (pp. 123–5) and SW8 (pp. 126–9). Watkins himself ran the Lockyer axis as far as Puncknowle Beacon, a hill on the Dorset coast: Watkins, The Old Straight Track (note 7), pp. 104–6.
- 9 Aubrey Burl, *Rings of Stone*, Frances Lincoln, 1979, p. 81.
- 10 Screeton (note 4), p. 13.
- 11 Alexander Weaver Ebin, Seven Acts at Stonehenge, n.d.; Clyde Franklin Reed, Stonehenge of Salisbury Plain, 1965.
- 12 Tom Graves, Needles of Stone, Turnstone, 1978, p. 73.
- 13 Mollie Carey in the *Ley Hunter*, quoted in Elizabeth Pepper and John Wilcock, *Magical and Mystical Sites*, Weidenfeld and Nicolson, 1977.
- 14 John Michell, *The Flying Saucer Vision*, 2nd edn., Sphere, 1977, pp. 44–5, following A. P. Sinnett.
- **15** Michell (note 14); Michael Behrend, *The Landscape Geometry of Southern Britain*, Institute of Geomantic Research Occasional Paper no. 1.
- 16 Keith Critchlow, 'Notes on the geometry of Stonehenge with comments on the Ming Tang', in Mary Williams (ed.), Britain: a Study in Patterns, Research into Lost Knowledge Organisation, 1971, pp. 31–45; Louis Charpentier, The Mysteries of Chartres Cathedral, Research into Lost Knowledge Organisation, 1972; Lyle Borst, 'English henge cathedrals', Nature, vol. 224, 25 October 1969, p. 335.
- 17 Michell (note 14); John Michell, Ancient Metrology, Pentacle, 1981, pp. 35–45.
- 18 Mike Saunders, *Stonehenge Planetarium*, Downs, 1979; Arthur Shuttlewood, *UFO Magic in Motion*, Sphere, 1979, p. 50.
- 19 Michael Dames, *The Avebury Cycle*, Thames & Hudson, 1977, pp. 219–21.
- **20** Guy Underwood, *The Pattern of the Past*, Abacus, 1972, pp. 102–39. Tom Graves (ed.), *Dowsing and Archaeology*, Turnstone, 1980.
- 21 Michell (note 14), pp. 14, 152-4.
- 22 Shuttlewood (note 18); Arthur

Shuttlewood, More UFOs over Warminster, Arthur Barker, 1979.

- 23 John Aubrey, *Miscellanies*..., quoted in Michael Hunter, *John Aubrey and the Realm of Learning*, Duckworth, 1975, p. 132.
- 24 Desmond Leslie and George Adamski, Flying Saucers Have Landed, Neville Spearman, 1970: Screeton (note 4), p. 158; Shuttlewood, UFO Magic... (note 18), More UFOs ... (note 22), pp. 144–8. The 1977 film of Stonehenge UFOs was shown on Granada's Reports Extra programme.
- 25 Anthony Roberts, Atlantean Traditions in Ancient Britain, Rider, 1977; Sowers of Thunder, Rider, 1978.
 26 Stonehenge Viewpoint, especially
- the first-quarter issue, 1974.
- **27** Anthony Roberts, preface to Behrend (note 15).
- **28** Thompson (note 6); Critchlow (note 16), p. 40.
- **29** Thompson (note 6); Michael Behrend, introduction to Institute of Geomantic Research Occasional Paper no. 3, 1976.
- **30** See, e.g., George Terence Meaden (ed.), *Circles from the Sky*, Souvenir, 1991.
- **31** George Terence Meaden, *The Goddess of the Stones: the Language of the Megaliths*, Souvenir, 1991.
- **32** E.g. Marilyn French, *Beyond Power:* on Women, Men and Morals, Cape, 1985.
- **33** See Biaggi and Lobell's plan for a Goddess Mound, *Antiquity*, vol. 61, 1987, pp. 7-8.
- 34 Isobel MacBryde (ed.), Who Owns the Past?, Melbourne, Oxford University Press, 1985.
- 35 C. Chippindale, P. Devereux, P. Fowler, R. Jones and T. Sebastian, *Who owns Stonehenge*?, Batsford, 1990.
- **36** R. Jones in Who owns Stonehenge? (note 35), pp. 62-87.
- 37 P. Devereux, in Who owns Stonehenge? (note 35), pp. 35-61.
- 38 T. Sebastian, in Who owns Stonehenge? (note 35), pp. 88-119.

CHAPTER 16 (pages 251-63)

- 1 Official figures for the number of visitors admitted.
- 2 Public Record Office WORK 14/ 2138.
- **3** *The Times*, various dates April–July 1954.
- 4 Amesbury barrow 39 is a good example. Clear and high in early 19thcentury paintings, it was 3 feet in

height when recorded by Grinsell, but down to little more than a foot when excavated in 1960: Paul Ashbee, 'Amesbury barrow 39: excavations 1960', WAM, vols 74/5, 1981, p. 3.

- 5 For details, and for access to relevant newspaper cuttings, here and on following pages I am in debt especially to Mr Austin Underwood.
- 6 Helen O'Neill, describing the 1955 solstice.
- 7 Contemporary newspaper reports and personal communications, together with my own notes on things I have myself seen at Stonehenge over the years, are the principal source here.
- 8 P. Fowler, in C. Chippindale and others, *Who owns Stonehenge*?, Batsford, 1990, pp. 139-69.
- 9 Edward Cullinan Architects, in *Visions for Stonehenge*, English Heritage, 1993.

CHAPTER 17 (pages 264-72).

- 1 J. Hawkes, 'God in the machine', *Antiquity*, 41, 1967, p. 174.
- 2 F. Hoyle, 'Speculations on Stonehenge, *Antiquity*, 40, 1966, p. 274
- 3 It follows Atkinson, as supplemented and revised by Richards.
- 4 This suggestion, which I owe to Stuart Piggott, would attractively tie up the story.

Acknowledgments

A book of this nature is made possible by the many people whose work it describes and illustrates. My main acknowledgment must be to them.

Of personal debts, my first are to those who taught me archaeology, especially Peter Addyman, Brian Hope-Taylor, and the late David Clarke. For this book, I am grateful for their very considerable assistance to Anne Lowe, Professor Stuart Piggott, Professor R. J. C. Atkinson, and, for the relentless nature of his encouragement, to Professor Glyn Daniel. Many other friends, acquaintances and strangers have given information, advice or practical help. I thank them all, and for the especial care they have taken in particular: Ken Annable, Celia Applegate, Ashley Augier, Bernhard Baer, Jeremy Bagge, J. A. Bakker, Miranda Barker, Griselda Baer, Harold Beaver, Daphne Bennett, Alan Blyth, Desmond Bonney, Paula Breslich, Bruce Brubaker, Hugh Bulley, Paul Caponigro, Patrick Carter, John Chandler, Ruth Chippindale, Mark Cohen, Pamela Coleman, John Crabbe, Donald Cyr,

Ruth Daniel, Haydn Davies, Peter Draper, Margaret Ehrenberg, Barbara Fergusson, B. N. L. Fletcher, Harvey Freer, Peter Gautrey, Peter Goodhugh, Peggy Guido, Frederick Hallworth, Anthony Harding, John Harris, Richard Hatchwell, Gerald Hawkins, John Hawkins, Douglas Heggie, Gertrude Hermes, John Hewett, Christopher Hogwood, Brian Hope-Taylor, Tiffany Hunt, Andrew Hutton, Peter Lloyd Jones, Jesse Lawrence, James Lemoyne, Jorge Lewinski, Valerie Lloyd, I. F. Lyle, Betty Matthews, John Michell, David Mitchinson, Gordon Moir, Theya Molleson, John Newman, D. L. T. Oppé, Norman Parker, the late Eric Peters, Ernest Piini, Mike Pitts, Kate Pretty, R. B. Pugh, Maurice Rathbone, Colin Ridler, Paul Robinson, Ken Rogers, Peter Rushton, Richard Sandell, Peter Saunders, Judith Shackleton, Denis Shaw, Jan Smaczny, Isobel Smith, Norman Stevens, Sir John Summerson, Julian Trevelyan, Austin Underwood, Bill Vazan, Robin Wade, Derick Webley, Mrs L. J. de Wet, Emily Wheeler, Laurence Whistler, David Wills, Charlotte Wilson, David Wilson, Roger Wilson, Tim Wilson, Kenneth Woodbridge, and Andrew Wyld.

The Wiltshire Archaeological and Natural History Society's library, housed in its museum at Devizes, contains all kinds of rare and curious Stonehenge material, accumulated over more than a century. This has been a major source for curiosities otherwise lost or untraceable.

Mr L. V. Grinsell has kindly let me take over a collection of quoted Stonehenge material he had accumulated.

Unpublished material in the Public Record Office is Crown copyright, and reproduced by permission of the Controller of Her Majesty's Stationery Office. Unpublished material in the British Museum archives is referred to by permission of the museum.

Copyright owners, whom I thank for permission to reproduce illustrations, are given in the sources of the illustrations. I am also indebted to Faber and Faber Ltd and the estate of Siegfried Sassoon for permission to use the quotation on page 195 from his *Collected Poems 1908-1956*, Faber, 1961, p.179.

For advice with the new edition, I thank Aubrey Burl.

Sources of the illustrations

Sources of the illustrations are as follows. Diagrams not otherwise credited are by Martin Lubikowski. Photographs not otherwise credited are generally by the author. 'WANHS' indicates the collections of the Wiltshire Archaeological and Natural History Society in Devizes Museum, 'Salisbury' the Salisbury and South Wiltshire Museum.

COLOUR ILLUSTRATIONS

I William Smith, Stonehenge, watercolour from Particular Description of England, 1588. British Library. II J. Wood, Stonehenge, watercolour, 1736. Salisbury. III After David Loggan, oil on panel, late 17th century. Private Collection. IV James Bridges, Stonehenge, watercolour. Private Collection. v James Bridges, Stonehenge, watercolour. Private Collection. vi Anthony van Dyck Copley Fielding, Stonehenge, watercolour, 1818. WANHS. vII John Constable, Stonehenge, watercolour, 1835. Victoria and Albert Museum. VIII J. M. W. Turner, Stonehenge, watercolour, 1828. Private Collection, photo Breslich and Foss Ltd.

MONOCHROME ILLUSTRATIONS

Half-title page Photo Bill Brandt. Title page Photo British Travel and Holidays Association. Imprint page Sarsen Press, Redwood City, Ca. c. 1980. 1 From C. G. Harper, The Exeter Road, 1899.2 Ingram Pinn, pen drawing, 1979. Courtesy IPC Magazines. 6 Photo West Air Photography, Weston-super-Mare. 7 From Megalithic Remains in Britain and Brittany, A. and A. S. Thom, (C) Oxford University Press, 1978. 11 Taken by the RAF from Old Sarum air station, early 1920s. Salisbury. 12 Photo Edwin Smith. 13 Julian Trevelyan, Stonehenge, soft-ground etching, two colours, 1960. 14 From a 14th-century French romance, British Library Egerton MS 3028, fo. 140v. 15 From a 14thcentury history of the world, Corpus Christi College MS 194, fo. 57r. Courtesy Master and Fellows of Corpus Christi College, Cambridge. 16 Brian Hope-Taylor, pen drawing, c.1959, for Antiquity. Courtesy Antiquity. 17 John Speed, map of Wiltshire, c. 1625.

WANHS. 18 Engraving from John Smith, Choir Gaur, 1770. 19 Lucas de Heere, watercolour from Corte Beschryvinghe van England, Scotlande, ende Irland, 1573-5. British Library, Add. MS 28330. 20 Photo R. J. C. Atkinson. 21 Lucas de Heere, watercolour, from Corte Beschryvinge ..., British Library, Add. MS 28330, fo. 36. 22 'R.F.', Stonhing, engraving, 1575. British Library, Dept of Maps, pressmark 5785(2). 23 Stonehenge, on Salisbury Plain . . ., watercolour, early 19th-century. Private Collection. 25 After R. J. C. Atkinson and P. A. Hill. 28 Photo Austin Underwood. 29, 30 Edmund Prideaux, watercolours, 1716. Collection Prideaux-Brune, photos National Monuments Record. 31 Sketch by John Aubrey in Monumenta Britannica as reproduced in William Long, Stonehenge and its Barrows, 1876. 32 From I Dieci Libri dell'Architettura di M. Vitruvio . . ., 1556, book 5. British Library. 33 Pen drawing, undated, British Museum. 34, 35 From Inigo Jones, Stone-heng Restored, 1725 edition. 36 Etching by W. Hollar, c. 1640. 37 From Johan Picardt, Korte Beschryvinghe van eenige Vergetene en Vorbegene Antiquiteten . . ., 1660. British Library. 38 From Olaus Worm, Danicum Monumentorum . . ., 1643, book 1. British Library. 39 Engravings by David Loggan, late 17th century. Salisbury. 40 From J. Britton, Memoir of John Aubrey, 1845. 41, 42 Photos British Tourist Authority. 43 Drawing by John Aubrey as lithographed by Harry Sandars for William Long, Stonehenge and its Barrows, 1876. 44 From Henry James, Plans and Photographs of Stonehenge and of Turusachan in the Isle of Lewis, 1867. 45 After Aubrey Burl, The Stone Circles of the British Isles, 1976. 46 Engraving by T. Kip from W. Camden, Britannia, 1695. 47 Engraving, late 18th-century. Salisbury. 48-51 From William Stukeley, Stonehenge, 1740. 52 J. Bridges, watercolour. Salisbury. 53 E. J. Burrow, pen and wash, c.1910. WANHS. 54 J. Carter, engraving, 1786, after his own sketch of 1781. Salisbury. 55 The Methuen Collection, Corsham Court. 56 The Trustees of Sir John Soane's Museum. 57, 58 From William Stukeley, Stonehenge, 1740. 59 From Archaeologia, vol. 8, 1787. 60 William O. Geller, The Druid's Sacrifice print, 1832. Salisbury. 61 Coloured aquatint from Samuel Rush Meyrick and Charles Hamilton Smith, The Costume of the

Original Inhabitants of the British Isles, 1815. 63 From Inigo Jones, Stoneheng Restored, 1725 edition. 67 Postcard, c.1910. Wiltshire County Council. 68 Thomas Cole, detail of The Arcadian or Pastoral State, oil, 1836. Courtesy of the New York Historical Society, New York City. 69 Artist unknown, Stonehenge, watercolour, 1790. Private Collection. 70 Herbert Pugh, Stonehenge, watercolour, early 19th century. City of Manchester Art Galleries. 71 From J. Hassell, Tour of the Isle of Wight, 1790. British Library. 72 Stone Henge, in Wiltshire, engraving published by Alexander Hogg, 19thcentury. Swindon Museum. 73 Engraving by William Byrne after watercolour by Thomas Hearne. Salisbury. 74 Thomas Rowlandson, Stonehenge, watercolour, c.1784. Salisbury. 75 John Constable, Stonehenge, drawing, 1820. Victoria and Albert Museum. 76 John Constable, Stonehenge, drawing, c.1835. Courtauld Institute Galleries, London (Witt Collection). 77 John Constable, Stonehenge, watercolour, c.1835. British Museum. 78 Thomas Girtin, Stonehenge, watercolour, 1794. Ashmolean Museum, Oxford. 79 Engraving by Robert Wallis after watercolour by J. M. W. Turner, 1829. British Museum. 80 William Marlow, Stonehenge, oil, late 18th century. Vancouver Art Gallery. 81 J. M. W. Turner, sketchbook drawing, 1811-13. British Museum. 82 Mezzotint by David Lucas after a drawing by John Constable, 1845. Victoria and Albert Museum. 83 J. M. W. Turner, Stonehenge at Daybreak, pen and wash, 1816-17. British Museum. 84 J. Bridges, watercolour, 1829. Salisbury. 85 Henry Thomson, Distress by Land, oil, 1811. National Trust, photo Courtauld Institute of Art. 86 James Barry, King Lear mourning the dead body of Cordelia, oil, 1786-8. Tate Gallery, London. 87 Engraving after watercolour by Samuel Palmer, The Lonely Tower. Victoria and Albert Museum. 88 Thomas Jones, The Bard, oil, 1774. Courtesy National Museum of Wales. 89 Philip Crocker, watercolour. National Trust. 90 Engraving, c. 1797. Salisbury. 91 Engraving after Philip Crocker, mid-19th-century. British Library. 92 Philip Crocker, Group of Barrows, South of Stonehenge, watercolour, c.1802. WANHS. 93 Drawing attributed to Joseph Windham, 1802. WANHS. 94 Philip Crocker, Urn

found in Barrow No. 1, watercolour, c.1802. WANHS. 95 Engraving by James Basire, Barrows on Lake Down, after watercolour by Philip Crocker, from Richard Colt Hoare, Ancient Wiltshire, vol. 1, 1810-12. 96 Philip Crocker, Tumuli xxIII, Stonehenge, watercolour. National Trust. 97 Sir Richard Colt Hoare's barrow tokens. National Trust. 98-100 From Richard Colt Hoare, Ancient Wiltshire, vol. 1, 1810-12. 101 Philip Crocker, watercolour map, c.1802. WANHS. 102 Print, late 19th century, WANHS. 103 From Thomas Smith, Sporting Incidents in the Life of Another Tom Smith, 1867. British Library. 104 From A. H. Layard, Nineveh and its Remains, 1849. 105 From Henry Barth, Travels and Discoveries in North and Central Africa..., vol. 1, 1857. British Library. 106 Photo Dept of the Environment, Crown Copyright Reserved. 107 Photo Marburg. 108 From J. D. Hooker, Himalayan Journals, vol. 2, 1854. British Library. 109 From Henry James, Plans and Photographs of Stonehenge ..., 1867. 110 Engraving, late 19thcentury. British Library. 111 From Charles Darwin, The Formation of Vegetable Mould, 1881. 112 Watercolour, early 19th century. The Trustees of Sir John Soane's Museum. 113 From Norman Lockyer, Stonehenge and other British Monuments Astronomically Considered, 1909. 114 Inn-sign, Farmer Peck's Hotel, Johannesburg, by J. Stockenberg, late 19th-century. Africana Museum, Johannesburg. 116 Early-19th-century models. WANHS. 117 From M. D. Mulock, A Life for a Life, 1859. WANHS. 118 B. C. Pugh, Interesting fossil found at Stonehenge, July 4 1885, watercolour. Private Collection. 119 R. Sedgfield, calotype, 1853. Reproduced by gracious permission of Her Majesty the Queen. 120 Photo, late 19th century. Wiltshire County Council. 121 From The Leisure Hour, 13 October 1853. 122 Barbara Boudochon, Afternoon 'A Sketch', watercolour, c.1870. Courtesy the Mistress and Fellows of Girton College, Cambridge. 123 Menu card, watercolour, 1880. WANHS. 124 Photo, 1877. BBC Hulton Picture Library. 125 Poster, 1896. WANHS. 126 William and Henry Barraud, The Wiltshire Great Coursing Meeting held at Amesbury, March 16, 17, 18, 19 and 20, 1847, oil, 1847. Private Collection. 127 Photo c.1895. Wiltshire County Council. 128 J.

Brown, watercolour. Salisbury, photo David Robson. 129 Engraving, early 19th-century. Great Bustard Trust. 130 Lithograph, c.1896. WANHS. 133 Seal, late 19th-century. Wiltshire County Record Office. 134 From Punch, 30 August 1899. 135 From the Graphic, 3 September 1898. WANHS. 136 From Wiltshire Times, 1902. WANHS. 138 WANHS. 139 From Archaeologia, vol. 58, 1905, fig. 10. 140, 141 WANHS. 142 Salisbury. 143 'Japanese' print, c.1900. Courtesy Stuart Piggott. 144 Imperial War Museum. 145 Courtesy British Army. 146 Fuller of Amesbury, postcard, c.1914. 147 From Archaeologia, vol. 60, 1907, pl. LXIX. 148, 149 Southampton Public Library. 150 Photo, 1979. Courtesy Bruce Brubaker. 151 Photo, 1920, Wiltshire County Council. 152 Photo, c. 1930. Courtesy Alexander Keiller Museum, Avebury. 153 Heywood Sumner, watercolour, c.1925, Salisbury. 154 Salisbury. 155 Cambridge University Collection, copyright reserved. 156 After Atkinson. 158 Photo, 1924. National Monuments Record, Air Photographs Collection. 159 Photo G. S. M. Insall, 1925. National Monuments Record Collection. 161 Public Record Office. 162 Pamphlet, 1943. WANHS. 163 Photo, c.1922. Wiltshire County Council. 164 Public Record Office. 165 Badge, c.1950. WANHS. 166 Architect's drawing, c. 1930. National Monuments Record. 167 Trade-mark, Avon Tyres, c.1930. Courtesy Avon Rubber Co. Ltd. 168 Edward Bawden, c. 1931. WANHS. 169 From Osbert Lancaster, Here of all Places, London, 1959. 170 E. McKnight

Kauffer, Stonehenge see Britain first on Shell, coloured lithograph, 1931. Reproduced by kind permission of Shell UK Ltd. 171 Photo, c.1944. Imperial War Museum. 172 From Antiquaries Journal, vol. 32, 1952, p.17. 173 Photo Austin Underwood. 174, 176 Photos J. F. S. Stone. 177-179 Photos Austin Underwood. 180 From Colin Renfrew, Before Civilization, 1973, fig. 21. 181 After Renfrew. 182 From Colin Renfrew, 'The Megalith Builders of Western Europe', fig. 3, in Antiquity and Man. ed. J. D. Evans et al., 1981. 183 Drawing by Stella Clarke. 184 From Lawson, 185 Photo West Air Photography, Weston-super-Mare. 186 Elizabeth James. 187 Salisbury Museum. 188 Photo John Evans. 189 From RCHM(E), Stonehenge and its Environs. 190 From J. Richards, The Stonehenge Environs Project, fig. 12, detail. 191 Ancient Monuments Laboratory, English Heritage. 192 Jane Brayne. 193 From J. Richards, The Stonehenge Environs Project, fig. 155D. 195, 196 After Wood. 197 After Hawkins. 198, 199 From Douglas Heggie, Megalithic Science, 1981, ills. 40, 41. 200 Bill Vazan, 6th circle, 1977. Courtesy Bill Vazan. 201 Photo J.M. Gorrie. 202 From A. and A.S. Thom, Megalithic Remains in Britain and Brittany, 1978, fig. 11.. Copyright Oxford University Press. 203 Woodcut by Kenneth Woodbridge, c. 1935. 204 Advertisement, 1981. Courtesy Pentax UK Ltd. 205 Advertisement, 1977. By permission of Gallaher Ltd. 206 From William Stukeley, Abury, 1743. 207 Commemorative medal, 1843. British Museum. 208, 209. From William Blake, Jerusalem, 1804. British Museum, 211 From Paul Devereux and Ian Thomson, The Lev-Hunter's Companion, 1979. 212 Jan Zrzavy, oil, 1937. WANHS. 213 After John Michell, Ancient Metrology, 1981. 214 Courtesy Athena International/Jimmy Cauty. 215 Courtesy Pan Books. 220 From Antiquity, vol. XI, 1937. 221 From C. Maclagan, The Hillforts, Stone Circles and other Structural Remains of Ancient Scotland, 1875. 222 Drawing by David Alexovich, from L.E. Stover and B. Kraig, Stonehenge and the Origins of Western Culture, 1979. 223 Haydn Llewellyn Davies, Homage, 1974. The Lambton College of Arts and Technology, Sarnia, Canada. 224 Norman Stevens, coloured etching, 1976. Courtesy Norman Stevens. 225 Courtesy George Wingfield. 226 Courtesy Dragon Project Trust. 227 Photo, 1978. Courtesy Jennie Wade. 228 Photo Austin Underwood. 229 Henry Moore, Cyclops, lithograph, from his Stonehenge suite, 1971-3. Courtesy Henry Moore Foundation. 230, 232, 233 Photos Austin Underwood. 234 Photo Norman Stevens. 235 Courtesy RESCUE. 236 Photo, 1968. Daily Telegraph. 237 Photo, 1979. Dept of the Environment. 239 Courtesy Carry Akroyd. 240 Courtesy Edward Cullinan Architects. 241 After Stonehenge and its Environs, 1979. 242 After Atkinson. 244 WANHS. 245 Dept of the Environment, Crown Copyright Reserved. 246 After Stonehenge and its Environs, 1979. 249 From cover of map of Ancient Britain, 1964. Ordnance Survey. 250 Cartoon by Dan Piraro, 1993. © Chronicle Features.

Index

Numerals in roman type (123) refer to pages in the text. Numerals in italic type (123) refer to the black-and-white illustrations and their numbered captions, and Roman figures (xu) to the colour illustrations on pages 49-56 and their captions. Many subject entries take the form of sub-entries to 'Stonehenge'

Abraham 85, 86, 234 Abury (Stukeley) 206 acupuncture system, of earth 241 advertising 162, 204, 205 Aeneas 20 aeroplanes, early 175, 146 Africa 22, 42, 64, 134, 105 air photography, early 175, 187, 188, 147, 158 Akrovd. Carry 239 Albert, Prince 119 Albion 20, 86, 234 Alexander Neckham 24 Alton Towers 88 Ambrius, Mount 22 Amesbury 10, 22, 29, 40, 48, 115, 119, 142, 146, 156, 157, 164, 176, 258 Amesbury (Mass.) 44 Ancient Monuments Acts 160-1, 164, 174, 186 Ancient Order of Druids see Druids. modern Ancient Wiltshire (Hoare) 107, 118, 123, 124, 129, 89 Annals (Tacitus) 48-57, 83 Antediluvians 146, 147 Antiquity 16 antler-picks 47, 168, 267, 187 Antrobus, Sir Edmund: 2nd Bart. 157; 3rd Bart. 159-62, 126; 4th Bart. 162, 164-6, 172, 174, 176, 179 Arabia 130 Arbor Low 129, 188, 237, 106 Ariosto 24, 37 Arminghall 188 arrowheads 188 Arthur, King 24, 37 ASL monoplane 175 Astor, John Jacob 174 astronomy see Stonehenge - astronomy Atkinson, Richard 169n, 185n, 201, 202, 204, 210, 215, 223, 253, 268, 25, 156, 173, 178 Atlantis 62, 134, 198 Aubrey, John 28, 46, 47, 66-71, 82, 85, 181, 241, 31, 39, 43 Aubrev holes see Stonehenge individual features Aurelius Ambrosius 22, 24, 26, 27, 129, 15

Avebury (Abury) 40, 66-8, 69, 72, 79, 92, 94, 126-8, 129, 146, 168, 174, 183, 198, 237, 240, 3, 42 Avebury, Lord see Lubbock, John Avenue see Stonehenge – individual features Avon, river (Bristol) 29, 268, 156 Avon, river (Hampshire) 10, 29n, 40, 134, 142, 146, 3, 25, 157 Avon Rubber Co. 167

Baldwin, Stanley 193 balloons 175, 147 Barbaro, Daniele 57 Barber, Horatio 175 Bard (Jones) 109, 88 Barraud brothers 126 barrows 28, 33, 34, 35, 36, 43, 68, 81, 83, 157, 158, 199, 216, 251-3, 268; chippings in 78, 122, 158, 183; digging by Cunnington 114-15, 121-2, 216, 92; digging by others 43, 47, 76-8, 129, 216; finds from 93, 94, 96-8; long 114-15, 123, 129, 240, 265; N and S 15; types 114, 122-3, 129, 91; and see Boles and Bush barrows barrow-tokens 120-1, 97 Barry, James 109, 86 Barth, Henry 134 Bath 37, 68, 81, 92, 94, 98, 119, 64 batter-dashers 47, 31 'Battle of the Beanfield' 259 Bawden, Edward 168 beads 78, 199, 200, 89 Beakers 211, 215, 183, 188 Beamish, Capt. 161 Beauties of Wiltshire (Britton) 113 Beddington, Jack 168, 170 Bede 20, 24 Behrend, Michael 239 **BEMA 204** Bender, Barbara 263 Bennett, Arnold 193 Birth of Merlin (Rowley) 26 Bladud, King 94 Blake, William 234, 87, 207-9 Blavatsky, Madame 248 Blow, Detmar 167 bluestones see under Stonehenge construction and materials and Boles Barrow Boadicea 61, 68 Bogles 230 Boles Barrow 186, 267, 157 Bolsterstone 129 Bolton, Edmund 61, 62 Borrow, George 112 Boudochon, Barbara 122 Bournemouth 27 Bowra, Sir Maurice 210 Brandt, Bill half-title Brayne, Jane 192

Bridger, Mr 131 Bridges, James 109, IV, V Brimham Rocks 88 Britannia (Camden) 29, 36, 41, 43, 71 Britannia Antiqua Illustrata (Sammes) 64 Britannia Baconica (Childrey) 66n British Association 161 British Museum 131, 147, 174, 194 Britons, ancient, as perceived 48-57, 83, 85, 90, 128-9, 234, 19 Browne, Caroline, Henry and Joseph 143-7, 159, 198 Brunel, Isambard Kingdom 267 Brut see Geoffrey of Monmouth Brutus 20 Buckingham, Duke of 47 Buckland, Len 253 Buckland, William 143, 146 Bulford 40, 148, 162 burials at Stonehenge: ancient 182, 201, 215, 188; modern 174, 190, 204, 253 Burke, Edmund 96 Burl, Aubrey 230 Burritt, Elihu 148 Bush Barrow 123, 199, 227, 228, 48, 98 bustard, great 157, 129 Byron, Lord 121 Byron, Robert 186

Cairnpapple Hill 201 Callanish 135, 44 Camden, William 29, 36, 41, 43, 61 Carlyle, Thomas 152 Carnac 130, 201 Carnarvon, Lord 156 car-parks 195, 215, 229, 238, 251, 262-3, 265,236 Castle Ditches 236, 211 Caxton, William 25 Cecil, Lord David 204 Celtic fields 219, 193 chalk plaques 215, 186 Charles I, King 47, 62 Charles II, King 66-8, 71 Charles, Prince of Wales 258 Charleton, Walter 61-2, 66 Chatterton, Thomas 105-7 Childe, Gordon 209 Childrey, Joshua 66n Chilmark 181 Chippendale, Thomas 119 Chronicle of England (Caxton) 25 Chubb, Cecil 176, 180 Church of the Universal Bond see Druids, modern Churchill, Winston 171 Chyndonax 82, 86, 58 Cibber, Susannah 27 Cicero 36 Cil-maen-Llwyd 185, 186 Civitates Orbis ... (Hoefnagel) 33, 36

Clearbury Ring 237, 211 Clerk, John 45, 85 Coelus 57 Cole, Thomas 68 computer, Stonehenge as 223 concert at Stonehenge 153, 125 Coneybury Hill 217, 191, 192 Constable, John 103-5, 107, VII, 75-7, 81 'Convoy' 259 Conway, Marshall 88 Corte Beschryvinghe... (de Heere) 33-5, 19 Cosmo the Third 65 Cotworth, Moses 198 counting the stones 45-6, 47, 72, 90, 141 Course of Empire (Cole) 68 coursing 126 Cow Down 236 Coxe, William 115, 118, 119 Craik, Mrs 112 Crawford, O.G.S. 187, 193 cricket 128 Crocker, Philip 107, 118, 120, 124, 89, 92, 94-8, 101 crop circles 244, 225 Crowley, Aleister 248 Cuckoo Stone 267 Cullinan, Edward, Architects 262-3, 240 Cunliffe, Sir Noel 210 Cunnington, B.H. 186 Cunnington, Henry 161 Cunnington, William 113-25, 142-3, 186, 93, 100 curative powers of stones 44 Cursus 76, 79, 83, 158, 201, 211, 236, 238, 241, 265, 50, 101, 184, 190; Lesser Cursus 265 custodians in 19th century 143-8, 159, 160.164.118 'Cyclops' (Moore) 223 Cyr, Donald and Annette 242

Dames, Michael 240 Danby, William 88 Danes 42, 61, 70, 84, 38 Daniel, Samuel 42 Darvill, Tim 211 Darwin, Charles 128, 136, 111 Davies, Haydn 223 De Antiquitate ... (Leland) 29 Dee, John 248 Defoe, Daniel 45, 96, 98, 186 Denmark see Danes Department of the Environment 251, 258 'Description of Stonehenge' 65 Devereux, Paul 248 devil 26-7, 40, 42, 45, 65, 66, 93, 141-2, 65 Devil's Den 26 diffusion 208-9, 210-11, 214 Diodorus Siculus 61, 83 Distress by Land (Thomson) 109-12, 85

Diviaticus 81 dolerite 185, 204 Dorchester 201 dowsing 240-1 Dragon Project 248, 249, 226 Drew, Sergeant 175 Druidical Antiquarian Company 146 Druids, ancient 105, 150, 151, 234, 272, 274, 59, 60, 61, 110, 160; Aubrey on 71, 72; in classical writings 62, 83-4; Jones on 48; and Romantics 88-95, 234; Stukeley and 82-6, 125, 58, 61; Wood on 92-5 Druids, modern 81, 86, 172-4, 176, 190, 193, 198, 248-9, 253, 260-1, 142, 161, 163, 233; burials 174, 190, 204 Druid's Head 98, 142 Druid's Temple (Goss) 27 Dryden, John 61-2 Duke, Edward 119, 95 Durrington 219, 236, 237, 267, 137 Durrington Walls 18, 209, 216, 229, 268, 189 dwarves 135 dysse 61, 38

earth mystery studies 248 earthworms 136, 111 eclipse forecasting at Stonehenge 225, 198-9 Eden 162 Egypt 75, 131, 134, 140, 166, 168, 198, 199, 200, 240, 242 Eliot, Thomas 29 Emerson, Ralph Waldo 152 Engleheart, George 182 English Heritage 258, 262-3 Erith. Mt 22 etymology of 'Stonehenge' 10, 20-1, 84, 85 Evans, Arthur 134, 140, 179 Evans, J.G. 215 Evelyn, John 45, 46-7 Even Cowgirls ... (Robbins) 274 evolution 128, 136

faces in the stones 216-19 'Faerie Queene' (Spenser) 25-6 faience 199, 200, 209 fairs at Stonehenge 43, 153 Fargo 43, 158, 175, 201 Farmer Peck's Hotel 114 Farwell, Mr Justice 165-6 feminism 244-5, 274 fences 161, 164, 166, 253, 132, 136 Fenton, Richard 119, 120, 142-3, 99 Fergusson, James 128 festival 257-61 Fielding, Copley v1 field-walking 216-19 Fiennes, Celia 45, 98

First World War 175-6, 179, 192 Flood, Biblical 143-6 'Foamhenge' 263 Folkerzheimer, Herman 29-30, 35, 18 follies 85, 88, 62 and see replicas Formation of Vegetable Mould (Darwin) 136 Frankenbury Camp 237, 211 'French Stonehenge' (Carnac) 130 Fyfield 38, 40, 24, 27 Gale, Roger and Samuel 71, 72, 75, 81, 82.85 Galliard, John 26 gallows 20, 33 Garden, James 69 gematria 240 Geoffrey of Monmouth and the Brut 22, 24-6, 29, 33, 40, 64, 84, 129, 15; disbelieved 25, 27-8, 37; recent opinions 139-40, 180, 186, 242 George V, King 193 Gerald of Wales 24 giants 22, 28, 33, 42, 64, 66, 37, 215 Giants Round (Dance, Ring) 22, 23, 25, 36,242 Gibson, Edmund 71 Gielgud, Sir John 210 gift to nation 176, 180 Gilpin, William 99-100 Girtin, Thomas 105, 78 Gladstone, W.E. 152 Glastonbury 239, 240, 241 Glisson, Dr 60 Goethe, Johann 141 Golden Age 234 Goss, John 27 Gough, Richard 64 Gowland, William 167, 180, 201, 138-41, 184 great bustard 157, 129 Greece, Greek: classical 19, 65, 71, 74, 94, 128, 198-9, 20; and see Mycenae grey wethers 40, 66 and see sarsens Grovely Castle 236, 211 Grovely triangle 140, 236, 113 'Gulag', Stonehenge as 259-61, 239 Half-Life (Mitchell) 210, 214 Halley, Dr 79, 91 hammering at stones 47, 72, 91, 98, 122, 136, 159, 47 Hardy, Thomas 112, 175 Harington, John 37, 41 Harwood, Dr 81 Hassell, Mr 71 Hawkes, Jacquetta 264 Hawkins, Gerald 220, 223, 225, 230, 197, 198 Hawley, Colonel William 180-3, 193, 201, 202, 264, 152, 154, 184 Hayns, Richard 79-81 Hayward, Thomas 43, 75, 79, 86 Heale House 47

Hearne, Thomas 102, 103, 73 'Hebridean Stonehenge' 44 Hecataeus 83n Heere, Lucas de 33-5, 36, 1, 19, 20, 21 henges 188, 199, 211 and see Woodhenge etc. Hengist 20, 22, 25 Henry of Huntingdon 20, 24 Hercules 65 'Heritage' (Akroyd) 239 hermit 88 Hevtesbury 99, 113, 115, 118, 120, 186 High Court 165-6 Hill, Samuel 150 Hill, William Burroughs 148, 149 Himilco 65 Historia Regium Britanniae (History of the Kings of Britain) see Geoffrey of Monmouth Hoare, Richard Colt 118-25, 126, 146, 89, 94 Hoefnagel, Joris 33, 36 Hogg, Thomas 72 Holborn Drollery 65 Holland 33-5, 61, 37 'Homage' (Davies) 223 Homer 203 Hooker, Joseph 130, 108 Hope-Taylor, Brian 202, 16 Hoyle, Sir Fred 225, 199 hunebedden 61, 37 Hunt, Gaffer 90-1, 93 Hyde Park 88 Hyperboreans 83n

IBM computer 223, 230-1 Insall, G.S.M. 188, 159 'Insectogram' crop circle 225 Ireland 22, 25, 29, 40, 42, 69, 130, 199 'Irish Stonehenge' 129

Jackson, W. 194 James I, King 47, 48 James, Henry 135, *109* Japan 168 *Jerusalem* (Blake) 234, *207-9* Jewel, Bishop 30, 35 Johannesburg *114* Johnson, Dr 96 Jones, Inigo 46, 48-57, 60, 62, 65, 66, 79, 118, 199, *32-5*, 63 Jones, Rhys 248 Jones, Thomas 109, *88* Judd, William 147-8, 152, 159, 160, *118*, *120*

Kauffer, E. McKnight 170 Keiller, Alexander 193, 166 Kerrig y Druidd 70 Khasia 130-1, 108 Killaraus, Mt 22 *King Lear Weeping*...(Barry) 109, 86 Knook 113

Lake 119, 120, 152, 95 Lambarde, William 36-7 Lancaster, Osbert 169 Lardner, G.A. 173 Larkhill 103n, 175, 190, 262-3 lavatories 251, 257 Lavengro (Borrow) 112 Lavard, Austen 131 Leisure Hour 150, 152, 121 Leland, John 29, 61 Leman, Thomas 114, 119, 122, 123-4 Lennon, John 249 Leopold, Prince 124 Lesbians rule 66 Lesser Cursus 265 leys 198, 236-8, 113, 211 Lhwyd, Edward 69 Libby, Willard 201 Library of Congress 10 Life for a Life (Craik) 112, 117 Lilye, Master 29 Llantwit Major 239 Lockeridge 40 Lockyer, Norman 140, 220, 236, 237, 113 Loggan, David 72, III, 39 Lonely Tower (Palmer) 87 Long Barrow Cross-roads 211 Lubbock, John (Lord Avebury) 126, 158, 160, 164 Lubbock, Lady 136

Mackie, Euan 229 Magheraghanrush 129 magic powers of Stonehenge 44 magnetism 79 magnetometer survey 191 Magpie Musicians 153, 125 Malton, James 102 Mann, Ludovic McLellan 198, 234 'March of the Druids' (Hain) 173 Marlborough 37, 38, 40, 81, 168 Marlow, William 105, 80 Marshall, General 171 Maryhill 141 Masham 88, 62 mauls, sarsen 168, 181, 140 medals 207 megalithic astronomy 225-7 and see Stonehenge: astronomy megalithic geometry, mathematics, science, units of length 226-30, 202 megalithic monuments 61, 69-70, 88, 129-31, 172, 226-9 and see stone rings and individual sites mensuration 74-5, 86, 91, 136-7 Merlin 22, 24, 25, 26-7, 29, 37, 40, 142, 186, 205, 14, 214

Merlin ... (Theobald) 26-7 Meyrick, Samuel 61 Michell, John 239, 240, 213 midsummer see summer solstice Midsummer Hill 239 Milford Haven 185-6, 201, 156 military 103n, 175, 241, 259, 135, 137, 144, 145, 156, 157 Mitchell, Julian 210, 214 models 146, 147, 183, 55, 56, 116 Montacute House 47 Montagu, Lord 258 Monumenta Britannica (Aubrey) 68, 71, 181, 39 moon alignments 220-2, 227, 230, 196, 197 Moore, Henry 229 Moore, Thomas 152-3 Most Notable Antiquity... (Jones and Webb) 48 museum at Stonehenge 193, 166 music 26-7, 173 Mycenae, Mycenaeans 134, 199-200, 202-3, 205, 208-9, 107, 174, 175 Myres, J.L. 134 National Trust 164, 176, 193, 195, 251,

253, 262-3 Natural History (Pliny) 83-4 Nennius 20 Newall, R.S. 181, 182, 193-4, 202, 204-5, 273 Newdigate Poetry Prize 150 Newdyk, Robert 44, 47 Newgrange 227, 228 Newham, 'Peter' 222, 225, 227, 229, 197 Niagara Falls 148 Nimrud 131, 104 Normanton Down and barrows 76, 123, 158, 190, 251, 253, 265, 52, 99 and see **Bush Barrow** Northcote, Stafford 128 numbering system for stones 12n, 14n, 15n 'Nurtiung Stonehenge' (Khasia) 131

Old Sarum 30, 142, 148, 182, 187, *18*; ley 237, 211 'old straight track' *see* leys Ordnance Survey 135, *109*, 244 *Orlando Furioso* (Ariosto) 24, 37 Owen, William 114

Palgrave, William 130 Palmer, Samuel 87 Park Place 88 Parker, John and Stephen 118, 123, 98 Particular Description ... (Smith) 35 Patterns of the Past (Underwood) 240 Pembroke, Earls of 47, 60, 72, 75, 76, 115, 52 Pepys, Samuel 47 Peter's Mound 227, 229 Petrie, Flinders 12n, 136-7, 164, 166, 180 Phillips, Robert 47 Phoenicians 42, 64-5, 66, 86, 92, 134, 172 photography, early 147-8, 152, 179, 109, 119,120 picnics 152, 160, 121, 124 picturesque 99-100, 107 Piggott, Stuart 199, 201, 204, 179 Piraro, Dan 250 Pitt-Rivers, General 160-1 Pitts, Mike 258 Pliny 71, 83-4 poetry 25-7, 42, 45, 62, 65, 90, 98, 102, 112, 119, 120, 150-2, 157, 173, 175, 193, 195, 121 Polanski, Roman 112n police 160-1, 164, 136, 141 Polydore Vergil 25, 27, 28 port, bottle of 181 Postern Gate, Mycenae 134, 107 Powys, Mrs 91 Pre-historic Times (Lubbock) 126 Preseli 185-6, 187, 155, 156 preselite 185 Prince of Wales, Charles 258 Pueckler-Muskau, Prince 141 Pugh, Herbert 70 Queensberry, Dukes of 43, 115, 143, 157 Quinta 88 rabbits 75, 79, 114, 160, 162 Radio Caroline 257

radiocarbon 201, 205, 208-9, 229, 265-71, 242 and see Stonehenge - date railway 148, 158-9, 130 Rastell, John 27 Ray, John 45 Reid, George MacGregor 190, 163 Religious Tract Society 143, 152 Renfrew, Colin, Lord 208, 210, 180 replicas 160, 190, 148, 150 RESCUE 235, 237 'R.F.' 36, 43, 22 rhyolite 185, 204 Richards, Julian 216 rights-of-way 164-6, 175, 190 roads near Stonehenge, closing 190, 194-5,262-3 Robbins, Tom 274 Roberts, Anthony 242 Robin Hood's Ball 211, 265, 268, 25 rocking-stone at Stonehenge 88 Rollright Stones 69, 71-2, 84, 90, 46, 132 Rome, Romans 60, 65, 70, 74, 123, 134, 205, 272; and building of Stonehenge 29, 30, 48, 57, 94, 128-9, 137, 139, 198-9; finds at Stonehenge 79-80, 114, 122, 168, 180, 181, 198; sites 33, 35, 113, 114, 136

Rowlandson, Thomas 102, 74 Rowley, Thomas 26 Royal Society 79, 91

sacrifices, human 83, 86, 95, 134, 135 St James's, Westminster 47-8 St John's College, Oxford 65 St Paul's Cathedral 10 St Paul's, Covent Garden 60, 36 Salisbury 10, 29, 30, 47, 141-2, 148, 176, 194 Salisbury Cathedral 28, 35, 96, 99, 141, 153, 237-8, 18, 211 Salisbury Plain 10, 26-7, 42, 46-7, 72, 98-107, 112, 142, 150, 157, 198 Salmon, Thomas 150-2 Sammes, Avlett 64-5 Sanctuary 188 Sandby, Paul 102 Sarsen Press imprint page sarsens: building in 38-40, 26, 27; source of 37-40, 124, 267, 24; and see Stonehenge - construction and materials Sassoon, Siegfried, 186, 195 'sausage-roll' view 36, 23 Saxons 20, 22, 25, 28, 49, 66, 70 Sebastian, Tim 248 Sedgfield, R. 119 senams 134, 105 sheep and shepherds 43, 47, 72, 98, 99, 105, 143, 148, 151, 157, 29, 52, 69, 114 Shepherds Bush 160 Shuttlewood, Arthur 241 Sidbury Hill 140, 236 Sidney, Philip 44 Silbury Hill 68, 203, 210, 240, 41, 182 Sirius 140 '6th Circle' (Vazan) 200 Smeeth, 'Sikher' 148 Smith, Mr 190 Smith, Charles Hamilton 60 Smith, John 92, 95 Smith, Len 242 Smith, Reginald 240 Smith, William (geologist) 124 Smith, William (topographer) 35, 36, 1 Soane, John 112 Society of Antiquaries 72, 118, 161, 167, 179, 182 Society of Roman Knights 82, 85, 233 solar alignments see solstice, summer and sun alignments solstice 'gap' 175 solstice, summer 30, 43, 92, 95, 172, 211, xIII; astronomy see Stonehenge astronomy; modern Druids 190, 204, 255, 233; as a public spectacle 156, 255, 259-61, 231-3 Soul, John 190 Southampton 160, 253, 148, 149 Southern TV 253

Sowerby, James 124 Spain-Dunk, Susan 27 Speed, John 43, 17 spelling of Stonehenge 20, 35 Spenser, Edmund 25-6 Stanton Drew 69, 75, 84, 90, 93, 94, 66 Stevens, Jocelyn 258 Stevens, Norman 224 Stone, Herbert 40 Stone, J.F.S. 201 stone rings 69-70, 71-2 Stone-heng Restored (Jones and Webb) 48, 60, 66, 32-5 Stonehenge - astronomy 220-31; early 92; eclipse cycle and prediction 223-5, 198, 199; Heel Stone and 112, 137, 139, 140, xIII, 65; Lockyer 140; moon's movements 190; obliquity of ecliptic 139; Petrie 137-9; and siting of Stonehenge 199; Station Stones 139, 220, 222, 223, 225, 227, 197; and statistics 220, 226, 229-30; Stukeley 79; summer solstice 75, 79, 137-40, 172, 220, 229, XIII, 30, 195; and see Hawkins, Hoyle, Newham, Thom Stonehenge - builders: antediluvians 146, 198; British 66, 70, 172; Danish 61; devil 66; Druids 70, 85-6, 135; dwarves 135; eastern 92, 131; exotic and foreign 60, 62-3; giants 28, 66; Merlin 22, 25, 14; Phoenicians 64-5, 66, 134; Romans 29, 30, 48, 57, 94, 128-9, 137, 139, 198-9; Saxons 66 Stonehenge - construction and materials: artificial stone 27-8, 36; bluestone 14, 46, 201, 204, 268-71; bluestone circle 14, 177; bluestone horseshoe 15; bluestone lintels 161, 186, 271, 176, 247; bluestone trilithons 14, 271; built of marble 135; construction methods 75, 113, 166, 167-9, 181, 102-3, 245; easy to build 37, 131; entasis 18-19, 198, 200, 12; geometry (Jones) 49, 34; (Thom) 227, 202; and levitation 239, 212; lintels 12, 36, 40, 180; mortice-and-tenon joints 12, 14, 33, 37, 168, 7, 247; moving stones 131, 168, 25; (by magic) 22, 24, 25, 42; petrology 72, 79, 124, 185; phases of 267-71; precision of design 19, 43-4, 198-9; rudeness of design 71, 96; sandstone, green 15; sarsens, source of 37-40, 124, 267, 24 and see sarsens; shaping stones 12, 16-17, 168-9, 12, 243, 244; siting of Stonehenge 10-11, 74; toggle joints 20; trilithons 14, 34, 40, 102, 105 Stonehenge - date 24, 60, 79-80, 81, 94,

122, 123, 137; Bronze Age 126-8, 137,
140, 186, 198-201; by astronomical orientation 139-40; by chippings in barrows 78, 122, 126, 158, 183; by
Mycenaean connections 199-200, 203;

by radiocarbon 201, 205, 208-9, 229, 265-71, *242*; Neolithic 129, 168, 169, 183; of two dates 124-5, 137, 198-9; phases 267-71 *and see* Stonehenge – builders

- Stonehenge excavation 184; by Atkinson, Piggott and Stone 201-4, 214, 179; by Beamish 161; by Cunnington 113-14, 117, 122, 124, 181; by Duke of Buckingham 47; by Gowland 167-9, 244; by Hawley 179, 180-3; by Pitts 258, 237; by Stukeley 75; lost finds 47, 76-8, 92, 114n, 51; reburied finds 194; Roman finds 79-80, 114, 122, 168, 180, 181, 198; 'Stonehenge layer' 167-8, 180; surviving finds 168, 193-4, 264, 187
- Stonehenge fall of stones: (1797) 102, 105, 113, 146, 90; (1900) 164, 136; (1963) 205; and see Stonehenge – restoration

Stonehenge - individual features: Aubrey holes 18, 181, 182, 183, 190, 194, 201, 220, 223-5, 267, 268, 153, 154, 172, (as eclipse predictor) 225, 198, 199; Avenue 15, 75-6, 79, 83, 139, 140, 187, 201, 236, 240, 253, 267, 268, 271, 49, 158, 184, 190; axis 15, 139, 236, 267; bank and ditch 15, 34, 181, 182, 188; barrows, N and S, 15, 11; burials, ancient 182, 201, 215, 188; burials, modern 174, 190, 204; carvings, prehistoric 10, 202-3, 205, 208-9, 174, 175; carvings, recent 159, 20, 131; causeway 15, 182; counterscarp 18, 11; A-H holes, 223; Q and R holes 268; Y and Z holes 18, 182, 198,271

Stonehenge - individual stones: Altar 15, 46, 57, 79, 83, 90, 92, 95, 117, 185, 240, 271, 248; Heel 15, 36, 75, 92, 95, 238, 240, 245, 260, 267, 268, 11, 81, 219 (and summer solstice) 112, 137, 139, 140, xIII, 65; missing 12, 14-15, 33, 46, 57; number of 10, 45-6; numbering system 12n, 14n, 15n; numbers (1) 180; (2) 180; (3) 202; (4) 202; (6) 179; (7) 179; (11) 16, 270; (22) 164, 205; (23) 205; (29) 180; (30) 180; (36) 176; (53) 202, 20, 174, 175; (55) 168, 169, 248; (56) 34-5, 105, 166-7, 169, 180, 12, 138-41, 244; (57) 113, 202; (58) 113; (59) 243; (68) 166, 169; (91) 268; (92) 139; (93) 139, 268; (94) 222; (122) 164; (150) 186; (156) 88, 248; (158) 113; Slaughter 15, 36, 95, 112, 117, 181, 240, 268-70, 10; Stations 15, 139, 220, 222, 223, 268; and see under Stonehenge astronomy

Stonehenge and the public: access 164-6, 253, 258-9, 262-3; Americans 152-3; approach to 11-12, 142-3; 'attending illustrator' 147-8; car-parks 195, 215, 238, 251, 265, 236; concert 153, 125; coursing 126; cricket 128; early tourists 29-30, 46-7, 72, 90, 93, 18, 29, 30, 39, 69; fairs 43, 153; Gaffer Hunt's stall 90-1; guidebooks, early 91; lavatories 251, 257; litter 159, 168; numbers of 90, 159, 195, 251; souvenirs 160, 115; Victorian 141-56; walking on lintels 75, 232, 233; and see counting the stones, custodians in the 19th century, fences, festival, hammering at stones, picnics, picturesque, police, rights-of-way, roads near Stonehenge, Salisbury Plain, sheep and shepherds, Sublime, summer solstice

- Stonehenge purpose: Asiatic solar temple 92; Boadicea's tomb 62; cargo cult to UFOs 241; collecting animals 134; crowning kings 61-2; Eden 162; grand orrery 92; Hindoo temple 131; images the world 94, 240, 213; lawcourt 90; magick circle 92; megalithic harvest hill 240; memorial to Aurelius Ambrosius 22-4; observatory see Stonehenge - astronomy; royal tomb 27, 139-40; sacrificial place 92, 95; sexmachine 238; shaped as a crown 27, 29; shaped as a yoke 30; solar temple 172; temple of Boodh 92; temple of the moon 94; tropical temple 92; trophy of victory 65; and see Stonehenge builders
- Stonehenge restoration 115, 161, 166-7, 179-82, 204-5, 151, 178
- Stonehenge (NSW) 44
- Stonehenge (Atkinson) 204, 214
- Stonehenge ... ('Mouldy') 112
- Stonehenge (pastoral) 65
- Stonehenge (Spain-Dunk) 27
- Stonehenge (Stukeley) 85-6, 92 and see Stukeley, William
- Stonehenge Aerodrome 175, 187, 192, 163
- Stonehenge archive 215
- Stonehenge Bottom 215, 184
- Stonehenge cable 258, 237
- Stonehenge Café 192, 195, 164
- Stonehenge Cricket Club 128
- Stonehenge Decoded (Hawkins and White) 220, 223, 230
- Stonehenge Environs Project 216, 184, 190, 193
- 'Stonehenge for Sale' 162, 165, 176
- Stonehenge Inn 137
- 'Stonehenge layer' 167-8, 180
- Stonehenge ley 236, 211
- 'Stonehenge of the North' 129
- Stonehenge urn 115, 118, 93, 94
- Stonehenge Viewpoint 246
- 'Stonehenges' elsewhere 129-31
- Stourhead 118, 125
- Stukeley, William 14, 36, 38, 71-81, 122,

123, 187, 201, 233, 48-50, 207; and Druids 82-6, 95, 57, 58, 206; and see Druids, ancient and modern Sublime 74, 75, 91, 96, 98-9, 105, 142, 157, 80 Sudbury Camp 211 Sumner, Heywood 153 sun alignments 220-2, 227, 228, 230, 195, 197 Swift, Jonathan 46 Symonds, Richard 38-40

'table of metall' found at Stonehenge 29, 71,272 Tacitus 48-57, 83 Tempest (Shakespeare) 228 'Templa Druidum' (Aubrey) 71, 82 Tess of the d'Urbervilles (Hardy) 112 Thatcher, Lady Margaret 214 Theobald, Lewis 26 Thom, Alexander 225-8, 229, 245, 201 Thom, Archibald 227 Thomas, H.H. 185 Thomson, Henry 111, 85 three-age classification 123, 126-8 Thurnam, John 128, 129, 156 toads 44 Toland, John 85 'Tongan Stonehenge' 130 Trevelyan, Julian 12 Tripoli 134, 105 Trotman, Mrs 47 Troy 20, 65 Turner, J.M.W. 105, 107, viii, 79, 82, 83 Tuscan order 57, 60, 65, 36

UFOs 62, 241, 242, 214 Underwood, Guy 240-1 United States of America 44 Utherpendragon 22, 23

Vail, Isaac 242 Vazan, Bill 200 Vespasian's Camp 81, 272 Victoria, Queen 152 *Vindication*... (Webb) 62 Vitruvius 57, 60, 74 volcanic ash 185 Volckins, Eli 160 Vortiger, Vortigern 22, 24, 25 Vortimere 25

Wace 24 Wales, Prince of, Charles 258 Wallies of Wessex 257 Wansdyke 81, 83, 53 Wansey, Hen 92 Warminster 241 Washington, Sir Lawrence 44 Watkins, Alfred 236, 237, 239, 245 Webb, John 48, 61, 62, 74, 115, 118 Wedd, Tony 241 Welsh language 70, 85 Wessex Archaeological Unit 214 Wessex culture 199, 202, 208-9, *181, 182* West Amesbury 44, 47, 187, 271 West Kennet 40 Westropp, Hodder 128 Wheeler, Sir Mortimer 210 White, John *19* White, J.B. 223 William of Newburgh 24 William of Orange 65 Wilsford shaft 216 Wilson, Daniel 128 Wilton 42, 45, 47, 48, 142 Wiltshire County Council 164, 133 Wiltshire Masonic Bowling Association 165 Wimpole Hall 88 Winchelsea, Lord 74-5, 82 Windmill Hill 268 Wood, George π Wood, John 92-5, 64, 66 Woodforde, Samuel 113, 124-5 Woodhenge 188, 268, 159 Woodhouse Park 160 Woodyates 81, 123 Wookey Hole 94 Woolcot, Mrs 152 Wordsworth, William 98 World Archaeological Congress 245-8 Worm, Olaus 61, 38 Wren, Christopher 38 Wyndham, H.P. 114, 115, 186